MEDIEVAL ART

MEDIEVAL ART
A Topical Dictionary

LESLIE ROSS

Greenwood Press

WESTPORT, CONNECTICUT • LONDON

Library of Congress Cataloging-in-Publication Data

Ross, Leslie, date.
 Medieval art : a topical dictionary / Leslie Ross.
 p. cm.
 Includes bibliographical references and index.
 ISBN 0–313–29329–5 (alk. paper)
 1. Art, Medieval—Dictionaries. 2. Christian art and symbolism—
To 500—Dictionaries. 3. Christian art and symbolism—Medieval,
500–1500—Dictionaries. I. Title.
N7850.R67 1996
709'.02'03—dc20 96–160

British Library Cataloguing in Publication Data is available.

Library of Congress Catalog Card Number: 96–160
ISBN: 0–313–29329–5

First published in 1996

Greenwood Press, 88 Post Road West, Westport, CT 06881
An imprint of Greenwood Publishing Group, Inc.

Printed in the United States of America

The paper used in this book complies with the
Permanent Paper Standard issued by the National
Information Standards Organization (Z39.48–1984).

10 9 8 7 6 5 4 3 2 1

Contents

Preface

This dictionary has been designed to provide a quick reference source for identifying and comprehending the subjects, stories, symbols, and themes frequently represented in early Christian, western medieval, and Byzantine art. Identifying and understanding the subject matter of works of art is a critical stage in art historical analysis and interpretation as well as in general appreciation of art. The entries in this dictionary provide information about pictorial subjects, terms, signs, and symbols and also include descriptions of texts and authors whose works were frequently illustrated or who provided inspiration for the visual arts during the Middle Ages. The purpose of this dictionary is thus to provide readers with basic information about the main subjects and interests found in western and Byzantine art of the medieval period.

The entries cover topics relevant to the beginnings and development of Christian pictorial arts in the first centuries A.D. up through the fifteenth century late Gothic period in the west, and, for the Byzantine world, the 1453 fall of Constantinople. Pictorial topics listed in this dictionary include many subjects, names, and narratives drawn from the Bible, the Apocrypha, the lives of saints, and numerous other texts, as well as entries explaining general subjects (such as ANIMALS, SYMBOLISM OF). The reader will also find entries identifying art historical terminology (such as ZOOMORPHIC DECORATION), historical events of importance for the arts (such as ICONOCLASTIC CONTROVERSY), and concepts significant for the general understanding of medieval art (such as TYPOLOGY).

The focus of this dictionary is on Christian pictorial art. Terminology specific to architecture will not be found in this dictionary, nor topics exclusive to medieval Jewish or Islamic art. Although many of the topics covered are by no means restricted to the medieval period, this dictionary concentrates on the distinctive ways in which the pictorial subjects were represented in the Middle Ages.

The entries themselves are preceded by an introduction which contains a short

chronological overview of medieval periods and art styles. This information was designed to provide a general historical framework and includes definitions of terms such as *Romanesque* and *Gothic*. Readers are encouraged to use the introduction to supplement and illuminate information in the entries. The introduction also includes comments on the evolution of Christian pictorial imagery and a general description of the types and categories of subjects found with greatest frequency in medieval art. Bibliographic information is found within the introduction as well as in listings at the end of the book.

The dictionary entries themselves are organized in an alphabetical format with a system of cross-references designed to direct readers to additional and related topics. Alternate titles are indicated so that a reader searching for KISS OF JUDAS, for example, will be directed to the entry BETRAYAL OF CHRIST. Within each entry, cross-references are signalled by asterisks at the first occurrence of the relevant words. Related topics are frequently indicated by *See also* suggestions.

At the conclusion of most of the individual entries, the reader will find one pictorial *example* listed plus abbreviated directions to the source where the example may be found illustrated. The choice of examples was thus governed by a desire to assist readers in easily locating pictorial imagery for sample or comparative purposes. The examples chosen generally typify fairly clearly the points suggested in the entries, and the illustration sources listed are, with some exceptions, largely standard texts on medieval art, such as should be available in public or university libraries. In a very few cases, the examples listed postdate the medieval period; in these cases, examples were chosen, based on ready pictorial availability, which still typify medieval conventions. A key to the abbreviation systems used in these example citations can be found preceding the introduction. Because the examples listed are keyed to these sources, and because only one example is listed per entry for quick reference purposes, the reader is reminded that the examples chosen are selected from among many, and often variant, other examples.

Acknowledgments

This project could not have been accomplished without the generous assistance of Sister Barbara Green, O.P., Professor of Biblical Studies at the Dominican School of Philosophy and Theology, Graduate Theological Union, Berkeley. Sister Barbara's expertise with the scriptural materials covered in this dictionary and her unfailing patience as a consultant and reader have not only kept this work progressing at a timely pace through several years but have also shaped the final results. I am deeply indebted to Sister Barbara for her many levels of guidance, help, and encouragement.

I have also profited from the assistance and suggestions of other readers including my colleague at Dominican College, Sister Patricia Dougherty (Chair, History Department) who kindly read and offered corrections on a number of entries. Dr. Barbara DeMarco, of the *Journal of Romance Philology* at the University of California, Berkeley, offered many helpful suggestions on numerous entries dealing with hagiography and literature. And Sister Marguerite Stanka, O.P., kindly reviewed my entries dealing with Arthurian material.

I would also like to express my thanks to Dr. Katherine Henderson, Vice President for Academic Affairs at Dominican College, for supporting and encouraging faculty research and development. A great portion of the research represented in this dictionary was completed during my sabbatical leave from Dominican College. I owe great thanks to Dr. Henderson for her role in creating a sabbatical leave policy at Dominican College and to the Professional Development and Faculty Welfare Committee at Dominican for their support.

Many thanks are also due to Marilyn Brownstein, formerly Senior Editor at Greenwood Press, for first suggesting this project to me, and to Alicia Merritt of Greenwood for her support and encouragement in seeing this project through to completion.

The support of many other friends and family members has been invaluable. My deepest thanks as well are due to my parents for their continued encouragement and to Jim Richmond for his endless patience in offering moral and technical support.

Introduction

CHRONOLOGICAL SURVEY

This book focuses upon the subjects and symbols found in art produced during the early Christian and medieval periods—a vast span of time with somewhat inexact and variously defined chronological limits. The centuries with which this book is concerned are, in most general terms, those which follow the "classical" period and which precede the "Renaissance."

The difficulty with setting more precise starting and ending dates for the Middle Ages is related to the problems of determining (or agreeing), for example, exactly when the Renaissance began (generally understood to be earlier in Italy than in northern Europe) and exactly when the classical period can be said to have concluded. Such chronological or stylistic designations as *late antique* and *proto-Renaissance* may be confusingly synonymous or contemporary with periods such as *early Christian* and *late Gothic*.

Setting aside such chronological debates, the topics referenced in this dictionary are drawn in from a very wide net—covering the first appearances of Christian subject matter in art in the first centuries A.D. up through the mid-fifteenth century. The 1453 date of the fall of Constantinople has been used as a convenient cut-off point for Byzantine art, while topics relevant for the late medieval art of northern Europe through the mid-fifteenth century are also included.

Within this range of well over 1,000 years of art and history, the reader of this dictionary will find references to specific periods, such as Carolingian, Romanesque, and Gothic. Many of these terms are used by art historians not only to indicate historical periods but also to describe styles. Hence, there is again some imprecision in the use and interpretation of these terms. While some scholars may hold that the *Gothic* period began in the mid-twelfth century with the architectural renovations of the Parisian abbey of Saint Denis, other scholars

have carefully pointed out that the specific elements combined to create the Gothic style not only predate the mid-twelfth century but also were not suddenly and comprehensively adopted through Europe after the 1140s. While some scholars may date the beginnings of the Renaissance period in Italy to the c.1300 paintings of Giotto, the fourteenth-century art of northern Europe generally maintains a decidedly different character—for which the term *late Gothic* has been generally chosen as a far more appropriate designation.

For the purposes of this dictionary, the term *early Christian* has been used to refer to the centuries before and after the emperor Constantine's Edict of Milan in 313—which signalled the end of persecution of Christians and the beginning of official toleration of Christianity within the Roman empire. Artistic evidence from this period comes in many forms and styles—works of art which maintain a very classical flavor, as well as works with more symbolic and schematic interests. Jewish iconographic traditions also provided much of the content and many of the themes found in the earliest Christian art, setting an important and lasting foundation for the development of Christian art through the Middle Ages. Sarcophagi, small-scale sculpture, and catacomb frescoes were all produced before the early fourth century and continued to be produced thereafter. The acceptance of Christianity in the early fourth century allowed for the creation of large scale and public architecture; these early churches were then decorated with frescoes and mosaics. It is in the early Christian period that many of the subjects and symbols found throughout medieval art were first developed.

The sack of Rome in 410 by the Visigoths and the deposition of the last western Roman emperor in Ravenna in 476 represent dramatic political events for the west which may be used to signal the transition to the *early medieval* period. The term *early medieval* is used in this dictionary to refer to the several centuries following the end of the western Roman empire until the reconsolidation of territory and political control under the early Carolingian rulers. This period, from the late fifth until the mid-eighth century, has received various alternate designations in other sources. The term *Dark Ages* has been avoided here for these centuries which represent the continuation of the *Migration period* when various cultural groups were on the move into and settling in western Europe. This age saw the creations of the kingdoms of the Franks (in central Europe), the Lombards (in Italy), and the Visigoths (in Spain). This was a period of great expansion for the Christian religion, significantly marked also by the growth and development of western monasticism under the Rule of Saint Benedict (composed in the early sixth century). Christian missionaries such as Saint Augustine (of Canterbury), who was sent to England in 597 under the direction of Pope Gregory the Great, spread the practice and influence of Roman Christianity widely throughout and beyond the confines of the old western Roman empire. The Christian art produced in the early medieval period in the British Isles may also be designated by the terms *Hiberno-Saxon, Insular,* or as productions of the *Northumbrian Renaissance.* Beautifully illustrated manuscripts

and liturgical objects in metalwork which combine Christian symbolism and subject matter with native styles of interlace and zoomorphic decoration are characteristic of the northern productions of this period.

This early medieval period also represents the age of the foundation and rapid expansion of Islam, initiated by the prophet Muhammad (571–632), as well as the continuity of the eastern Roman empire centered at the capital of Constantinople (formerly Byzantium). The official separation of the western and eastern parts of the Roman empire had occured in the late fourth century; and although the Byzantine emperor Justinian (who reigned from 527 to 565) attempted and briefly achieved some reunification of territories, the disintegration of the western empire in the early medieval period contrasts with the greater stability and continuity of the Byzantine empire during these centuries. The sixth and seventh centuries for the eastern empire are thus often referred to as the *First Golden Age* of Byzantine art. This was the era of magnificent architectural constructions such as the church of Hagia Sophia in Constantinople, the creation of brilliant works in mosaic and small-scale sculpture, as well as the production of icons and illustrated manuscripts in the now traditional book (or codex) form.

The eighth and ninth centuries were periods of political turmoil, invasions, and the Iconoclastic Controversy in the Byzantine world (during which time the creation of pictorial art was questioned and indeed halted). This time span is roughly contemporary with the political reconstruction, territorial expansion, and flourishing of the arts associated with the Carolingian Renaissance in the west. The rise to power of the Carolingian dynasty began within the Frankish (Merovingian) kingdom in the seventh century and reached a peak during the period of the emperor Charlemagne (768–814) and his son Louis the Pious. The arts produced during the Carolingian period reflect the official dominance of Benedictine monasticism, classically oriented scholarship, and the ecclesiastical and educational reform policies of Charlemagne and his heirs. Small-scale sculpture, large-scale wall paintings, and illustrated manuscripts (produced at divergent and primarily monastic centers) copy as well as expand upon the pictorial vocabulary developed in the preceding centuries—representing a synthesis of classical, Germanic, and Christian elements.

The mid-ninth century for Byzantium, with the official reversal of iconoclastic policy, ushered in the *Second Golden Age of Byzantine art,* associated with the rule of the Macedonian dynasty (through the early eleventh century) followed by the Comnene rulers (through the mid-thirteenth century). During this period in the west, internal and external disintegration seen in the mid-ninth century division of the Carolingian empire (843), coupled with the invasions of the Vikings, Saracens, and Hungarians, resulted in a short period of turmoil and decline until the rise to power in Saxon Germany of the Ottonian rulers. From the early tenth century, leaders such as Otto I (936–973) and his Salian successors of the eleventh century recreated the vast and powerful *Holy Roman Empire*. Pictorial arts associated with the Ottonian period show renewed interest

in and the further development of complex Christian symbolism, as well as the expansion of narrative illustrations (especially Christological) and typological programs.

The period of the *High Middle Ages* in the west may be dated from the mid-eleventh through the thirteenth centuries and further divided into the Romanesque (eleventh through mid-twelfth century) and Gothic period (mid-twelfth century onward). The terms *Romanesque* and *Gothic* are largely convenient as designations of architectural style; in simplest terms, the heavy, dark, and round-arched structures of the Romanesque period (as seen in many monasteries throughout Europe and perhaps especially in the churches created along the pilgrimage routes to Santiago da Compostela) exhibit an architectural vocabulary and ambiance which is altered by the combined use of pointed arches, rib vaulting, and flying buttresses in the Gothic period. In the twelfth and thirteenth centuries, churches become taller and more light filled; stained glass windows and exterior sculpture abound. The pictorial arts associated with the Romanesque and Gothic period underwent similar stylistic evolution and change, while also exhibiting a vast number of regional influences and distinct styles (e.g., the complex typological programs associated with metalwork and manuscripts produced in the Mosan region, and the elegant Parisian *Court style* associated with the mid-thirteenth-century period of Louis IX).

For the Byzantine world, this was also a period of renewed turmoil and the shrinkage of the Byzantine empire under the invasions of the Seljuk Turks. The reconquest of territories captured by the expanding Islamic world inspired a series of responses from the west, beginning with the First Crusade in 1095. The Christian reconquest of Islamic-controlled territories in Spain, ongoing through this period, resulted in important victories by the early thirteenth century, leaving only the Muslim kingdom of Granada as the last Moorish stronghold in western Europe from 1248 until the final defeat in 1492. Western *Crusader States* were established in the *Holy Land* regions (e.g., Palestine) through the thirteenth century, and from 1204–1261, western rulers reigned over Constantinople itself. The reestablishment of Greek rule over the diminished Byzantine empire was effected by the Palaeologue dynasty, ushering in another and final phase of Byzantine art production until the final capture of Constantinople by the Ottoman Turks in 1453.

Concurrently, the late medieval period in the west was also characterized by warfare, religious disputes, and the disastrous epidemic of the bubonic plague (or *Black Death*) which swept through Europe beginning in the mid-fourteenth century. Although the proto-Renaissance period may be said to have begun in Italy c.1300, the fourteenth-century decimation of population had far-ranging social, economic, and religious consequences which are also reflected in the visual arts. Increasingly sober, moralistic, and mystical themes as well as images designed to inspire and fulfill intense and personal devotional needs developed during these decades. These interests were reflected well into the fifteenth century, along with and often assimilated into the elegant and courtly works of the

International Gothic style of the late fourteenth and fifteenth centuries when precious and costly objects in all media were created for wealthy and elite patrons while the Italian Renaissance continued to evolve and expand into northern Europe.

THEMATIC SURVEY

Although many centuries and art styles are involved with the time span covering the early Christian through late medieval period, a number of unifying factors are evident as well. The topics, themes, and symbols referenced in this dictionary are primarily associated with the Christian religion—at first simply "tolerated," then declared (by the late fourth century) as the "official" religion within the vast Roman empire. The growth and expansion of Christianity through the following centuries, both within and beyond the geographical confines of the empire, firmly established the dominance of the Christian religion in western medieval Europe and the Byzantine world. The primary subject matter of medieval and Byzantine art is thus Christian, though it may also be further categorized into several groups and types.

Illustrations of events from the life of Jesus Christ, the founder of Christianity, appear quite early in Christian art. Such subjects may be termed *Christological*—a useful designation for both independent subjects and those which appear in narrative cycles. Depictions of the birth, ministry, and miracles performed by Jesus during his lifetime reflect the concerns of early Christians during the initial centuries of legitimization and codification of scripture and doctrine.

The early funerary arts associated with Christian burial practices, such as catacomb frescoes and carved sarcophagi, show narrative scenes as well as a variety of symbolic devices used to signal concepts as well as to represent abbreviated stories. Devices such as the *Chi-rho* monogram, loaves and fishes, vines and grapes, triumphal victory wreaths, and the *Good Shepherd,* may also be seen to derive, in various ways, from the previously developed pictorial vocabularies of the pre-Christian, classical, and Judaic world.

Stories well familiar to early Christian converts were frequently drawn from the Old Testament and reflected the Jewish foundations of the new religion. Themes of salvation and God's miraculous intervention on behalf of believers were certainly of special relevance during the periods of persecution of Christians. These stories continued to provide inspiration and frequent pictorial subject matter through the Middle Ages.

The use of Old Testament subject matter and the interest in symbolism already found in the early Christian period provide foundations for a number of guiding principles found throughout medieval art and theology. Of greatest importance is the interest in connection making between the Old and New Testaments, which is a fundamental principle of early and medieval Christianity. The articulation, in literature and the visual arts, of allegorical linkages between the Old and New Testaments is known as *typology*. Events and concepts from the Old

Testament were assiduously correlated with episodes and teachings contained in the New Testament. This complex network of Old Testament prefigurations and New Testament fulfillments continued to engage and preoccupy authors and visual artists from the early Christian period and throughout the Middle Ages.

Illustrations of subjects drawn from the Old Testament, representations of Christological themes and narratives, and the development of symbolic devices all form important (and frequently overlapping) categories in the arts produced during the Middle Ages. To these must also be added the illustration of events from the lives of saints and the representation of episodes from the life of Mary, the mother of Jesus. Both *Marian* and *hagiographical* subjects appear in the early Christian period and continue to develop and increase in the following centuries.

The veneration of saints (beginning originally with the martyrs of the persecution periods) resulted, from the early centuries onward, in an enormous production of hagiographic literature and art. Scenes from the lives of saints are found in an enormous variety of media, ranging from small-scale objects or pilgrimage tokens associated with their shrines to large-scale compositions in wall painting and stained glass. Manuscripts containing texts and narrative illustrations of the lives of individual saints as well as illustrated books containing texts and pictures concerning a number of saints were widely produced during the Middle Ages. A number of the texts and images devoted to saints also have thematic and pictorial linkages with Christological subjects, although saints may generally be recognized through the use of particular iconographic attributes, symbols, or relatively unique narrative episodes.

Works of art focusing upon the Virgin Mary developed in frequency and complexity through the medieval period. Given the title *Theotokos* ("Mother of God") in the early fifth century, Mary features initially in representations with the infant Jesus and in other Christological contexts. As the centuries progressed, Mary also began to appear in cycles and scenes which focused upon her own birth and childhood as well as her death, assumption, and coronation in heaven. These narratives were supplied not only by apocryphal texts but were also supplemented by a growing body of mystical and devotional writings dedicated to Mary, reflective of the growth of the *Cult of the Virgin* in the High Middle Ages. Scenes involving her husband, Joseph, and her parents, Anne and Joachim, similarly expand upon the narratives supplied in the canonical Gospels.

The textual sources for the pictorial arts of the medieval period are wide and varied. The Old and New Testaments (including the numerous apocryphal works), texts from classical antiquity, hagiographical compositions, and the writings of theologians, historians, mystics, philosophers, poets, and encyclopedists all provided inspiration for the visual arts. Astronomy and astrology, geography and natural history, moralizing, didactic, and devotional treatises were all influential in creating and consolidating the interconnected subjects, symbols, themes, and topics illustrated in medieval art.

BIBLIOGRAPHIC SURVEY

Virtually without exception, the medieval art topics referenced in this dictionary may also be found described in a number of other sources. The bibliography at the conclusion of this volume represents simply a selection of the numerous books, articles, and encyclopedias in which information about medieval art subjects may be found. In many cases, individual articles and entire books have been devoted to a number of the topics which have been treated far more briefly in this present volume. Readers desirous of more detailed information on specific topics are encouraged to consult the bibliographic suggestions at the end of this dictionary, and all readers are reminded of the function of this volume as a quick reference tool. Consultation of numerous reference sources is a critical requirement for research in any field and may especially be the case in areas such as medieval studies, which have occupied numerous scholars for many decades.

The selected bibliography at the conclusion of this book has been divided into three categories. The first section contains general reference sources such as dictionaries, encyclopedias, handbooks, and comprehensive texts covering medieval art in general. The second section lists sources dealing with particular periods and specific art media. Finally, the third section of the bibliography contains a list of books and articles dealing with specific subjects and themes in medieval art. Readers interested in topics such as botanical or animal symbolism, the representation of the Labors of the Months, depictions of the Virtues and Vices, illustrations of specific texts, and studies of marginal imagery in medieval art will find detailed studies referenced in the third section of the bibliography. Readers interested in specific periods or media (Gothic sculpture, Romanesque manuscripts, Byzantine icons, art of the early Christian period) will find the second section of the bibliography most useful. The general sources and comprehensive texts listed in the first section of the bibliography are fundamental reference tools containing detailed information on specific topics as well as surveys of periods and styles.

The sources listed in the bibliography as a whole range widely in date, scope, and purpose. This reflects the ongoing process of scholarly debate, revision, and reassessment that enlivens our studies. A number of the older sources listed in the bibliography have provided essential foundations for the continuing study of medieval art—either through offering materials and ideas to be questioned and disputed by successive scholars or through providing preliminary information which has been expanded in the increasingly detailed studies of single periods and themes.

Among the general reference sources listed in the first section of the bibliography will be found standard works such as James Hall's *Dictionary of Subjects and Symbols in Art* and George Ferguson's *Signs and Symbols in Christian Art*. These are excellent sources for medievalists, although references such as

these represent more comprehensive coverage than the principles which guided the creation of this present volume. Works such as Hall and Ferguson include information not only relevant for the medieval period but also for the classical and postmedieval periods. Such information has been excluded here to allow a greater focus upon the Middle Ages. Magisterial studies such as Gertrud Schiller's *Iconography of Christian Art* and the venerable but dated set of Louis Réau's *Iconographie de l'art chrétien* include detailed descriptions, lengthy listings, and (in Schiller) copious illustrations of immense usefulness, although the scope of these studies also transcends the medieval period specifically. Several of the numerous sources concerning saints listed in the first section of the bibliography similarly include postmedieval materials within the individual entries. These hagiographic dictionaries remain essential sources, however, from which the researcher may sift the information purely relevant to the Middle Ages. More wide-ranging reference tools including entries on all aspects of medieval history and culture, such as the thirteen-volume *Dictionary of the Middle Ages,* have also been included in this section of the bibliography.

The sources on periods and media included in the second section of the bibliography also vary widely in terms of date and authorial interests. Some of these sources are chronologically arranged; others are organized geographically. Here, the reader will find the general surveys of medieval art periods included in series such as the volumes of the Pelican History of Art, the Praeger World of Art series, and the beautifully illustrated Braziller publications on illuminated manuscripts. To cite a few, works such as Walter Cahn's *Romanesque Bible Illumination*, Otto Demus's *Romanesque Mural Painting*, C. R. Dodwell's *The Pictorial Arts of the West: 800–1200,* André Grabar and Carl Nordenfalk's *Early Medieval Painting* and *Romanesque Painting,* Louis Grodecki and Catherine Brisac's *Gothic Stained Glass: 1200–1300*, Peter Lasko's *Ars Sacra: 800–1200*, Willibald Sauerländer's *Gothic Sculpture in France: 1140–1270*, Hanns Swarzenski's *Monuments of Romanesque Art*, and Wolfgang Volbach's *Early Christian Art* are essential and copiously illustrated sources.

Some of these studies focus upon particular media at specific sites (e.g., Adolf Katzenellenbogen, *The Sculptural Programs of Chartres Cathedral*; Otto Demus, *The Mosaic Decoration of San Marco, Venice*) or concentrate upon particular media in specific times and places (e.g., Robert Branner, *Manuscript Painting in Paris during the Reign of St. Louis*; Linda Seidel, *Songs of Glory: The Romanesque Facades of Aquitaine*), or trace the history of a specific form of art (such as Kurt Weitzmann's studies on Byzantine icons and the histories of manuscript illustration authored by Otto Pächt, Jean Porcher, and David M. Robb). Authors such as Robert Calkins (*Illuminated Books of the Middle Ages*) and Christopher De Hamel (*A History of Illuminated Manuscripts*) have organized their studies of specific media according to types or categories of works, while authors such as J.J.G. Alexander (*Medieval Illuminators and Their Methods of Work*) have included essential technical information on creation and construction processes.

Other authors have adopted a more thematic approach to their studies; while dealing with particular periods, these scholars have concentrated upon identifying and interpreting dominant categories of subject matter. The works of Emile Mâle (from the late nineteenth and early twentieth century, edited and translated in the 1950s through 1980s) continue to provide important sources and inspiration for general as well as specific studies of particular topics and themes in medieval art.

Works (listed in the third section of the bibliography) which focus upon single subjects or thematic groups range from André Grabar's *Christian Iconography: A Study of Its Origins* (a study concentrating upon the sources and evolution of Christian pictorial arts) to works such as Ilene Forsyth's *The Throne of Wisdom: Wood Sculptures of the Madonna in Romanesque France* (which concentrates on a single and prevalent sculptural image). Many of these specifically focused sources, as well as the general references, also include interpretations of the meaning and significance of selected themes and pictorial types. Studies reflecting the revisionist approaches in contemporary scholarship are included along with the older and foundation sources. The reader will hence find works published in the 1930s (Adolf Katzenellenbogen, *Allegories of the Virtues and Vices in Medieval Art*; A. Watson, *The Early Iconography of the Tree of Jesse*; J. C. Webster, *The Labors of the Months in Antique and Medieval Art to the End of the Twelfth Century*) listed along with more recent studies such as Barbara Abou-el-Haj (*The Medieval Cult of Saints: Formations and Transformations*) and Michael Camille (*The Gothic Idol: Ideology and Image-making in Medieval Art*). Works on medieval bestiaries (W. Clark and M. McMunn; F. McCulloch), herbals (W. Blunt and S. Raphael), model books (R. W. Scheller), scientific illustrations (J. Murdoch), the Arthurian legends (R. and L. Loomis), subjects such as angels (M. Godwin), heaven (C. McDannell and B. Lang), Lucifer (J. Russell), and illustrations of the Apocalypse (F. van der Meer) will all be found covered in the sources listed in this section of the bibliography. In some cases, the materials in these focused studies also cover pre-and postmedieval periods as well.

The Middle Ages is, without doubt, a complex and varied span of time that has fascinated researchers for centuries. The topics referenced in this dictionary represent only a selected portion of the many themes, stories, and symbols which contribute to the rich and intriguing nature of medieval art.

Abbreviations

EXAMPLES

cp. = colorplate

f. = folio

fig. = figure

MS = manuscript

p. = page

pl. = plate

ILLUSTRATION SOURCES

(Please consult bibliography for complete citation.)

Abou-el-Haj = Abou-el-Haj, B. *The Medieval Cult of Saints: Formations and Transformations.*

Alexander = Alexander, J.J.G. *Medieval Illuminators and Their Methods of Work.*

Beckwith = Beckwith, J. *Early Medieval Art.*

Boeckler = Boeckler, A. *Das Stuttgarter Passionale.*

Bologna = Bologna, G. *Illuminated Manuscripts: The Book before Gutenberg.*

Cahn = Cahn, W. *Romanesque Bible Illumination.*

Calkins = Calkins, R. *Illuminated Books of the Middle Ages.*

Caviness = Caviness, M. *The Early Stained Glass of Canterbury Cathedral.*

Cuttler = Cuttler, C. *Northern Painting from Pucelle to Bruegel.*

D'Ancona = D'Ancona, P., and E. Aeschlimann. *The Art of Illumination.*

De Hamel = De Hamel, C. *A History of Illuminated Manuscripts.*

Demus = Demus, O. *Romanesque Mural Painting.*

Demus, SM = Demus, O. *The Mosaic Decoration of San Marco, Venice.*

Dodwell = Dodwell, C. R. *The Pictorial Arts of the West: 800–1200.*

Gaehde and Mütherich = Gaehde, J., and F. Mütherich. *Carolingian Painting.*

Gough = Gough, M. *The Origins of Christian Art.*

Grabar, CI = Grabar, A. *Christian Iconography: A Study of Its Origins.*

Grabar and Nordenfalk, Rmsq. = Grabar, A., and C. Nordenfalk. *Romanesque Painting from the Eleventh to the Thirteenth Century.*

Grodecki = Grodecki, L., and C. Brisac. *Gothic Stained Glass: 1200–1300.*

Hartt = Hartt, F. *History of Italian Renaissance Art: Painting, Sculpture, Architecture.*

HIHS = *Holy Image, Holy Space: Icons and Frescoes from Greece.*

Hutter = Hutter, I. *Early Christian and Byzantine Art.*

The Icon = Weitzmann, K., et al. *The Icon.*

Kaftal, C&S = Kaftal, G. *Iconography of the Saints in Central and South Italian Painting.*

Kaftal, NE = Kaftal, G. *Iconography of the Saints in the Painting of North East Italy.*

Kaftal, NW = Kaftal, G. *Iconography of the Saints in the Painting of North West Italy.*

Kaftal, Tuscan = Kaftal, G. *Iconography of the Saints in Tuscan Painting.*

Künstler = Künstler, G. *Romanesque Art in Europe.*

Mâle, LMA = Mâle, E. *Religious Art in France, The Late Middle Ages.*

Marrow = Marrow, J. *The Golden Age of Dutch Manuscript Painting.*

Martindale = Martindale, A. *Gothic Art from the Twelfth to the Fifteenth Century.*

Morgan (I) = Morgan, N. *Early Gothic Manuscripts (I): 1190–1250.*

Morgan (II) = Morgan, N. *Early Gothic Manuscripts (II): 1250–1280.*

Ouspensky = Ouspensky, L., and V. Lossky. *The Meaning of Icons.*

Pächt = Pächt, O. *Book Illumination in the Middle Ages.*

Porcher = Porcher, J. *French Miniatures from Illuminated Manuscripts.*

Rice = Rice, D. T. *Art of the Byzantine Era.*

Robb = Robb, D. *The Art of the Illuminated Manuscript.*

Rodley = Rodley, Lyn. *Byzantine Art and Architecture: An Introduction.*

Ross = Ross, L. *Text, Image, Message: Saints in Medieval Manuscript Illustrations.*

Sauerländer = Sauerländer, W. *Gothic Sculpture in France: 1140–1270.*

Swarzenski = Swarzenski, H. *Monuments of Romanesque Art.*

Synder = Synder, J. *Medieval Art: Painting, Sculpture, Architecture, 4th–14th Century.*

Synder, NR = Synder, J. *Northern Renaissance Art: Painting, Sculpture, the Graphic Arts from 1350 to 1575.*

Thomas = Thomas, M. *The Golden Age: Manuscript Painting at the Time of Jean, Duc de Berry.*

Volbach = Volbach, W. *Early Christian Art.*

Weitzmann = Weitzmann, K. *The Icon: Holy Images, Sixth to Fourteenth Century.*

Weitzmann, LA&EC = Weitzmann, K. *Late Antique and Early Christian Book Illumi-nation.*

Weitzmann, Studies = Weitzmann, K. *Studies in Classical and Byzantine Manuscript Illumination.*

Wieck = Wieck, R. *Time Sanctified: The Book of Hours in Medieval Art and Life.*

Williams = Williams, J. *Early Spanish Manuscript Illumination.*

Zarnecki = Zarnecki, G. *Art of the Medieval World.*

LOCATIONS

BM = Bibliothèque Municipale

BR = Bibliothèque Royale

CL = Cathedral Library

PL = Palace Library

RL = Royal Library

UL = University Library

Berlin, SB = Berlin, Staatsbibliothek

Berlin, SM = Berlin, Staatliche Museen

Bern, Burgerb = Bern, Burgerbibliothek

Cambridge, CCC = Cambridge, Corpus Christi College

Cambridge, TC = Cambridge, Trinity College

Darmstadt, HB = Darmstadt, Hessische Landesbibliothek

Darmstadt, HL = Darmstadt, Hessische Landesmuseum

Dublin, TC = Dublin, Trinity College

Florence, BML = Florence, Biblioteca Medicea-Laurenziana

The Hague, KB = The Hague, Koninklijke Bibliotheek

Hamburg, SB = Hamburg, Stadtbibliothek

London, BL = London, British Library

London, BM = London, British Museum

London, V&A = London, Victoria and Albert Museum

Madrid, BN = Madrid, Biblioteca Nacional

Moscow, Tretyakov = Moscow, Tretyakov Gallery

Munich, BS = Munich, Bayerische Staatsbibliothek

New York, Met = New York, Metropolitan Museum of Art

New York, PML = New York, Pierpont Morgan Library

Oxford, BL = Oxford, Bodleian Library

Oxford, UC = Oxford, University College Library

Paris, BA = Paris, Bibliothèque de l'Arsenal

Paris, BMaz = Paris, Bibliothèque Mazarine

Paris, BN = Paris, Bibliothèque Nationale

Rome, BAV = Rome, Biblioteca Apostolica Vaticana

Stuttgart, WLB = Stuttgart, Württembergische Landesbibliothek

Stuttgart, WLM = Stuttgart, Württembergisches Landesmuseum

Tournai, BS = Tournai, Bibliothèque du Séminaire

Trier, SB = Trier, Stadtbibliothek

Vienna, ON = Vienna, Osterreichische Nationalbibliothek

Walters = Baltimore, Walters Art Gallery

A

AARON. Aaron was the older brother of *Moses and the first appointed in the dominant line of Jewish priests. He assisted Moses during the journey of the Israelites out of Egypt and in their battles with the Amalekites (e.g., in holding up Moses' arm to ensure victory, Exodus 17:8–13, interpreted by Christian theologians as a prefiguration of the *Crucifixion), but later angered *God and Moses by constructing a golden calf for the Israelites to worship, as per their request. (See: *Worship of the Golden Calf.) Several challenges to his authority took place (Numbers 16, 17); those disputing his right to offer incense were swallowed up by the ground; on another occasion Aaron's staff flowered and produced ripe almonds, signifying the leadership of his tribe (Levi). In medieval Christian interpretation, this sign prefigured the flowering staff of *Joseph, when he was chosen to wed the Virgin *Mary. (See: *Marriage of the Virgin.) An elaborate description of Aaron's priestly robes is found in Exodus 28. He often accompanies Moses in art or appears in the narratives mentioned above. His attributes are a censer and/or flowering rod.

Example: Deuteronomy initial with Moses and Aaron, Lobbes Bible, 1084, Tournai, BS, MS 1, f. 77. (Cahn, fig. 81)

ABEL. See CAIN AND ABEL.

ABRAHAM. Abraham was the first Hebrew *patriarch; his life is described in Genesis chapters 11–25. Scenes from his life most often represented in early Christian and medieval art include his parting company with his nephew *Lot, his blessing by *Melchizedek, the visit he received from three *angels who announced that his barren wife *Sarah would bear a son, and *God's testing of his faith by ordering him to sacrifice his son *Isaac (this deed prevented by angelic intervention at the last moment). All of these scenes are found in early Christian mosaics and in various media throughout the Middle Ages. Abraham's

obedience to the will of God was emphasized by Christian writers, in particular, his willingness to sacrifice his son was typologically understood as a prefiguration of the sacrifice of Jesus. In art, Abraham is generally shown with white hair and a beard and often carries a knife (in reference to the sacrifice of Isaac). He also appears, especially in Romanesque and Gothic portal sculpture, as a seated or standing figure holding small people (representing *souls) in the drapery folds of his lap; this is in reference to the passage in *Luke 16:22 where Jesus describes the beggar Lazarus (see: *Dives and Lazarus) being carried by angels into Abraham's bosom.

Example: Feast of Abraham, c.432–440, mosaic, Rome, Santa Maria Maggiore. (Synder, cp. 3)

ABSALOM. The handsome, vain, and willful Absalom was the third son of King *David; his life is described in 2 Samuel 13–18, and he is depicted in medieval art (Carolingian frescoes, Romanesque sculpture, Romanesque and Gothic manuscripts) primarily in narrative cycles dealing with the life of David. He avenged the rape of his sister Tamar by killing his half-brother Amnon, rebelled against his father, fled from the battle and was caught in a tree by his long hair; he was murdered by David's chief lieutenant (against the orders of David); David mourned for him greatly.

Example: Scenes from the Life of David, Leaf from *Winchester Bible,* c.1180, New York, PML, MS 619v. (Robb, fig. 131)

ACHEIROPOIETA. *Acheiropoieta* is a Greek term for an image that was not created by human hands; the most famous example is the imprint of *Christ's face on the veil of Saint *Veronica (see also: *Mandylion, *Sudarium*). Divinely created or miraculously duplicated, these images were frequently cited during the Byzantine *Iconoclastic Controversy as evidence in support of holy images.

Example: Christ of Veronica, twelfth century, icon, Moscow, Tretyakov. (*The Icon,* p. 259)

ACTIVE LIFE. *Luke 10:38–42 recounts *Christ's visit to the house of *Martha and Mary, the sisters of Lazarus (see: *Raising of Lazarus). While Mary sat at Christ's feet and listened to his words, Martha, the busy housekeeper, kept active in the kitchen. Irked by her sister's idleness, Martha asked Christ to bid Mary to assist her, but Christ replied that Mary had chosen wisely. Several medieval interpretations of and commentaries on this passage (such as Saint *Gregory's, *Moralia in Job*) discuss the merits of both the active and the *contemplative life—the life of work and service in the world and the life of prayer and study withdrawn from worldly concerns. In art, the active life may be represented by the figure of Martha, or by *Leah, the wife of *Jacob. Female figures

performing household tasks, such as spinning and weaving, may also personify the active life.

Example: Vita activa, c.1120–1130, Chartres Cathedral, north porch, archivolts. (Sauerländer, fig. 105)

ADALBERT OF PRAGUE, SAINT. The stormy career of Adalbert of Prague (c.956–997) involved numerous trips between Prague and Rome as well as several missionary journeys. Appointed bishop of Prague in 982 or 983, he left his post c.990 to become a Benedictine monk in Rome, returned to Prague and became embroiled in disputes, was forced to leave, and eventually was murdered during missionary work in Prussia. Also popular in Germany and Italy, his life was notably illustrated in the bronze doors of Gniezno Cathedral, c.1175.

Example: Adalbert Preaching and Saying Mass, c.1175, Gniezno Cathedral, doors. (Abou-el-Haj, fig. 48)

ADAM AND EVE. In Christian tradition, Adam and Eve were the parents of all other human beings. They are among the most frequently represented subjects in early Christian and medieval art in all media. Their story is recounted within and following the *Creation narratives (Genesis 1–3) and provided material for numerous commentaries and interpretations by theologians throughout the medieval period.

Genesis 1:26–27 states that *God created humans (male and female) "in his own image," while the account in Genesis 2 describes how God first shaped Adam (from Hebrew *adamah:* "earth") out of the "dust of the ground" and placed him in the paradisical *Garden of Eden. Adam was instructed to tend the garden and to give names to all the newly created animals (see: *Naming of the Animals). God then created Eve, out of one of Adam's ribs, as a companion for Adam (Genesis 2:21–22). Although God had told Adam to eat freely of all the trees provided in the garden, he specifically directed Adam not to eat of the fruit of the *Tree of the Knowledge of Good and Evil. Encouraged by a crafty serpent (see: *Animals, Symbolism of), both Adam and Eve ate of the forbidden fruit, became aware and ashamed of their nakedness, and were sent out of the garden by God who assured them (and all their offspring) of continuing suffering and sorrow for their disobedience.

All episodes above are featured in medieval art; God may be shown creating Adam by touching him, breathing upon him, or animating him with a ray of light; Eve may be shown reclining beside Adam or standing up—issuing from his side while God bends over Adam. The single most prominent and quickly recognized narrative vignette involving Adam and Eve is the moment of their disobedience in eating the forbidden fruit; they are frequently shown as naked figures standing by a fruit tree with a serpent twining in its branches. Eve often grasps and eats the fruit first or is shown handing the fruit to Adam, who also eats it. God's appearance and questioning of the couple is often illustrated; God may point questioningly to Adam, who points to Eve; she in turn points to the

serpent. The shameful expulsion of Adam and Eve from paradise is also represented; a sword-bearing *angel drives them out of the gate. Post-expulsion scenes will show Adam and Eve engaged in such tasks as digging the earth and spinning wool. Christian doctrine holds that the sins of Adam and Eve are redeemed by *Christ, son of the Virgin *Mary; hence, Christ is typologically the "new Adam" and Mary is the "new Eve." The skull of Adam may thus be seen at the base of the cross of Christ's *Crucifixion. (See also: *Calvary).

Example: Adam and Eve, c.1090, Cluny III, ambulatory capital. (Snyder, fig. 345)

ADORATION OF THE LAMB. See APOCALYPSE.

ADORATION OF THE MAGI. *Matthew's Gospel (2:1–12) tells the story of the "wise men" (*magi*) who came "from the east" after the birth of Jesus. Alerted by a star which had appeared in the sky, they journeyed to Jerusalem to pay homage to the "King of the Jews." They consulted King *Herod, who sent them to Bethlehem where they discovered and presented gifts to the infant Jesus. Warned by *God in a dream not to return to Herod with confirmation of the child's existence, they returned to their own country. Herod, threatened by the knowledge of a potentially powerful rival, subsequently ordered the slaughter of all children aged two years and younger in Bethlehem and the region (see: *Massacre of the Innocents), but the *Holy Family, warned by an *angel, had fled to Egypt (see: *Flight into Egypt).

The Adoration of the Magi is one of the most important and frequently represented subjects in early Christian and medieval art. The event is celebrated, liturgically, with the feast of Epiphany (the acknowledged manifestation of God in Jesus), adopted by the late fourth century in both east and west. Although the Adoration of the Magi is linked, and often mingled in art, with scenes of the birth of Christ (see: *Nativity), the magi themselves significantly represent the potential, universal acceptance of Christianity by all people.

In early Christian art, the "eastern" origin of the magi may be indicated by their depiction in the exotic dress of Persian astrologers or Mithraic priests, for example, short robes and the forward-folded Phrygian cap. The Gospel account does not state the exact number of magi, and so some scenes show two, four, six, or even twelve; however, the three gifts which are mentioned in the Gospel result in the traditional and most common representation of the magi as three. Tertullian (c.160–230) described them as kings, but they are not customarily depicted with crowns until about the tenth century. In Romanesque and Gothic art, the "eastern" appearance of the magi may be indicated by their sumptuous and colorful garments, although their costume and crowns increasingly give them the appearance of European kings.

They may be shown riding on horseback, walking toward, kneeling in front of, or positioned around the seated or enthroned Mary and the baby Jesus. *Joseph and an angel may be present; a star may hover over the scene. They offer their gifts to Jesus who may stretch out his hand in acceptance or with a

gesture of *benediction. The gifts may be shown as jeweled containers, bowls, a horn, a crown, or coins. Writers from at least the sixth century interpreted these gifts as symbols of Christ's kingship and power (gold), his divine nature (frankincense), and his humanity/mortality (myrrh). Texts from the sixth century also give names to the magi (Melchior, Caspar, Balthasar), and these names appear as inscriptions in art from the late tenth century. The association of the magi with the ages of man and the three parts of the world (Asia, Africa, and Europe) dates to the later medieval period; hence the magi may range in age from youthful to elderly and Africa/Balthasar may be shown as a black man.

The subject of the Adoration of the Magi appears in early Christian catacomb painting and mosaics, on ivories and sarcophagi, in Byzantine and Ottonian manuscript illustration, and in sculpture, fresco, manuscripts, and stained glass through the Middle Ages. Related narrative scenes may show the magi speaking with Herod, the magi seeing the star, the journey of the magi, and their dream vision, where, especially in French Romanesque sculpture, they are charmingly rendered, crowned and sleeping under one cover in a single bed while the angel gestures to the star above them.

Example: Adoration of the Magi, Pericope Book of Saint Erentrud, c.1140–1160, Munich, BS, MS Clm. 15903, f. 17. (Dodwell, fig. 300)

ADORATION OF THE SHEPHERDS. See NATIVITY.

AEGIDIUS, SAINT. See GILES, SAINT.

AELFRIC. Aelfric (c.955–c.1020) was an Anglo-Saxon monk, abbot, and influential scholar whose writings include works in both Latin and Anglo-Saxon, several of which were illustrated. He joined the Benedictine community at Winchester under Saint Ethelwold, became abbot of Evesham (Oxfordshire) in c.1005, and wrote *saints' lives, commentaries, and an Anglo-Saxon paraphrase of the Hexateuch (the first six books of the Old Testament), one copy of which was especially lavishly illustrated with detailed narrative scenes in the mid-eleventh century.

Example: Aelfric Paraphrase, c.1025–1050, London, BL, Cotton MS Claudius B.IV, f. 68. (Cahn, fig. 54)

AGATHA, SAINT. Legends recount that the third-century Sicilian virgin martyr Agatha, a member of the wealthy nobility, refused the advances of the Roman consul Quintian who, knowing of her faith, sent her to a brothel and later to prison. Of all the tortures to which she was subjected, the most notable was the cutting off of her breasts. She was healed that night when Saint *Peter appeared to her in prison in a miraculous vision. She is depicted in art being tortured, carrying her breasts on a plate, with the tongs or shears used in her mutilation, as well as with the typical attributes of martyrs: a crown and palm frond. She may also carry a torch, candle, or burning building because on the

first anniversary of her *death, her veil protected the inhabitants of Catania from the flow of lava from Mount Etna.

Example: Torture of Saint Agatha, Passionary, early twelfth century, Rome, Lateran Archives, cod. A/79, f. 127. (Ross, fig. 19)

AGNES, SAINT. The Roman virgin Agnes was martyred in the early fourth century at age twelve or thirteen for refusing to worship the Roman gods and refusing to marry the son of the prefect of Rome. One of the most esteemed of the virgin martyrs, Agnes appears in art from the fourth century, when a basilica was erected in her honor in Rome. Her usual attribute is a lamb, by association of her name with the Latin *agna* ("lamb"), though probably derived from the Greek *agne* ("chaste"). She may also be shown with long hair, which miraculously covered her entire body when she was led naked through the streets of Rome and sent to a brothel, surviving the flames of a burning pyre, or being stabbed in the throat by a sword.

Example: Saint Agnes, c.625–638, mosaic, Rome, Santa Agnese fuori le mura, apse. (Rodley, fig. 92)

AGNUS DEI. Latin for the "Lamb of God," the *Agnus Dei* is a symbol for *Christ which is frequently found in diverse contexts and with some variations in medieval art. The symbolism of the sacrificial lamb can be traced to Old Testament sources such as the stories of Abel (see: *Cain and Abel) and *Abraham. Saint *John the Baptist described Christ as the Lamb of God who takes away the sins of the world (*John 1:29); the lamb is thus often depicted with John the Baptist. In the book of Revelation, the lamb appears prominently as an object of adoration and instigator of the *Apocalypse. The image appears primarily in early Christian and later medieval art in the west. The *Agnus Dei* may be represented in a mandorla (see: *Halo), with a cross-inscribed halo, with the *Instruments of the Passion, surrounded by the symbols of the *Four Evangelists, with scrolls or a book, with a triumphal cross staff and banner, standing on an altar or atop a mountain, bleeding into a chalice, and adored by a great crowd.

Example: Adoration of the Lamb, Beatus Commentary on the Apocalypse, c.1047, Madrid, BN, MS B. 31, f. 205. (Zarnecki, cp. 31)

AGONY IN THE GARDEN. An event close to the end of Jesus' life described (with some variation in details) in the Gospels of *Matthew, *Mark, and *Luke, the agony (or trial) in the garden of Gethsemane on the *Mount of Olives is the episode in which Jesus prayed for deliverance from *death but accepted it nonetheless. This is symbolized by the "cup" (an Old Testament image for *God's anger) which he asked to be taken away from him, but which he stated his willingness to accept, according to God's will. The Gospels also describe Jesus' companions in the garden (three of the *apostles; the others waited nearby), who fell asleep during his solitary prayer in spite of his request that

they stay awake with him. Luke also describes the appearance of an *angel to Jesus. Immediately after this episode, Jesus was arrested (see: *Arrest of Christ, *Betrayal of Christ).

The subject appears in early Christian art of the fourth century and is found in manuscript illustration, mosaics, wall paintings, and sculpture throughout the medieval period in various formats. Abbreviated versions may depict simply Jesus in *prayer with three sleeping apostles in a landscape setting on a rock or mountain. In early Christian art Jesus may be shown as an *orant figure. The hand of God and the angel (sometimes bearing a *cross and/or chalice) may be included, as well as the eleven apostles (minus *Judas).

Example: Christ in the Garden of Gethsemane, c.1183, mosaic, Monreale Cathedral, transept. (Synder, fig. 200)

AHASUERUS. The king of Persia in the fifth century B.C., traditionally identified as Xerxes I (486–465 B.C.), Ahasuerus took *Esther as his queen after having dismissed his previous wife, Vashti. Esther intervened successfully with him to prevent a massacre of the *Jews plotted by his chief minister *Haman. He is depicted in medieval art primarily in connection with Esther; scenes include their marriage, the banquet prepared by Esther, and Esther kneeling before him. He is dressed as a king, often crowned, holding a sceptre.

Example: Esther scenes, Florence Cathedral Bible, c.1100–1125, Florence, BML, MS Edili 126, f. 83. (Cahn, fig. 112)

ALBAN, SAINT. Although venerated as the first British martyr, Saint Alban's death date is uncertain (c.209? c.254? c.305?). Legends recount that as a Roman soldier, Alban gave shelter to and was converted to Christianity by a priest (named *Amphibalus) who was fleeing from persecution. Alban exchanged clothes with the priest (who managed to escape) and was arrested, tortured, and decapitated. The eyes fell out of the head of his executioner. In art, Alban may be dressed as a Roman soldier holding a sword and cross; he also appears as a *cephalophor. His life was illustrated in the mid-thirteenth century by Matthew Paris, a monk of Saint Albans abbey (which had been founded on the site of Alban's *martyrdom in the late eighth century).

Example: Life of Saint Alban, c.1240, Dublin, TC, MS 177 (E.1.40), f. 35. (Alexander, fig. 177)

ALBINUS, SAINT. See AUBIN, SAINT.

ALEXANDER THE GREAT. The life and deeds of Alexander III of Macedon (356–323 B.C.) were recorded soon after his *death and expanded and translated through the late classical and early Christian period. Various fantastic stories evolved which provided the foundation for the continuing fascination with Alexander during the Middle Ages. Poems and prose narratives were produced in Latin and numerous vernacular languages from the twelfth through fourteenth

inspiring Saint *Augustine's return to Christianity. Directed by a vision, he discovered the *relics of Saints *Gervase and Protase and installed them in a church (now Sant' Ambrogio Maggiore) which he dedicated in Milan. His writings include treatises on Christian ethics, hymns, letters, sermons, instructional works, commentaries on scripture (e.g., the *Hexameron,* concerning the *Creation of the universe), texts on the ascetic and monastic life, and (probably) the Athanasian Creed (a profession of faith used in the western church). His life was recorded by his secretary Paulinus and later elaborated in the *Golden Legend.* He is depicted in art garbed as a bishop (with mitre and *cross, or a scourge with three knots symbolizing the *Trinity and his fight against heresy); he may also be shown with a beehive (from the tradition that a swarm of bees descended over his mouth when he was an infant in his cradle, symbolizing his future gift for public speaking). In the ninth century, his life was notably illustrated in relief sculpture on the golden altar for the church of Sant' Ambrogio, Milan.

Example: Scenes from the Life of Saint Ambrose, 824–859, *Altar of Saint Ambrose,* Milan, Sant' Ambrogio. (Zarnecki, fig. 136 and cp. 19)

AMPHIBALUS, SAINT. Because of a mistranslation by the twelfth-century English chronicler Geoffrey of Monmouth, Amphibalus is the name given to the priest sheltered by and who exchanged his cloak (*amphibalo*) with Saint *Alban. His relics were discovered at Saint Albans abbey in the twelfth century, and the lives of Alban and Amphibalus were illustrated by Matthew Paris in the mid-thirteenth century.

Example: Martyrdom of Saints Alban and Amphibalus, Psalter, c.1250, London, BL, Royal MS 2.B.VI, f. 10v. (Morgan I, fig. 286)

ANANIAS. See PAUL, SAINT.

ANANIAS AND SAPPHIRA. See PETER, SAINT.

ANASTASIS. *Anastasis* is the Greek term for *"Resurrection." It refers, in general, to *Christ's triumph over *death as well as to specific events which took place during the three-day span of time between Christ's *Entombment and his resurrected reappearance on earth (e.g., see: *Noli me tangere*) before his *Ascension to *heaven. Several New Testament passages (e.g., *Matthew 12:40; Acts 2:24, 27, 31) imply that Christ descended into the realm of the dead (limbo or *hell) during this period after his death and before his Resurrection. The meaning of this event was interpreted in various ways by early Christian writers, although belief in Christ's descent into limbo became an article of faith in the fourth century. Apocryphal works such as the *Gospel of *Nicodemus* provided more detailed descriptions of the event and sources for visual imagery. According to this text and commentaries by numerous early Christian and medieval authors (such as *Vincent of Beauvais, and Jacobus de Voragine's

Golden Legend) Christ descended into limbo to free the *souls of those persons who had lived righteously before his coming (e.g., Old Testament *prophets and *patriarchs) and hence triumphed over death, *Satan, and *Hades. Alternative terms for this event and image are the *Descent into Limbo* and the *Harrowing of Hell*.

The image is normally considered a Byzantine creation, although the first dated examples occur in the west in the early eighth century (frescoes in Santa Maria Antiqua, Rome). Perhaps ultimately derived from imperial iconography of triumph and liberation, the image develops several variants: Christ pulling *Adam from his tomb, Christ flanked by Adam and Eve, Christ pulling both Adam and Eve from their tombs. Other identifiable figures may be included: *David, *Solomon, *Moses, *John the Baptist, Abel (see: *Cain and Abel), or otherwise undifferentiated souls of the just (clothed or nude). Christ may carry a *cross staff with a triumphal banner; the broken gates of the underworld may be depicted; Hades may appear as a grotesque *demon. As an image of Christ's triumph over death and sin and the redemption of humankind, the Anastasis figures prominently in Christological and festal cycles for Easter, especially in Byzantine art, and is reflective of much complex theological speculation about the aspects of Christ's death and Resurrection. The image is also linked theologically and sometimes pictorially with the *Last Judgment.

Example: Last Judgment (including the *Anastasis*), late twelfth century, mosaic, Torcello Cathedral, west wall. (Synder, fig. 190)

ANCESTORS OF CHRIST. The Gospels contain two somewhat divergent lists of the ancestors of *Christ; the genealogy found in *Luke 3:23–38 lists seventy-six fathers and sons; *Matthew 1:1–17 names forty ancestors. The figures include *patriarchs, kings, and *prophets, many of whom also feature prominently in other biblical narratives and illustrations as well as being represented as a group.

Among the many figures named in both Matthew and Luke who also appear frequently in other artistic contexts are: *Abraham, Boaz, *David, *Isaac, *Jacob, *Joseph (the husband of the Virgin *Mary), Lamech, *Noah, and *Solomon. Other figures found among the ancestors of Christ whose artistic roles are otherwise somewhat restricted include: Abijah, *Enoch, Hezekiah, Jared, Jeconiah, Jesse, Josiah, Methuselah, Neri, Obed, Rehoboam, and Shem.

A number of different ways of picturing the genealogy of Christ were developed in medieval art, including series of portrait busts in medallions, groups of seated or standing figures (in both two and three dimensional media), and the *Tree of Jesse, which presents Christ's genealogy on the branches of a leafy stem springing from the reclining figure of Jesse. All of these formats appear in a variety of media: manuscripts, mosaics, frescoes, sculpture, and stained glass. Sometimes the figures may be identifiable by iconographic attributes, inscriptions, or actions, although many examples do not clearly distinguish among all of the figures. The genealogy of Christ was a topic of great interest for

medieval theologians eager to explain the various Old Testament figures as spiritual precursors of Jesus—which interest is reflected in the artistic attention devoted to these themes, especially in Romanesque and Gothic art. See also: *Holy Family, *Holy Kinship.

ANCIENT OF DAYS. The *prophet *Daniel (7:9, 13, 22) described an apocalyptic dream vision in which the Ancient of Days appeared, enthroned, with white hair and garments, sitting in judgment. In Christian interpretation, influenced as well by references from the *Apocalypse (1:13–14), the Ancient of Days is an awe-inspiring image of *God or *Christ as an aged man with white hair. The figure appears especially in illustrations of the Apocalypse and in related themes such as the *Last Judgment and *Majestas Domini. See also: *Creation, *Trinity.

Example: A Dead Man Face to Face with his Judge, Rohan Hours, c.1418–1425, Paris, BN, MS lat. 9471, f. 159. (Porcher, pl. LXXVII)

ANDACHTSBILDER. Andachtsbild is a German term for an image made for contemplation or private devotional purposes, an aid to *prayer. Produced in sculpture, painting, and other media, especially in northern Europe in the later Gothic period, the images generally show holy figures extracted from a narrative context to form a highly focused, and often very emotionally powerful, vignette. Subjects such as the *Pietà (the Virgin *Mary holding *Christ's dead body), the *Man of Sorrows (Christ displaying his wounds and the *Instruments of the Passion), *Crucifixion scenes which emphasize the physical suffering of Christ, and Christ with the sleeping Saint *John the Evangelist were especially popular andachtsbilder reflective of the mystical trends of the later Gothic period. Images of the *Veronica cloth (impressed with the face of Christ), the decapitated head of Saint *John the Baptist on a platter, the Instruments of the Passion (or *Arma Christi) as independent images, and other themes which inspire intense spiritual emotion are known as andachtsbilder.

Example: Pietà, c.1330, wood sculpture, Bonn, Landesmuseum. (Synder, fig. 559)

ANDREW, SAINT. One of the twelve *apostles and previously a disciple of *John the Baptist, Andrew was among the first to follow Jesus (John 1:40–42). He is termed protoclete in Greek, the "first-called." He is often depicted in art with his fisherman brother Simon who was renamed *Peter by Jesus. They became "fishers of men" (*Mark 1:17). Andrew is credited, in the postbiblical tradition, with much *preaching and missionary activity and, although mentioned several times in the Gospels, sources for the imagery of Saint Andrew in medieval art largely derive from apocryphal works and the *Golden Legend. Pictorial narratives include various *miracle scenes, *exorcisms, tortures, and his *crucifixion on an X-shaped (saltire) *cross, believed to have taken place at Patras in c.60. The form of the cross varies in medieval art: early representations

show him bound to a Latin cross; in Byzantine art, a Y-shaped cross is sometimes seen. His attributes include fishing nets and a cross.

Example: Saint Andrew, c.1250, Bordeaux, Saint Seurin, south portal, left jamb figure. (Sauerländer, fig. 305)

ANGELS. From the Greek *angelos* (''messenger''), angels play important roles in the Old and New Testaments and figure prominently in medieval art. They serve as intermediaries between *God and humans; they announce God's will, assist, protect, punish, guide, and often appear in dreams and visions both in scripture and hagiography. Scripture provides the names of three specific angels (*Gabriel, *Michael, and *Raphael), while implying countless more. Visions recorded in *Isaiah (6:1–2) and *Ezekiel (1:4–14) include descriptions of angels as multiwinged (and sometimes multiheaded), bright, bodiless beings. According to the influential, apocryphal book of *Enoch (second century B.C.), the fallen angels, led by Lucifer or *Satan, rebelled against God and were ejected from *heaven to become *devils in *hell. (See also: *Fall of the Rebel Angels.)

In the medieval period, many authors (including *Augustine of Hippo, *Gregory the Great, *Peter Lombard, and Saint *Thomas Aquinas) attempted to define and classify angels. The most influential writing on angels was that of Dionysius (the Pseudo-Areopagite, c.500) whose work, *De hierarchia celesti (Celestial Hierarchies)* categorizes angels into nine ranked choirs of three triads. The highest order of angels, in direct communion with God, are the seraphim, cherubim, and thrones. Artistic representations of these may show cherubim as blue or yellow and seraphim as red. Additional eyes may be depicted on the wings; wheels may be included. The middle order of angels are the dominions, virtues, and powers, who are intermediaries to the lowest order of principalities, archangels (seven), and angels. The latter two groups are the actual ''messengers'' from God to humans.

In art, all of these generally appear with human bodies (angels are neither male nor female specifically), usually winged, dressed in flowing garments, and often with *haloes. Winged figures depicting messengers or ''victories'' appear in ancient and classical art; angels in early Christian art are often similar to these classical depictions. Other distinguishing attributes of angels in medieval art may include crowns, globes, sceptres (dominions), lilies or red roses (virtues), and armor (powers, archangels). Angels are often shown singing or playing *musical instruments or with candles or censers. Angels (single or in groups) may appear in many scenes such as the *Adoration of the Magi, *Agony in the Garden, *Annunciation, *Ascension, *Assumption and *Coronation of the Virgin, *Crucifixion, *Last Judgment, *Nativity, and *Resurrection.

Example: The Expulsion of Adam and Eve, Saint Albans Psalter, c.1120–1135, Hildesheim, Saint Godehard, p. 18. (Dodwell, fig. 336)

ANGER. See VICES.

ANIMALS, SYMBOLISM OF. In medieval art and literature, animals are fre-
quently used to symbolize modes of behavior, *virtues and *vices, moral les-
sons, and events in the life of *Christ and other holy figures. Some animals
accompany particular *saints and Old Testament figures and provide attributes
for iconographic identification, deriving from the saints' names, or from events
in the person's life (e.g., the LAMB of Saint *Agnes, LION of Saint *Jerome,
STAG of Saint *Eustace, ASS of *Baalam).

The *Four Evangelists are associated with animal symbols (LION for Saint
*Mark, OX or BULL for Saint *Luke, EAGLE for Saint *John, and Man or *Angel
for Saint *Matthew). These symbols derive from visions recorded in *Ezekiel
(see also: *Tetramorphs) and the *Apocalypse.

Descriptions and interpretations of animals and their characteristics have a
lengthy tradition in literature; the medieval illustrated bestiaries (see: *Manu-
scripts), widely produced especially in the twelfth and thirteenth centuries, are
ultimately founded upon the influential *Physiologus text of the second century
A.D. plus other sources such as the fourth-century Hexameron of Saint *Ambrose
and the seventh-century Etymologiae of *Isidore of Seville. Classical authors,
such as *Aristotle and *Pliny, also provided sources for later medieval encyclo-
pedists and their Christian allegorical interpretations of animals and the world
of nature.

Numerous animals mentioned in the Bible feature in narrative as well as
symbolic contexts in medieval art. Proper interpretation of animal symbolism in
medieval art requires study of the narratives in which animals appear as well as
their use as independent motifs.

Animals with especially virtuous connotations include the humble ASS and
OX (present at the birth of Christ), the dignified and temperate CAMEL, the faith-
ful DOG, the LAMB (symbol for Christ and Christians in general; see also: *Agnus
Dei and *Good Shepherd), the courageous and vigilant LION (after three days
the Lioness breathes life into her cubs, who are born dead; this symbolizes
Christ's *Resurrection), and the mighty RAM, which symbolizes Christ's sacri-
fice.

Other animals exemplify evil and sinful ways; APES are cunning and slothful;
BEARS are wild and cruel; CATS are lazy and lustful; GOATS symbolize unbe-
lievers; PIGS represent gluttony; RABBITS signify lust (but also defenseless *souls
awaiting salvation); WHALES symbolize the cunning *Devil and *death (but also,
as per *Jonah's adventures, relate to Christ's Resurrection). SNAKES, SERPENTS,
DRAGONS, and various other MONSTERS are all evil creatures, symbolic of the
Devil.

Mythological creatures also play significant roles; the UNICORN is a symbol
of purity and virginity; the BASILISK (half bird, half snake) and the GRIFFIN (half
eagle, half lion) are symbols of evil and oppression. Other composite creatures
from classical mythology, such as Centaurs (see: *Zodiac) and *Satyrs (symbols
of evil and lust), may also be found in medieval art. Saint *Bernard of Clairvaux,
in the twelfth century, complained especially about the composite creatures and

animal peculiarites popular in Romanesque sculpture. The fantastic creatures which cavort in the margins of Gothic manuscripts are termed *grotesques. (See also: *Naming of the Animals.)

ANNE, SAINT. Saint Anne was the mother of the Virgin *Mary. Neither she nor her husband *Joachim are mentioned in the canonical Gospels; their lives are described in apocryphal sources such as the second-century *Protevangelium of James*. This text recounts how the unhappily childless couple, after twenty years of marriage, were individually visited by an *angel, who announced that their prayers for a child were to be answered. The angel directed them to meet at the Golden Gate of the city of Jerusalem (see: *Meeting at the Golden Gate) where they embraced joyfully. In due course Anne gave birth to Mary. The remarkable nature of the elderly Anne's pregnancy is connected with the doctrine of the *Immaculate Conception of Mary (Mary's exclusion from the effects of original sin from the moment of her conception by natural human means). Anne's story is similar, in some ways, to that of the Old Testament *Hannah (whose name similarly means "grace"), the mother of *Samuel.

The cult of Saint Anne developed first in the east. During the reign of Justinian in the sixth century churches were dedicated to her in Jerusalem and Constantinople. Veneration of Saint Anne spread to the west in the early Middle Ages and, as dedication to Mary developed and increased in the west from the twelfth century following, so did interest in Anne and Joachim. Their tales were retold and popularized especially in the thirteenth-century *Golden Legend* and the *Speculum historiale* of *Vincent of Beauvais. The important *relic of the head of Saint Anne was brought to Chartres Cathedral in 1204.

Anne appears in art as a single figure and also in narrative scenes. In sculpture at Chartres, she wears a long robe and veil and holds the infant Mary on her arm. Mary holds a book which refers to her *wisdom and the excellent education she received under Anne's tutoring. Anne teaching Mary also appears as an independent artistic motif in late medieval and Byzantine art (see: *Education of the Virgin). Other narrative scenes found in sculpture, manuscript illustration, wall painting, and mosaic include Anne's *prayer in the garden and the appearance to her of the angel and dove of the *Holy Spirit, the birth of Mary, and the *Presentation of the Virgin in the Temple. See also: *Holy Kinship.

Example: Saint Anne, c.1205–1210, Chartres Cathedral, north transept, trumeau. (Sauerländer, fig. 87)

ANNUNCIATION TO MARY. Annunciation scenes in medieval art are required in those instances where special news conveyed from *God to humans needs to be depicted. Usually, an *angel (Greek: *angelos*, "messenger") is the news bearer. The most important and frequently represented scene of this type is the announcement, by *Gabriel to the Virgin *Mary, that she will miraculously conceive without human assistance and give birth to Jesus. Other annunciation scenes include: the *Annunciation to the Shepherds, the Annunciation

to *Zacharias (about the birth of *John the Baptist), and the Annunciation of the *death of the Virgin.

The Annunciation to Mary of the conception and birth of Jesus is described in *Luke 1:26–38 and in the apocryphal *Protevangelium of James*. The earliest representations of the scene appear in fourth-century catacomb paintings; Mary is seated, and a man stands speaking to her. Some early Christian and Byzantine representations include details unique to the apocryphal account, e.g., Mary is depicted spinning wool when the angel appears for the second time; the angel first appeared when she was drawing water from a well. The annunciation at the well is rarely depicted in western medieval art, although Mary may be shown with a basket of wool or a spindle or engaged in spinning when the angel appears. She may be seated or standing and may raise her hand in a gesture of response to the angel, who may be shown standing or walking toward her. Frequently, the angel carries a staff and gestures in greeting and *benediction toward her.

By the eleventh century, Mary is more often shown with a book, a motif which first appears in the ninth and tenth century and symbolizes her *wisdom, as discussed by medieval commentators. In the late thirteenth century, the book more specifically becomes the text of *Isaiah, open to the prophecy of 7:14 ("Behold, a virgin shall conceive . . ."). By the late twelfth century, artists will often include scrolls inscribed with the conversation, recorded in Luke, between Mary and the angel. The angel may hold a lily, symbolic of Mary's virginity. (See: *Flowers and Plants, Symbolism of.)

Although the dove of the *Holy Spirit is included in a few early representations, it becomes more common from the eleventh century onward as a critical symbol of God's presence at the moment of the conception of Jesus. The hand of God emanating rays of light toward Mary reinforces this theme. In Byzantine art of the eleventh and twelfth centuries, the conception of Jesus in Mary's womb may be shown by the image of the child inside her or held in a medallion before her (see: *Platytera). In western art after 1300, under influence from Franciscan theologians, the baby Jesus with the *cross, as well as the dove, may be shown traveling down a light ray from *heaven or God, directed to Mary.

Settings for the Annunciation to Mary vary from the nonspecific to indications of exterior or interior architecture. Landscape elements, such as a tree, may make reference to the *Tree of the Knowledge of Good and Evil from the *Garden of Eden, a typological connection to the fall of humankind through *Adam and Eve and the redemption of humankind through Christ as the "new Adam" and Mary as the "new Eve."

Found in all art media through the Middle Ages, the compositionally simple image of the Annunciation to Mary is one of the most powerful and frequently represented symbolic images in Christian art.

Example: Annunciation, Codex Egberti, c.977–993, Trier, SB, Cod. 24, f. 9. (Synder, fig. 292)

ANNUNCIATION TO THE SHEPHERDS. As described in the Gospel of *Luke (2:8–20), shortly after the birth of Jesus, an *angel appeared to shepherds

who were watching their flocks at nighttime and announced the birth of a savior. Luke records the shepherds' initial alarm at the radiant heavenly visitation and the appearance of a multitude of angels. When the angels departed, the shepherds quickly went to Bethlehem, found *Mary, *Joseph and the newborn baby, and praised *God.

Although frequently included within *Nativity scenes, the Annunciation to the Shepherds also appears as an independent image in manuscript illustration and ivories from the ninth century onward. Most often, three or four shepherds are shown (the Gospel states no specific number); three is most common, paralleling the three magi (see: *Adoration of the Magi). A landscape setting may be indicated; the number of sheep varies. The primary angel may appear in the sky, on a hill, or standing before the shepherds while other angels may be seen hovering in the sky above. Often, at least one of the shepherds is shown walking, already en route to the birthplace of Jesus. The image (independent of Nativity scenes) becomes less common in late medieval art.

Example: Annunciation to the Shepherds, Pericopes of Henry II, c.1002–1014, Munich, BS, MS Clm. 4452, f. 8v. (Robb, fig. 82)

ANSELM, SAINT. Born in Lombardy, Anselm (c.1033–1109) studied under Lanfranc at the Norman abbey of Bec from 1059, took monastic vows there, was appointed prior (1063), then abbot of Bec (1078). In 1093, Anselm was appointed archbishop of Canterbury (following Lanfranc) by King William Rufus, beginning a stormy career fraught with controversies over church/state relations through the reigns of William Rufus and Henry I. He was exiled from England several times until eventually, with papal assistance, reached a compromise with Henry I on the issue of lay investiture. His copious writings include important theological treatises, a vast collection of letters, philosophical works, prayers and meditations (devotional exercises). These latter were first illustrated during Anselm's lifetime, and probably at his direction, with a variety of biblical and hagiographic subjects relevant to the texts. Anselm's biography was written by his close friend, the Canterbury monk Eadmer. In art, Anselm appears in ecclesiastical vestments, with mitre and crozier.

ANTHONY, SAINT. Saint Anthony (Antony, or Anthony Abbot) of Egypt (c.250–356) is often termed the ''founder of monasticism.'' After the *death of his parents c.270, he provided for his sister and gave away the remainder of his goods to the needy. He went to live as a hermit in a tomb in a cemetery until c.285 when he moved to an abandoned fort on Mount Pispir. He lived alone there for twenty years, although his fame inspired others to gather around his retreat and emulate his austere and pious lifestyle. In 305 he organized a colony of ascestics at Fayum and founded another monastery at Pispir in 311. He became involved in contemporary politics and religious issues when he went to Alexandria in 311 to provide encouragement for Christians being persecuted, and on another trip to Alexandria in 355 to assist his friend Athanasius (c.296–

373, bishop of Alexandria from 328) to combat the Arian heresy. Between these journeys, he lived in a cave on Mount Kolzim near the Red Sea, where he also spent the last year of his life. He occasionally received visitors, gave advice, and corresponded with several people including the emperor *Constantine. The earliest account of his life was written by Athanasius. The "temptations" he underwent during his solitary sojourns became popular subjects in medieval art; Anthony may be shown attacked by *demons and wild beasts, or warding off the advances of a female figure symbolizing Lust. Normally depicted as an elderly bearded figure wearing a hood and long robes, he may hold a bell (to scare away the *Devil) and be accompanied by a pig (a former wild boar which he tamed). He may support himself on a T-shaped crutch; the *tau* *cross (derived from an ancient Egyptian symbol) was an emblem of Alexandrian Christians, and may also be depicted on the shoulder of Saint Anthony's cloak. Saint Anthony visiting Saint *Paul the Hermit, encountering a centaur and *satyr on the way, and the two old hermits being brought their daily bread by a raven are also narratives found in medieval art, deriving from the *Golden Legend*. The Order of Hospitallers of Saint Anthony was founded c.1100 to care for *pilgrims, the sick, and especially those suffering from ergotism ("Saint Anthony's Fire"); hence flames and fire are also attributes of Saint Anthony.

Example: Saint Anthony, Icon of King Agbar, tenth century?, Mount Sinai, Monastery of Saint Catherine. (Rodley, fig. 123)

ANTHONY OF PADUA, SAINT. Born in Portugal, Saint Anthony of Padua (1195–1231) became a Franciscan friar and was famed for his *preaching throughout France and Italy. He was admired by Saint *Francis, who approved his appointment as lector in theology to the Franciscan order. He is represented in art holding a lily, symbolizing his purity (see: *Flowers and Plants, Symbolism of), or a book, symbolizing his knowledge. Numerous *miracle stories (his preaching to attentive fishes; a mule kneeling before the consecrated host at his direction; his healing the severed leg of a boy who had kicked his mother; his vision of the infant Jesus) became popular subjects especially in Italian art of the fourteenth and fifteenth centuries.

Example: Saint Anthony, late fifteenth century, fresco, Rovata, San Stefano. (Kaftal, *NW,* fig. 114)

ANTIPHONARY. See MANUSCRIPTS.

APE. See ANIMALS, SYMBOLISM OF.

APOCALYPSE. The Apocalpyse (from Greek: "unveiling"), or Book of Revelation, is the last book of the New Testament and is traditionally ascribed to Saint *John, writing in exile on the island of Patmos in the late first century A.D. The twenty-two chapters contain, in complex symbolic language, exhortations for believers to remain steadfast even in the face of persecutions, phrased

in the form of vivid descriptions of the author's visions of the end of the world, the battles between good and evil, the *Last Judgment, Second Coming of *Christ, and triumphal appearance of the *Heavenly Jerusalem. Difficult to interpret, the Apocalypse provided rich materials for commentary by many medieval theologians (e.g., see: *Beatus of Liébana) and a wealth of subject matter found in all (especially western) medieval art media, both in narrative cycles, and as isolated motifs.

The text begins with a voice directing John to convey his visions to the SEVEN CHURCHES of Asia Minor, usually represented in art as *angels. John sees a vision of "one like unto the Son of Man" enthroned and radiant, in the midst of seven stars and seven candlesticks. As the visions unfold, four beasts (see: *Tetramorphs) and the *Twenty-four Elders of the Apocalypse appear, singing and praising *God. This theme (see: *Majestas Domini) was an especially popular subject for church facades and interiors from the early Christian through Gothic periods. The Lamb appears in their midst, providing the awesome image of the ADORATION OF THE LAMB. (See also: *Agnus Dei.) This subject is frequently depicted as a grand composition with a great crowd kneeling down before the sacrifical lamb elevated on an altar, or, in simpler versions, the theme is abbreviated to include simply the lamb and altar. The lamb goes on to open the SEVEN SEALS on a book (sometimes depicted as seven sealed scrolls); after each seal is opened, cataclysmic events ensue, including the appearance of the FOUR HORSEMEN OF THE APOCALYPSE (Conquest, War, Famine, and *Death, riding on, respectively, a white, red, black, and "pale" horse, carrying, in order, a bow, sword, and scales; death is accompanied by *Hades).

Earthquakes rumble, the sun turns black, the moon turns to blood, the heavens roll up, more angels appear, human-headed locusts and two especially horrific great beasts arrive (the first with multiple heads and horns), and battles rage. The WOMAN CLOTHED WITH THE SUN, wearing a crown of stars and standing on the moon, gives birth to a male child and both escape from a dragon. The luxuriantly dressed WHORE OF BABYLON, sitting upon a scarlet, multiheaded beast, appears, and the sinful city of Babylon burns. Death and *hell are thrown into the lake of fire and the Last Judgment is enacted with God enthroned. This event is often depicted as the WEIGHING OF THE SOULS with an angel (*Michael) balancing *souls in a pair of scales; *demons await to carry off the damned; angels escort the saved to *heaven. The visions conclude with the appearance of the *Heavenly Jerusalem, described as a radiant, jeweled city with twelve gates, the abode of the lamb and all the blessed.

In spite of the multiple complexities of the text, or perhaps because of the extreme detail with which the visions are described, scenes from the Apocalypse appear with great frequency in early Christian mosaics, Romanesque and Gothic wall paintings, architectural sculpture, stained glass, in other media such as tapestry (the fourteenth-century series at Angers), and in illuminated manuscripts (notably the Spanish productions of Beatus's Commentary and the thirteenth-century "Anglo-Norman" cycle; a ninth-century Carolingian manuscript at Trier

may be a copy of the earliest illustrated Apocalypse of c.500). The biblical text of the Apocalypse also provided inspiration for several other medieval visionary texts and illustration cycles (e.g., see: *Herrad of Landsberg).

APOCRYPHA. The term *apocrypha* comes from the Greek *apokryphos* ("hidden"). It refers to a number of texts historically or thematically related to both the Old and New Testaments but whose positions in the accepted canon (official catalogue of scriptural writings) have varied.

The Old Testament Apocrypha consist of about fourteen books, fragments, or additions to previous texts, written in Greek mostly between the second century B.C. and the first century A.D. These writings were regarded as sacred by Greek-speaking *Jews and included in the Septuagint (the Greek translation of the Old Testament) but not in the Hebrew Bible. Among these are the books of *Tobit, *Judith, the Wisdom of *Solomon, and Maccabees. Early Christians considered all books of the Septuagint as sacred scripture until the fourth century, when a number of scholars, notably Saint *Jerome, in his translation of both Hebrew and Greek scriptures into the Latin Vulgate Bible (c.382–389), drew a distinction between the texts received in Hebrew from those in Greek and placed the Apocrypha in a separate category (*libri ecclesiastici* versus *libri canonici*). Throughout the medieval period however, the Apocrypha were included in the Vulgate Bible and, with a few scholarly exceptions and rearrangements of material, were accepted as canonical. (It was not until the wake of the Protestant Reformation that many of the apocryphal books were removed from the "Authorized" or "King James" version of the Bible, though many were retained in the Roman Catholic Bible and by the eastern church.)

The New Testament Apocrypha are writings produced between the first and third centuries which parallel or expand upon the texts of the canonical Gospels, Epistles, Acts, and Apocalypse. This vast body of material includes works such as the *Protevangelium of James,* the *Gospel of *Nicodemus* (or: *Acts of Pilate*), the *Acts of *Peter,* of *John, of *Andrew, of *Thomas, and of *Paul (from which was extracted the *Acts of Paul and *Thecla*), the Epistles of Clement and of Barnabus, the Correspondence of *Christ and Agbar, and the *Apocalypse of Peter,* among many other texts. Although the New Testament canon was established in the late fourth century, subject matter from apocryphal writings, frequent in early Christian art, continued to play an important role in Christian iconography and literature through the Middle Ages. A great many subjects which were extremely popular in medieval art are based on apocryphal writings and later literary and hagiographic elaborations of these tales.

APOLLONIA, SAINT. Patron *saint of dentists, the Alexandrian virgin Apollonia was martyred c.249 for refusing to renounce her faith. A riotous mob tore out her teeth and threatened to burn her alive, at which she threw herself into

the flames. She is recognizable in art by her chief attribute: a pair of pincers in which she holds an extracted tooth.

Example: Martyrdom of Saint Apollonia, Hours of Etienne Chevalier, 1452–1460, Chantilly, Musée Condé. (Snyder, *NR,* fig. 248)

APOSTLES. The term "apostle" comes from the Greek *apostolos:* "envoy" or "messenger." It is used primarily but not exclusively to refer to the chief companions of Jesus and is sometimes also applied to a number of later figures who continued the evangelization and missionary work of the first apostles. The original apostles are traditionally understood to have been twelve in number (although the exact number and their names differ slightly from Gospel to Gospel and in the Acts of the Apostles). The symbolism of the number twelve is rooted in the Twelve Tribes of Israel descended from the twelve sons of *Jacob (Genesis 49). The apostles were chosen by Jesus, from the larger group of his followers, specifically to be with him in his historical life, and to be sent out to preach, heal, and exorcize. The apostles gave testimony to the *Resurrection, and according to later traditions were also all martyrs (except John).

Matthew 10:1–4 lists the brothers *Andrew and (Simon) *Peter, the brothers *James and *John, *Philip, *Bartholomew, *Thomas, *Matthew, *James (son of Alpheus), Lebbeus (Thaddeus), Simon, and *Judas Iscariot. Matthias was chosen by lot to take Judas's place after Judas committed suicide. *Paul and Barnabas are also called apostles in the book of Acts.

The apostles feature frequently in medieval art, as individuals, in groups, and in narratives from the lives of *Christ and the Virgin *Mary. See individual entries for attributes and iconography for the apostles named above, also: *Ascension, *Assumption, *Betrayal of Christ, *Calling of Peter and Andrew, *Communion of the Apostles, *Crucifixion, *Deposition, *Entry into Jerusalem, *Last Supper, *Mission of the Apostles, *Pentecost, *Transfiguration.

Example: Apostle statues, c.1241–1248, Paris, Sainte-Chapelle, interior. (Sauerländer, figs. 184–185)

APOTHEOSIS. Apotheosis is the Greek term for "deification." In classical art, emperors and figures such as *Hercules may be represented being carried, after *death, up to the realm of the gods by winged spirits. Related imagery appears in early Christian and medieval art for subjects such as the *Ascension of Christ, *Assumption of the Virgin, and, in hagiographic illustration, depictions of the *souls of *saints rising up to *heaven. See also: *Elijah.

Example: The Apotheosis of Giangaleazzo Visconti, Funeral Eulogy, early fifteenth century, Paris, BN, MS lat. 5888, f. 1. (Thomas, pl. 5)

APPLE. See FRUIT AND TREES, SYMBOLISM OF.

AQUARIUS. See ZODIAC.

ARATUS. The Greek poet Aratus (c.315–240 B.C.) composed his most famous work, the *Phaenomena,* in Athens for the Macedonian ruler Antigonus Gonatas. The poem consists of 1,154 verses, which describe the stars, constellations, circles of the heavens, and movements of planets. The work was translated, revised, and widely disseminated in antiquity and the Middle Ages. The treatise was illustrated in the late antique period (if not earlier). Carolingian copies of Latin translations (known as the *Aratea*) preserve the late classical style in diagrams and illustrations. The work was extremely influential in providing a general guide to astronomy and inspiring artistic depictions of celestial phenomena up through the Renaissance period.

Example: Aratea, 830s, Leiden, UL, MS Voss. lat. Q. 79, f. 30v. (Dodwell, fig. 35)

ARCHANGELS. See ANGELS.

ARCHER. See ZODIAC.

ARIES. See ZODIAC.

ARISTOTLE. The works of the Greek philosopher and student of Plato, Aristotle (384–322 B.C.), were extremely influential in the High Middle Ages. In the twelfth and thirteenth centuries a number of his writings on metaphysics, political theory, and scientific subjects were acquired and translated into Latin from Arabic and Greek and reintroduced in the west primarily through Arab and Jewish scholars. The study of Aristotle became a critical aspect of the medieval university curriculum, the basis of medieval scholasticism, and influenced a great many scholars and theologians such as Peter Abelard, Albertus Magnus, and *Thomas Aquinas, who were interested in issues of faith, reason, and the reconciliation of pre-Christian scholarship with church doctrine. In medieval art, Aristotle may appear in representations of the *Seven Liberal Arts as an exemplar of Logic (or Dialectic) and also in the farcical form of *Aristotle and Campaspe.

Example: Seven Liberal Arts, c.1145–1155, Chartres Cathedral, west portal, archivolt. (Sauerländer, fig. 15)

ARISTOTLE AND CAMPASPE (OR PHYLLIS). The story of Aristotle and Campaspe is a late medieval tale, of a popular genre, concerning the power of women over men. Known in the thirteenth century, the subject appears in thirteenth- and fourteenth-century sculpture, metalwork, and ivory, and was illustrated in paintings, prints, and tapestries of the fifteenth century. According to the legend, Campaspe (alternately Phyllis) was the wife (or favorite concubine) of *Alexander the Great. Aristotle, as Alexander's tutor, cautioned him against women; Campaspe, in revenge, caused Aristotle to fall in love with her and required that he allow her to ride on his back. Aristotle is shown as a silly old

man on all fours with Campaspe sitting on top of him. Alexander watches the event and determines to mistrust women and be wary of the power of love.

Example: Housebook Master, *Aristotle and Phyllis,* c.1480, engraving. (Synder, NR, fig. 302)

ARITHMETIC. See SEVEN LIBERAL ARTS.

ARK. See NOAH.

ARK OF THE COVENANT. As described in Exodus 25, *God instructed *Moses to supervise the creation of a portable, gilded chest of acacia wood to serve as a container for the two tablets of the law and to symbolize the agreement (covenant) between God and the Israelites. It was the most sacred object, carried by the Israelites and eventually installed, by *Solomon, in the Holy of Holies in the Temple in Jerusalem until the conquest of Jerusalem in the sixth century B.C. Some traditions also indicate that the ark contained a pot of manna (see: *Gathering of the Manna) and *Aaron's rod. A pair of golden cherubim (see: *Angels) were placed on the side ends of the cover.

Example: Ark of the Covenant, early ninth century, mosaic, Germigny-des-Prés, Oratory of Theodulf. (Snyder, fig. 244)

ARMA CHRISTI. *Arma Christi* is a Latin term for the "weapons of Christ." It refers to the "weapons" used by *Christ in his victory over *death and the *Devil. The *Arma Christi* represent Christ's suffering as well as his triumph and include the *cross, *Instruments of the Passion, as well as other objects, events, or results associated with Christ's passion, for example, his wounds and the veil of *Veronica. The *Arma Christi* appear especially in representations of the *Crucifixion and *Last Judgment. In later medieval art, they are also found as independent devotional images and in representations of the *Man of Sorrows. Meditations on the suffering of Christ and all episodes leading up to the Crucifixion were a frequent focus of mystical writings especially from the fourteenth century following; hence, the visual symbols of the *Arma Christi* expand greatly in later medieval art. Sometimes the *Arma Christi* are depicted on shields held by *angels. See also: *Andachtsbilder, *Mandylion, *Sudarium, *Mass of Saint Gregory.

ARREST OF CHRIST. The arrest of Jesus is described in all four Gospels. The episode follows the *Agony in the Garden and precedes the *Trials of Christ. A group of soldiers (temple guards, plus, according to *Luke, Jewish priests and elders) were led at night, by *Judas, to Jesus and the other *apostles in the garden of Gethsemane. Judas identified Jesus by kissing him (this not mentioned in *John), and the soldiers arrested Jesus. As an independent image, this important episode appears very early in Christian art (e.g., early sixth-century mosaics of Sant' Apollinare Nuovo, Ravenna) and throughout the me-

dieval period, frequently following the kiss of Judas (see: *Betrayal of Christ) in sequential narratives. Soldiers (variable numbers, sometimes bearing lances and torches) approach, surround, or seize Jesus; Jesus may be shown standing calmly or being led away; his hands may be bound behind him. Landscape details of the outdoor setting may be indicated. Other episodes, which may be included within the scene, are *Peter cutting off the ear of Malchus (the high priest's servant) with a sword, Jesus healing Malchus's severed ear, and the apostles fleeing.

Example: Arrest of Christ, Book of Kells, c.800, Dublin, TC, MS A.1.6, f. 114. (Dodwell, fig. 69)

ARS MORIENDI. The *Ars moriendi (The Art of Dying)* refers to two related works of the fifteenth century that provide directions and illustrations on the preparations and procedures for *death. A short version of the text, frequently illustrated with woodcut prints from the mid-fifteenth century, depicts deathbed scenes such an *angels and *demons awaiting the *soul of the dying person, and *devils tempting the dying person with despair, impatience, and pride. The illustrations are accompanied by a short text adapted from a longer and more detailed version produced c.1415, the *Tractatus artis bene moriendi (The Art of Dying Well),* which also includes directions to onlookers and instructions for appropriate prayers. Concern about death and salvation were overwhelming preoccupations throughout the medieval period; the *Ars moriendi* is, however, the first practical manual on how to prepare for a ''good death'' and was used by clerics as well as lay people. The deathbed iconography of the illustrations also appears in earlier and contemporary Books of Hours (see: *Manuscripts) in scenes for the Office of the Dead and elsewhere. See also related themes: *Dance of Death, *Three Living and Three Dead, *Triumph of Death.

Example: Ars moriendi, 1460–1465, block book illustration. (Synder, NR, fig. 268)

ARTHURIAN LEGENDS. Of disputed historical authenticity, King Arthur appears in early Welsh poetry and in the ninth-century chronicle *(Historia Brittonum)* of the Welsh writer Nennius. He is described as a brave warrior who led the Britons in a number of victorious battles against the Saxons in the early sixth century. The deeds of Arthur were expanded in folklore and oral tradition. Geoffrey of Monmouth included a very detailed account of Arthur's reign in his *Historia regum Britanniae* (1136). This text, widely copied throughout the Middle Ages, inspired a number of offshoots and translations. Geoffrey also composed a life of the magician Merlin (the *Vita Merlini,* c.1135). These works, plus earlier and contemporary, related and independent compositions in Welsh and Irish, were translated, adapted, expanded, and revised in French, notably by Chrétien de Troyes and Marie de France in the late twelfth and early thirteenth century. Chrétien's works include especially influential narratives concerning Lancelot, Percival, and the quest for the *Holy Grail. In the thirteenth century, a number of Arthurian tales were expanded and recast into prose form (the

"Vulgate Cycle" of c.1215–1235); these compositions include: the *Queste del Saint Graal, Mort Artu, Lancelot en prose, Estorie del Saint Graal,* and the *Estoire de Merlin.*

Arthurian legends appear in German literature of the late twelfth century and important compositions of the thirteenth century include Gottfried von Strassburg's *Tristan und Isolt* and Wolfram von Eschenbach's *Parzival.* Numerous other Arthurian stories were composed in Norse, Dutch, Hebrew, Italian, Latin, and English from the thirteenth through fifteenth century, notably the monumental *Le Morte d'Arthur* of c.1470 by Sir Thomas Malory.

Corresponding with the vastness, variety, and complexity of the Arthurian legends in medieval literature, pictorial representations exist in a myriad of forms and media including sculpture, painting, tapestry, embroidery, metalwork, ivory, tilework, illuminated manuscripts, and woodblock prints. The very first example of Arthurian imagery may be in sculpture on the north portal of Modena Cathedral in Italy (c.1100–1140). Lavishly illustrated Arthurian manuscripts were created for wealthy patrons, especially in France, Italy, and Flanders, beginning in the early thirteenth century, and scenes from Arthurian romance were extremely popular on French ivory jewel caskets, combs, and mirror backs of the fourteenth century. The brave deeds of the Knights of the Round Table are found in wall paintings, especially in castles, other dwellings, and in secular/ civic buildings, as well as in tile pavements (Otranto Cathedral, c.1165; Chertsey Abbey, c.1270). Sculptures, manuscripts, stained glass, and tapestries depicting the Nine Worthies (famous world conquerors detailed in *Les Voeux du paon,* a French text of the early fourteenth century) were also very popular. Arthur is included with the Christian heroes: *Charlemagne, and Godefroy de Bouillon, who accompany the "pagan" heroes: Hector, Julius Caesar, and *Alexander the Great, and the Jewish heroes: *Joshua, *David, and *Judas Maccabeus.

Example: Roman de Lancelot du Lac, c.1300, New York, PML, MS 805, f. 67. (De Hamel, fig. 135)

ASCENSION. *Christ's ascent to *heaven is described in Acts 1:9–11. Although the Gospel of *John (20:17) implies that the event took place immediately after his *Resurrection and meeting with *Mary Magdalene (see: *Noli me tangere), traditionally the Ascension is placed forty days after Christ's *death and Resurrection, and was witnessed by the *apostles on the *Mount of Olives. The Acts of the Apostles states that he was "taken up" to heaven and received into a cloud. Two men dressed in white (perhaps *angels) appeared to the apostles, remarking that Christ will again return in like manner. Artistic representations of the event vary. In early Christian art, Christ may be shown as a full-length figure in profile, striding up a mountain, with the hand of *God reaching down from heaven to assist him upward. Sometimes the mountain is not represented, and Christ strides up within a mandorla (see: *Halo). He may also be shown as a full-length frontal figure in a mandorla being lifted upward by angels. In Romanesque art, sometimes only the feet or toes of Christ are

shown as he disappears up into heaven. The image may also include the witnessing apostles, two men in white, and the Virgin *Mary. Ascension imagery is not restricted to Jesus; the prophet *Elijah was taken up to heaven in a fiery chariot, and the body of the Virgin *Mary was carried up to heaven (see: *Assumption). Little figures representing the *souls of numerous *saints may also be shown carried up to heaven. Figures ascending to heaven, such as Roman emperors and characters from classical mythology, appeared in non-Christian art and may have influenced the Christian iconography (see: *Apotheosis).

Example: Ascension of Christ, Rabbula Gospels, c.586, Florence, BML, MS Plut. 1, 56, f. 13v. (Synder, cp. 8)

ASS. See ANIMALS, SYMBOLISM OF.

ASSUMPTION. The term assumption comes from the Latin *adsumere,* "to take up." The belief that the body and *soul of the Virgin *Mary were taken up to *heaven after her *death is first found in late fourth-century apocryphal writings which give various accounts of her death, entombment, and bodily assumption. Accepted, and celebrated liturgically, in both western and eastern churches from at least the sixth or seventh century, the event was illustrated in art by the eighth century and became especially popular in the Romanesque and Gothic periods with the increasing veneration of Mary and the retelling of the event in the *Golden Legend.* Although often linked or conflated with scenes depicting Mary's death (see: *Dormition) and her *Coronation in heaven, the Assumption is normally distinguished by the presence of *angels who surround and elevate Mary's body. She may be shown reclining, or in *orant position, transported to heaven in a mandorla (see: *Halo) supported by angels. Although thematically related to *Ascension scenes, the angelic action required in the Assumption is distinctive. The *Golden Legend* specifies that the *apostles, *Christ, and Saint *Michael were also present, although they are not always represented in art. If present, Christ may be depicted holding a tiny human figure representing Mary's soul, as common also in Dormition scenes. Frequent in Gothic sculpture, the Assumption of Mary is also often illustrated in Books of Hours (see: *Manuscripts). In late medieval art, Mary may be shown letting her belt drop down to "doubting" *Thomas to convince him of her Assumption.

Example: Assumption of the Virgin, c.1170, Senlis Cathedral, west portal, lintel. (Sauerländer, fig. 43)

ASTRONOMY. See SEVEN LIBERAL ARTS.

AUBIN, SAINT. The life of Saint Aubin (or Albinus, d. c.550) was composed in the late sixth century by Venantius Fortunatus and notably illustrated in the late eleventh century in a manuscript produced at the abbey of Saint-Aubin in Angers. Saint Aubin was born in Brittany, became a monk and later abbot of the monastery of Tincillac, and from 529 served as bishop of Angers. He was

especially renowned for his charity and posthumous *miracles which were recorded and illustrated during the eleventh century.

Example: Life of Saint Albinus, late eleventh century, Paris, BN, MS nouv. acq. lat. 1390, f. 2. (Dodwell, fig. 218)

AUDOMARUS, SAINT. See OMER, SAINT.

AUGUSTINE OF CANTERBURY, SAINT. "Apostle to the English," the Italian-born Benedictine monk Augustine (d. c.604/605) was selected by Pope *Gregory the Great to lead the mission to England. He arrived in 597, established the cathedral and monastery in Canterbury and worked successfully to convert King Ethelbert of Kent and other southern Anglo-Saxons to Roman Christianity. He was the first archbishop of Canterbury and founder of England's first cathedral. He is depicted in art as a bishop and probably owned an important sixth-century manuscript of the Gospels (with two illustrated pages) now in Cambridge.

Example: Gospels of Saint Augustine, late sixth century, Cambridge, CCC, MS 286, f. 129v. (Robb, cp. III)

AUGUSTINE OF HIPPO, SAINT. One of the four Latin *Doctors of the Church, Saint Augustine's life (354–430), deeds, and writings have had a profound impact on the history of Christianity. Details of his life are contained in his autobiographical work, the *Confessions* (c.400). He was born at Tagaste (North Africa) and although brought up as a Christian by his mother, Saint Monica, abandoned Christianity and spent much of his youth exploring classical philosophy and the teachings of the Manichaeans (a popular heretical sect). He studied and later taught in Carthage before moving to Rome in 383 and to Milan in 384 where he reconverted to Christianity under the influence of Saint *Ambrose. He was baptized in 387. He returned to Africa determined to lead a semimonastic lifestyle with a few companions, which he did until 391, when he visited the town of Hippo Regius, and his reputation inspired the citizens to insist on his ordination as a priest. He became the bishop's assistant in 395 and was appointed bishop of Hippo in 396, which position he held until his *death. Augustine was the author of numerous sermons, letters, treatises, devotional works, and commentaries; he is also credited with composing or inspiring an important monastic rule which was adapted for use by several orders especially from the eleventh century following, in the west. His writings refuting several popular heresies (Manichaeism and the Donatist and Pelagian controversies) were instrumental in the formation of church doctrine. Among his many important works, *City of God (De civitate Dei,* c.413–426) is notable for presenting a theory of history from the Christian point of view. The works of Augustine, especially the *Confessions, City of God,* and his treatises on the Psalms and the *Trinity, were widely copied and studied during the Middle Ages and some appear in illustrated versions. Augustine may be represented in frontispiece il-

lustrations to these works, as an *author, teacher, or engaging in dispute with heretics. He is normally shown in bishop's robes although he may also appear as a monk. Detailed narrative scenes from his life are more common in Renaissance than in medieval art.

Example: Portrait of Saint Augustine, City of God, c.1120, Florence, BML, MS Plut. XII.17, f. 3v. (Dodwell, fig. 330)

AUTHOR. Authors are frequently depicted in medieval art as seated figures holding books or scrolls or engaged in writing, following the traditional forms of representing authors from classical art. Author ''portraits'' (e.g., of the *Four Evangelists) often preface their Gospels in medieval manuscripts. Some medieval scribes depicted themselves in ''self-portraits,'' and authors may also be shown in dedication portraits, presenting their works to their patrons or to *God. Several figures, especially famed for their writing and scholarship, are typically depicted as authors, including: Saints *Augustine, *Bernard of Clairvaux, *Jerome, *Gregory the Great, and *Thomas Aquinas.

Example: Saint Matthew, Lindisfarne Gospels, c.700, London, BL, Cotton MS Nero D.4, f. 25v. (Synder, fig. 218)

AVARICE. See VICES.

B

BABEL, TOWER OF. See TOWER OF BABEL.

BABYLON, WHORE OF. See APOCALYPSE.

BAGPIPE. See MUSICAL INSTRUMENTS, SYMBOLISM OF.

BALAAM. Balaam appears in Numbers 22–24; he was commissioned by the king of Moab to curse the Israelites who were arriving in the Transjordan area. He set off on his task, riding on an ass, but three times a sword-bearing *angel appeared to the ass, inhibiting the animal from moving. Balaam, increasingly infuriated, beat the animal and threatened to kill it. The ass finally spoke to Balaam, explaining, and the angel appeared to him also. Balaam was convinced of *God's power and refused to curse the Israelites; rather, he followed God's directions, offered sacrifices to God and blessings on the Israelites. Numbers 24: 17 cites Balaam's prophetic vision of a ''Star Out of Jacob,'' which language seems to speak to the primacy of the Davidic dynasty. Later, however, living with the Midianites, he encouraged the Israelites into the cult of Baalpeor (Numbers 31); he was eventually killed by the Israelites. Balaam is depicted in art most often riding on an ass and being halted by a sword-bearing angel; he is occasionally also shown pointing to a star in the sky.

 Example: Balaam, c.1220, Chartres Cathedral, north transept, right door, jamb figure. (Sauerländer, fig. 92)

BAPTISM. Baptism is the formal ceremony of initiation into the Christian church. Initiation rituals involving water or symbolic cleansing ceremonies were practiced in Judaism and were also popular in several sects and mystery cults of the late antique period. The procedures and preparations for Christian Baptism are outlined in early church manuals (such as the *Didache*) and described by

early authors such as Tertullian (*De baptismate,* c.200). Baptism may take place by immersion in water or by infusion (pouring water on the head). The ceremony is normally performed by bishops or priests. Descriptions and discussions of the rite were continued by numerous authors (such as *Augustine and *Thomas Aquinas) through the Middle Ages.

Baptisms are frequently depicted in early Christian and medieval art, most especially the Baptism of Jesus in the river Jordan by Saint *John the Baptist, which is one of the subjects most often represented in medieval art. This event is mentioned in all four Gospels and marks the beginning of Jesus' public life and ministry. At the moment of his Baptism, the dove, suggesting the *Holy Spirit, appeared and the voice of *God was heard proclaiming Jesus as his son. In art, the scene normally involves Jesus (standing in the river), John the Baptist (approaching or pouring a cup or handful of water on Jesus' head), and the dove hovering above. Other witnesses and *angels may also be present. Baptisms of or performed by *saints are frequent in illustrated hagiography, and the baptisms of rulers (such as *Constantine) were also popular subjects in medieval art.

Example: Baptism scene, third century, fresco, Rome, Catacomb of Callixtus. (Synder, fig. 6)

BARABBAS. See TRIALS OF CHRIST.

BARBARA, SAINT. Legends recount that the third-century virgin martyr Saint Barbara was a beautiful young noblewoman of Nicomedia who was imprisoned in a tower by her father, who wished to keep away her suitors and/or shield her from Christian influences. During her father's absence, she converted to Christianity and proclaimed her faith by having a third window built in her tower (symbolizing the *Trinity). She escaped from the tower but was pursued by her angry father, who eventually turned her in to the Roman authorities who tortured her. She refused to renounce her faith and was decapitated by her own father, who was then struck dead by a lightning bolt. Her chief attribute in art is her tower; she may also be shown holding a chalice, reading a book, or accompanied by a peacock (see: *Birds, Symbolism of). Narrative scenes include her escape from her tower, tortures, and decapitation.

Example: Saint Barbara, Hours of Englebert of Nassau, c.1485–1490, Oxford, BL, MS Douce 219–220, f. 41. (Robb, fig. 214)

BARTHOLOMAEUS ANGLICUS. The English Franciscan scholar Bartholomaeus Anglicus, authored, c.1240, an extremely influential and comprehensive encyclopedia titled *De proprietatibus rerum (On the Properties of Things).* The work draws from a number of previous sources as well as the author's own observations and contains nineteen well-organized books covering a variety of topics (e.g., natural history, the human body, medical procedures). It was one

of the most frequently copied late medieval works of this genre, was translated into a variety of languages, and often illustrated.

Example: Creation scene, De proprietatibus rerum, mid-fourteenth century, London, BL, Add. MS 11612, f. 10. (Alexander, fig. 243)

BARTHOLOMEW, SAINT. Although included in the lists of the *apostles in the New Testament, Bartholomew (or Nathanael) plays an extremely minor role in the canonical narratives. Later traditions (e.g., as recounted by Eusebius) describe his missionary work in ''India'' (Persia, Egypt, Mesopotamia, Armenia) and attribute to him a Hebrew version of *Matthew's Gospel. An apocryphal *Gospel of Bartholomew* was also circulating by the fifth century. Traditionally, Bartholomew was martyred (flayed and then decapitated) either in India or Armenia—from where his *relics were eventually translated to Rome in the tenth century. Scenes of his *martyrdom appear frequently in medieval art; his primary iconographic attribute is a large knife; he is also depicted holding his own skin (over his shoulder or draped over one arm) or with a small chained *demon which he exorcised from the son of the king of Armenia.

Example: Saint Bartholomew, mid-twelfth century, mosaic, Cefalu Cathedral. (Kaftal, C&S, fig. 172)

BASIL, SAINT. The well-educated Basil of Caesarea (c.329–379) studied in Constantinople and Athens (along with Saint *Gregory of Nazianzus) before traveling to various monasteries in Spain, Palestine, and Egypt, eventually becoming a hermit, and establishing a number of monastic communities in Asia Minor. He was responsible for composing an austere and influential monastic rule (the foundation of eastern monasticism) as well as noted for his active participation in combating heresy. He was appointed bishop of Caesarea in 370. He is represented in both western and Byzantine art from the early medieval period and is often grouped with the other *Doctors of the eastern church (Saint *Gregory of Nazianzus and Saint *John Chrysostom) in Byzantine *icons. He is depicted in bishop's robes, often holds a *cross, and may have a dove (symbol of the *Holy Spirit) perched on his shoulder. He may also be shown (e.g., in tenth-century Cappadocian frescoes) disputing with the Arian emperor Valens or visited by Saint Ephraem the Syrian.

Example: Saint Basil the Great, c.1405, icon, Moscow, Kremlin, Cathedral of the Annunciation. (*The Icon,* p. 264)

BASILISK. See ANIMALS, SYMBOLISM OF.

BATHSHEBA. Bathsheba became the wife of King *David after he caused her husband Uriah (one of his military captains) to be positioned so as to be killed in battle. David's lust for the beautiful Bathsheba, whom he first glimpsed from the roof of his palace while she was bathing, is described in 2 Samuel 11:2. Her response to his royal demands resulted in her pregnancy, the *death of

Uriah, her subsequent marriage to David, their rebukes by the prophet *Nathan, the death of her first son by David and the later birth of their son *Solomon; all of these events are detailed in 2 Samuel 11–12. Bathsheba features again, at David's deathbed, in 1 Kings 1, ensuring the succession and anointing of Solomon. Scenes from the life of David involving Bathsheba are found throughout medieval art; the subject of David viewing her bathing became especially popular in the later medieval period, when it may involve an elaborate landscape and architectural composition with the small figure of David peering down upon a partly clothed or nude Bathsheba in a garden setting. Illustrations of their rebuke by Nathan, her marriage to David, and the birth of Solomon are all also found earlier, especially in the detailed cycles of biblical illustrations in Romanesque and Gothic manuscripts.

Example: Bathsheba at her Bath, Book of Hours, c.1500, Walters, MS 427, f. 133v. (Wieck, fig. 66)

BAVO, SAINT. A wealthy landowner, Bavo (c.589–c.653) turned from his indulgent lifestyle and became a penitent and hermit after the *death of his wife. He was converted to Christianity by Saint *Amand and accompanied him in missionary work in France and Flanders. He spent the last years of his life living as a recluse in the forests near Ghent. His attributes in art include a falcon (symbolic of his former lifestyle) and the hollow tree where he lived as a hermit.

BEAR. See ANIMALS, SYMBOLISM OF.

BEASTS. See ANIMALS, SYMBOLISM OF; MANUSCRIPTS; PHYSIOLOGUS; TETRAMORPHS.

BEATITUDES OF THE SOUL. During the *Sermon on the Mount, Jesus pronounced a series of blessings characterizing those who live in accord with *God's kingdom (*Matthew 5:2–11). Each saying begins, ''Blessed (or happy) are . . .'' (the poor in spirit, mourning, meek, righteous, merciful, pure in heart, peacemakers, and persecuted). These spiritual qualities and consequences, similar to those spoken about by Jesus to his disciples in *Luke 6:20–22, may be illustrated in medieval art by female figures bearing scrolls inscribed with the words of each blessing.

Additionally, medieval theologians (notably Saint *Anselm in the eleventh century) expanding upon the biblical beatitudes, identified a series of ''gifts'' to be anticipated by the righteous in the renewed state of the world after the *Last Judgment. These fourteen beatitudes of the body and the *soul are also depicted in medieval art, especially during the Gothic period, as personified figures representing: *Beauty, Agility, Strength, Freedom, Health, Pleasure, and Longevity* (the gifts of the body), and *Wisdom, Friendship, Concord, Honor, Force, Serenity, and Joy* (the gifts of the spirit). The figures are accompanied

by appropriate attributes, for example, Roses for *Beauty,* Doves for *Friendship.* For related themes, see: *Seven Gifts of the Holy Spirit, *Virtues.

Example: Chalice (base), c.1170, Tremessen, Abbey Church. (Swarzenski, fig. 435)

BEATUS OF LIEBANA. Beatus (d. c.798), a monk of the monastery of Lié-bana in northern Spain in the Christian territory of Asturias-León, composed his Commentary on the Apocalypse c.776. The work is arranged in twelve books, with selections from the *Apocalypse followed by interpretation and commentary from various sources. More than twenty richly illustrated versions exist, dating from the tenth through the thirteenth centuries, exhibiting a distinctive bright-colored style and detailed visual narrative presentation of this complex, visionary text. While the Apocalypse was an essential text in the Spanish liturgy of the Easter season, the popularity of the Beatus *Commentary* may also be explained by doctrinal disputes within the Spanish church and the uneasy political situation caused by the growing Islamic territorial domination. The struggle with anti-Christian forces and the triumph of good in the cataclysmic *Last Judgment are emphasized in the text and illustrations.

Example: Christ Appearing in the Clouds, Silos Beatus, 1109, London, BL, Add. MS 11695, f. 21. (Dodwell, fig. 247)

BELL. See MUSICAL INSTRUMENTS, SYMBOLISM OF.

BELSHAZZAR. According to the book of *Daniel, Belshazzar, ruler of Babylon, gave a great feast one evening for a thousand of his courtiers, wives, and concubines. As they were drinking wine served in golden vessels, which had been stolen from the Temple in Jerusalem by Belshazzar's father, *Nebuchadnezzar, a mysterious vision of a hand, writing on the wall, appeared. Daniel was called upon to interpret the words: *"Mene, mene, tekel, upharsin"* and explained that Belshazzar was "weighed in the balances and found wanting." As Daniel warned, the kingdom was invaded that night by Darius, and Belshazzar was killed. The scene of Belshazzar's feast is found in medieval illustrated manuscripts of the Bible and *Apocalypse and in architectural sculpture.

Example: The Story of Daniel, Farfa Bible, c.1000–1125, Rome, BAV, MS lat. 5729, f. 227v. (Robb, fig. 102).

BENEDICT, SAINT. Saint Benedict (c.480–c.550), the "Father of Western Monasticism," was Italian, born at Nursia and educated in Rome. Around 500 he chose to live as a hermit in a cave at Subiaco, where eventually he was joined by a small community of followers. From this beginning, twelve monasteries grew, each with twelve monks, the abbots chosen by Benedict. Around 525 he founded the monastery at Monte Cassino, where he lived for the rest of his life. At Monte Cassino he wrote his influential guidebook for monastic life: *The Rule of Saint Benedict,* based on an earlier *Rule of the Master.* The Benedictine nuns, established by Benedict and his sister, Saint *Scholastica, also

followed this rule. Benedictine monasticism became one of the largest and most powerful forces in medieval religious life, although it was subject to a number of later reforming movements.

The life of Saint Benedict was composed by Pope *Gregory, and scenes from Benedict's life often represented in art derive primarily from Gregory's text. Episodes include various *miracles, healing scenes, encounters with the *Devil, Benedict's triumphs over temptation, his visions, and *death. These subjects appear in sculpture (especially at Benedictine abbeys) and in manuscript illustration (notably the late eleventh-century *Vita Benedicti* from Monte Cassino). He may be shown wearing the black habit of the original order or white habit of later reformed orders; he may be clean-shaven or shown as an old man with a white beard.

Example: Scenes from the Life of Saint Benedict, Vita Benedicti, late eleventh century, Rome, BAV, MS Vat. lat. 1202, f. 80. (Synder, fig. 393)

BENEDICTION. From the Latin *benedictio* (''blessing''), a benediction is a blessing performed by members of the clergy through spoken *prayer and gesture. Benedictions are pronounced by priests and bishops at various points in the liturgy and during other ritual occasions. The practice ultimately derives from Jewish customs, adapted by the early Christian church, of giving thanks to and asking blessings from *God. The Greek term for acts of blessing is *eucharistia* (''to give thanks''). As developed in Christian practice, the traditional hand gesture required (and as illustrated in art) involves the raising of the arm and extension of three fingers (symbolizing the *Trinity); the fingers and their position diverge slightly in western and Byzantine practice. Gestures of benediction appear frequently in medieval art, performed by *saints, *angels, clerics, *Christ, and *God the Father. In early Christian and medieval examples, often simply the hand of God making a gesture of benediction will appear in the heavens during important events. A Benedictional (see: *Manuscripts) is a book which contains blessings spoken by bishops.

Example: A Bishop Pronouncing a Blessing, Benedictional of Saint Aethelwold, 971–984, London, BL, Add. MS 49598, f. 118v. (Dodwell, fig. 91)

BENEDICTIONAL. See MANUSCRIPTS.

BENEFICENCE. See VIRTUES.

BERNARD OF CLAIRVAUX, SAINT. Reviver and promoter of the Cistercian order, Bernard (c.1090–1153) exerted a profound and lasting influence on both religion and politics in the Middle Ages. An eloquent preacher (e.g., of the Second Crusade in 1146), famed for his pious austerity and mystical and devotional writings, Bernard joined the reformed Benedictines (Cistercians) at Citeaux c.1113 but left with twelve others, to establish the community at Clairvaux in 1115, from which, with papal support, numerous other communities

were established as the Cistercian order grew rapidly through the twelfth century. Bernard's mystical and theological works (e.g., *On the Love of God*), sermons (e.g., *On the Song of Songs*), hymns, and his devotion to the Virgin *Mary were extremely influential in the development of later medieval mysticism and the growth of the cult of the Virgin. He was canonized in 1174 and appears in art from the late twelfth century onward, generally dressed as a monk in the white Cistercian habit, and carrying a book, abbot's crozier, or *cross. He may be shown with a beehive, symbolizing his eloquent (mellifluous) speech. Narrative episodes from his life (visions of the Virgin, the Virgin nourishing Bernard with milk from her breast, combats with *demons, and his resistance of lustful temptations) are primarily found in the later and postmedieval periods.

Example: Bernard in His Study, Verses of Saint Bernard, c.1470, Walters, MS 285, f. 100. (Wieck, fig. 81)

BERTIN, SAINT. A monk of Luxeuil, Saint Bertin (c.615–698) accompanied Saint *Omer in missionary work in northern France; in 663 they founded a church which became the cathedral of Saint-Omer; they also established several monasteries. Bertin was appointed abbot of Sithiu, which was later named the abbey of Saint-Bertin. He is depicted in art as a Benedictine monk and often also with a boat (required to reach Sithiu).

Example: Saint Bertin and his Companions, Vie des Saints Bertin, Folquin, Silvin, et Winnoc, c.1000, Boulogne, BM, MS 107, f. 6v. (Porcher, pl. VI)

BESTIARY. See ANIMALS, SYMBOLISM OF; MANUSCRIPTS; PHYSIOLOGUS.

BETRAYAL OF CHRIST. Following the *Agony in the Garden and leading to the *Arrest of Christ, the Gospels recount how *Judas, following up on earlier negotiations, led temple guards, elders, and priests to Jesus and the other *apostles in the Garden of Gethsemane at night. All Gospels, apart from *John, describe that Judas identified Jesus to the guards by kissing him. The moment of betrayal is frequently and dramatically depicted in art from the early Christian period following. Judas may approach Jesus from left or right, put his arms around Jesus or touch his shoulder while kissing him. Jesus normally appears calm and majestic. The (often armed and torch-bearing) onlookers may watch quietly, be shown as poised to seize Jesus, or they may gesture actively. The scene is often conflated with the arrest; soldiers may seize Jesus while Judas is in the act of kissing him. Additional incidents, such as Saint *Peter cutting off the ear of Malchus, the high priest's servant, may also be included.

Example: Betrayal and Arrest of Christ, c.1085, fresco, Sant' Angelo in Formis, nave arcade. (Synder, fig. 390)

BETROTHAL OF THE VIRGIN. See MARRIAGE OF THE VIRGIN.

BIBBIE ATLANTICHE. The term *Bibbie atlantiche* (''Atlantic'' or ''Giant Bibles'') refers specifically to a number of extremely large illustrated Bibles (i.e., most are approximately two feet tall) which were produced, especially in central and northern Italy, from the mid-eleventh through twelfth centuries.

Example: Giant Bible from Todi, c.1125, Rome, BAV, MS lat. 10405, f. 4v. (Robb, fig. 106)

BIBLE. See MANUSCRIPTS.

BIBLE HISTORIALE. The *Bible historiale* is a late thirteenth–early fourteenth century adaptation and translation into French, by Guyart des Moulins, of the twelfth-century Latin textbook by Peter Comester known as the *Historia scholastica.* It provides prose summaries and commentaries on the historical sections of the Bible from Genesis through Acts, plus texts drawn from other authors to fill in the historical chronology. Accompanied by copious illustrations (normally column pictures), this very popular work survives in about seventy copies, many containing 100 or more illustrations.

Example: Bible historiale, 1357, London, BL, Royal MS 17.E.VII, f. 1. (De Hamel, fig. 152)

BIBLE MORALISEE. ''Moralized Bibles'' are large Bible picture books produced in mid-thirteenth century France, probably for a courtly audience. Several multivolume copies survive; the largest contains close to 5,000 pictures. The illustration format involves eight pictorial medallions in two columns of four per page (similar to and perhaps influential on, or influenced by, contemporary stained glass compositions) with short vertical columns of text alongside the pictures. The captions provide moral, allegorical, or typological commentary on the selected biblical scenes depicted. Brilliantly illustrated in a distinctive ''court style,'' these sumptuous manuscripts also reflect contemporary revisions of the Vulgate text and scholastic commentaries emanating from the University of Paris.

Example: Bible moralisée, c.1220, London, BL, Harley MS 1527, f. 27. (De Hamel, fig. 111)

BIBLIA PAUPERUM. A type of picture Bible, especially popular in the later medieval period, the *Biblia pauperum* (Bible of the Poor) contains a typological illustration scheme correlating scenes from the life of *Christ in the New Testament with pairs of Old Testament illustrations, accompanied by short, explanatory captions. Typically, about forty pictures were included. Not many medieval examples still survive of this popular work which was used for religious instruction (probably of poorer or semiliterate clerics and lay people of varying wealth and literacy). The text was often illustrated with woodblock prints from the fifteenth century following.

Example: Biblia pauperum, early fifteenth century, London, BL, King's MS 5, f. 20. (De Hamel, fig. 216)

BIRDS, SYMBOLISM OF. The symbolism of birds in medieval art derives from the same sources and motivations as medieval animal symbolism in general (see: *Animals, Symbolism of; *Physiologus). Particular birds mentioned in the Bible feature in pictorial narratives and also as independent symbols for human conduct and religious concepts.

For example, the DOVE, which plays a critical role in the story of *Noah and the *Deluge, is a symbol of peace and purity. Hence, doves are offered at the Temple in scenes such as the *Presentation and *Purification in the Temple. The dove descends from *heaven at the moment of *Christ's *Baptism as a symbol of the *Holy Spirit and thus also appears in representations of the *Annunciation, *Pentecost, and *Seven Gifts of the Holy Spirit. The dove is also the attribute of several *saints (see: *Benedict, *Catherine of Siena, *Gregory, *Scholastica).

The strong and high-soaring EAGLE is the attribute of Saint *John the Evangelist, as well as a symbol of Christ's *Resurrection, of human salvation, courage, and generosity. The proud and beautiful PEACOCK may symbolize vanity but more often is seen to represent the Resurrection (because it was believed that peacocks' flesh did not decay) and the "all-seeing" *Church, because of the "eyes" of its tail feathers. The PELICAN symbolizes Christ's sacrifice because it was said to pierce its own breast to revive its offspring by feeding them with its own blood, after having killed them in anger. The mythical long-lived PHOENIX, which rises periodically, refreshed from the flames of its own funeral pyre, is also a symbol of Christ's Resurrection and triumph over *death.

Other birds, such as the RAVEN, have less positive connotations. The raven was also featured at the Deluge, sent out from Noah's ark before the waters had subsided; ravens can thus symbolize evil omens, death, and the *Devil. However, ravens also are described as having brought food to several *saints and holy figures (see: *Elijah, Saints *Anthony and *Paul the Hermit).

Birds may also be used as symbols for human *souls, and frequently inhabit scenes of Paradise.

BLACHERNITISSA. Named for the original image in the no longer extant fifth/sixth century Church of the *Theotokos* in the Blachernae district of Constantinople, the *Blachernitissa* is a representation of the Virgin *Mary standing in *orant pose with the infant Jesus suspended in front of her. The *Platytera* (where *Christ is depicted as a bust medallion) is a variant of this iconographic type.

BLAISE, SAINT. The bishop of Sebaste, Saint Blaise was martyred c.316. The colorful tales of his life include numerous *miracles: he cured a boy who had

strangled on a fish bone; he directed a wolf to return the only pig belonging to a poor woman; he healed and was befriended by wild animals. Before he was decapitated, he was tortured by being torn with iron wool-combs. He may be depicted in art wearing bishop's robes and mitre, holding a comb, or holding candles (brought to him by the woman whose son he cured).

Example: Martyrdom of Saint Blaise, c.1100, Portable altar from Helmarshausen, Paderborn, Church of Saint Francis. (Swarzenski, fig. 232)

BLESSING. See BENEDICTION.

BLIND, HEALING OF THE. See HEALING OF THE BLIND.

BOCCACCIO, GIOVANNI. The important and influential author and scholar Giovanni Boccaccio (1313–1375) is known as the founder of Italian prose literature. Educated in Florence and Naples, he associated with a cosmopolitan and courtly group of humanists, scholars, artists, and authors, including *Petrarch and perhaps Giotto. His works show inspiration from wide-ranging sources: classical mythology and history, medieval theology, contemporary poetry, and historical works. Of Boccaccio's many works in both Latin and Italian, the *Decameron* (begun c.1350) is considered his masterpiece. It contains 100 tales, narrated by seven young women and three young men, who sought refuge from the plague of 1348 by leaving the city and escaping to country villas and gardens outside Florence. The stories range from serious to sensual, intellectual to comic. The *Decameron* immediately became a popular "bestseller," widely copied and frequently illustrated (for wealthier patrons). Boccaccio was also active in politics, traveled widely in Italy, and delivered (in 1373) a series of sixty public lectures about *Dante. He was enormously popular and respected during his time and an inspiration to many later authors, including *Chaucer and Shakespeare.

Example: Decameron, 1467, Oxford, BL, MS Holkham misc. 49, f. 5. (De Hamel, fig. 130)

BOETHIUS. The philosopher and politician Boethius (Anicius Manlius Severinus, c.480–c.526) was born into an important Roman family and became a member of the senate and friend and advisor to the Arian, Ostrogothic ruler Theodoric. In 523, political intrigue resulted in Boethius' being accused of treason; he was imprisoned at Pavia and later executed. His writings were of profound influence throughout the medieval period, especially his *De consolatione philosophiae (The Consolation of Philosophy),* which he wrote in prison. This treatise, in five books, reflects his considerations on evil, free will, fate, and divine providence. It became a standard text in medieval libraries and was frequently copied and illustrated up through the fourteenth century. Other works by Boethius include translations and commentaries on writings of *Aristotle,

*Cicero, and Porphyry, treatises on the *Seven Liberal Arts, and various theological subjects. (See also: *Philosophy, *Wheel of Fortune).

Example: De consolatione philosophiae, c.975–1000, Cambridge, TC, MS 0.3.7, f. 1. (Dodwell, fig. 82)

BONAVENTURA, SAINT. The Tuscan-born scholastic theologian and philosopher Giovanni de Fidanza (1221–1274, later named Bonaventura, "good fortune") joined the Franciscans in 1243. After studies at the University of Paris, he was appointed master of the Franciscan School in Paris in 1253 and in 1257 was appointed minister-general of the Franciscans, after receiving his doctorate in theology with Saint *Thomas Aquinas (whose views he often opposed in his own writings). Bonaventura was a capable administrator whose leadership assured the continued existence and success of the Franciscan order. His treatise, *On the Poverty of Christ,* was influential on Pope Alexander IV's official approval and protection of the mendicant orders in 1256. Elected cardinal bishop of Albano by Pope Gregory X in 1273, Bonaventura's involvement with church politics brought about a brief reunion of the western and Byzantine churches at the Council of Lyons in 1274. Among many works (treatises, sermons, and scriptural commentaries—notably his *Commentary on the Sentences of *Peter Lombard*) Bonaventura authored the official biography of Saint *Francis. Bonaventura was canonized in 1482; scenes from his life are rare until the later Middle Ages and Renaissance period. He otherwise appears as an *author, dressed in the Franciscan habit, or wearing the bishop's mitre or cardinal's hat.

Example: Saint Bonaventura, c.1470, fresco, Mondavi Piazza, Santa Croce. (Kaftal, NW, fig. 246)

BONAVENTURE, SAINT. See BONAVENTURA, SAINT.

BONIFACE, SAINT. "The Apostle of Germany," the English *saint Boniface (c.675–755) left his scholarly monastic life at Exeter c.716/717 to become a missionary in northern Europe with Saint Willibrord and later became archbishop of Mainz c.744/745. He founded the monastery at Fulda c.744 and maintained correspondence with popes and rulers such as Charles Martel. He was martyred during further missionary work in Holland by being stabbed. His attributes in art include bishop's vestments, a book pierced with a sword, and an ax and tree (symbolic of the sacred oak of Thor which he cut down in public at the town of Geismar).

Example: Saint Boniface, twelfth–thirteenth century, mosaic, Venice, San Marco. (Kaftal, NE, fig. 216)

BOOKS OF HOURS. See MANUSCRIPTS.

BOSOM OF ABRAHAM. See ABRAHAM.

BRAZEN SERPENT. See MOSES.

BREVIARY. See MANUSCRIPTS.

BULL. See ANIMALS, SYMBOLISM OF; FOUR EVANGELISTS; ZODIAC.

BURNING BUSH. See MOSES.

C

CAIAPHAS. Joseph Caiaphas was the Jewish high priest who officiated over the first of the *Trials of Christ. After Jesus' *Betrayal and *Arrest, he was brought before the Jewish high court (the Sanhedrin) in Jerusalem and questioned by Caiaphas. When Jesus allowed acknowledgment of himself as the Messiah, Caiaphas accused him of blasphemy and called for a sentence of *death. Jesus was then taken to the Roman authorities. Caiaphas appears in scenes of Jesus' first hearing, as a seated figure, sometimes accompanied by his father-in-law, Annas, and other priests. He is often shown tearing his own garments, which the Gospels record as his reaction to Jesus' blasphemy.

 Example: Scenes from the Life of Christ, Gospels of Saint Augustine, c.600, Cambridge, CCC, MS 286, f. 125. (Weitzmann, LA&EC, pl. 41)

CAIN AND ABEL. The brothers Cain and Abel were the first children of *Adam and Eve. Their stories are recounted in Genesis 4, and they feature frequently in medieval art in illustrated Genesis cycles and typological programs. The firstborn, Cain, became a farmer; Abel became a shepherd. They are often shown in art presenting offerings to *God: Abel holds a sheep, and Cain offers a sheaf of wheat or corn. The hand of God is directed toward Abel, indicating preference for his offering (interpreted by medieval theologians as a prefiguration of the sacrifice of *Christ as Lamb of God; see *Agnus Dei*). Sometimes an *angel will be shown accepting Abel's offering. In Romanesque and Gothic examples the two offerings may appear placed on one or two altars, and a *demon may accompany Cain. Cain was very angered by God's rejection and later murdered his brother Abel, which deed is often illustrated. The murder weapon (not specified in the text) is frequently shown as a club or bone (e.g., a jawbone of an ass, as wielded by *Samson), or it may be indicated as a stone, an ax, a hoe, or some other agricultural tool. This first murder in human history is often correlated with the later *death of Jesus (Abel prefigures Jesus; Cain

prefigures *Judas). God rebuked Cain for his deed (which subject also appears in art), banished him from the place—to wander the earth, and Cain was later accidentally slain by his relative Lamech, who mistook him for a wild animal and shot him with an arrow. The death of Cain is also depicted in medieval sculpture and manuscripts although the event is not specifically described in the Genesis text and derives from later legends. Adam and Eve's mourning of the death of Abel is another apocryphal episode occasionally illustrated in art.

 Example: Offerings of Cain and Abel, c.1015, bronze doors, Hildesheim Cathedral. (Swarzenski, fig. 107)

CALENDAR. See LABORS OF THE MONTHS; ZODIAC.

CALLING OF PETER AND ANDREW. All four Gospels contain various accounts of Jesus meeting and summoning those who would become his disciples. Among the earliest of such scenes illustrated is the calling of the first two *apostles, the brothers *Peter and *Andrew, who were fishermen. The compositional type seen in early sixth century mosaics remains relatively consistent through medieval art. Jesus is shown standing on the shore of the Sea of Galilee, gesturing toward the two men in their boat; they look up at him (often still holding their nets and oars) or begin to disembark. Sometimes the scene is combined with the calling of the fishermen *James and *John, the sons of Zebedee, which follows in the texts (e.g., *Matthew 4:18–22; *Mark 1:16–20) and which is depicted similarly. Jesus stands on the shore and two boats are shown, or Jesus calls James and John while Peter and Andrew stand next to him on the shore.

 Example: Initial letter with Calling of Peter and Andrew, c.1030, Paris, BMaz, MS 384, f. 138. (Swarzenski, fig. 165)

CALVARY. Mount Calvary was the location of the *Crucifixion of Jesus. Formerly outside the city walls of Jerusalem, it was the site for executions of criminals. Known in Aramaic as *Golgotha* ("the place of the skull"), it was translated into "Calvary" from Latin *calvaria* ("skull"). *John's Gospel (19: 17) states that Jesus, sentenced to be crucified, carried the *cross to Golgotha; the other Gospels tell that Simon of Cyrene carried the cross for a portion of the journey. *Luke (23:27) mentions that a great crowd of people and weeping women followed the procession. The bearing of the cross to Calvary is thus represented in several different ways in early Christian and medieval art. Early examples (on sarcophagi and ivories) depict either Jesus or Simon carrying the cross; guards and onlookers may be present, and the episode of *Pontius Pilate washing his hands may be included within the scene. Simon and Jesus may be shown carrying the cross together, or the cross itself may be omitted and Jesus will be shown with his hands bound with rope, led by soldiers. Simon, bearing the cross, may also appear following or preceding this group. By the twelfth century, with some exceptions, the image most often shows Jesus bearing the

cross surrounded by an increasing number of figures—among whom may be identified the Virgin *Mary and various other holy women (e.g., Saint *Veronica, found in examples especially from the thirteenth century onward). Narrative details not found in the Gospels derive from apocryphal descriptions and later medieval reflective and mystical texts such as the *Meditationes vitae Christi. The *Instruments of the Passion, carried by various members of the crowd, are often depicted in late medieval examples, which tend also to emphasize the suffering of *Christ, grief of the women, and violence of the crowd. In late examples, Jesus may be shown falling to his knees and tormented by the malevolent bystanders. See also: *Stations of the Cross.

Example: Christ Carrying the Cross, Hours of Etienne Chevalier, c.1450–1455, Chantilly, Musée Condé. (Robb, fig. 213)

CAMEL. See ANIMALS, SYMBOLISM OF.

CANA. See WEDDING AT CANA.

CANCER. See ZODIAC.

CANON TABLE. See MANUSCRIPTS.

CANTIGAS DE SANTA MARIA. See ALFONSO X.

CAPELLA, MARTIANUS. The fifth-century North African author, Martianus Minneus Felix Capella, is best known for his work De nuptiis philologiae et mercurii libri novem (The Marriage of Philology and Mercury), which was of great influence on medieval thought and art. This allegorical treatise, frequently copied and commented upon, especially in the ninth and tenth centuries, describes the areas of classical learning, the *Seven Liberal Arts, as personified female figures with specific attributes and historical companions. His descriptions inspired the frequent representations of the Seven Liberal Arts in medieval art (especially architectural sculpture) and his text (or selected books, especially Book Eight, on Astronomy) was often copied and illustrated.

Example: Seven Liberal Arts, c.1145–1155, Chartres Cathedral, west portal, archivolt. (Sauerländer, fig. 15)

CAPRICORN. See ZODIAC.

CARMINA FIGURATA. The term carmina figurata refers to "word pictures" or "figured songs" in which shapes (appropriate to the textual content) are created by the outlines of letters, phrases, or verses of poetry, often within a continuous text. These clever constructs were popular with late antique writers, notably Optatianus Porphyrius, the court poet of *Constantine, and were copied

and imitated especially in Carolingian astrological manuscripts (see: *Aratus*) and such works as *De laudibus sanctae crucis* (see: *Maurus, Hrabanus).

 Example: Aratea, c.830, London, BL, Harley MS 647, f. 10v. (Dodwell, fig. 34)

CARPET PAGE. Carpet page is a term used to describe the full pages of all-over geometric and interlacing patterns, sometimes based on or including *cross shapes, especially found in insular Gospel books of the seventh to ninth century. The name derives from the visual resemblance to Oriental carpets.

 Example: Carpet page, Lindisfarne Gospels, c.700, London, BL, Cotton MS Nero D.4, f. 26v. (Synder, cp. 31)

CAT. See ANIMALS, SYMBOLISM OF.

CATHERINE OF ALEXANDRIA, SAINT. The immensely popular but historically dubious virgin martyr Catherine of Alexandria (c.290–c.310) enraged the emperor Maxentius by denouncing him for his persecution of Christians and by converting his wife and 200 of his soldiers to Christianity. She argued successfully for her faith with fifty pagan philosophers who converted and then were executed by Maxentius. She refused an offer of a royal marriage, stating that she was the bride of *Christ. She was tortured on a wheel fitted with iron spokes, but the wheel was destroyed by a lightning bolt. Eventually she was decapitated. *Angels transported her body to *Mount Sinai. The stories about Saint Catherine date to the eighth or ninth century and were greatly expanded in the thirteenth century *Golden Legend*. She appears frequently in medieval art, often identifiable by her wheel, the sword of execution, and the ring of her marriage to Christ. The mystic marriage of Saint Catherine is represented by the infant Jesus held on *Mary's lap offering Catherine a ring. She is also often shown with books and other symbols of learning or debating with the pagan philosophers.

 Example: Saint Catherine Disputing with the Philosophers of Alexandria, c.1200, fresco, Montmorillon-sur-Gartempe, Notre Dame, Chapelle Sainte-Catherine. (Demus, fig. 180)

CATHERINE OF SIENA, SAINT. The biography of Catherine of Siena (1347–1380) was recorded by her confessor, Raymond of Capua. She was the youngest in a large Sienese merchant family, joined the Dominican order at age sixteen, experienced mystical visions throughout her life, was active in caring for the very sick, subjected herself to extreme austerities, and was involved with contemporary politics (she traveled to Avignon in 1376 to speak on behalf of Florence and persuade Pope Gregory XI to return to Rome and wrote letters to Popes Clement VII and Urban VI). Many of her letters survive as well as a mystical work, the *Dialogo*. She is depicted in art wearing black and white Dominican robes, often holding a book, rose, rosary, or lily. She may be accompanied by a dove, which her father saw with her while she was praying, and may also bear the marks of the *stigmata, which she is said to have received

in 1375 but which were not visible until her *death. Additional narrative scenes may include her mystic marriage to *Christ (see also: Saint *Catherine of Alexandria), her accepting the crown of thorns (see: *Instruments of the Passion) from Christ, and her visit to Avignon.

Example: Saint Catherine Presenting a Carthusian Monk to the Madonna and Child, fifteenth century, panel, New York, Met. (Kaftal, NW, fig. 264)

CECILIA, SAINT. Tales of the second or third century Roman virgin martyr Ceclia date from the fifth or sixth century. Having vowed a life of chastity, she convinced her husband to do the same on their wedding night; an *angel crowned them both with roses and lilies. She converted both her husband and his brother to Christianity; all were executed, but Cecilia first underwent various tortures (attempted suffocation in a steam bath, immersion in boiling oil) and a decapitation attempt which, in spite of three blows of a sword, she survived for three days. Her attributes in medieval art may include flowers or a crown. Narrative cycles and her representation as patroness of music date largely to the Renaissance period.

Example: Saint Cecilia with Saints Tiburtius and Valerianus, Bible of Santa Cecilia, c.1100–1125, Rome, BAV, MS Barb. lat. 587, f. 4v. (Cahn, fig. 189)

CEPHALOPHORS. A number of *saints share the distinction of being carriers of their own severed heads. They are depicted in art, usually decapitated, either standing or walking with their heads held in their hands. In some cases, the severed head continues to speak. Among the sixty or so cephalophors may be mentioned: Saints *Alban, *Denis, *Lucy, and *Nicasius.

CHANSON DE ROLAND. The *Chanson de Roland (Song of Roland),* composed c.1100 in France, dramatically recounts the emperor *Charlemagne's military campaigns against the Saracens in northern Spain. Based on earlier historical works and legends (e.g., the *chansons de geste,* songs of great deeds, as recounted by minstrels to *pilgrims en route to the shrine of Saint *James the Greater at Compostela), this epic poem was adapted and translated into a number of different languages during the Middle Ages (e.g., the c.1170 German *Rolandslied*). The warrior Roland, Charlemagne's nephew, perishes bravely and dramatically in the tale, which enjoyed renewed popularity during the Crusades for the descriptions of conflict between Christians and pagans. Early manuscript copies are not illustrated; however, the exploits of Roland and Charlemagne inspired a great variety of later art works, in sculpture, stained glass, and tapestry.

Example: Roland (?) Receiving Communion, c.1250–1260, Reims Cathedral, interior west wall. (Sauerländer, pl. 230)

CHARITY. See VIRTUES.

CHARLEMAGNE. Charlemagne (c.742–814) became king of the Franks in 768, king of the Lombards in 774 (by right of conquest), and was crowned emperor of the Romans by Pope Leo III on Christmas day, 800, in Rome. Charlemagne significantly expanded his territory and spread Christianity through military conquests, as well as systematizing government administration. The "Carolingian Renaissance," centered at the court in Aachen, was a period of ecclesiastical and educational reform and patronage of the arts. His empire was seen, in later ages, as the ideal Christian commonwealth but in reality disintegrated shortly after his *death.

Charlemagne appears in art as a military leader (e.g., in equestrian portraits) or as an enthroned emperor with appropriate attributes (crown, orb, sceptre—the sceptre often topped with the *fleur-de-lys,* the emblem of French kings). He appears in art of the fourteenth and fifteenth centuries as one of the "Nine Worthies" (see: *Arthurian Legends). Einhard wrote a contemporary biography of Charlemagne, but the narrative episodes from the life of Charlemagne found in medieval art largely derive from later legends (especially the twelfth-century *Chronicle* of the Pseudo-Turpin) and include such tales as Charlemagne's journey to Constantinople and meeting with *Constantine, his *pilgrimage to Jerusalem, his visions of Saint *James the Greater, who inspired him in his conquests of Islamic Spain (see also: *Chanson de Roland*), and the Mass of Saint *Giles, where an unconfessed sin of Charlemagne was carried on a scroll by an *angel who appeared when Saint Giles was celebrating Mass. Charlemagne confessed and was given absolution. He was canonized in the mid-twelfth century by the antipope Paschal III.

Example: Charlemagne Tapestry, late twelfth century, Halberstadt, Cathedral Museum. (Dodwell, fig. 17)

CHASTITY. See VIRTUES.

CHAUCER, GEOFFREY. The works of the English poet Geoffrey Chaucer (c.1340–1400) enjoyed great popularity in the later medieval period and occasionally appeared in illustrated copies. The *Canterbury Tales* (c.1386–1390) consists of a series of twenty-four stories narrated by *pilgrims en route from London to the shrine of Saint *Thomas Becket at Canterbury. The *pilgrimage framework provides the storytellers with the opportunity to recount tales ranging from the serious to the bawdy. Although many early manuscript copies of this popular work survive, very few are illustrated (the early fifteenth-century "Ellesmere" manuscript, Huntington Library MS 26.29, contains marginal illustrations of twenty-three pilgrims). Other popular but also rarely illustrated works by Chaucer include the *Book of the Duchess* (c.1370), the *Parlement of Foules* (c.1377–80), *Troilus and Criseyde* (c.1382–85), and the *Legend of Good Women* (c.1395).

Example: Chaucer Reading before an Audience, Troilus and Criseyde, early fifteenth century, Cambridge, CCC, MS 61, f. 1v. (Thomas, pl. 39)

CHERUBIM. See ANGELS.

CHI-RHO. Constructed of the first two Greek letters for the name of *Christ, *Chi* (X) and *Rho* (P), this symbolic monogram appears especially in early Christian art and is found throughout the Middle Ages. According to tradition, this is the sign which appeared to *Constantine in his dream vision, was adopted as his imperial standard, and is also known as the *labarum.* Sometimes the Greek letters *alpha* and *omega* are included in the monogram. The *Iota* (I) *Chi* (X) for Jesus Christ is a variant form which also appears in early Christian art.

Example: Passion sarcophagus, detail, fourth century, Rome, Lateran Museum. (Grabar, CI, fig. 297)

CHRIST, JESUS, LIFE AND PASSION OF. Jesus of Nazareth (d. c.30 A.D.) was the founder of Christianity. Acknowledged by some of his fellow Jewish followers as the long-awaited Messiah (*Christ*), his teachings were quickly disseminated to a non-Jewish audience as well. Christians believe that Jesus is the son of *God (human and divine), the second person of the *Trinity, and that his incarnation and teachings fulfill and in some cases supplant Old Testament prophecies and laws. The Christian religion was officially accepted in the Roman empire in the early fourth century and was the predominant religion in both western Europe and the Byzantine empire through the Middle Ages.

Events from the life of Jesus thus form a core repertory of subjects in medieval art from the early Christian through late Gothic period. The literary sources for these subjects include not only the four Gospels but numerous apocryphal works which expand upon the Gospel accounts and provide important sources for much artistic subject matter. The commentaries by early Christian and medieval theologians, encyclopedists, hagiographers, and later medieval mystics also influenced the development and presentation of Christological subject matter in medieval art.

In very early Christian art (e.g., catacomb paintings, sarcophagi, and other sculptural works) Jesus is often represented in the symbolic form of the *Good Shepherd. Representations of the *Crucifixion do not appear before the fifth century, by which point numerous other subjects from Jesus' life were developed and continued to be expanded through the early medieval period. Ivories and mosaics of the fifth and sixth centuries show detailed narrative cycles which were further expanded in Carolingian and especially Ottonian manuscript illustration; these cycles provide the foundation for representations in all media during the Romanesque and Gothic periods.

Standard types as well as iconographic variations are described in detail in the individual entries for the subjects cross-indexed below. A rough chronological outline of the most frequently represented subjects (referenced in this dictionary) is as follows.

The news of the miraculous birth of Jesus was conveyed in advance to his mother, the Virgin *Mary, by the archangel *Gabriel. The *Annunciation to

Mary is thus often the critical commencement point in Christological subject matter, followed by the birth (*Nativity) of Jesus, the *Annunciation to the Shepherds, and the *Adoration of the Magi. The *Presentation in the Temple and *Circumcision of the infant Jesus precede the *Flight into Egypt of the *Holy Family and their eventual return to Nazareth. The twelve-year-old Jesus engaged in a *Dispute in the Temple in Jerusalem, and at close to age thirty, he received *Baptism in the river Jordan from Saint *John the Baptist, at which point the dove of the *Holy Spirit appeared. This marked the beginning of Jesus' public life.

Following a vigil in the desert (*Temptation of Christ), Jesus began to attract followers and disciples (see: *apostles, *Calling of Peter and Andrew) and to perform *miracles such as turning water into wine at the *Marriage at Cana. Jesus traveled through Galilee and Judea, *preaching (see: *Sermon on the Mount, *Beatitudes of the Soul) and teaching, often using parables or short stories to illustrate his points (e.g., see: *Dives and Lazarus, *Good Samaritan, *Prodigal Son, *Wise and Foolish Virgins). He performed numerous acts of healing (see: *Healing of the Blind, *Healing of the Leper, *Healing of the Paralytic, *Woman with an Issue of Blood), exorcism (see: *Healing of the Demoniac) and brought his friend Lazarus and several others back to life (see: *Raising of Jairus's Daughter, *Raising of Lazarus, *Raising of the Widow's Son). Further miracles include Jesus' *Multiplication of the Loaves and Fishes, two accounts (one post-*Resurrection) of a *Miraculous Draught of Fishes, and Jesus walking on the water to rescue disciples during a *Storm on the Sea of Galilee (see also: *Navicella). His conversations with the *Woman of Samaria and *Woman taken in Adultery are often represented in art as well as his *Transfiguration, which was witnessed by several apostles.

The events leading up to and including Jesus' Crucifixion are known as the Passion of Christ and begin with his *Entry into Jerusalem on Palm Sunday, followed by the *Cleansing of the Temple, *Last Supper, *Washing of the Feet, and *Agony in the Garden. The *Betrayal of Christ by *Judas led to the *Arrest of Christ and his trials and examinations before both Jewish and Roman authorities (see: *Caiaphas, *Pontius Pilate, *Trials of Christ). The *Mocking of Christ, *Flagellation, *Crowning with Thorns, and Pilate's presentation of Christ to the people of Jerusalem (see: *Ecce homo) precede the carrying of the *cross to *Calvary, the *Raising of the Cross, and Jesus' Crucifixion along with two others (see: *Thieves on the Cross).

Postcrucifixion events include Christ's body removed from the cross (*Deposition), the *Lamentation (see also: *Pietà), and *Entombment of Christ. The events from Jesus' sentencing by Pilate to his entombment also form a devotional and pictorial cycle, with variations, known as the *Stations of the Cross (see also: Saint *Veronica). Before Christ's *Resurrection (after three days in the tomb), the event of the *Anastasis (Descent into Hell/Limbo; Harrowing of Hell) took place. Christ's resurrection was discovered by women who found that his tomb was empty (see: *Three Marys at the Tomb).

Christ made several appearances after his resurrection, including his appearance to *Mary Magdalene (see: *Noli me tangere*), to disciples traveling to Emmaus (see: *Road to Emmaus, *Supper at Emmaus), and to Saint *Thomas. The *Ascension of Christ to *heaven concludes the cycle, until the *Apocalypse and *Last Judgment (also known as the Second Coming of Christ, or *Majestas Domini*).

Apart from these narratives, Christ is also represented in symbolic form as the Lamb of God (*Agnus Dei*), as the imposing *Pantocrator* (ruler of the world), as *Salvator Mundi* (savior of the world), as the suffering *Man of Sorrows (often with the *Instruments of the Passion), and in various other visionary forms, mystical events, and nonbiblical episodes; see: *Deësis*, *Dormition of the Virgin, *Holy Kinship, *Mass of Saint Gregory, *Mystic Wine Press, *Traditio legis*.

CHRISTINE DE PISAN. The author Christine de Pisan was born in Venice in 1363–64 and died in France sometime between 1429 and 1434. Information about her life is found in her autobiography: *Avision-Christine* (1405). She lived at the French court of Charles V in Paris from 1368, where her father, Thomas, served the king. After the deaths of the king and her father, Christine's husband suddenly died in 1389 when she was twenty-five years old. Faced with caring for her mother, three children, and a niece, Christine became the first French woman to support herself by a career as an author. Her writings, which include love poetry, religious works (prayers, meditations), moral treatises, and works concerning history and politics, became immediately popular. Her *Trésor de la cité des dames* offers moral advice for all social classes of women; her *Livre du corps de policie* contains moral advice for men; the *Epistre d'Othéa* describes 100 model figures from antiquity and mythology; the *Livre de la cité des dames* (1405) is a catalogue of important historical women and their contributions (inspired by *Boccaccio); the *Livre de la mutacion de fortune* (1403) describes world history, people, cultures, and branches of learning. She also wrote a biography of Charles V and a work celebrating Joan of Arc. Christine achieved recognition also for her published views on the *Roman de la rose;* her *Epistre au dieu d'amours* (1399) criticized Jean de Meun's negative views on women (see: *Guillaume de Lorris and Jean de Meun), and the debate was continued in numerous letters. Christine and her works were highly regarded during her own time and well after; luxury copies of her writings were frequently illustrated.

Example: Collected Works of Christine de Pisan, c.1405, Paris, BN, MS fr. 606, f. 35. (Thomas, pl. 18)

CHRISTOPHER, SAINT. One of the most popular and frequently represented *saints in medieval art, Christopher was said to have been martyred in the mid-third century (c.251) in Asia Minor. Early legends about him were elaborated through the Middle Ages. The *Golden Legend* contains an especially detailed

account which describes him as a strong and gigantic Canaanite, in search of the greatest king in the world to whom he might offer his services. His succession of adventures and disappointments in the services of a mighty ruler, and later the *Devil, eventually led him to a Christian hermit who instructed him to serve *Christ by safely carrying people across a swift river. One day, a child appeared and asked to be carried across. Midway through the journey, the child became heavier and heavier, but Christopher persisted and, upon reaching the river bank, was informed by the child (who identified himself as Christ) that Christopher had carried the weight of the whole world, and that of him who had created the world, on his shoulders. Christopher is hence the "Christ-bearer." His subsequent life included attempts by a Lycian king to sway him from his faith; Christopher was imprisoned with and tempted by two prostitutes (whom he converted to Christianity), and he was shot with arrows and eventually beheaded.

Saint Christopher appears in both western and Byzantine art from the tenth century onward. He may be bearded or clean-shaven and generally appears as a huge man, holding a pole or staff, standing in a river, with the infant Jesus on his shoulders. Large wall paintings or statues of Christopher were frequently located in western medieval churches to be seen by worshippers as they entered; this reflects his position as the patron saint of travelers and safe journeys. An eastern variant shows Christopher with a dog's head—perhaps due to a confusion of *cananeus* (Latin for "Canaanite") with *canineus* (Latin for "canine" or "doglike"). Western illustrations of the later medieval period often include more narrative and landscape details: the hermit, Christopher's hut by the river, and his miraculously flowering staff.

Example: Saint Christopher, c.1400–1410, panel, Antwerp, Musée Mayer van den Bergh. (Cuttler, fig. 21)

CHURCH. The female figure *Ecclesia* is a personification of the Christian church frequently found in medieval art. Generic or recognizable architectural structures are also used to represent the Christian church or specific churches. In the *Apocalypse, the seven churches of Asia may be represented by *angels or by small buildings. The Virgin *Mary may represent the church, as the bride of Christ (*sponsa Christi;* see *Sponsa-sponsus*). A small church may be held by donor figures to symbolize church construction or dedication, especially in mosaic or fresco within the edifice indicated.

Example: Abbot Desiderius Offering the Church to Christ, c.1085, fresco, Sant' Angelo in Formis, apse. (Synder, fig. 391)

CICERO. In medieval illustrations of the *Seven Liberal Arts, the Roman statesman, orator, philosopher, and author Marcus Tullius Cicero (106–43 B.C.) often appears as a representative of the art of Rhetoric. His works, dealing with public speaking, politics, philosophy, arithmetic, astronomy, and geography,

were extremely popular through the Middle Ages, notably his translation of the *Phaenomena* of *Aratus and the *Dream of Scipio*.

Example: Seven Liberal Arts, c.1145–1155, Chartres Cathedral, west portal, right door, archivolt. (Sauerländer, pl. 6)

CIRCUMCISION. The ritual and practice of circumcision is first mentioned in the Bible in Genesis 17:9–14, specified to *Abraham by *God as a symbol of the covenant between God and his people. Following this long-established custom, *Luke (2:21) includes mention of the circumcision of the eight-day-old infant Jesus (as well as of Saint *John the Baptist; Luke 1:59). Depictions of the circumcision of Jesus appear in Byzantine art of the tenth century and in western art of the eleventh century onward, in cycles illustrating events from the infancy of Jesus and in typological programs (e.g., correlated with the circumcisions of *Isaac and *Samson). Although Luke's account includes no specific details about the event, the apocryphal *Gospel of the Pseudo-Matthew* implies that Saint *Joseph performed the ritual (hence, he appears in some examples approaching the Virgin *Mary and the infant with a knife). In later western examples, the scene is frequently shown enacted specifically by a priest but (incorrectly) as taking place within the Temple (the setting derived from scenes of the *Presentation in the Temple).

Example: Nicholas of Verdun, *Circumcision of Jesus*, c.1181, detail from enamel altarpiece, Klosterneuberg, Stiftsmuseum. (Synder, fig. 434)

CITY OF GOD. The *City of God (De civitate Dei)* is the title of an important and frequently illustrated work authored by Saint *Augustine, c.413–426. The image of a heavenly or spiritual city (contrasting with the earthly or human-made) features in a variety of medieval art contexts both in schematic, simplified forms and more grandiose compositions. Architectural elements or enframements may appear in images of *All Saints, *heaven, the *Heavenly Jerusalem, *Last Judgment, and in illustrations of the *Apocalypse and other visionary texts. *Saints, *angels, the symbols of the *Four Evangelists, the *Agnus Dei*, dove of the *Holy Spirit, *prophets, the Virgin *Mary, *apostles, and *God or *Christ enthroned are frequently included in images of the heavenly city.

Example: Augustine's *City of God*, late twelfth century, Prague, CL, MS A.VII, f. 1v. (Dodwell, fig. 320)

CLARE, SAINT. Disciple of Saint *Francis, Clare (1194–1253) gave up her noble lifestyle to adopt a life of poverty and penance, joining the Franciscans in Assisi in 1211. In 1215 she became abbess of the female community eventually known as the Order of Poor Clares, devoted to strict poverty and austerity. Canonized two years after her *death, she appears in art from the late thirteenth century, often in connection with Saint Francis, and recognizable in the gray robes and white veil adopted by her order. Her rope belt with three knots symbolizes the vows of poverty, chastity, and obedience. She may carry a crozier

or a monstrance (a metal and glass container for the host) with which she is said to have repelled invaders from the city of Assisi. Scenes from her life include Saint Francis cutting her hair, her taking leave of Francis, and several visions (of the infant Jesus).

Example: Saint Clare in Prayer, 1347, fresco, Bergamo, Santa Maria Maggiore. (Kaftal, NW, fig. 276)

CLEANSING OF THE TEMPLE. All four Gospels contain accounts of Jesus driving out money changers and merchants who had been conducting business in the Temple in Jerusalem. He rebuked them for having transformed the house of *God into a place of commerce, a "den of thieves" (*Matthew 21:13). The scene is illustrated in art from at least the sixth century and may be included in cycles of the life of Jesus or more specifically in cycles of the Passion (e.g., following the episode of the *Entry into Jerusalem). Jesus may be shown driving away animals (oxen and sheep), overturning the merchants' tables, or lashing out with a scourge or whip (*John 2:15), while figures attempt to collect their goods or flee. An architectural backdrop indicates the Temple setting. The subject appears in various media (manuscript illustration, mosaic, sculpture, and metalwork) through the Gothic period.

Example: Scenes from the Life of Christ, c.870–880, metal book cover, *Codex Aureus of Saint Emmeram,* Munich, BS. (Snyder, fig. 271)

CLEMENT, SAINT. The pope and martyr Clement (d. c.100) was the third bishop of Rome after Saint *Peter. Legends of his life and *martyrdom, dating from the fourth century, provided inspiration for pictorial narratives especially from the eleventh century following. These tales include his exile, under the emperor Trajan, to the Crimea to work in the mines and his successful missionary activity, which displeased the emperor so greatly that he ordered Clement to be drowned in the sea with an anchor tied around his neck. Thus, Clement's chief attribute is an anchor. *Angels created a tomb for him on the ocean floor; it was yearly uncovered by low tide and became a popular *pilgrimage site. One year, a little boy was accidentally left behind at Clement's funerary chapel but was miraculously recovered by his mother the following year. Clement's *relics were brought back to Rome in the mid-ninth century by Saints *Cyril and Methodias and enshrined in a basilica.

Example: Mass of Saint Clement, c.1100, fresco, Rome, San Clemente, lower church. (Demus, fig. 48)

CLIMACUS, JOHN. See JOHN CLIMACUS.

CLIPEUS. See IMAGO CLIPEATA.

COLUMBINE. See FLOWERS AND PLANTS, SYMBOLISM OF.

COMMUNION OF THE APOSTLES. Similar to the *Last Supper, the image of the Communion of the *Apostles illustrates the institution of the Eucharist but also reflects liturgical practices developed in the early church. Rather than following the Gospel narratives of the last meal which Jesus shared with his disciples, the Communion of the Apostles is illustrated as a church ceremony; Jesus is shown distributing bread to the apostles who approach him in a procession, or he is depicted (sometimes twice) standing behind an altar (which is often topped with a canopy or ciborium) giving bread and wine to two groups of apostles approaching the altar from either side. The image appears in eastern art of the sixth century (in manuscripts and on liturgical patens) and is found in Byzantine examples through the medieval period. The format is rarely found in western art until the fourteenth century, when it developed especially in Italian panel painting, but still maintains the interior setting and representation of the apostles seated at a table more typical of western images of the Last Supper.

Example: Communion of the Apostles, fourteenth century, fresco, Mistra, Saint Demetrius, apse. (Rice, fig. 237)

CONCORDIA. See VIRTUES.

CONFESSION. See SEVEN SACRAMENTS.

CONFESSORS. See SAINTS.

CONSTANTINE. Constantine the Great (c.280–337) was the first Christian Roman emperor. His Edict of Milan (313) proclaimed toleration of Christianity within the Roman empire, brought to an end the official periods of Christian persecution, and provided for the development of Christian art. He founded a new Roman capital in the east (Constantinople, formerly Byzantium), called the first council of the Christian church to resolve doctrinal disputes (at Nicaea, 325), and was responsible for founding a number of important early churches in Rome, Constantinople, and elsewhere.

The biography of Constantine (written by his contemporary Bishop Eusebius of Caesarea) was greatly elaborated in later legends. Many of the events in the life of Constantine illustrated in medieval art thus have little factual basis. The most popular scenes include the Dream of Constantine (during which an *angel appeared and announced his victory in battle under the sign of the *cross; see also: *Chi-rho* monogram), his successful battle against Maxentius at the Milvian Bridge, and his *baptism by Pope *Sylvester. Constantine often appears in art with his mother, Saint *Helena, or with *Charlemagne. He is normally dressed as a soldier or an emperor and appears as an equestrian figure in relief sculptures in a number of Romanesque churches in western France.

Example: Scenes from the Life of Constantine, c.1154, Stavelot Triptych, New York, PML. (Synder, cp. 54)

CONTEMPLATIVE LIFE. The contemplative life of *prayer, study, and meditation is symbolized in medieval art most often by the figure of Mary of Bethany, the sister of *Lazarus (see: *Raising of Lazarus), who sat at *Christ's feet and listened to his words during his visit to their home (Luke 10:38–42), while her sister *Martha, exemplifying the *active life, kept busy with kitchen and serving duties. The virtues of both the active and contemplative lives were discussed by several medieval authors (e.g., Saint *Gregory in his *Moralia in Job*), and treatises on the stages of the contemplative life were authored by theologians such as *Hugh of Saint-Victor. The favored wife of *Jacob, *Rachel, is also seen as an exemplar of the contemplative life, which is otherwise symbolized in art by unidentifed female figures praying or studying.

Example: Vita contemplativa, c.1220–1230, Chartres Cathedral, north porch, archivolt. (Sauerländer, fig. 105)

CONVERSION OF SAINT PAUL. See PAUL, SAINT.

CORONATION OF THE VIRGIN. An extremely popular image in all media during the Romanesque and especially Gothic periods, the Coronation of the Virgin *Mary in *heaven (following her *Dormition and *Assumption) is not described in the New Testament but was discussed by a number of early Christian and medieval theologians. The *Golden Legend* tells of her "splendid reception" in heaven when she was greeted by *Christ, who seated her on a throne beside his. The image presents Mary as *Regina coeli,* Queen of Heaven, and also as a symbol of the Christian *church. The scene is depicted in several ways: (1) Mary, already crowned, is enthroned next to Christ (normally to his right, or viewer's left, side—as she frequently appears at the *Crucifixion and in *Deësis* images); (2) Mary, enthroned beside Christ, is crowned by one or two *angels; (3) Mary, seated beside or kneeling before Christ, with her hands clasped in *prayer at her breast, is crowned by him; (4) Mary is crowned by *God the Father or (5) by the Holy *Trinity, in the presence of angels and *saints. The latter two images became popular in the fourteenth and fifteenth centuries, whereas the majority of examples from the earlier Gothic period depict either Christ or angels placing a crown upon Mary's head. The scene appears frequently in exterior sculpture on French Gothic cathedrals dedicated to Mary and is also often found in Books of Hours (see: *Manuscripts).

Example: Coronation of the Virgin, c.1205–1215, Chartres Cathedral, north transept, central portal. (Synder, fig. 477)

CORPUS CHRISTI. *Corpus Christi* is Latin for the "body of *Christ." The term primarily refers not to Christ's earthly body (or images of him), but to the Eucharist (bread and wine, see: *Last Supper, *Seven Sacraments). A special observation in honor of *Corpus Christi* was officially established in 1264 after the visions (of black spots on the full moon) earlier experienced by the Augustinian nun Juliana of Liège, who urged that a special feast day be instituted.

The feast falls on the Thursday after *Pentecost. By the late thirteenth and fourteenth centuries in Europe, *Corpus Christi* celebrations involved great processions, floral displays, floats, and liturgical dramas increasingly elaborated into lengthy pageants staged by guilds and other civic groups.

Example: Corpus Christi Procession, Gradual, second half of the fifteenth century, Florence, BML, MS Cor. Laur. 4, f. 7v. (D'Ancona, pl. 126)

COSMAS AND DAMIAN, SAINTS. Patron *saints of doctors, Cosmas and Damian were Christian physicians of the late third or early fourth century who offered their services to all without charge. Legends credit them with several miraculous cures (notably the grafting of a new white leg onto a diseased black person, or vice versa). They were decapitated in Syria after suffering gruesome tortures for their faith. They appear in art with the attributes of medical doctors (such as boxes of ointments or vials), or undergoing tortures (they were thrown in the sea, stoned, burned, shot with arrows, and crucified before being decapitated). They appear in early Christian, western medieval, and Byzantine art and enjoyed renewed popularity in the Renaissance.

Example: Christ with Saints, c.526–530, mosaic, Rome, Church of Saints Cosmas and Damian, apse. (Rodley, fig. 56)

COSMAS INDICOPLEUSTES. The sixth-century "Indian Navigator," Cosmas, was a merchant of Alexandria who later became a monk. He is most known for his *Christian Topography* (or *Cosmography*) of c.547, which contains a history and description of the world in twelve books and includes important and somewhat unusual geographic information for its time. The illustrations include diagrams of the earth and heavens plus scenes from the Old and New Testaments. No versions from the sixth century survive, but the work continued to be copied and illustrated in the Byzantine world; one extensively illustrated version in the Vatican Library dates to the ninth century.

Example: Diagram of the World, Christian Topography, ninth century, Rome, BAV, MS gr. 699, f. 43. (Rice, fig. 75.)

COVETOUSNESS. See VICES.

COWARDICE. See VICES.

CRAB. See ZODIAC.

CREATION. *God's creation of the universe, the earth, and its inhabitants are described in two slightly different accounts in the first two chapters of Genesis and alluded to in several other biblical books (e.g., *Job and Proverbs). Sequential narrative illustrations often depict each of the six days as a separate vignette in the order described in Genesis 1, with the figure of *God or *Christ directing the (1) separation of light from darkness, (2) separation of the waters

above and below the firmament, (3) creation of dry land and plants, (4) creation of sun, moon, and stars, (5) creation of birds and fishes, and (6) creation of animals and humans. Some versions show God creating and measuring the earth with compasses. *Angels may also be present, witnessing or assisting. Illustrated cycles appear in early manuscripts of the fifth and sixth centuries and continue to be found in all medieval art media. See also: *Adam and Eve, *Fall of the Rebel Angels, *Garden of Eden, *Naming of the Animals.

 Example: The Creation, c.1100 (?), embroidered hanging, Gerona Cathedral. (Dodwell, fig. 14)

CROSS. The t-shaped (or Latin) cross (*crux immissa*) is found in art from the early Christian period as a symbol for *Christ and Christianity. In catacomb frescoes, funerary inscriptions, and on sarcophagi, the cross itself predates images of the *Crucifixion and continued to be used as a symbolic device in art through the Middle Ages. Early examples frequently combine the cross with the *Chi-rho* monogram of Christ or show a triumphal victory wreath on or around the cross. The Greek letters *alpha* and *omega* (signifying totality: the Beginning and the End, Rev. 1:8) may be shown below the horizontal bars of the cross. *Angels may be shown bearing a cross or *Chi-rho* monogram as an *imago clipeata,* and a lamb, or lambs (see: *Agnus Dei*), often carry or flank the cross in early examples.

 The equal-armed (or Greek) cross (*crux quadrata)* is also found in art from the early Christian period (with the same symbolic implications as above), and other variations are to be noted in different regions and contexts. The Coptic T-cross, topped with an oval or a circle, resembles the ancient Egyptian *ankh* (the symbol for life) and hence was adopted for Christian use in Egypt. The wheeled (or Celtic) cross (a Latin cross with a circle enclosing the upper intersection) is found in early medieval examples in the British Isles. The *tau* cross (*crux commissa,* shaped like a capital T) appears in early examples and is also specifically associated with Saint *Anthony of Egypt.

 Other *saints associated with particular cross forms include: Saint *Andrew, whose legend has him martyred on an X-shaped (saltire) cross (Saint Andrew's cross, or *crux decussata*) and Saint *Peter (who was crucified on an upside-down Latin cross).

 Crosses used on altars and in processions may be of simple construction or richly elaborated; the *crux gemmata* (decorated with stones and jewels) is a triumphal image and appears in both two-and three-dimensional media. A jeweled cross placed on a throne is a symbol for the *Trinity.

 A cross with two upper bars, the top one smaller *(crux gemina)* indicates the plaque nailed to Jesus' cross with the identifying inscription (Jesus of Nazareth, King of the *Jews, or INRI) placed there at the direction of *Pontius Pilate; a cross with an additional short bar placed horizontally or diagonally near the base indicates the *suppedaneum,* or footrest (this type is most frequently seen in Byzantine examples). The papal cross may have three crossbars of diminishing

width, indicating the Trinity. Various other cross forms were developed as emblems and heraldic devices, especially during the Crusades; for example, the Maltese cross (a Greek cross with fanned or wedged extremities) for the Order of Saint John and the cross with stylized lilies (or *fleurs-de-lys*) at the ends of the bars.

A cross made of leafy or living branches signifies the *Tree of Life. Crucifixion images from the late medieval period may show a dramatic Y-shaped cross. Crosses (with various other devices) also serve as attributes for a number of saints. The cross naturally features in scenes associated with the Crucifixion as well as the preparations and events following (see: *Calvary, *Deposition, *Thieves on the Cross) and in the tale of the history and discovery of the *True Cross.

CROSSING OF THE RED SEA. When *Moses was leading the Israelites out of Egypt, *God caused the Red Sea to part miraculously so that they could pass through (Exodus 14:21–23). The water then returned and drowned the pursuing army of *Pharaoh. This scene is one of several miraculous salvation themes especially popular in early Christian art and appears in frescoes, mosaics, sarcophagi, and other sculpture. It is also prevalent in later western medieval and Byzantine manuscript illustration and may be interpreted as a prefiguratory type of Christian *Baptism (see: *Typology). Related sequential details may include the pillar of cloud, which God created to guide the Israelites on their journey by day, and the guiding pillar of fire by night. After the successful crossing, the Israelites, led by Moses' sister Miriam, may be shown dancing and celebrating. The sea is often depicted in two segments or filled with the drowned bodies and broken chariots of Pharaoh's army.

Example: Crossing of the Red Sea, Bible, 960, León, Colegiata de San Isidoro, Cod. 2, f. 39. (Cahn, fig. 42)

CROWNING WITH THORNS. The Gospels of *Matthew (27:27–30), *Mark (15:16–19), and *John (19:2–3) describe how Roman soldiers, following Jesus' sentencing by *Pontius Pilate (see: *Trials of Christ) and *Flagellation, mocked and humiliated Jesus by clothing him in a purple robe, placing a crown of thorns upon his head and a reed sceptre in his hand, and beating and spitting on him. The soldiers scornfully bowed down before Jesus and taunted him as the "King of the *Jews." This episode precedes the carrying of the *cross to *Calvary and the *Crucifixion. The image appears frequently in medieval art, in various compositional formats. Early examples (e.g., fourth-century sarcophagi) depict Jesus standing calmly while a Roman soldier places a wreath upon his head; this atmosphere of victory and triumph is maintained in some Carolingian and Ottonian illustrations in which the episode is often combined with the carrying of the cross. Jesus may be shown walking in a procession, following Simon of Cyrene, who bears the cross, while a figure approaches Jesus from behind and places a crown of rope and thorns upon his head. By the eleventh century, the

image is often extracted from this sequential narrative and depicts Jesus standing or seated frontally while variable numbers of figures surround him on both sides. They place the crown of thorns upon him, hand him the reed sceptre, or kneel down. They may be shown spitting, with their mouths open. Later medieval examples tend to portray the scene in a less solemn and more violent manner. Jesus remains calm, while the tormentors gesture more actively and beat him with sticks. The presence of the crown of thorns (one of the *Instruments of the Passion) generally differentiates this episode from the earlier, and less frequently represented, *Mocking of Christ by the Jews.

Example: Crowning with Thorns, c.1317, fresco, Staro Nagoričino. (Rice, fig. 188)

CRUCIFIXION. The Crucifixion of Jesus is one of the most frequently represented subjects in medieval art; the image developed in the early Christian period and appears in a variety of formats through the Middle Ages. The event is described, with some variation in details, in all four Gospels as well as in apocryphal works such as the *Acts of Pilate.*

Although a central episode for Christianity, the image of the Crucifixion is not consistently found before the fifth century, after many other events from the life of Jesus had been developed in art. The Crucifixion had previously been symbolized (e.g., on third-and fourth-century sarcophagi) by the image of a lamb (see: *Agnus Dei) with a *cross, or by a cross bearing the *Chi-rho monogram and a triumphal wreath. The figure of Jesus himself was generally excluded from these early symbolic formulae. The apparent reticence in picturing the body of Jesus upon the cross in the early Christian period has been explained by the negative associations of the punishment of crucifixion, reserved under Roman law (but outlawed by *Constantine in the fourth century) as the most extreme form of punishment for slaves or noncitizens. It was perhaps also to combat early heretical claims that Jesus only *appeared* to die on the cross that his body began necessarily to be included in the image.

The earliest images, following the previously developed symbolism of the triumphal cross, show Jesus in an *orant pose, with open eyes. Although nails are represented in his hands and feet, the cross itself is downplayed, and the image emphasizes life and victory rather than *death and suffering. An ivory plaque of c.420–430 shows a youthful, beardless Jesus and includes the figures of the Virgin *Mary, *John the Evangelist, and *Longinus (the spear bearer). The wooden doors of Santa Sabina in Rome (c.432) include two smaller orant figures of the thieves crucified with Jesus (see: *Thieves on the Cross); Jesus is here represented with long hair and a beard. These early western images depict Jesus naked, apart from a loincloth. The *titulus* (sign or plaque) erected by *Pontius Pilate is shown in the early ivory, bearing the abbreviated Latin inscription INRI, identifying the crucified as ''Jesus of Nazareth, King of the *Jews'' (John 19:19–22).

Jesus appears wearing a long robe (or *colobium*) in late sixth-century Byzantine examples; he is bearded, fastened to the cross with four nails, surrounded

by the two thieves, plus Longinus and Stephaton (the sponge bearer), Mary and John, and three holy women. Soldiers casting dice for his garments are seated at the base of the cross.

The patterns set by these early western and Byzantine examples are fundamentally maintained through the subsequent centuries with some alterations in attitude, personnel, and overall ambiance. The positioning and inclusion of figures changes from time to time; additional details may be added, such as *angels and the skull of *Adam buried beneath the cross. The site of the Crucifixion was also known as *Golgotha*—the place of the skull; the presence of Adam's skull makes a typological connection between the sin of Adam and the redemption of Christ. A serpent winding around the base of the cross also serves to make this connection. The figures of *Ecclesia* (holding a chalice into which Jesus bleeds) and *Synagogue (or other symbols of Christianity and Judaism) may be found in Crucifixion images from the Carolingian period onward. Sometimes roundels containing personifications of the sun and the moon are included. The hand of *God may also appear, or angels, bearing a crown.

The image of the victorious Jesus with open eyes is, by the ninth century in Byzantine art, gradually replaced by a closed-eyed Jesus with bowed head. This type was firmly established in western art of the Ottonian period and, especially after c.1000, became the most standard image. Theological discussions of the physical death and human nature of Jesus as well as increasing interest in the redemptive suffering and wounds of Jesus may explain this shift in attitude. The suffering of Jesus is also reflected in the increasingly mournful attitudes of the accompanying figures and angels. Mary (normally on the left of the composition) may wring her hands, weep, or bury her face in her veil in an increasingly dramatic display. By the later Gothic period, she may be shown quite overcome with grief, fainting into the arms of her companions (see also: *Mater dolorosa*). Saint John (normally on the right of the composition) may similarly weep and wring his hands. The body of Jesus also pulls and slumps more dramatically in Romanesque and Gothic examples. By c.1200, artists frequently show a three-nail crucifixion (one of the feet nailed on top of the other), further creating and emphasizing the slumping, swaying angle of Jesus' body.

Some examples from the twelfth century onward include the figure of God the Father seated or standing behind the cross and helping to support it. The dove of the *Holy Spirit often hovers over Jesus' head. This image, known as the "Throne of Grace," combines the Crucifixion with a representation of the *Trinity. Other pictorial types, which develop in the eleventh through thirteenth centuries, include the representation of the cross as a flowering or leafy tree (see: *Tree of Life) and the inclusion of personified figures of the *Virtues nailing Jesus to the cross and embracing him. Like the image of the Y-shaped cross (which appears in twelfth-century German art and even further emphasizes the suffering of Jesus with painfully upraised arms) many of these dramatic images may be explained by devotional and mystical writings meditating upon all the details and the significance of the Crucifixion. Images of the Crucifixion

may also include donor or patron figures arrayed in *prayer, as well as various Old Testament figures and *prophets holding books or scrolls.

Illustrations of the crucifixions of persons apart from Jesus are distinguished by different forms of crosses and different positions of figures (e.g., see: Saint *Andrew, Saint *Peter).

Example: Crucifixion, Psalter of Robert of Lindseye, c.1212–1222, London, Society of Antiquaries, MS 59, f. 35v. (Robb, fig. 148)

CUTHBERT, SAINT. The Anglo-Saxon Cuthbert (c.634–687) became a monk and later prior of Melrose abbey before becoming prior of Lindisfarne (from c.663–664). Famed for his piety and austerity as well as his *preaching, healing, and prophetic abilities, he was buried at Lindisfarne in 687. His body was later and eventually moved to Durham in the late tenth century and several times exhumed and discovered to be incorrupt. Biographies of the late seventh century were expanded and updated in the eleventh and twelfth centuries with numerous *miracle stories, providing materials for narrative illustrations in Romanesque manuscripts and later manuscripts, paintings, and stained glass. As an independent figure Cuthbert may appear carrying the head of King Oswald (said to have been buried with him) or with ducks or sea otters at his feet, because of his famed kindness to animals.

Example: Bede's *Life of Saint Cuthbert,* early twelfth century, Oxford, UC, MS 165. (Alexander, figs. 137–140)

CYMBAL. See MUSICAL INSTRUMENTS, SYMBOLISM OF.

CYPRESS. See FRUIT AND TREES, SYMBOLISM OF.

CYRIL AND METHODIAS, SAINTS. ''Apostles of the Slavs,'' the brothers Cyril and Methodias, educated in Constantinople, were sent by the emperor Michael III as Christian missionaries to Russia in 861 and in 863 were sent as missionaries to Moravia. Their great success was due to their knowledge of the native language, their teaching in the vernacular, and their translation of some of the scriptures and liturgy into Slavonic. They created a writing system for their translations which became the basis for the Cyrillic alphabet. Opposition from German missionaries and bishops led the brothers eventually to leave for Rome, where Cyril became a monk (taking the name Cyril) and died in 869. They brought the *relics of Saint *Clement to Rome and a shrine was constructed. Methodias (d. 885) was consecrated bishop of Moravia and, in spite of continued Germanic opposition, received papal approval for his continued work and for his practice of celebrating the Mass in Slavonic. Cyril and Methodias are often depicted on Byzantine *icons; they may be shown holding a church between them, or surrounded by converts.

Example: Saints Cyril and Methodias, c.869, fresco, Rome, San Clemente. (Kaftal, C&S, figs. 367–370)

D

DAMNED. See HELL; LAST JUDGMENT.

DANCE OF DEATH. The Dance of Death (or *Danse macabre*), a subject which became especially popular in late medieval art and literature, reflects the increasing preoccupation with mortality in the wake of the bubonic plague, which first swept through Europe in the mid-fourteenth century. Images of *death and the *Last Judgment are, however, found in earlier medieval art, and sermons, literary works, and dramas elucidating the unselective nature of death also predate the development of the specific pictorial iconography of the Dance of Death in the early fifteenth century. The image involves a procession of people, of all social classes, accompanied by skeletons. The first recorded example is a (now destroyed) fresco cycle in the Parisian Cemetery of the Innocents (1424). These images were reproduced in woodcuts by the late fifteenth century, during which period the imagery was widely disseminated. The theme emphasizes that men and women, rich and poor, kings, clerics and laypersons alike will all be taken by death. The different social classes are carefully indicated; the figures are touched or pulled along by skeletons holding arrows, scythes, shovels, shrouds, coffin lids, and other appropriate objects.

Example: Danse macabre, 1490, woodcuts, Paris, BN, Rés. Ye 1035. (Mâle, LMA, figs. 206–210)

DANDELION. See FLOWERS AND PLANTS, SYMBOLISM OF.

DANIEL. The life and visions of Daniel, one of the four major *prophets, are described in the Old Testament book which bears his name. According to the book of Daniel and related *Apocrypha, Daniel was captured by soldiers and taken to the court at Babylon, where he remained throughout his life (during the reigns of *Nebuchadnezzar, *Belshazzar, and Darius). He became increas-

ingly renowned for his prophetic gifts and interpretation of dreams. His series of dramatic visions, recorded in the text, both prefigured and contributed to later apocalyptic writings and imagery (see: *Apocalypse).

Several scenes from Daniel's life appear with some frequency in early Christian and medieval art. The episode of his ordeal in and miraculous rescue from the lions' den is one of the earliest subjects found in Christian art and remained popular through the Middle Ages. Daniel was twice condemned to the lions: when he was accused of disobeying a religious edict of King Darius, and later, when he was credited with having caused the *death of a sacred dragon. Apocryphal additions relate that the prophet *Habakkuk (informed by the archangel *Michael) brought food to Daniel in the lions' den. Darius was convinced of *God's power by Daniel's remarkable survival and subsequently had the courtiers who plotted against Daniel thrown to the lions. A related incident of miraculous salvation (when Daniel's three companions survived their ordeal in the *Fiery Furnace) was also very popular in early Christian art, as were the stories involving *Susanna (apocryphal additions to the end of the book of Daniel).

As a symbol of faith, salvation, and a prefiguration of *Christ's *Resurrection, Daniel appears on early Christian sarcophagi, in catacomb frescoes, in Romanesque and Gothic manuscript illustration, and frequently in Romanesque and Gothic architectural sculpture. He is usually accompanied by lions; the motif of a human figure between confronted animals has antecedents in ancient near eastern art and mythology.

Example: The Story of Daniel, Farfa Bible, c.1000–1125, Rome, BAV, MS lat. 5729, f. 227v. (Robb, fig. 102)

DANTE ALIGHIERI. The life and works of the great Italian (Florentine) poet Dante (1265–1321) were of profound influence on the late medieval and Renaissance period. His involvement with contemporary politics and religious matters, his championing of the use of the vernacular, and his many works (poetry, treatises on literature and politics, and letters) earned him enormous fame and lasting influence.

His major work, the *Commedia* (which he completed, after several decades of work, shortly before his death in 1321) is a trilogy divided into nearly equal parts: the *Inferno, Purgatorio,* and *Paradiso.* Each part consists of thirty-three cantos (sections), which, along with the introductory canto, total one hundred; this numerical symbolism reflects perfection, the tri-part unity of the *Trinity. The story is framed in the author's personal journey through *hell, purgatory, and *heaven, guided (in succession) by the ancient poet Virgil, the author's beloved Beatrice, and Saint *Bernard of Clairvaux. The compelling detail and powerful symbolism provided immediate inspiration for visual artists; lavishly illustrated (as well as many less elegant) manuscript copies were produced from the mid-fourteenth century onward. Dante's descriptions of the structures of heaven and hell, the torments of sinners and rewards of the blessed, influenced many artistic compositions of the later medieval period (e.g., scenes of the *Last Judgment, *Triumph of Death, *Virtues and *Vices).

Dante himself is frequently depicted in frontispieces and illustrations through-
out the *Commedia;* he may be shown wearing a laurel crown, as a witness or
bystander, or holding a book.
 Example: Inferno, c.1345, Chantilly, Musée Condé, MS 1424, f. 114. (De Hamel, fig.
139)

DAVID. David was the king of Israel around c.1000 B.C. His significance in
both Jewish and Christian tradition is reflected in his prominent position in the
visual arts. Scenes from the life of David appear in all media from the early
Christian through late Gothic period. He appears in narrative cycles, frequently
as an independent figure in illustrated manuscripts prefacing the Psalms (which
he is credited with composing), in cycles of the Old Testament *ancestors of
*Christ (see also: *Tree of Jesse), and as one of the Nine Worthies (see: *Ar-
thurian Legends).
 David, the son of Jesse, is introduced in 1 Samuel 16:11–13 during the reign
of King *Saul. *God instructed the prophet *Samuel to find and anoint the
shepherd boy David as the next king. David was summoned to Saul's court and
served as Saul's musician and armor bearer. His harp playing relieved Saul's
melancholy. Although Saul relied upon David greatly, his jealousy was activated
shortly after David defeated the Philistine giant *Goliath and as David became
increasingly prominent at the court. David's friendship with Saul's son *Jona-
than, and his marriage to Saul's daughter Michal, further fueled Saul's endemic
suspicions that David was his rival for the throne, although David remained
ostensibly loyal to the king and continued to prove himself as a heroic warrior
in the ongoing conflicts between the Israelites and the Philistines. Saul several
times attempted to murder or have David murdered, resulting in increased ani-
mosity between them and in David's flight from court and life as an outlaw and
independent military leader. When Saul and several of his sons were killed in
a battle with the Philistines, David mourned greatly and angrily executed the
Amalekite messenger who had brought the news. David and his nephew *Joab
then went to war against Saul's son Ishbaal and Saul's former commander Ab-
ner; when both Ishbaal and Abner were assassinated, David was eventually
anointed as king of Israel in c.1000 B.C. He established his capital at Jerusalem,
was victorious in further conflicts with the Philistines, brought the *Ark of the
Covenant to Jerusalem, and extended his empire with further military campaigns.
It was during one of these wars that David became enamored of *Bathsheba,
the wife of his comrade Uriah. David's successful plot to cause Uriah's *death
(so as to marry Bathsheba) began a series of troubles (articulated to David by
the prophet *Nathan). Conflicts between David's sons (by several wives) re-
sulted in the rape of his daughter Tamar, the death of his sons *Absalom and
Adonijah, and the eventual anointing of David and Bathsheba's son *Solomon
as the next king.
 Scenes from the life of David appear in Christian art as early as the third
century and throughout the Middle Ages. Detailed narrative cycles are found in
seventh-century metalwork and in Bible illustrations of the Romanesque and

Gothic periods. Specific episodes (the battle with Goliath; David as a youthful shepherd rescuing a lamb from the jaws of a lion, 1 Samuel 17:34–37; David as harpist; David as an enthroned king; David watching Bathsheba bathing) frequently also appear as independent subjects.

David often appears in Psalter illustration (also in Breviaries and Books of Hours, see: *Manuscripts) as a harpist and author of the Psalms. He frequently appears in prefatory miniatures (alone or accompanied by dancers and other musicians) and within historiated initials marking the major divisions of the Psalms. For example, at Psalm 26 (27) he entreats God to open his eyes; at Psalm 68 (69) he is shown kneeling or standing in water requesting God's deliverance; at Psalm 80 (81) he praises God by playing on bells, or a harp, or dancing before the Ark of the Covenant.

The rich iconography of David in Christian art presents him in many guises: from a youthful shepherd, victorious warrior, to a troubled, reflective, aged, and triumphant king.

Example: David in Prayer, Book of Hours, c.1425–1430, Walters, MS 289, f. 94v. (Wieck, pl. 31)

DEATH. Images of death appear in a variety of formats in early Christian and medieval art: in narrative episodes, as didactic devices and aids to devotion, and in symbolic and personified forms.

In narrative contexts, images of the deaths of holy figures abound from the early Christian through late Gothic period. The *Crucifixion of Jesus, the *Dormition of the Virgin *Mary, as well as the last earthly moments of *saints and martyrs are frequently illustrated. Death scenes often provide pictorial clues identifying the figures represented, either through method of death, instruments of torture and *martyrdom (e.g., see: *Cephalophors, *Decollation), the presence of attendant figures, or details such as *angels bearing the *soul of the deceased to *heaven or *demons carrying the soul of the deceased to *hell. The *Resurrection of the Dead is often found in scenes of the *Last Judgment and *Apocalypse; the naked or half-clothed figures of the deceased rise from their tombs or clamber out of the earth.

The promise of salvation for the righteous and punishment for the wicked supplied a potent source of inspiration for theologians, mystics, and artists in all media through the Middle Ages. Pictorial admonishments stressing judgment were expanded, especially in later medieval art, with didactic themes emphasizing the sudden, unpredictable, and nonselective nature of death (e.g., see: *Dance of Death, *Three Living and Three Dead, *Triumph of Death). The reminder about the inevitability of death *(memento mori)* was also aided by texts and illustrations describing the preparations required for a ''good'' death (see: *Ars moriendi*).

Deathbed scenes, funeral services, and burial images are also often found in devotional contexts, for example, as illustrations accompanying prayers for the dead in Books of Hours (see: *Manuscripts). Focused meditation upon death

was also aided by the development of images such as the *Pietà* and other depictions of the sorrows and sufferings of the Virgin Mary and Jesus (see: *Mater dolorosa,* *Man of Sorrows).

The figure of death itself also received various symbolic and personified treatments: as a skull, corpse, skeleton, or as the fourth horseman of the Apocalypse, riding on a pale horse, wielding a sword, followed by Hell or *Hades. The bubonic plague which swept through Europe in the fourteenth century intensified the medieval preoccupation with death and resulted, in later medieval art, in increasingly grim images of death, as dessicated and worm-eaten corpses (e.g., in tomb sculpture) and triumphantly crowned or cavorting skeletons.

Example: A Dead Man Before God, Rohan Hours, c.1418–1425, Paris, BN, MS lat. 9471, f. 159. (Porcher, pl. LXXVII)

DECOLLATION. Decollation is another term for beheading or decapitation, a common form of *martyrdom frequently depicted in art which illustrates the tortures and deaths of *saints. See also: *Cephalophors.

Example: Beheading of Saint John the Baptist, Bury Gospels, c.1135–1145, Cambridge, Pembroke College, MS 120, f. 5v. (Dodwell, fig. 340)

DEESIS. *Deësis* is a Greek term for "supplication." It refers to the image of *Christ enthroned or standing, flanked by the figures of the Virgin *Mary and Saint *John the Baptist who intercede for humankind. The image is frequently found as the focal point of the Byzantine *iconostasis. *Angels, *apostles, and *saints may also be included.

Example: Deësis, Psalter of Queen Melisende, c.1131–1143, London, BL, Egerton MS 1139, f. 12v. (Zarnecki, cp. 43)

DELUGE. The wickedness of humans prompted *God to decide to destroy them all with the exception of *Noah and his family. Genesis 6–9 describes the forty days and forty nights of rain and the flood which lasted for 150 days. All living things perished except for Noah and his family and the sets of animals of each kind carried in Noah's ark. When the flood subsided, the ark came to rest on Mount Ararat, and Noah sent out a raven and then a dove (which eventually returned with an olive branch and then, sent out again, didn't return to the ark). Determining that the earth was now habitable, Noah sent his family and animals out of the ark. Artistic representations of the deluge vary in detail and complexity. In early Christian catacomb frescoes, Noah floats alone in a small box, emphasizing the concept of salvation. The ark may appear as a floating chest, house, or as a more boatlike vessel. Sometimes Noah, his family or the animals are shown peering out to observe the waters and the floating, drowned bodies of humans and animals. The image continues to feature in biblical narrative depictions through the Middle Ages.

Example: The Deluge, Ashburnham Pentateuch, late sixth–early seventh century, Paris, BN, MS nouv. acq. lat. 2334, f. 9. (Cahn, fig. 9)

DEMETRIUS, SAINT. Saint Demetrius, martyred in the early fourth century, is one of several Byzantine soldier *saints frequently depicted wearing armor and carrying a shield, sword, or lance. His legend recounts that he refused to kill Christians and was thrown in prison. Narrative cycles may illustrate the successful combat of his friend Nestor against the gladiator Lyaeus, and Nestor and Demetrius's subsequent *martyrdoms. The *relics of Saint Demetrius at Thessalonica were famed for exuding a sweet-smelling and healing oil or myrrh (he is thus termed a *myroblytos*). He is one of the most important saints of the Byzantine church, frequently represented in art.

 Example: Saint Demetrius, c.650, mosaic, Thessalonica, Hagios Demetrios, chancel pier. (Synder, fig. 132)

DEMONIAC, HEALING OF THE. See HEALING OF THE DEMONIAC.

DEMONS. The word *demon* derives from the Greek *daimon* (spirit). In Jewish and Christian usage, demons are specifically malevolent spirits, capable of possessing humans or otherwise causing evil in the world. When pictured in art, demons have the general attributes of the *Devil: they are often shown with horns, wings, fangs, or claws, are dark or black, and have a grotesque, hybrid, humanoid, or otherwise contorted appearance.

 Expelling demons is known as *exorcism. The Bible contains several accounts of exorcism, and Jesus' power over demons and his ability to drive them away with succinct words and gestures (versus elaborate rituals or incantations) is described in the Gospels and illustrated in art from the early Christian period onward (see: *Healing of the Demoniac). Small winged demons are shown issuing from the mouths of possessed people or hovering above them (e.g., in sixth-century ivories illustrating Jesus' *miracles and many later examples). Demons appear inciting or tempting people to do evil (e.g., *Pontius Pilate) or coming to take away the *soul of a sinner to *hell (e.g., *Judas). Demons thus may feature in scenes of the *Apocalypse and *Last Judgment, tormenting and torturing the damned, or contesting with *angels over the souls of the deceased (see also: *Ars moriendi, *Leviathan, *Mouth of Hell).

 The origin of demons was an issue of frequent discussion and varied interpretation among both Jewish and Christian writers through the Middle Ages. The theory that demons were originally disobedient angels who, led by *Satan, rebelled against *God at the time of *Creation, is illustrated in the image of the *Fall of the Rebel Angels. Particular *saints were especially provoked or tested by demons (e.g., Saint *Anthony), and demons often feature in hagiographic pictorial narratives attacking saints or being exorcised by them. See also: *Fall of Simon Magus.

 Example: Last Judgment, c.1120–1132, Autun Cathedral, tympanum. (Snyder, fig. 359)

DENIAL OF PETER. See PETER, SAINT.

DENIS, SAINT. The patron *saint of France, Denis (Denys, Dionysius, d. c.250) was sent as a missionary to Gaul from his native Italy, successfully established a Christian center, and became bishop of Paris. According to Gregory of Tours, writing in the sixth century, Denis was eventually martyred (decapitated) by the Roman authorities along with his companions: the priest Rusticus and deacon Eleutherius. This account was greatly elaborated and complicated by a series of later authors, notably the ninth-century Abbot Hilduin of Saint Denis, who composed a treatise which identified Denis with the fifth-century mystical writer, Dionysius the Pseudo-Areopagite, further confused with the Dionysius of Athens converted by Saint *Paul in Acts 17:34. In addition, the story of his *martyrdom was later expanded with descriptions of how the decapitated saint picked up his head and walked from the site of his martyrdom (Montmartre—the "martyr's hill") to a location two miles away (which became his burial place and eventual site of the abbey of Saint-Denis). (For other head-carrying saints see: *Cephalophors.) The Parisian abbey of Saint-Denis, which became the burial place of many members of the French royalty, was especially prominent through the Middle Ages, and the cult of Saint Denis was avidly promoted. Hence, Saint Denis appears frequently in French art of the Romanesque and Gothic periods. He is often shown as a cephalophor, dressed in bishop's robes, carrying his head (which may be bare or wearing a bishop's mitre). The illustration of his decapitation (before which he was visited in prison and received final communion from *Christ) is also a popular subject; Denis may be shown reaching out for his head as it falls or picking it up from the ground. The life of Saint Denis received detailed pictorial narrative treatment in manuscript illustrations of the mid-thirteenth and early fourteenth centuries, and episodes from his life are also found in Gothic stained glass, sculpture, and fresco painting in France and elsewhere.

Example: Saint Denis Preaching, Life of Saint Denis, c.1317, Paris, BN, MS fr. 2091, f. 99. (Snyder, fig. 563)

DENYS, SAINT. See DENIS, SAINT.

DEPOSITION. The Deposition (or Descent from the Cross) is briefly described in all four Gospels. It is the episode where *Christ's dead body was taken down from the *cross by *Joseph of Arimathaea and (according to *John) *Nicodemus. The subject appears in western and Byzantine manuscript illustrations of the ninth century and occurs very frequently thereafter in a variety of media, tending to increase in complexity and detail through the centuries.

The early images depict simply Nicodemus removing the nails from Christ's hands or feet and Joseph of Arimathaea supporting the body as it falls from the cross. Sometimes Nicodemus is absent and Joseph alone supports the body. The image is often linked with the episodes that follow in the narrative: the bearing of Christ's body to the tomb, the *Entombment, and the *Lamentation. The subject is so closely related to images of the *Crucifixion that figures often

present in Crucifixion scenes (e.g., the Virgin *Mary and Saint *John the Evangelist) also appear, standing, as traditional, on either side of the cross (Mary on the left, John on the right). Mary may take one of Christ's hands and express her grief by pressing it to her face. John may incline his head in grief or grasp Christ's other hand.

From the eleventh century onward, more figures were added; *angels may hover above the scene or assist with removing the body from the cross, *Ecclesia and *Synagogue may be included as well as the grieving *Mary Magdalene, additional mourners, crowds of onlookers, and Roman soldiers.

Example: Benedetto Antelami, *Deposition,* c.1178, Parma Cathedral, pulpit, relief. (Synder, fig. 422)

DESCENT FROM THE CROSS. See DEPOSITION.

DESCENT OF THE HOLY SPIRIT. See PENTECOST.

DESCENT INTO LIMBO. See ANASTASIS.

DESPAIR. See VICES.

DEVIL. The word *devil* (from the Greek and Latin *diabolos* and Hebrew *satan*) becomes the term used to refer to the forces of evil in the world. Devils are malevolent spirits or *demons, whose origins were variously explained by Jewish and Christian theologians. The theory, found in Old Testament *Apocrypha, that *angels rebelled against *God at the time of *Creation, was adopted by many Christian thinkers (see: *Fall of the Rebel Angels); the leader of the rebel angels was identified as Satan, or the Devil.

Demons are represented in early Christian art as small winged creatures, like monstrous angels (see: *Exorcism, *Healing of the Demoniac); hence the Devil may be shown as a hybrid creature, humanoid or bestial. The imagery was developed in early medieval art and amplified especially in the Romanesque and Gothic periods where the Devil frequently occurs in pictorial narratives of the *Apocalypse and *Last Judgment as a dark, horned, hairy, winged creature with clawed feet and a tail or various distorted human features. The Devil is often found in depictions of the *Temptation of Christ and as an inhabitant of *hell, for example, in scenes of the *Anastasis. The Devil is also represented by a snake, serpent, or dragon (see: *Animals, Symbolism of) being identified (following Wisdom 2:24) with the serpent-tempter of *Adam and Eve in the *Garden of Eden and with the great dragon of the Apocalypse with which Saint *Michael does battle (Rev. 12:7–9). See also: *Leviathan, *Mouth of Hell.

Example: The Third Temptation of Christ, Winchester Psalter, c.1145–1155, London, BL, Cott. MS Nero C.IV, f. 18. (Dodwell, fig. 362)

DIALECTIC. See SEVEN LIBERAL ARTS.

DIONYSIUS, SAINT. See DENIS, SAINT.

DIOSCURIDES. A Greek physician who lived in Asia Minor in the first century A.D., Dioscurides produced an extremely influential and frequently illustrated treatise on the medicinal properties of plants: *De materia medica*. The herbal (see: *Manuscripts) is distinguished by its careful, comprehensive descriptions of plants and their uses. A magnificent copy was produced in Constantinople c.512 for the Byzantine princess Juliana Anicia and contains nearly 400 full-page, color illustrations of plants. The *Materia medica* was frequently copied during the Middle Ages, translated into several languages including Latin, Anglo-Saxon, and Hebrew, and provided a source for many later herbals.
 Example: Author Portrait, Vienna Dioscurides, c.512, Vienna, ON, Cod. med. gr. I, f. 4. (Synder, cp. 5)

DISCORD. See VICES.

DISCOVERY OF THE TRUE CROSS. See TRUE CROSS.

DISHONESTY. See VICES.

DISPUTE IN THE TEMPLE. The only episode in Jesus' youth which is described in the New Testament, the disputation in the Temple took place when Jesus was twelve years old. His parents (the Virgin *Mary and Saint *Joseph) took him to Jerusalem to celebrate Passover but lost track of him among the group of their friends and family when they were journeying back home to Nazareth. After three days of distressed searching, they discovered Jesus in the Temple back in Jerusalem, engaging in discussion with the astonished Jewish elders and teachers. The event was a premonition of Jesus' future ministry. The episode is recorded in *Luke 2:41–52 and was elaborated also in the second century apocryphal *Gospel of Thomas*. The subject appears somewhat infrequently in early Christian art and becomes more common in the later medieval period. Early examples depict simply the boy Jesus seated on a high throne engaging in discussion with two or three seated or standing figures. Mary is included by the sixth or seventh century and Joseph somewhat later. They enter the scene with joyful gestures or stand, quietly observing the seated Jesus, who is traditionally shown elevated on a throne or platform, surrounded by listening or conversing figures. Mary's emotional reaction is emphasized in later medieval art as this episode of loss and recovery was identified as both one of the *Seven Joys and *Seven Sorrows of the Virgin.
 Example: Dispute in the Temple, Queen Mary Psalter, early fourteenth century, London, BL, Royal MS 2.B.VII, f. 151. (D'Ancona, pl. 89)

DIVES AND LAZARUS. In *Luke 16:19–31, Jesus tells the parable of the greedy and finely dressed rich man (*dives* in Latin) and the poor beggar Lazarus

who lay outside the gate futilely hoping to receive crumbs from the rich man's table. Dives is usually depicted as a corpulent figure (a personification of the *vice of Gluttony) feasting indoors, surrounded by his servants or musicians, while dogs lick the sores of the emaciated (or leprous) Lazarus. When they both died, Lazarus went to *heaven, where his earthly suffering was rewarded; he may be shown carried by *angels or held in *Abraham's bosom (lap). Dives went to *hell, where his earthly vices were punished; he may be shown tortured by *demons and flames.

Example: Dives and Lazarus, c.1030, bronze column, Hildesheim Cathedral. (Swarzenski, fig. 117)

DOCTORS OF THE CHURCH. The title *Doctor* (in the Latin sense of *teacher*) is given by papal council or decree to individuals whose authoritative scholarship and holiness of life is worthy of outstanding acknowledgment. Over thirty Doctors of the Church are now recognized, but in the Middle Ages only four were officially proclaimed in 1298 by Pope Boniface VIII. The four medieval Doctors of the western church are: Saints *Ambrose, *Jerome, *Augustine of Hippo, and *Gregory the Great, all of whom contributed greatly to Christian life through their writings and teachings. They may be found in art depicted as a group with appropriate attributes as ecclesiastics and scholars. In medieval Byzantium, the acknowledged "great universal teachers" were Saints *Basil, *Gregory of Nazianzus, and *John Chrysostom. (See also: *Fathers of the Church.)

DOG. See ANIMALS, SYMBOLISM OF.

DOMINIC, SAINT. Dominic de Guzman (c.1170–1221), founder of the Dominican order (Friars Preachers), was born in Spain and died in Bologna. While a canon of the cathedral chapter at Osma, Dominic and his bishop were sent on a royal mission to Scandinavia. As they crossed the Pyrenees, Dominic encountered the dualistic Albigensians in southern France. Later, he returned to preach to these heretics and founded an order (c.1206) whose emphasis would be on *preaching and teaching. He established communities for nuns and friars in southern France, Italy, and Spain, and sent the friars to teach at universities (e.g., Paris and Bologna). He received papal approval for his order in 1216 and adopted the Rule of Saint *Augustine as the foundation for the Order of Preachers—which was devoted to study, education, *prayer, and preaching. Dominic was canonized in 1234, by which point the Dominicans were already a large and well-organized group who continued to expand through the later medieval period.

Dominic and scenes from his life appear in art from the thirteenth century onward; as a single figure he is often identifiable by the black hooded cloak (the Dominicans are hence also called the Black Friars) and white habit of the order. He may be shown with a star on his breast, shoulder, or forehead (indi-

cating the star which purportedly appeared over his head when he was christened as an infant); he may carry books, a lily (symbol of his purity), or be accompanied by a dog holding a flaming torch in its mouth. His mother was said to have seen this dog in a dream before Dominic's birth with the premonition that the dog would set the world on fire; it is also perhaps a pun on the Latin *Domini canes*—the Dominicans as the "watchdogs of the Lord" in their combat against heresy. Dominic is also frequently shown with rosary beads, a method of prayer he advocated and encouraged (though did not invent, as some traditions recount).

Narrative scenes include images of Dominic preaching, receiving the Gospels and a staff from Saints *Peter and *Paul in a vision, supporting a crumbling church with his shoulder (as recorded in a dream of Pope Innocent III), in an apocryphal meeting with Saint *Francis, plus various *miracles (saving *pilgrims from drowning, bringing a boy killed in a riding accident back to life, and *angels appearing to feed Dominic and several companions).

Example: Saint Dominic Teaching, Bible, c.1262, London, Estate of Major Abbey, J A. 7345, f. 1. (De Hamel, fig. 114)

DOMINIONS. See ANGELS.

DOMINUS LEGEM DAT PETRO. See MISSION OF THE APOSTLES; PETER, SAINT; TRADITIO LEGIS.

DOOMSDAY. See LAST JUDGMENT.

DORCAS. See TABITHA.

DORMITION. The term *dormition* is a Latin translation of the Greek *koimesis* (falling asleep). The *death of the Virgin *Mary is not described in the Gospels but is detailed in various early apocryphal sources, some of which state that she did not die but simply fell asleep for three days before her *Assumption to *heaven. This theme was later taken up especially in the *Golden Legend,* which includes a detailed account of the deathbed scene to which all the *apostles (previously in various locations around the world) were transported back in clouds and witnessed the *soul of the Virgin received into the arms of *Christ.

The image appears in early Byzantine art and is frequently found in both western and Byzantine examples from the tenth century following. Traditionally, Mary is shown reclining on a bed or couch surrounded by the apostles, who exhibit various expressions of grief. Some of the apostles may be identifiable by dress or iconographic attributes. *Additional disciples, women, and *angels may also be present. Christ stands behind the prone figure of Mary, holding a tiny effigy meant to represent her soul. Sometimes the hand of *God or a crown appear at the top; this is a reference to Mary's *Coronation in heaven. Related and similar scenes, such as the funeral and entombment of Mary, also appear as independent images in western art, and the bodily Assumption of the Virgin

(her transportation to heaven by angels) may be included in both western and Byzantine Dormition scenes. The image can be found on Byzantine icons and ivories, in mosaics, manuscripts, and frescoes, and in western manuscripts, stained glass, and sculpture, especially of the twelfth and thirteenth centuries.

Example: Death of the Virgin, c.1230, Strasbourg Cathedral, south transept, tympanum. (Snyder, fig. 542)

DOROTHEA, SAINT. Listed in early martyrologies as having died at Caesarea (c.313), later legends tell how the virgin martyr Dorothea (or Dorothy) was mocked by a young lawyer when she was being led to her execution. He asked her to send him the fruits from the garden of paradise (*heaven), where she had said she was going. At the moment of her decapitation and in answer to her prayers, an *angel appeared with a basket of three roses and three apples, which Dorothea sent to the lawyer, inspiring his own conversion and resulting in his later *martyrdom. Dorothea appears primarily in late medieval art in Italy, Germany, and England, identifiable by her crown of flowers or a basket of roses that she carries or is given to her by an angel or the infant Jesus.

Example: Saint Dorothy, c.1420, woodcut. (Synder, NR, fig. 262)

DOROTHY, SAINT. See DOROTHEA, SAINT.

DOUBTING THOMAS. See THOMAS, SAINT.

DOVE. See BIRDS, SYMBOLISM OF; HOLY SPIRIT.

DRAGON. See ANIMALS, SYMBOLISM OF.

DREAM OF CONSTANTINE. See CONSTANTINE.

DREAM OF THE MAGI. See ADORATION OF THE MAGI.

DRUNKENNESS OF NOAH. See NOAH.

E

EAGLE. See BIRDS, SYMBOLISM OF; FOUR EVANGELISTS.

ECCE HOMO. *Ecce homo* is Latin for "Behold the man," the words (according to *John 19:5) which *Pontius Pilate spoke upon presenting Jesus to the people before sentencing him to execution. The image appears in tenth-and eleventh-century manuscript illustrations included in narratives picturing the *Crowning with Thorns and the bearing of the *cross to *Calvary. (See also: *Trials of Christ.) In the early fifteenth century, the scene developed into an independent image and is frequently found in northern panel painting. Jesus, crowned with thorns, his hands bound and his body covered with bleeding wounds, stands or stoops beside Pilate who gestures toward him while the angry people below them gesticulate and call out for Jesus' *Crucifixion. See also: *Man of Sorrows.

ECCLESIA. *Ecclesia,* the Latin term for *church, is personified in medieval art by a female figure who represents Christianity. She first appears in ninth-century art, holding a chalice to collect *Christ's blood in *Crucifixion images. Ecclesia is frequently also found as an independent figure in non-narrative contexts through the Middle Ages. Apart from the chalice, her other attributes include a crown, *cross staff, and triumphal banner. Most often, Ecclesia is paired with *Synagogue (Synagoga), the personification of the old covenant and Hebrew tradition. Frequently, the pairing is confrontational; Ecclesia is shown demanding or removing the attributes of power (crown, lance, globe) from Synagogue, who is perceived and presented as a negative figure (as per writings of Church *Fathers such as Saint *Augustine and as reflective of increasing anti-Jewish attitudes during the medieval period). The personified figure of Ecclesia also appears as the *Sponsa Christi* (bride of Christ, see: *Sponsa-sponsus*)

embracing Christ or piercing him with a lance (symbolizing love) in Crucifixion scenes especially from the thirteenth century following.

Example: Ecclesia, c.1240, Strasbourg Cathedral, formerly south transept, jamb figure. (Synder, fig. 543a)

EDEN, GARDEN OF. See GARDEN OF EDEN.

EDMUND, SAINT. King Edmund of East Anglia (c.840–870) reigned successfully and peacefully until the Danish invasion of his territory and the defeat of his army. He was captured and refused to pay tribute to the enemy or renounce his faith. According to various accounts, he was tortured, scourged, shot full of arrows (like Saint *Sebastian), and eventually decapitated. His cult became popular very quickly, and stories of his life, *martyrdom, and posthumous *miracles were composed, elaborated, and illustrated especially at the important abbey of Bury-Saint-Edmunds, founded c.1020. A detailed pictorial cycle was created there in a manuscript of the early twelfth century. Saint Edmund is otherwise recognizable in art as a crowned figure, carrying an arrow or accompanied by the wolf who guarded his still-speaking decapitated head until searchers recovered it.

Example: The Coronation of Saint Edmund in Heaven, Miracles and Passion of Saint Edmund, c.1125–1135, New York, PML, MS 736, f. 22v. (Dodwell, fig. 338)

EDUCATION OF THE VIRGIN. Stories concerning the childhood of the Virgin *Mary are found in apocryphal sources which recount her birth to *Anne and *Joachim and her *Presentation in the Temple where she served from the age of three until her *Marriage to Saint *Joseph. The *Protevangelium of James* tells of her seven first steps (guarded by an *angel) at the age of six months; the *Gospel of the Pseudo-Matthew* also describes her virtuous service in the Temple and her nourishment with bread daily brought by an angel. The *Golden Legend,* expanding these accounts, describes how her mother taught her to read and sew and explains how the episode of her pricking her finger when sewing can be seen as a prefiguration of her *Seven Sorrows. Scenes of the childhood of Mary are especially prevalent in Byzantine art from the eleventh century onward and are found in western art largely during the Gothic and later medieval periods.

Example: The First Steps of the Virgin, c.1310, mosaic, Istanbul, Kariye Camii. (Rice, fig. 210)

EDWARD THE CONFESSOR, SAINT. Edward (1003–1066) was the last Anglo-Saxon king of England (with the exception of the brief reign of Harold Godwinson). He spent much of his early life in exile in Normandy. He died childless, and his *death, followed by Earl Harold's coronation, sparked the Norman invasion and conquest of England in 1066. Famed for his piety, generosity, and patronage of the arts, he was canonized in 1161. A shrine for his

*relics was created in 1163 in Westminster abbey (which had been lavishly rebuilt with his support), and his relics were transferred to an even more magnificent shrine in 1269. Biographies of Edward, composed in the early and mid-twelfth century, provided sources for illustrations in a variety of media, especially thirteenth-century and later manuscripts, sculpture, and stained glass. As seen in the late eleventh-century Bayeux Tapestry, Edward is normally shown as a tall, bearded man, often crowned, and with his chief attribute: a ring, which, according to the life composed in the mid-twelfth century, he had generously given to a beggar. Later English *pilgrims in the Holy Land met an old man claiming to be Saint *John the Apostle who returned the ring to them, asking that they take it back to England and alert Edward of his impending *death. Edward is also shown seeing a vision of *Christ (in the host, during Mass) and seeing a vision of the *Seven Sleepers of Ephesus.

Example: Scenes from the Life of Edward, Abbreviated Doomsday Book, c.1250–1260, London, Public Record Office, MS (E 36) 284, f. 2v. (Morgan, II, pl. 88)

ELDERS OF THE APOCALYPSE. See TWENTY-FOUR ELDERS OF THE APOCALYPSE.

ELEOUSA. *Eleousa* is a Greek term for "compassionate" or "merciful." It refers to a specific form of Byzantine imagery of the *Madonna and Child, frequently found on *icons from the eleventh century and popular throughout Europe by the twelfth century. It derives from the *Hodegetria* but is characterized by the affection displayed by the two figures; the Virgin *Mary tilts her head toward the infant Jesus who grasps her neck and presses his face to her cheek. The figures may be half-or full-length; Mary may be seated or standing; she often supports the infant on her right arm and gestures toward him with her left hand. The powerful scene combines a mood of maternal affection (in Russia, the image is termed "Lovingkindness") with melancholy; the viewer senses that Mary is grieving in advance for the suffering and *death of her son.

Example: The Virgin of Vladimir, c.1131, icon, Moscow, Tretyakov. (Weitzmann, pl. 21)

ELEVATION OF THE CROSS. See RAISING OF THE CROSS.

ELIGIUS, SAINT. The highly skilled and economical goldsmith Eligius (or Eloi, c.588–660) worked for the French royalty, later became a priest, and was appointed bishop of Noyon in 641. Famed for his superb craftsmanship as well as his *preaching and piety, his early established cult grew extremely widespread, making Eligius one of the most popular of medieval *saints: the patron of metalworkers and smiths. Episodes from his legend are found in Romanesque and especially later Gothic art, including the scene of Eligius cutting off and later restoring the leg of a restive horse he was shoeing, and Eligius holding the *Devil's nose in a pair of pincers (the Devil had accosted him in his metalworking shop). Frequently depicted as a craftsman with various tools of the

metalworking trades, Eligius is also represented wearing the bishop's mitre and holding a *cross.

Example: Roll of Saint Eloi, mid-thirteenth century, Paris, Musée Carnavalet. (Morgan, II, fig. 27)

ELIJAH. The life and deeds of Elijah, an important Hebrew *prophet who lived in the ninth century B.C., are described in the books of Kings. Numerous visions, *miracles, and spectacular events characterize his life; he was fed by ravens in the wilderness; he brought the widow of Zarephath's son back to life; he predicted a great drought; he called down sacrificial fire from *heaven during a contest with the priests of Baal on Mount Carmel; an *angel brought him food and drink during another sojourn in the desert, and he concluded his dramatic life by being swept up to the heavens in a chariot of fire. He is mentioned several times in the New Testament as well, and he appears at the *Transfiguration of *Christ. Traditionally envisioned as a rather wild and unkempt figure, he prefigures Saint *John the Baptist. Events in his life also prefigure episodes in the life of Christ; the angel who visited Elijah in the desert is linked with the angelic visitor to Jesus in the *Agony in the Garden; Elijah's raising of the widow's son is linked with Jesus' *Raising of Lazarus (and others); Elijah's fire from the heavens is linked with the descent of the *Holy Spirit at *Pentecost, and his translation to heaven in the fiery chariot is linked with the *Ascension of Christ. The latter, especially popular scene appears very early in Christian art (e.g., in catacomb paintings, sarcophagi, and other sculpture) also symbolizing the *Resurrection of Christ. Elijah was very popular in Byzantine as well as western medieval art and is considered by the Carmelites to be the founder and patron of the Carmelite Order. See also: *Elisha.

Example: Elijah and Elisha, Dover Bible, c.1145–1155, Cambridge, CCC, MS 3, f. 161v. (Dodwell, fig. 358)

ELISHA. When the *prophet *Elijah was taken up to the heavens in the fiery chariot, he dropped down his cloak to his loyal disciple Elisha. As successor to Elijah, Elisha also performed many *miracles which can be seen to prefigure events in the New Testament. He filled a widow's empty jars with oil, restored a Shunammite woman's son to life, fed many people with only some fruit and twenty loaves of bread, and cured Naaman's leprosy by having him bathe in the river Jordan. These scenes appear especially in medieval art works with typological programs (twelfth-century Mosan enamels, thirteenth- and fourteenth-century stained glass windows). Elisha is often represented bald. In 2 Kings 2:23–24, the children who made fun of his baldness were eaten by bears (this can be interpreted as a prefiguration of the *Mocking of Christ).

Example: Elijah and Elisha, Dover Bible, c.1145–1155, Cambridge, CCC, MS 3, f. 161v. (Dodwell, fig. 358)

ELIZABETH, SAINT. Elizabeth was the mother of Saint *John the Baptist, the wife of the priest *Zacharias, and a kinswoman of the Virgin *Mary (see:

*Holy Kinship). She is mentioned in the Gospel of *Luke as a righteous, elderly, and childless woman (Luke 1:5–7) whose husband, visited by the *angel *Gabriel, received news that she would bear a son to be named John. Zacharias's lack of belief is detailed in Luke 1 (18–22) which chapter also describes Elizabeth's pregnancy, Mary's *Visitation to her relative (39–56), and the birth and naming of John (57–64). The apocryphal *Protevangelium of James* describes how Elizabeth took the infant John and sought refuge in a cave during the *Massacre of the Innocents while *Herod's soldiers murdered Zacharias at the Temple.

Scenes from the life of Elizabeth found in early Christian and medieval art include the birth of Saint John (Zacharias, previously rendered speechless by the angel Gabriel, is usually present, writing John's name on a tablet), and the flight of Elizabeth and her infant to the cave. She is depicted most often, however, in scenes of the Visitation, a subject which appears in art of the fifth and sixth century and with great frequency throughout the Middle Ages. The two women are shown embracing, standing and conversing, or, especially in later medieval art, Elizabeth may be depicted kneeling before Mary. Elizabeth is often shown as an elderly figure, wearing a veil.

Example: Elizabeth, c.1235–1240, Bamberg Cathedral, now interior, pier figure. (Snyder, fig. 552a)

ELMO, SAINT. See ERASMUS, SAINT.

ELOI, SAINT. See ELIGIUS, SAINT.

EMMAUS, ROAD TO. See ROAD TO EMMAUS.

EMMAUS, SUPPER AT. See SUPPER AT EMMAUS.

ENOCH. The long-lived Old Testament figure Enoch is briefly mentioned in Genesis 5:21–24 and Hebrews 11:5. He disappeared from earth, "taken up" by *God, without seeing *death; hence he is generally depicted in art as an elderly, bearded figure with arms upraised toward his heavenly destination. Because his departure from earth was similar to that of *Elijah, the two have been interpreted as the "two witnesses" who appear in the *Apocalypse. Numerous noncanonical writings bearing Enoch's name (and dating from the second century B.C. to the early Christian period) contain descriptions of *heaven, *angels, and various visions and insights about *Creation, revealed to Enoch, which provided influential subject matter for medieval art (see: *Fall of the Rebel Angels).

Example: Enoch Taken up into Heaven, c.1100, fresco, Saint-Savin-sur-Gartempe, nave vault. (Demus, fig. 133)

ENCLOSED GARDEN. See HORTUS CONCLUSUS.

ENTHRONED MADONNA AND CHILD. See MADONNA AND CHILD.

ENTOMBMENT. All four Gospels recount that after *Christ was taken down from the *cross (see: *Crucifixion and *Deposition), his body was carried to and placed in a tomb provided by *Joseph of Arimathaea. Various stages in the process and different settings are represented in medieval art. Early Byzantine examples (e.g., ninth-century manuscript illustrations) depict Joseph of Arimathaea and *Nicodemus carrying the (normally cloth-wrapped) body toward a cave or rock-hewn grave or placing the body within, or on the ground in front of, the cave. Early western examples may instead show an architectural structure (mausoleum) or sarcophagus into which the body is lowered. In both western and Byzantine examples of the tenth and eleventh century, additional figures may be present; the Virgin *Mary and Saint *John the Evangelist may carry, or assist with carrying, the body; they may walk alongside or stand or sit in attitudes of mourning (see: *Lamentation). Two other women watching or sitting by the grave may also appear (see: *Three Marys at the Tomb). As developed by the eleventh and twelfth century, western examples particularly emphasize the moment when Christ is lowered into the sarcophagus, surrounded and supported by the mourning figures of Mary, John, Joseph of Arimathaea, and Nicodemus. Occasionally, in both western and Byzantine examples, the anointing or embalming of the body may be shown, as part of, or as a separate episode from the Entombment itself. In this case, figures are shown pouring oil upon and rubbing the body with their hands. In Byzantine art, the representation of the body of Christ on the anointing stone, alone, or with *angels and the symbols of the *Four Evangelists, is known as the *epitaphios* (shroud image), as it was often depicted on shrouds used in Good Friday liturgical commemorations.

Example: Entombment, c.1075–1100, fresco, Sant' Angelo in Formis, nave. (Dodwell, fig. 156)

ENTRY INTO JERUSALEM. All four Gospels describe *Christ's arrival at Jerusalem on the Sunday before his *Crucifixion (which took place on the Friday of the same week). The Entry into Jerusalem can be seen as the first episode in the Passion of Christ and was celebrated liturgically with Palm Sunday processions from as early as the fourth century in the east. The earliest pictorial representations of the event also date from the fourth century, and the subject appears consistently in art throughout the medieval period. With some variation in details, the image traditionally shows Christ astride a donkey (or, in some Byzantine examples, riding side-saddle), accompanied by a varying number of disciples walking (normally behind him), being greeted by several figures, or a larger crowd, some of whom spread garments and palm branches on the ground before him signalling their recognition of him as *God's anointed (or Messiah), as per the prophecy of *Zechariah. The *Gospel of *Nicodemus* describes children breaking olive branches from a tree and following the crowd; hence children, and other figures climbing trees to break branches and to observe, may be in-

cluded. The city or city gate of Jerusalem is frequently shown in schematic or more detailed form; understood also as the *Heavenly Jerusalem, it can be seen to symbolize Christ's triumph over *death. With rare exceptions, the pictorial action progresses from left to right. The subject is found in ivory carving, manuscript illustration, on sarcophagi and architectural sculpture, and in fresco and panel painting. Life-size free-standing wood sculptures of Christ riding on a donkey (placed on boards with wheels) were drawn in processions from at least the tenth century; a number of examples survive from the later medieval period in the west.

Example: Entry into Jerusalem, mid-twelfth century, mosaic, Palermo, Cappella Palatina, south transept. (Synder, cp. 28)

ENVY. See VICES.

EPHRAIM. Ephraim and Manasseh were the sons of *Joseph. They were brought by their father to be blessed by their grandfather *Jacob, when the elderly man was near *death. Although Joseph positioned the boys so that the elder Manasseh would receive the firstborn right-hand blessing, Jacob crossed his arms, in spite of Joseph's objections, in preference for the younger Ephraim, predicting greatness for Ephraim's descendants (Genesis 48). Not unlike the blessing stolen by the youthful Jacob from his brother *Esau, the event was interpreted by early Christian and medieval theologians as a prefiguration of *Christ; the preferred Ephraim represents the triumph of the Christian *church over the Jewish *synagogue, and Jacob's crossed arm gesture prefigures the *Crucifixion. The image appears on sixth-century ivories, in illustrated manuscripts from the sixth century onward, and features frequently in typological programs, for example, twelfth-century Mosan enamels and Gothic manuscripts, sculpture, and stained glass.

Example: Blessing of Ephraim and Manasseh, Vienna Genesis, sixth century, Vienna, ON, Cod. theol. gr. 31, pict. 45. (Weitzmann, LA&EC, pl. 28)

EPIPHANY. See ADORATION OF THE MAGI.

EPITAPHIOS. See ENTOMBMENT.

ERASMUS, SAINT. Little historical information is known about the bishop of Formiae, Erasmus (or Elmo, d. c.303) although he is a very popular figure in medieval art. Perhaps because of a confusion with a bishop Erasmus of Antioch, his legend describes his escape from Syria to Italy to avoid the persecutions of Diocletian (after having been tortured by being rolled in pitch and set on fire), his journey by boat, guided by an *angel, across the Mediterranean, and his eventual *martyrdom by having his intestines wound out on a windlass. Erasmus is the patron *saint of sailors, and the tradition that he preached in a thunder-and-lightning storm gave rise to the designation ''Saint Elmo's Fire'' for the

lights (electrical discharges) often seen on ships' mastheads after storms. He is represented in art as a bishop, may hold a small ship, or may be depicted nude apart from his mitre while being disembowelled in a reclining position surrounded by several assailants in an interior or landscape setting. Scenes of Erasmus's martyrdom appear in eighth-century frescoes and with some frequency in later medieval hagiographic manuscripts and Books of Hours (see: *Manuscripts).

Example: Martyrdom of Erasmus, Book of Hours, c.1470–1475, private collection, f. 204v. (Marrow, pl. 88)

ESAU. Esau was the firstborn son of *Isaac and *Rebecca, the twin brother of *Jacob. The twins contended in their mother's womb, and at birth Jacob emerged holding onto Esau's heel. This competition set the lifelong pattern of struggle and rivalry between the brothers which culminated in two episodes: the exhausted and famished hunter Esau sold his birthright to his brother Jacob in return for food (Genesis 25:29–34), and later, with the assistance of Rebecca (who favored Jacob), Jacob was able to trick his blind, elderly father into giving him the blessing intended for the firstborn Esau (whom his father favored) by dressing in animal skins to appear and feel as hairy as Esau (Genesis 27). Jacob left home, and although Esau was initially very angered, both brothers prospered and were eventually reconciled (Genesis 33). Illustrations of the two brothers, Esau conversing with Isaac when Isaac asked him to bring him meat, and the episode of the stolen blessing, appear in early Christian biblical manuscripts and mosaics and in Romanesque and Gothic sculpture and manuscripts. Esau may be dressed as a hunter, often carries a bow, and is identifiable by his hairy appearance.

Example: Isaac and Esau, cutting with initial letter, late fifteenth century, Manchester, John Rylands UL, MS Latin 14, f. 10. (Alexander, fig. 217)

ESTHER. The life of Esther is described in the Old Testament book bearing her name. She is acclaimed (and celebrated in the Jewish festival of Purim) for having prevented the massacre of *Jews in the Persian empire by her courageous intercession to King *Ahasuerus (or Xerxes, fifth century B.C.). Esther had become the wife of Ahasuerus after he dismissed his previous queen, Vashti; when Ahasuerus chose Esther to be queen, he was unaware that she was Jewish. She was an orphan, raised by her cousin *Mordecai, who was an enemy of *Haman, the chief minister of the king and an enemy of the Jews. When Haman decreed that all Jews in the kingdom were to be killed, Mordecai asked Esther to approach the king to prevent this from happening. She did this successfully, although she endangered her life by boldly approaching the king unsummoned. She prepared a great banquet for the king and Haman, and the king granted her request. Haman was hung on the gallows he had intended for Mordecai, and Mordecai took Haman's place at court. Events from the life of Esther represented in medieval art include her marriage to Ahasuerus, her kneeling as a

suppliant before the king, and the king indicating his favor to her by raising his golden sceptre. In Christian interpretation, Esther is typologically related to the Virgin *Mary in prefiguring Mary's intercession with *God for humankind as well as Mary's *Coronation in *heaven.

Example: Esther scenes, Florence Cathedral Bible, c.1100–1125, Florence, BML, MS Edili 126, f. 83. (Cahn, fig. 112)

ETIENNE, SAINT. See STEPHEN, SAINT.

EUCHARIST. See LAST SUPPER; SEVEN SACRAMENTS.

EUCLID. The Greek mathematician Euclid (c.300 B.C.) appears in medieval art as a representative of Geometry in illustrations of the *Seven Liberal Arts. His works on geometry and numerical theories (e.g., the *Elements*) became more widely known, translated (from Arabic sources), and studied in the twelfth and thirteenth centuries.

Example: Seven Liberal Arts, c.1145–1155, Chartres Cathedral, west portal, right door, archivolt. (Sauerländer, pl. 6)

EULALIA, SAINT. The Spanish virgin martyr Eulalia of Mérida (d. c.304) suffered a series of horrible tortures and eventually (accounts vary) was burned alive, crucified, or beheaded when she, at the age of twelve (or fourteen) admonished the governor for carrying out Diocletian's edict requiring all to worship the pagan gods. The subject of a sermon by Saint *Augustine and a hymn by *Prudentius, Eulalia's story also inspired one of the earliest surviving poems in French, the *Cantilène de Sainte Eulalie,* composed when her *relics were translated to Barcelona in the ninth century. She appears in art from as early as the fifth century; her attributes are a *cross (X-shaped, e.g., Saint *Andrew's) and a dove, representing the dove of her *soul seen flying away to *heaven from her body at her *martyrdom.

Example: Saint Catherine of Alexandria and Saint Eulalia of Barcelona, Book of Hours, c.1510–1520, Walters, MS 420, f. 271v. (Wieck, fig. 103)

EUSTACE, SAINT. According to legend, Eustace (d. c.118) was a Roman general in Trajan's army. Formerly named Placidus, he was converted to Christianity and baptized as Eustace after seeing a vision of a stag with a crucifix between its antlers when he was out hunting. The stag spoke to him, inspiring his conversion, and the animal later appeared again to warn Eustace that he would suffer greatly for his faith. Eustace's *Job-like tribulations included the loss of all his goods, the abduction of his wife by the boat captain on their journey of escape to Egypt, and his two sons being carried away by a wolf and a lion. After the family was reunited, they were all roasted to death in a hollow bronze bull. The scene of Eustace's vision of the crucifix-bearing stag was extremely popular in medieval art and appears in Romanesque sculpture, Gothic

stained glass, and manuscript illustrations. Eustace is dressed as a Roman soldier and kneels before the stag. Narrative cycles showing other episodes from his life and *martyrdom also appear in Byzantine manuscripts, and especially in French Gothic sculpture and stained glass.

Example: The Conversion of Saint Eustace, Pantocrator Psalter, tenth century, Mount Athos, Pantocrator Monastery, MS 61, f. 138. (Rodley, fig. 140)

EVANGELISTS. See FOUR EVANGELISTS.

EVE. See ADAM AND EVE.

EXALTATION OF THE CROSS. Also known as "Holy Cross Day" or the "Elevation of the Holy Cross," the feast of the Exaltation of the *Cross is celebrated by both western and Byzantine churches on September 14. The ceremonies commemorate the *relic of the *True Cross discovered by Saint *Helena in 326 and returned to Jerusalem by the emperor *Heraclius in 630. In Byzantine manuscripts of the tenth century onward, the event may be illustrated by a depiction of the liturgical ceremonies enacted on the feast day: the patriarch or bishop is shown raising the cross before the congregation or above the cave where the relic was discovered. Illustrations showing Heraclius returning the cross to Jerusalem also commemorate this date.

Example: Elevation of the Holy Cross, Menologion of Basil II, late tenth century, Rome, BAV, MS Vat. grec. 1613, p. 35. (Weitzmann, *Studies,* fig. 296)

EXORCISM. Exorcism is the act of expelling evil spirits. The procedures may involve incantations, animal sacrifices, and preparation of various animal, mineral, or vegetable materials. Accounts of persons possessed by evil spirits and the exorcism of *demons are found in the Bible (e.g., *Tobias exorcised demons with the internal organs of a fish). Acts 13:6 and 19: 13–16 attest to the continued importance of magic and exorcism among the *Jews of the pre-and early Christian period, and the New Testament contains numerous accounts of Jesus expelling demons, though without the elaborate rituals or incantations traditionally associated with the practice (see: *Healing of the Demoniac). The *apostles were given the charge and power to drive away demons (e.g., *Matthew 10:1; see also *Mission of the Apostles). Exorcism (by *prayer, breathing, and laying on of hands) was routinely included in the rite of *Baptism through the Middle Ages. A number of *saints were also credited with special abilities to drive away demons and may be represented doing so in pictorial narratives (e.g., see: Saints *Anthony, *Bartholomew, *Benedict, *Nicholas).

EXPULSION FROM THE GARDEN. See ADAM AND EVE.

EXPULSION OF THE MONEY CHANGERS. See CLEANSING OF THE TEMPLE.

EZEKIEL. One of the four major *prophets whose visions are contained in the Old Testament book bearing his name, Ezekiel lived during the sixth century B.C. with the exiled Hebrews in Babylon. His dramatic visions and prophecies provided material for interpretation and artistic depiction from the early Christian through late Gothic period. Scenes most frequently shown include his visions (Ezekiel 1 and 10) of *God enthroned in the midst of four winged beasts (see: *Tetramorphs*) and *angels, among wheels and fire (often shown in art as a fiery wheeled chariot); his sensational vision (Ezekiel 37) of the resurrection of the dry bones of Israel in a valley (prefiguring the *Last Judgment); and his detailed description of the ideally reconstructed Temple including a closed door or gate (Ezekiel 44), interpreted by Christian theologians as a symbol for the Virgin *Mary as intact door to *heaven (See also: *Hortus conclusus*). Additional scenes include Ezekiel receiving from God, and per God's instruction, eating a scroll (Ezekiel 2–3) and, (Ezekiel 5) cutting his hair, shaving his beard, and weighing and dividing the hair, some to be burned, some to be cut, and some thrown to the wind (predictions of the destruction of Israel).

 Example: Visions of Ezekiel, third century, fresco, Dura Europas, Synagogue. (Synder, fig. 94)

EZRA. A Jewish scribe and priest of the fifth or fourth century B.C., Ezra was sent from Persia to Jerusalem and is described in the books of Ezra and Nehemiah as a reformer of Jewish law and tradition, especially in urging fidelity to intra-Jewish marriages. He is traditionally considered the *author of the two books of Chronicles as well as the books of Ezra and Nehemiah and is depicted in art as a scribe, priest, and scholar.

 Example: Ezra, Codex Amiatinus, late seventh century, Florence, BML, Cod. Amiat. 1, fol. V. (Cahn, fig. 12)

F

FAITH. See VIRTUES.

FAITH, SAINT. See FOY, SAINT.

FALL OF MAN. See ADAM AND EVE.

FALL OF THE REBEL ANGELS. The *angels who rebelled against *God and were cast out of *heaven onto the earth, with the *Devil, are mentioned in Revelation 12:7–9. The account is not found in the Old Testament (although *Isaiah 14:12 describes Lucifer cast out of heaven, and a reference in *Job 4: 18 mentions angels ''charged with folly''). The early source for the tale of the rebel angels is the apocryphal *Book of the Secrets of Enoch* (first century A.D.), which includes descriptions of the heavens and insights revealed to *Enoch about *Creation. The rebel angels were, according to this source, 200 in number. This theme of angelic disobedience was taken up in the New Testament and by numerous early Christian and later medieval writers (e.g., *Augustine, *Isidore of Seville, Origen, and many others) who increased the number of rebel angels and offered various explanations for their rebellion (pride, greed, lust) while emphasizing the factors of free will and choice involved with the sin of disobedience. The angels were created good but chose to become evil. They became, on earth, evil people, *demons, or demonic forces. In pictorial form, the subject can be found in illustrations of Genesis, the *Apocalypse, and may be linked with *Last Judgment images which depict Saint *Michael battling with the great dragon during the war in heaven between the forces of good and evil. The rebellious angels tumble from heaven, turn into demons, and may be shown swallowed up in the *Mouth of Hell.

Example: Fall of the Rebel Angels, Caedmon Genesis, c.1000, Oxford, BL, MS Junius 11, p. 3. (Cahn, fig. 52)

FALL OF SIMON MAGUS. The magician *(magus)* Simon is mentioned in Acts 8. He lived in the city of Samaria and exerted great influence over the people with his sorceries. Impressed by the preaching of Philip the Deacon, Simon converted to Christianity and was baptized; however, he later tried to offer money to *John and *Peter to purchase the power to perform *miracles through the *Holy Spirit. He was rebuked by Peter and repented (Acts 8:18–24). A much more detailed account of Simon the magician appears in the second-century apocryphal *Acts of Peter* (which provided the source for later elaboration in the *Golden Legend*). These texts describe how Simon, in Rome and favored by the emperor Nero, challenged Peter and *Paul to various contests of miracle working and magic skills. Simon (unlike Peter) was unable to restore dead people to life, and the trials came to a dramatic conclusion when Simon, flying through the air with the help of *demons, crashed down to earth as a result of Peter's prayers. (The *Acts of Peter* recount that he broke many bones but lived on; the *Golden Legend* states that he broke his skull and died.) Various scenes appear in Romanesque and Gothic art: Peter refusing Simon's money, Peter restoring a dead youth to life, and, most popularly, Simon Magus falling out of the sky while his demon supporters flee.

Example: Fall of Simon Magus, c.1120–1140, Autun Cathedral, capital. (Künstler, pl. 9)

FATHERS OF THE CHURCH. The Fathers *(Patres)* of the Church are a somewhat loosely defined group of early Christian and early medieval theologians, from the first through eighth centuries, whose writings are recognized as carrying certain authority and whose holiness of life and contributions to the establishment of church doctrine were noteworthy. The list of those considered as Church Fathers varied through the first centuries of Christianity; the title was first applied only to bishops but by the late fourth and fifth century was expanded to include other authors who did not necessarily hold high ecclesiastical positions but whose writings were critical in the formation of Christian doctrine. The title is popular rather than formally conferred (in contrast to the *Doctors of the Church who are, in any case, also considered Church Fathers). The authority and consensus of the Church Fathers were frequently invoked in the theological controversies of the early Christian period. Those considered Church Fathers now conclude in the west with the seventh-century Saint *Isidore of Seville, and in the east, with the eighth-century Saint *John of Damascus. Others include: Eusebius, Tertullian, and Saints *Ambrose, *Augustine, *Basil, *Gregory the Great, *Gregory of Nazianzus, Irenaeus, *Jerome, and *John Chrysostom. (See individual entries for iconography and writings.) The study of the writings of the Church Fathers is known as Patristics.

FEAST AT CANA. See MARRIAGE AT CANA.

FEAST OF HEROD. The fateful birthday banquet hosted by *Herod Antipas which resulted in the decapitation of Saint *John the Baptist is described in the

Gospels of *Matthew (14:3–11) and *Mark (6:14–28). Herod Antipas, one of the sons of Herod the Great, was the ruler of Galilee and Peraea. He divorced his first wife in order to marry Herodias, the wife of his brother (or half-brother). John the Baptist rebuked him for this and angered Herodias. Herodias's daughter, Salome, pleased Herod with her dancing at the feast, and Herod offered to grant her any wish. Consulting with her mother, Salome requested the head of John the Baptist (who had previously been imprisoned by Herod). John was decapitated, and his head was brought forth on a platter. Depicted in art, the subject will include figures seated at a banqueting table, Salome dancing or performing acrobatics, the decapitation of John, and the presentation of John's head on a tray or in a bowl. Extracted from this narrative context, the decapitated head of John the Baptist also appears in art as an independent, devotional image (see: *Andachtsbilder).

Example: Feast of Herod, c.1240, Rouen Cathedral, west portal, left tympanum. (Sauerländer, fig. 182)

FEEDING OF THE FIVE THOUSAND. See MULTIPLICATION OF THE LOAVES AND FISHES.

FIERY FURNACE. Shadrach, Meshach, and Abednego, the companions of *Daniel in captivity at the Babylonian court, were thrown into a fiery furnace for refusing to worship a golden statue set up by *Nebuchadnezzar. The power of the Hebrew *God was demonstrated when they survived the flames untouched. An image of salvation, the scene was especially popular in early Christian art (catacomb frescoes and sarcophagi) where the three youths often appear as *orant figures standing in flames. The subject also appears in Byzantine and western manuscript illustration and in Romanesque and Gothic architectural sculpture. The preservation of the youths was also interpreted by Christian theologians as a prefiguration of *Mary's virginity.

Example: Three Youths in the Fiery Furnace, third century, fresco, Rome, Catacomb of Priscilla. (Zarnecki, fig. 3)

FIG. See FRUIT AND TREES, SYMBOLISM OF.

FINAL JUDGMENT. See LAST JUDGMENT.

FINDING AND PROVING OF THE TRUE CROSS. See TRUE CROSS.

FISH, SYMBOLISM OF. The fish is one of the commonest and earliest Christian symbols, in use by the second century to signify *Baptism, *Christ, and Christians. Tertullian (c.160–230), in his writings on baptism, referred to converts as pisciculi ("little fish") and the baptismal font as piscina ("fish pond"). Fish may have been spared *God's wrath in the *Deluge; baptized Christians may be seen as similarly saved. Fish require water to survive; Christians require

baptism. Saint Clement of Alexandria (c.150–215) advised Christians to use the fish symbol on their seals, rather than pagan motifs. The Greek letters for the word fish: IXOYC *(ichthos)* form an acrostic for "Jesus Christ, Son of God, Savior," although whether the fish symbol derives from this, or vice versa, is unclear.

The fish appears in early Christian art, on lamps, sarcophagi, and in catacomb paintings. Fish may be accompanied by bread and wine as a symbol of the Eucharist (see: *Last Supper, *Seven Sacraments) or to symbolize the *miracle of the *Multiplication of the Loaves and Fishes.

Christ, in the *Calling of Peter and Andrew and in the episode of the *Miraculous Draught of Fishes, spoke of the *apostles as "fishers of men." The fish is also the special attribute of Saint *Peter (a former fisherman), Saint *Anthony of Padua (who preached to the fish), Saint *Zeno (who enjoyed fishing), and *Tobias (who restored his father's eyesight with the gall of a fish). In early Christian depictions of *Jonah, the whale often appears as a dragonlike fish. Fish also appear in medieval bestiaries (see: *Manuscripts; *Physiologus) and as the *zodiac sign of Pisces.

Example: Fish and Bread, third century, fresco, Rome, Catacomb of Callixtus. (Synder, fig. 4)

FIVE SENSES. Interest in the five human faculties of sight, hearing, smell, touch, and taste is exhibited in medieval medical treatises and encyclopedic works in sections concerning the properties and nature of the human body. In diagrams illustrating these texts, the five senses may be linked to the planetary influences and to the *Four Elements (hence, sight derives from fire, hearing and smell from air, touch from the earth, and taste from water). The microcosm of the human body was understood to mirror the macrocosm of the universe, as developed also in the doctrine of the *Four Humors. Human personifications of the Five Senses, and their related animal attributes, develop largely in the post-medieval period; for example, the early sixteenth-century series of tapestries in the Cluny Museum in Paris depicting courtly scenes of an elegant lady accompanied by a unicorn has been interpreted as an allegory of the Five Senses. She is shown holding a mirror (sight), playing an organ (hearing), stroking the unicorn (touch), being offered sweets from a dish (taste), and holding a floral wreath (smell).

Example: Man as Microcosm, Commentary of Salomo of Constance, c.1165, Munich, SB, MS Clm. 13002, f. 7v. (Pächt, fig. 165)

FLAGELLATION. Following the *Arrest and *Trials of Christ, the Roman governor *Pontius Pilate ordered *Christ to be whipped (as permissible before *crucifixion, in Roman law). The event is briefly described in all four Gospels and was elaborated in later medieval mystical writings. The subject is found in western art from the ninth century onward but is somewhat less frequent in Byzantine art. Normally, Christ is depicted standing upright with his hands tied

to a column or pillar while two figures lash him with whips. The attackers are frequently placed to either side of Christ, creating a symmetrical composition. Pilate may be shown seated and observing. The architectural setting of Pilate's judgment hall may be indicated. Early examples may show Christ wearing a long robe; from the twelfth century he is more often shown with simply a loincloth, and in the thirteenth century, the wounds on his body tend to be emphasized dramatically. The subject appears in manuscript illustration, wall paintings, stained glass, and sculpture, and was especially favored by the Franciscans; hence it appears frequently on Italian painted processional crosses of the thirteenth century onward.

Example: Christ's Betrayal and Flagellation, Psalter of Blanche of Castile, c.1230, Paris, BA, MS 1186, f. 23v. (Robb, fig. 142)

FLAYING OF BARTHOLOMEW. See BARTHOLOMEW, SAINT.

FLIGHT INTO EGYPT. After the birth of Jesus, when the Magi (see: *Adoration of the Magi) returned to their homeland without further contact with King *Herod, *Joseph was warned by an *angel in a dream about Herod's plans for the *Massacre of the Innocents. Joseph took *Mary and the infant from Bethlehem to Egypt. The brief description of this event in *Matthew 2:13–15 was expanded in apocryphal writings, the *Golden Legend, and late medieval devotional works. These texts include descriptions of the *Holy Family resting en route (miraculously refreshed by a spring which appeared and a palm tree which bent over to provide fruit), their encounter with thieves (who, impressed with the infant, left them unmolested; these are the men who were later crucified with Jesus; see: *Thieves on the Cross), their arrival in Egypt (when the pagan *idols fell and broke and where they were greeted by the governor), and their return from Egypt to Nazareth (also in Matthew 2:19–23). Representations of the Flight into Egypt may thus include details drawn from these sources, although the core figures for the scene are Joseph leading Mary and the infant on a donkey. They may be guarded by angels, accompanied by the midwife, a servant, or Joseph's son from a previous marriage. Occasionally Joseph is shown riding on the donkey; he may also be depicted walking and carrying the infant on his shoulders, especially in Byzantine examples. The theme appears in early Christian mosaics of the fifth century and frequently in all media throughout the Middle Ages.

Example: Flight into Egypt, c.1120–1132, Autun Cathedral, capital. (Synder, fig. 361)

FLOOD. See DELUGE.

FLORUS OF LYONS. Deacon of Lyons and master of the cathedral school, Florus (c.800–860) was a scholar of the classics and theology and the *author of numerous works including poems, letters, sermons, treatises in defense of

liturgical traditions, commentaries on the Epistles of Saint *Paul, and a revised version of the Martyrology of Bede (see: *Manuscripts).

FLOWERS AND PLANTS, SYMBOLISM OF. Early Christian theologians and medieval encyclopedists, drawing upon biblical references and classical works on natural history, frequently used flowers and plants to signify spiritual and moral concepts, holy persons, and events. Particular flowers and plants in medieval art may thus be associated with specific figures or ideas; however, not all foliage depicted in medieval art is symbolic, and the researcher should beware of overly specific interpretations that are not always applicable.

The botanical world was created by *God on the third day of *Creation and figures importantly in the divine scheme. Along with the specific theological explications mentioned below, plants and flowers may more generally signify the beauty, abundance, and usefulness of nature—worthy of observation and naturalistic depiction—as well as symbolic interpretation. Scenes of Paradise or the *Garden of Eden, for example, may include lavish flora in general, with a few specific symbolic elements (see: *Tree of the Knowledge of Good and Evil, *Tree of Life). The enclosed garden, full of plants and flowers, is a symbol for the Virgin *Mary (see: *Hortus conclusus).

The ROSE and LILY are among the most frequently found symbolic flowers in medieval art, both associated especially with Mary. According to Saint *Ambrose, the roses in the Garden of Eden were thornless but acquired thorns after the fall (see: *Adam and Eve) as a reminder of sin. Because Mary was conceived "without stain of original sin," (see: *Immaculate Conception), she is called the "rose without thorns," which is also a reference to the "rose of Sharon" from the Song of Solomon (2:1). Saint *Bernard compared Mary to a white rose (for her virginity) and a red rose (for her charity). Red roses also symbolize the blood of *Christ and the martyrs. Garlands of roses may be worn by the blessed in *heaven or may symbolize the Rosary (a series of prayers to the Virgin, often credited to Saint *Dominic). Roses are also associated with Saints *Catherine of Siena and *Dorothy. The lover's quest for the symbolic rose is the theme of the lengthy allegorical work of the thirteenth century: the *Roman de la Rose* (see: *Guillaume de Lorris and Jean de Meun), and the rose is also used by *Dante (in the *Commedia*) as a symbol for God's love.

White lilies are also symbolic of purity and feature especially in scenes such as the *Annunciation, where they are often held by the *angel *Gabriel. As a symbol of chastity, lilies are associated with several virgin *saints (*Catherine of Siena, *Clare, and *Scholastica) as well as *Anthony of Padua, Dominic, *Francis, *Thomas Aquinas, and *Joseph. The lily brought by an angel to the Frankish king Clovis (481–511) evolved into the stylized *fleur-de-lys* (emblem of the French monarchy).

Other flowers which may have specific symbolism in medieval art include the dove-shaped COLUMBINE (symbolic of the *Holy Spirit; the customary seven blossoms indicating the *Seven Gifts of the Holy Spirit), the bitter DANDELION

(symbolic of grief and the Passion of Christ), and the VIOLET (symbolic of humility, especially of Mary and Christ).

Many illustrations of plants and flowers are found in medieval herbals (see: *Manuscripts) which derive from classical studies on the identification and medicinal properties of plants (e.g., see: *Dioscurides) but which show a tendency to become increasingly abstract in illustration style. Akin to the interest in allegorical symbolism noted with *Animals, the herbals and their illustrations may include imaginary or fantastic material such as the MANDRAKE with its human-shaped root that utters a lethal shriek when pulled from the ground; this symbolizes the forces of evil.

FLUTE. See MUSICAL INSTRUMENTS, SYMBOLISM OF.

FOLLY. See VICES.

FOOL. Fools and jesters are recognizable in medieval art largely by their costume (a cap with bells and a ridiculously short or multicolored garment) and the objects they carry (a staff or club and a round bread or stone—which they are often depicted attempting to eat). Traditionally the attendants of kings and nobles, jesters are frequently found in scenes of court life and as marginalia in Gothic manuscripts. In illustrated Psalters (see: *Manuscripts) an enlarged initial letter containing an image of a fool is frequently found at Psalm 52 (53) marking one of the eight liturgical sections into which the Psalms were divided for weekly reading and illustrating the opening of the Psalm text: *Dixit insipiens in corde suo: Non est Deus* (''The fool said in his heart, There is no God.'') The club and bread are references to later passages in the Psalm which describe the iniquities of humans (''There is none that do good'') and the evildoers who ''eat up my people as they eat bread.'' In illustrations of, and derived from, the *Psychomachia* of *Prudentius, a fool (personifying the *vice of Folly) is often opposed to the *virtue of Prudence.

Example: Initial with a Fool, Windmill Psalter, late thirteenth century, NY, PML, MS 102, f. 53v. (Calkins, cp. 18)

FORTITUDE. See VIRTUES.

FORTUNE. See WHEEL OF FORTUNE.

FORTY MARTYRS OF SEBASTE. The Forty Martyrs of Sebaste were Christian soldiers of several nationalities, who were martyred c.320 under the persecution of the emperor Licinius. Their *martyrdom took place on a frozen lake outside the city of Sebaste (now Sivas in Turkey) where they were forced to remain naked all night, although tempting baths of hot water were prepared to test their perseverance. The soldiers who did not freeze to death were killed the next day. One defector was replaced by another inspired soldier, keeping the

total at forty. Their cult was extremely popular in Byzantium; they generally appear in art as a group of nude male figures in contorted poses.

Example: Forty Martyrs of Sebaste, late thirteenth century, mosaic icon, Washington, D.C., Dumbarton Oaks. (Hutter, fig. 164)

FOUNTAIN OF LIFE. A number of biblical passages refer to the fountain, well, waters, or rivers of life. Psalm 36 declares that the fountain of life is with the Lord; Psalm 42 describes the soul thirsting for *God; *Ezekiel 47 includes a vision of healing waters; and the closing chapter in the book of Revelation describes Saint *John's vision of a crystal clear river of the water of life issuing from the throne of God and the Lamb. Revelation 7 also describes the Lamb (see: *Agnus Dei*) leading the saved to the living fountains of waters. The healing and redemptive power of these life-giving waters was understood by Christians to refer to *Christ, the Virgin *Mary, *Baptism, paradise, and the Gospels. The Four Rivers of Paradise were thus symbolically connected with the four Gospels. In early Byzantine manuscript illustration, the image of the Fountain of Life was placed with the canon tables (see: *Manuscripts) of concordant passages in the four Gospels, symbolizing the Gospels as the source of eternal life. The image appears in Carolingian manuscripts showing the fountain as a covered, circular structure with columns, set in a landscape, garden, or surrounded by vegetation and symbolic *birds and *animals such as deer, peacocks, and pelicans.

In later medieval art, the image of the redemptive fountain may be shown as a blood-filled basin within which stands the *cross of Christ's *Crucifixion. Blood pouring from his wounds fills the fountain; *angels and *saints may be present, assisting people who climb into and bathe in the basin. (See also: *Mystic Wine Press.)

Example: The Fountain of Life, Gospels of Godescalc, c.781–783, Paris, BN, MS nouv. acq. lat. 1203, f. 3v. (Synder, fig. 247)

FOUR BEASTS. See ANIMALS, SYMBOLISM OF; FOUR EVANGELISTS, TETRAMORPHS.

FOUR CARDINAL VIRTUES. See VIRTUES.

FOUR ELEMENTS. Derived from classical scholarship and imagery, the Four Elements (Earth, Air, Fire, and Water) may be depicted in early Christian and medieval art as personified figures or *animals, chosen to indicate the appropriate properties. They are frequently illustrated in medieval encyclopedias and scientific treatises and may also appear in scenes such as the *Crucifixion, *Last Judgment, *Resurrection of the Dead, and various other apocalyptic contexts.

Terra (Earth) is often personified by a partly clothed female figure who suckles children, snakes, or other animals at her breasts. *Aer* (Air) may be shown as a figure riding on an eagle or accompanied by birds and the *Four Winds. *Ignis*

(Fire) holds a lighted torch, may have a flaming head and ride on a lion. *Aqua* (Water) frequently appears as a river god, pouring water from an urn, accompanied by *fish. The elements may also be abbreviated into symbols: a flaming triangle or flames for fire; a disk, clouds, or light rays for air; a flower or waves for water; and a square, rectangular platform, or plants, for earth. Medieval authors and illustrators frequently connected the Four Elements with numerous other foursomes (*Four Evangelists, *Four Humors, *Four Seasons, Four Rivers of Paradise; see *Garden of Eden) creating grand conceptual, and pictorially diagrammed, schemes of the universe.

Example: Terra, Exultet Roll, c.1075, Rome, BAV, MS Barberini lat. 592. (Snyder, fig. 394)

FOUR EVANGELISTS. The word *evangelist* derives from the Greek for ''proclaimer of the gospel'' and in widest usage refers to preachers and missionaries. Specifically, the Four Evangelists, *Matthew, *Mark, *Luke, and *John are the named authors of the four Gospels, the first four books of the New Testament canon which each recount, with somewhat different details, the life of *Christ. Matthew and John were named among the original twelve *apostles; Mark and Luke were apparently companions of Saint *Paul.

The evangelists are depicted throughout medieval art in several ways. They are often shown as *authors, holding or writing in books or on scrolls, and as such, frequently appear in *manuscripts as prefatory illustrations before their Gospels. The Four Evangelists are regularly accompanied by symbolic *animals which derive from passages in *Ezekiel (1:5–14; his vision of four beasts; see also: *Tetramorphs*) and the *Apocalypse (4:6–8; the vision of the beasts around the throne of *God). Matthew is accompanied, or represented by, the man or *angel (his Gospel begins with the genealogy of Christ); the symbol of Mark is the lion (his Gospel begins with a description of the voice crying in the wilderness); Luke is represented by an ox (his Gospel begins with an account of sacrifice); the symbol for John is the eagle (which flies close to heaven; this refers to John's visions). The evangelists may be shown as human figures accompanied by these animals or simply the animals themselves may be represented. A variant type depicts the evangelists as animal-headed human authors.

Example: Four Evangelists, Aachen Gospels, c.810, Aachen, Cathedral Treasury, f. 13. (Synder, fig. 251)

FOUR HORSEMEN OF THE APOCALYPSE. See APOCALYPSE.

FOUR HUMORS. The theory that human temperament and behavior are governed by bodily fluids and planetary influences was developed in the classical period and accepted and elaborated upon by medieval scientists and encyclopedists. The four fundamental, dominating fluids within the human body were identified as: *Phlegm* (causing a phlegmatic or sluggish temperament), *Blood* (causing a sanguine or optimistic temperament), *Red Bile* (or *Choler,* causing a

choleric, or excitable, temperament), and *Black Bile* (causing a melancholic or lazy temperament). The Four Humors were also linked with the *Four Elements, the planets, *zodiac signs, and specific *animals with shared characteristics (e.g., Phlegmatic/Water/Lamb, Sanguine/Air/Ape, Choleric/Fire/Lion, Melancholic/Earth/Pig). The systems are often illustrated in medieval works dealing with science, medicine, and astrology and also find pictorial form in human personifications of the various temperaments, accompanied by the appropriate animals and carrying attributes indicative of their natures (e.g., the choleric holds a sword, the melancholic has a crutch).

Example: Four Temperaments, Calendrier des bergers, 1491, Paris, BMaz, Incunables 584 (617), f. c iiiiv. (Mâle, LMA, fig. 166)

FOUR LIVING CREATURES. See ANIMALS, SYMBOLISM OF; FOUR EVANGELISTS; TETRAMORPHS.

FOUR RIVERS OF PARADISE. See FOUNTAIN OF LIFE; GARDEN OF EDEN.

FOUR SEASONS. The four seasons of the year are represented somewhat less frequently in medieval art than the full yearly cycle (see: *Labors of the Months; *Zodiac) though examples do appear in illustrated scientific treatises, encyclopedias, and sculptural programs on church facades. Largely based upon antique prototypes, the seasons may be personified by human figures bearing appropriate attributes. Spring *(Ver)* wearing a short robe, may carry plants or flowers; Summer *(Aestas)* may be unclothed and carrying a basket of produce, a sickle, or other tool for harvesting; Fall *(Autumnus)*, more warmly dressed, may be shown with a basket of grapes or holding plants; Winter *(Hiemps)* may be depicted indoors, warming his feet or hands before a fire or brazier. The four seasons are frequently connected with the *Four Elements, *Four Humors, and *Four Winds in scientific diagrams of the world and cosmos.

Example: The Cycle of the Year, Miscellany, 1138–1147, Stuttgart, WLB, MS hist. fol. 415, f. 17v. (Dodwell, fig. 292)

FOUR TEMPERAMENTS. See FOUR HUMORS.

FOUR WINDS. Although classical and medieval authors identified and named up to twelve winds (corresponding with directional points, *zodiac signs, the seasons and elements) in scientific treatises and encyclopedias, the four major winds are frequently singled out for pictorial depiction. (*Zephyrus,* west; *Boreas,* north; *Notos,* south; *Euros,* east). Following antique traditions, winds are generally shown in medieval art as small disembodied heads, often with wings, with their cheeks puffed, blowing out visible air or breath. *Angels are often depicted holding the winds (grasping the little heads in their arms or elevating them in

chalices) in illustrations of the *Apocalypse, following the passage of Rev. 7: 1, where four angels restrain the four winds from blowing on the earth or sea.

Example: Angels with the Four Winds, Apocalypse, c.1230, Cambridge, TC, MS R.16.2, f. 7. (Robb, fig. 147)

FOURTEEN HOLY HELPERS. Also known as the fourteen "auxiliary" *saints, the Holy Helpers are a group of saints especially invoked for their assistance against disease and illness as well as their intercession for salvation upon *death. Their veneration, which originated in Germany, dates from the late thirteenth century but was especially popular during the fourteenth-century period of the Black Death (bubonic plague). Their names vary somewhat, but the list includes: Saints Acacius, *Barbara, *Blaise, *Catherine of Alexandria, *Christopher, Cyriacus, *Denis, *Erasmus, *Eustace, *George, *Giles, *Margaret of Antioch, *Pantaleon, and Vitus. Alternates include: Saints *Anthony, Leonard, *Nicholas, *Sebastian, and *Roch. They may be represented as a group, especially on painted altarpieces, often placed around the Virgin *Mary, and identifiable by their specific attributes (see individual entries).

FOY, SAINT. Martyred at age twelve, Saint Foy (or Faith, d. c.303) was roasted on a gridiron and later beheaded. Her *relics were translated to Conques in the ninth century, and the church of Sainte-Foy became an important *pilgrimage center during the Romanesque and Gothic periods, located on one of the main routes to Compostela. Apart from the magnificent reliquary statue at Conques, scenes from the life, *martyrdom, and numerous posthumous *miracles of Saint Foy appear especially in Romanesque and Gothic sculpture and stained glass in France and England. She is often depicted with the gridiron or with the dove, which flew down during her martyrdom to quench the flames with dew from *heaven.

Example: Sainte Foy, eleventh-twelfth century, reliquary, Conques, Cathedral Treasury. (Snyder, cp. 43)

FRANCIS OF ASSISI, SAINT. Founder of the Franciscan Order (Friars Minor), Francis of Assisi (1182–1226), son of a wealthy Italian merchant, spent his youth in business and military service. After being captured in battle, held for a year as a prisoner of war, he returned to Assisi in ill health in 1205 and received a vision of *Christ, who appeared to him in church and instructed him to "Repair my home, which is in disrepair." Francis renounced his inheritance, became a *pilgrim and a beggar, raised money to rebuild the church of San Damiano in Assisi, continued to live in poverty, and attracted followers who formed a community of mendicants. Pope Innocent III sanctioned Francis's work in c.1210. In 1212, he established, with Saint *Clare, the order of Poor Clares, then went on a *pilgrimage and missionary journey to Egypt and the Holy Land and returned to find the number of Franciscans enormously expanded. In 1223 the rule was officially approved by Pope Honorius III, and the Franciscan Order

continued to expand through the later medieval period. Francis was canonized two years after his *death and became immediately popular in art; detailed cycles of scenes from his life are found as early as ten years after his death.

As a single figure, Francis is recognizable by his brown robes (the Franciscan habit) and rope belt with three knots symbolizing the vows of poverty, chastity, and obedience. He may hold a crucifix (indicating his inspirational vision of Christ as well as his devotion to *prayer) or a lily (symbol of purity). Early stories of his life were collected and expanded in his authorized biography, composed by Saint *Bonaventura in the mid-thirteenth century. Among the many scenes from his life found in cycles from the early thirteenth century onward are: his vision of Christ speaking to him from a crucifix, his renunciation of worldly goods, his "marriage" to "Lady Poverty," Pope Innocent III's vision of Francis supporting the crumbling church, his charity in dividing his cloak with a beggar, his apocryphal meeting with Saint *Dominic, his *preaching to the birds, his pact with the wolf of Gubbio, his being tested by walking through fire before the Egyptian sultan, his construction of a *Nativity scene (Christmas crib) at Greccio, receiving the *stigmata, his death, funeral, the vision reported of his *ascension to *heaven in a fiery chariot, and various posthumous *miracles.

Example: Saint Francis Preaching to the Birds, c.1325–1330, stained glass, Konigsfelden. (Grodecki, fig. 198)

FRERE LORENS. The Dominican Frère Lorens (or Laurent) was the confessor of King Philip III of France for whom he composed, in 1279, the *Somme le Roi,* a moral treatise on the Ten Commandments and the *virtues and *vices. A number of copies of this work survive ranging in date from the thirteenth through fifteenth centuries. The treatise was conceived with a cycle of fifteen illustrations (which vary slightly between copies) covering Old Testament scenes from the lives of *Moses, *Abraham, *Isaac, and *Joseph, as well as personified figures of virtues and vices.

Example: Somme le Roi, c.1373, Paris, BN, MS fr. 14939, f. 5. (Alexander, fig. 201)

FRUIT AND TREES, SYMBOLISM OF. Similar to the *Flowers and Plants depicted in medieval art, fruit and trees may have specific symbolism (theological connotations or associations with particular holy figures), or they may be more abstract, even decorative, indications of the beauty and bounty of *God's *Creation.

The trees and fruit growing so abundantly in the *Garden of Eden are unidentified apart from the *Tree of Life and the *Tree of the Knowledge of Good and Evil. Eating the forbidden fruit from the latter caused *Adam and Eve to be expelled from the garden. Although not so named in the Bible, this fruit is traditionally represented as an APPLE (perhaps because the Latin word for apple, *malum,* also means "evil"). When held by Adam or Eve, or in the mouth of a

serpent, the apple signifies sin, but in the hands of *Christ or the Virgin *Mary, the apple signifies salvation (see also: *Typology).

Sometimes, the Tree of the Knowledge of Good and Evil is represented as a FIG tree; Adam and Eve covered themselves with fig leaves (Genesis 3:7) and the many-seeded fig fruit may be a symbol both of lust and fertility. Multiseeded POMEGRANATES also symbolize fertility, as well as the Christian *souls safely contained in the community of the *church. The bright red seeds of the pomegranate may also symbolize blood (the sacrifice of Christ, blood of the martyrs).

OAKS, OLIVE, AND PALM trees all may have symbolic value. The sturdy OAK signifies strength, faith, and endurance (although it was also sacred to the Druids and hence may be shown cut down by Saint *Boniface). The OLIVE branch borne by a dove back to *Noah represents peace (signalling the end of God's wrath displayed in the *Deluge), and olive branches may be carried by *Gabriel in scenes of the *Annunciation. PALM branches were thrown down in the road upon Christ's *Entry into Jerusalem, and are carried by martyrs, symbolic of victory over *death (the latter an adaptation of the ancient classical use of palms in military victory processions). A palm tree sheltered and nourished the *Holy Family on their *Flight into Egypt, and clothing of palm fronds may be worn by desert *saints such as *Paul the Hermit and *Onuphrius.

The ALMOND symbolizes God's favor (from the miraculous flowering rod of *Aaron indicating his chosen status in Numbers 17:1–8) and hence became a symbol of Mary, also favored by God. Almond-shaped body *haloes are known as mandorlas. Dark CYPRESS trees are associated with death and cemeteries, and in general, withered and barren trees signify sin, evil, and death, while healthy trees represent life and redemption.

GRAPES and *vines are among the most frequent and important symbols in early Christian and medieval art. Often used in the Old Testament as symbols of God's relationship with the Israelites, the vine became the emblem of Christ who, in *John 15:1, referred to himself as the "true vine." The infant Jesus may thus be depicted with a bunch of grapes, this also signifying the wine symbolic of Christ's blood partaken at the *Last Supper. Figures or *angels harvesting grapes may symbolize the *Last Judgment as described in the *Apocalypse where a great winepress signifies God's anger at injustice (see also: *Mystic Wine Press, *Fountain of Life). The *Cross and Tree of Life may be represented as, or with, grape vines.

In addition to the theological interpretations above, trees and fruit are represented in medieval herbals (see: *Manuscripts) founded upon such classical works of natural history as *Dioscurides' *De materica medica*.

G

GABRIEL, SAINT. The *angel of the *Annunciation and one of the seven archangels, Gabriel brought advance news to Zacharias about the birth of *John the Baptist (*Luke 1:11–19) and announced to the Virgin *Mary that she would give birth to Jesus (Luke 1:26–38). New Testament *Apocrypha have Gabriel announcing the birth of Mary to *Joachim and *Anne as well. In the Old Testament, Gabriel assisted *Daniel with interpreting his visions (Daniel 8 and 9). In art, Gabriel is winged, has a *halo, and often bears a staff, lily, or scroll with the greeting from Luke 1:28, *Ave Maria* (or *Ave Maria gratia plena Dominus tecum* ("Greetings Mary most favored, the Lord is with you"). The archangel's hand is often raised toward Mary in a gesture of blessing (see: *Benediction). Gabriel is found most frequently in scenes of the Annunciation to Mary, a subject which appears in early Christian painting, sculpture, and mosaics, and consistently throughout Byzantine and western medieval art.

Example: The Annunciation, Codex Egberti, 977–993, Trier, SB, Cod. 24, f. 9. (Synder, fig. 292)

GARDEN OF EDEN. In the account of *Creation found in Genesis 2, *God is described as planting a garden (or "paradise," from Greek: *paradeisos,* "enclosed park") eastward in Eden. In this garden, God placed *Adam and all the newly created animals which he had Adam name (see: *Naming of the Animals). God also created a woman from one of Adam's ribs to be Adam's wife; Adam eventually named her Eve. The garden is described as full of beautiful and fruit-bearing trees, watered by a river which divides into four branches. These Four Rivers of Paradise are named: Pishon, Gihon, Tigris, and Euphrates. Two trees in the garden are mentioned specifically: the *Tree of Life and the *Tree of the Knowledge of Good and Evil. God forbade Adam to eat fruit from the latter tree, warning him that eating this fruit would cause Adam to die. In Genesis 3, a subtle serpent told Eve that, in spite of God's warning, they would not die

from eating this forbidden fruit but rather would become wise, godlike. Both Adam and Eve ate the fruit, became ashamed of their newly noticed nakedness, and hid from God, who then cursed the serpent and sent Adam and Eve out of the garden, henceforth guarded by a cherubim (see: *Angels) and a flaming sword. Other references to the luxuriant and fertile Garden of Eden are found in *Isaiah 51:3, *Ezekiel 28:13, 31:9, and Joel 2:3.

The Garden of Eden features frequently in early Christian and medieval illustrations of the Genesis narratives, either as a minimally indicated landscape setting or a more detailed background of trees, plants, animals, and flowers. The personified figures of the Four Rivers of Paradise, which medieval theologians connected with the four Gospels and the *Four Evangelists, are also found extracted from the narrative context (e.g., in Romanesque and Gothic sculpture) or, as first seen in early Christian art, as four streams flowing out of a mound upon which stands the Lamb of God (see: *Agnus Dei).

The symbolism of the Garden of Eden as a place of perfect harmony before it was marred by human disobedience is also reflected in the theological and pictorial themes of the *Hortus conclusus (the sinless Virgin *Mary as the "enclosed garden"), the *Heavenly Jerusalem (the future paradise of the *Apocalypse), and *heaven itself, which, especially in later medieval art, may be depicted as a beautiful gardenlike setting.

Example: Genesis Scenes, Alciun Bible, c.840, Bamberg, SB, MS Misc. class. Bibl. 1, f. 7v. (Robb, fig. 65)

GASTON DE FOIX. See PHEBUS, GASTON.

GATHERING OF THE MANNA. As described in Exodus 16:11–36 (and Numbers 11:6–9), in the second month of the Israelites' journey out of Egypt, when they complained to *Moses and *Aaron of their hunger, *God miraculously provided them with a breadlike food substance which they called *manna*. It appeared to have fallen from the sky like dew, was white and round, and tasted like "wafers made with honey." This miraculous food was continuously provided and saved the Israelites from hunger in the wilderness for forty years. Various episodes are illustrated in art: the *manna* raining down from *heaven, the Israelites collecting it from the ground, and placing it in pots. The subjects appear in early catacomb paintings as symbols of salvation and are found in Romanesque sculpture and metalwork (e.g., in typological programs, connected with the sacrament of the Eucharist: see *Last Supper, *Seven Sacraments).

Example: Gathering of the Manna, twelfth century, Ripoll, Monastery of Santa Maria, facade relief sculpture. (Künstler, pl. 79)

GEMINI. See ZODIAC.

GENEVIEVE, SAINT. Patron *saint of Paris, Geneviève (c.422–c.500) became a nun at age fifteen, having expressed (at age seven) her desire to do so to Saint

Germanus of Auxerre. She was noted for her austerity, prophetic gifts, and courageous actions on behalf of the imprisoned citizens of Paris during a seige by the Franks. Prayers to Saint Geneviève were credited with having stopped an epidemic in the city in 1129. Episodes from her life depicted in medieval art derive from several later versions of her legend and include scenes of the saint as a young shepherdess, restoring the eyesight of her mother, and an incident in which the *Devil repeatedly attempted to scare her by blowing out her candle when she was praying at night in church but an *angel kept relighting the candle. Hence she may be depicted with candle in hand, an angel on her shoulder.

Example: Saint Geneviève, c.1220–1230, from the abbey church of Sainte-Geneviève, west portal, Paris, Louvre. (Sauerländer, fig. 158)

GEOMETRY. See SEVEN LIBERAL ARTS.

GEORGE, SAINT. The exceedingly popular soldier *saint, George, may have been martyred in Palestine or Nicomedia in the mid-third or early fourth century. Legends from at least the sixth century were elaborated throughout the Middle Ages, reaching detailed form in the *Golden Legend*. This source describes him as a third-century warrior from Cappadocia whose special adventure involved subduing a dragon that had been terrorizing townspeople in Sylene (Libya). He rescued the king's daughter (whose turn had come to be fed to the dragon), captured and tamed the dragon, and later killed it, as promised, after 15,000 townspeople converted to Christianity. Accounts of his later tortures and *martyrdom follow; he refused to worship the emperor Diocletian and was dragged by wild horses, roasted in a bronze bull, and eventually beheaded. The cult of Saint George grew significantly during the Crusades; he was credited for the successful seige of Antioch (1089), and he was named patron saint of England in the mid-thirteenth century.

A very popular figure in both Byzantine and western art, Saint George is typically portrayed riding on a white horse or as a standing figure, dressed as a soldier. He may be piercing a dragon with a lance or spear, or his horse may be trampling upon the dragon. Narrative cycles include the princess (leading the tamed dragon) and episodes of George's tortures and martyrdom.

Example: Legend of Saint George, Bedford Breviary, c.1424–1435, Paris, BN, MS lat. 17294, f. 447v. (Porcher, pl. LXXII)

GERVASE AND PROTASE, SAINTS. The *relics of the martyred twin brothers, Gervase and Protase (second century?), were discovered in Milan in c.386 by Saint *Ambrose, who had been inspired by a vision. Ambrose established their cult by translating their relics to a newly constructed basilica and later requesting to be buried beside them. Accounts of numerous *miracles (especially healings and *exorcisms) were recorded at their shrine, and their cult became widespread, especially in Italy and France, in the later Middle Ages. Legends tell that they were scourged and decapitated under the direction of the emperor

Nero for refusing to worship pagan gods. An alternate account describes them as the sons of Saint Vitalis of Ravenna; they became hermits and were martyred for refusing to serve in the military. They are found in art from the sixth century onward, frequently shown with the instruments of their tortures or in scenes of their *martyrdom.

Example: The Scourging of Saint Gervase, c.1254, stained glass, Le Mans Cathedral. (Grodecki, fig. 122)

GETHSEMANE. See AGONY IN THE GARDEN.

GIDEON. Gideon appears in the Old Testament book of Judges (chapters 6–8) and is mentioned in the New Testament (Hebrews 11:32) as a man of faith who both tested and was tested by *God. He was visited by an *angel, called upon to save the Israelites from the Bedouin Midianites, and succeeded in leading an army which drove out the Midianites. While carrying out these deeds, he several times was offered, or asked God for, proof of God's support. Thus God, at Gideon's request, caused a fleece laid on the ground to become covered with dew while the ground around it remained dry and also caused the fleece to remain dry while the ground around it became damp with dew. When preparing for battle against the Midianites, God sorted out the appropriate 300 soldiers for Gideon's army in a test involving the men's way of drinking, or lapping, water at a stream. Although victorious, Gideon later set up an *idol and caused apostasy in his city. Early Christian and medieval theologians linked the (meat and bread) sacrifice of Gideon (Judges 6:19–21) to the Eucharist, the sorting of his army at the stream to a type of *Baptism, and the miraculously dew-covered fleece to the incarnation of *Christ and the virginity of *Mary. Gideon's fleece may thus be found in medieval art accompanying scenes of the *Annunciation, *Nativity, and *Tree of Jesse. Other scenes, in manuscripts and sculpture, include his visit by the angel, his destruction of the altar to Baal, his preparing his men for battle, and the victorious battle.

Example: Gideon Scenes, Admont Bible, c.1140, Vienna, ON, N.S. Cod. 2701, f. 94v. (Cahn, fig. 117)

GIFTS OF THE HOLY SPIRIT. See SEVEN GIFTS OF THE HOLY SPIRIT.

GILBERT DE LA POREE. The theologian Gilbert of Poitiers (c.1075–1154) was bishop of Poitiers from 1142 until his *death. After studies at Poitiers and Chartres, he taught at Chartres and Paris, adopting methods of logic in his approach to theology. Saint *Bernard of Clairvaux accused him of heresy, but he was tried and cleared of any offense at the Synod of Reims in 1148. His

commentaries on *Boethius and interpretations of *Aristotle were especially influential textbooks, often copied throughout the medieval period.

Example: Glossed Psalter, c.1160, Oxford, BL, MS Auct. D.4.6, f. 91. (De Hamel, fig. 78)

GILES, SAINT. One of the most popular medieval *saints whose life is first described in legends of the tenth century, Saint Giles (Gilles, or Aegidius) was born in Athens but moved to France to avoid the fame he had achieved through his generosity and miraculous deeds. After studying with Saint Caesarius of Arles (d.542), he became a hermit, lived in the forest near Nimes, and later founded a monastery near Arles. Giles died c.710. Scenes from his life which appear in medieval art (especially from the twelfth century following) include his giving his cloak to and hence healing a sick beggar, his being wounded while protecting a deer from the arrows of the Visigothic King Wamba (this animal had nourished the saint with its milk during his sojourn as a hermit), and his officiating at Mass when *Charlemagne (d.814) was present. An unconfessed sin of Charlemagne appeared to the saint in a vision, written on a tablet or a scroll held by an *angel. Saint Giles also appears in art garbed as a Benedictine monk, holding a deer in his arms and an arrow in his hand.

Example: Saint Giles Giving His Cloak to a Beggar, 1125–1150, fresco, Saint-Aignan-sur-Cher, crypt. (Dodwell, fig. 236)

GILLES, SAINT. See GILES, SAINT.

GIVING OF THE KEYS TO SAINT PETER. See PETER, SAINT.

GIVING OF THE LAW. See TRADITIO LEGIS.

GLORY. See HALO.

GLUTTONY. See VICES.

GOAT. See ANIMALS, SYMBOLISM OF; ZODIAC.

GOD THE FATHER. For Christians, God the Father is the first person of the *Trinity, and the "Lord" (rendered as Yahweh or Jehovah) from Jewish tradition who features throughout the Old Testament as creator, lawgiver, and sovereign, true divinity. The *Creation narratives of Genesis 1–3 state that God created humans in his own image and describe *Adam and Eve hearing the sound of the Lord God as he was walking in the *Garden of Eden. Hence, God is traditionally depicted in Christian art as a human: an elderly man in flowing robes with white hair and a beard (see also: *Ancient of Days) or as a younger male figure (more properly *Christ, the second person of the Trinity). The opening words of *John's Gospel state the original coexistence of both God and "the

Word'' (the Father and Son) which may partially explain the Christian predilection to depict God the Father as Christ, or, with the cruciform *halo traditionally reserved for Christ, in illustrations of both Old and New Testament narratives, including scenes of Creation.

The hand of God emerging from clouds or *heaven is often substituted for the full figure of God and frequently appears in numerous pictorial contexts requiring God's presence (e.g., appearing in the sky during the *Ascension of Christ). God's presence may also be symbolized in manifestations such as the burning bush on *Mount Sinai from which he spoke to *Moses. (See also: *Theophany.)

In later medieval art, God the Father may be represented wearing a priestly hat (like a mitre), a crown, or a five-tiered tiara (expanding upon the papal three-tiered tiara), and he may hold a globe inscribed or topped with a *cross. The third person of the Trinity, the *Holy Spirit (in the form of a dove) frequently accompanies or represents God in images of the *Annunciation to the Virgin *Mary and the *Baptism of Jesus. God the Father may also be shown in scenes of the *Coronation of the Virgin, and, from the twelfth century onward, may appear in images of the *Crucifixion (behind or supporting the cross over which the dove hovers, an image known as the ''Throne of Grace''). In illustrations of the *Apocalypse and *Last Judgment, the awesome figure of the enthroned judge, the ''Son of Man,'' holding a book, with a sword projecting from his mouth, surrounded by stars and candlesticks, may combine the image of Christ with the Ancient of Days to dramatic effect. (See also: *Quinity.)

Example: The Lamentation, Rohan Hours, c.1418–1425, Paris, BN, MS lat. 9471, f. 135. (Thomas, pl. 33)

GOLDEN LEGEND. The *Golden Legend (Legenda aurea)* is the title of an extremely popular compendium of *saints' lives and other religious stories arranged for reading according to the church calendar. It was composed, c.1255–1266, by the Italian Dominican Jacobus de Voragine (c.1230–1298), archbishop of Genoa from 1292. Jacobus was also the author of numerous sermons, a chronicle of the history of Genoa, and a treatise on the Dominican order. His most famous work, the *Golden Legend,* was translated into a variety of vernacular languages. This medieval ''best-seller'' was copied, revised, condensed, and expanded through the Middle Ages, and appeared in copious printed versions from the mid-fifteenth century, falling somewhat out of favor during the later Renaissance period. Frequently illustrated in manuscripts and printed editions, the text and pictures were of profound influence on, and often used as sources for, much later medieval literature and artistic iconography.

Example: Saint Giles with the Deer, Legenda aurea, early fourteenth century, San Marino, Huntington Library, MS HM 3027, f. 118v. (Alexander, fig. 94)

GOLGOTHA. See CALVARY; CRUCIFIXION.

GOLIATH. The huge and mighty Philistine warrior Goliath features in 1 Samuel 17 as a formidable opponent of the Israelite army during the reign of King *Saul. He daily challenged the Israelites to send forth a man to engage him in single combat, but none would dare until the *shepherd boy (and future king) *David heard his threats and went out to fight Goliath armed only with five smooth stones and a sling. David was able to topple Goliath with a single slingshot and then cut off Goliath's head with the giant's own sword. David collected Goliath's armor and brought the severed head back to Jerusalem, where the young shepherd then became an even more favored (but also feared) member of the court of King Saul.

The combat with Goliath is one of the most frequently represented scenes from the life of David and can be found in art from the early Christian through late Gothic period both as an independent image and in pictorial narrative cycles. The subject appears in third-century frescoes, fifth-century sculptures, seventh-century metalwork, with great frequency in western medieval and Byzantine manuscript illustration and in other media throughout the medieval period. In early Christian examples, Goliath will often appear dressed as a Roman soldier, while later examples may show him with the costume and arms of a medieval knight. The disparity in size between the two opponents is often emphasized; the imposing Goliath in full armor towers over the youth, who nevertheless defeats him. Sequential narrative treatments will frequently include the decapitation scene as well as the preceding combat in which David will be shown slinging a stone at the menacing giant. Sometimes an *angel or the hand of *God are shown, symbolizing David's faith and God's assistance in this deed. David's triumphal return to Jerusalem is also illustrated; he carries the head of Goliath and is greeted by joyful women. As an image of triumph and faith in God, the subject was interpreted by Christian theologians as the victory of *Christ over evil; David's triumphal return to Jerusalem is seen as a prefiguration of Christ's *Entry into Jerusalem.

Example: Combat of David and Goliath, Paris Psalter, tenth century, Paris, BN, MS gr. 139, f. 4v. (Synder, fig. 163)

GOMORRAH. See SODOM AND GOMORRAH.

GOOD SAMARITAN. Jesus' parable of the Good Samaritan is recounted in *Luke 10:29–37. He was responding to a lawyer who had asked for a definition of ''neighbor,'' so as to follow the commandment of loving one's neighbor as oneself. Although the *Jews who worshipped in Jerusalem were hostile toward the Samaritans, the Samaritan in Jesus' story assisted a man who had been robbed and beaten while traveling from Jerusalem to Jericho. A priest and Levite had previously chosen to disregard the injured man. In contrast, the charity and compassion shown by the Samaritan was a model of acting as a neighbor. Medieval authors expanded the interpretation to describe *Christ as the Good Samaritan who saves and redeems humankind when Judaism fails to do so. Hence,

the Good Samaritan is often shown as Christ, assisting the injured traveler, bathing and bandaging his wounds, taking him to an inn, and paying the innkeeper for his food and lodging. *Angels may also be present. The subject was popular throughout early Christian and medieval art.

Example: Parable of the Good Samaritan, Rossano Gospels, mid-sixth century, Rossano, Archiepiscopal Treasury, f. 7v. (Robb, fig. 10)

GOOD SHEPHERD. The motif of the *shepherd as leader and protector occurs frequently in the Old Testament, often used to symbolize *God. The imagery was also applied to political (especially royal) leaders, not always with positive connotations (e.g., *Ezekiel 34 describes the disastrous consequences wrought by bad shepherds, poor leaders). In the New Testament (*Luke 15:3–7 and *John 10:1–18), Jesus used the image of the Good Shepherd, who diligently watches over and leads his flock and who carefully retrieves lost sheep. Jesus described himself as the Good Shepherd (John 10:11, 14), which provided inspiration for the subject's popularity in early Christian art. Jesus as Good Shepherd may appear as a youthful, beardless, seated figure, surrounded by sheep (representing members of the Christian flock), or he may appear as a standing figure carrying a sheep on his shoulders (representing a strayed sinner, rescued). Both types appear in early Christian sculpture (sarcophagi, statuettes), in frescoes and mosaics. Classical precedents in general bucolic or pastoral imagery as well as specific prototypes (Orpheus among the *animals, Mercury as protector of flocks) are often cited in the development of this symbolism. Other biblical references include: Psalm 23 (''the Lord is my shepherd''), *Isaiah 40: 11, and Hebrews 13:20.

Example: The Good Shepherd, c.425–450, mosaic, Ravenna, Mausoleum of Galla Placidia. (Synder, fig. 135)

GOSPELS. See FOUR EVANGELISTS; MANUSCRIPTS.

GRADUAL. See MANUSCRIPTS.

GRAMMAR. See SEVEN LIBERAL ARTS.

GRAPE. See FRUIT AND TREES, SYMBOLISM OF; VINE, VINEYARD.

GRATIAN. Very little is known about the life of the monk Gratian (d. c.1179), the ''Father of Canon Law,'' who taught in Bologna and, in the 1140s, created the basic textbook for medieval law: the *Decretum* or *Concordantia discordantium canonum* (Concordance of Disconcordant Canons). The text contains Gratian's commentaries on a collection of approximately 4,000 quotes from papal letters (decretals), council decrees, and patristic writings. It is arranged systematically by subject headings and is divided into three sections: (1) the sources of canon law and the offices of the clergy; (2) hypothetical cases of special

difficulty; and (3) laws relevant to church rituals and sacraments. The work became immensely popular and was further glossed and commented on. Illustrated copies will include *author portraits and scenes of legal councils and disputes taking place, accompanying each of the thirty-six cases (*causae*) in the second section of the book.

Example: Decretum Gratiani, early fourteenth century, Paris, BN, MS lat. 3988, f. 69. (Robb, fig. 182)

GREED. See VICES.

GREGORY I THE GREAT, SAINT. ''Father of the medieval papacy'' and a *Doctor of the Church, the Roman-born aristocrat Gregory (c.540–604) was elected pope by acclamation in 590. He had previously held positions in the Roman civil government and had been a deacon and papal ambassador to Constantinople. He had founded seven monasteries and lived as a monk and later abbot of Saint Andrew's in Rome. His importance rests primarily on his effective administration, keen political sense, and scholarship; he reorganized and greatly increased the power of the papacy during a period that was extremely troubled, politically and economically. He undertook defense and management of the city of Rome especially against the invading Lombards. Concerned with education and an ardent supporter of monasticism, Gregory is also responsible for the mission to England of Saint *Augustine (of Canterbury). His copious writings include 854 letters (the *Registrum Gregorii*), numerous homilies and biblical commentaries, the *Liber regulae pastoralis* (*Pastoral Care,* c.591, a guidebook for bishops), the *Dialogues* (c.593, a collection of stories about Italian *saints, including Saint *Benedict), and the *Moralia in Job* (a long, somewhat mystical treatise on the book of *Job, emphasizing moral lessons for the edification of monks). He developed the concept of purgatory, promoted the veneration of *relics, made important changes in the liturgy, claimed papal supremacy based on the Petrine doctrine (see: Saint *Peter), and is credited with developing the Gregorian Chant. Gregory's writings were copied and often illustrated in manuscripts throughout the medieval period.

His biography was written in the eighth century by Paul the Deacon and later elaborated in the *Golden Legend,* from which sources derive most of the pictorial narratives featuring Gregory. One of the most common is Gregory's representation as an *author working in his study while his secretary secretly observes him through a curtain and notes the dove of the *Holy Spirit perched on Gregory's shoulder, inspiring his writing. This image first appears in the ninth century and is often found as a frontispiece in manuscripts of Gregory's works, in other liturgical and hagiographic manuscripts, and in ivory and sculpture. The odd story of Gregory's prayers releasing the *soul of the emperor Trajan from the flames of purgatory is told in the *Golden Legend*; hence a small naked figure of the emperor may be seen with Gregory. Other legends include various *miracles (*Christ appeared as the thirteenth guest in a supper Gregory

offered to the poor; his prayers released the soul of a disobedient monk from purgatory). The visionary appearance of Christ during the *Mass of Saint Gregory was also a popular image in later medieval art. Gregory often appears with the other Latin Doctors, wearing papal vestments and tiara, and holding a crozier.

Example: Pope Gregory the Great, Registrum Gregorii, c.977–993, Trier, SB. (Zarnecki, cp. 27)

GREGORY OF NAZIANZUS, SAINT. Gregory "The Theologian" (329–389), son of the bishop of Nazianzus in Cappadocia, studied in Athens, where he became friends with Saint *Basil and with whom he lived a solitary life as a monk for several years. Ordained as a priest c.362, in c.372 he was appointed bishop of Sasima (a village in Cappadocia that he never visited). He assisted his father in Nazianzus and was called to Constantinople in 379 where he was appointed bishop (381) but resigned before the year's end. A scholarly contemplative, Gregory's fame rests in his *preaching and teaching, which were influential in combating heresy. His writings include a large collection of poems, letters and, most significantly, his theological orations (or sermons) from his years in Constantinople. Numerous illustrated copies of these sermons were produced in the Byzantine world; one richly illustrated example from the late ninth century produced for the emperor Basil I contains forty-six pictures of biblical scenes and *saints' lives. When Gregory appears in art, he is often accompanied by Saints Basil and *John Chrysostom (together they are the three *Doctors of the Byzantine church recognized in the medieval period).

Example: Sermons of Gregory of Nazianzus, c.880–886, Paris, BN, MS gr. 510, f.409v. (Robb, fig. 19)

GRIFFIN. See ANIMALS, SYMBOLISM OF.

GROTESQUES. Grotesques are peculiar, deformed, contorted, exaggerated, or hybrid forms that appear especially in medieval painting and sculpture. Found within and creating decorated initials in manuscripts of the Carolingian and Romanesque periods, they were especially popular as marginalia in Gothic manuscripts from the thirteenth century onward. Grotesques are also often found carved beneath wooden choir seats (misericords). They may be comic in appearance (drolleries) or disturbing monstrosities with demonic appearances. Sometimes silly, erotic, or scatological, grotesques may cavort, combat each other, or convey cynical pictorial comments on church or society. The combination of human and animal elements was common, as well as fantastic beasts combining parts of several different *animals. Saint *Bernard of Clairvaux complained about the distracting nature of these seemingly pointless forms in Romanesque sculpture, although some may have origins in or meanings derived from bestiaries (see: *Manuscripts) or the popular medieval travel books de-

scribing the monstrous races or marvels of the world. Gargoyles (drainspouts) on the exteriors of cathedrals often have grotesque, dragonlike, or hybrid forms.

Example: Bible of William of Devon, c.1250, London, BL, Royal MS 1.D.I, f. 5. (Robb, fig. 152)

GUILLAUME DE DEGUILEVILLE. The Cistercian monk Guillaume de Deguileville (c.1294–c.1358) composed several influential works in French during the early fourteenth century, among the most popular of which was *Le Pèlerinage de la vie humaine (The Pilgrimage of Human Life)*. The story is a lengthy allegorical narrative of the *pilgrim's dream journey to the heavenly city of Jerusalem and his encounters with a series of personified figures of both positive and negative characteristics (e.g., Grace, Reason, Idleness, Avarice). Composed for and appreciated by a wide audience, the work was extremely popular, translated into several languages, and frequently illustrated throughout the fourteenth and fifteenth centuries.

Example: The Pilgrim and Grace Dieu, Pèlerinage, early fifteenth century, Paris, BN, MS fr. 829, f. 39. (Alexander, fig. 84)

GUILLAUME DE LORRIS AND JEAN DE MEUN, *ROMAN DE LA ROSE.* The immensely popular thirteenth-century French romance the *Roman de la Rose* is a lengthy allegorical poem of over 20,000 lines which tells the story of a lover searching for his heart's desire: the rose. The lover's quest and adventures, phrased in the form of a dream-vision, are described in a series of symbolic venues (e.g., the Garden of Delight) and encounters with personified concepts, both positive (e.g., Fair Welcome, Youth, Happiness) and negative (e.g., Slander, Shame, Jealousy). While the general concept of the allegory and certain themes and characters derive from earlier authors (especially Ovid), the work is a brilliant example of a medieval, courtly romance.

The work was composed by two writers; Guillaume de Lorris began the work probably c.1230–1235 but left it unfinished after 4,058 lines. The well-known Parisian poet Jean de Meun (who never met Guillaume de Lorris) so appreciated the work that he finished the poem (c.1275–1280) with 17,000 additional lines. Over 300 manuscripts survive of this successful and influential work; many copies produced for wealthy patrons are lavishly illuminated with over 100 illustrations detailing episodes in the complex narrative.

Example: Roman de la Rose, late fourteenth century, Oxford, BL, MS e. Mus. 65, f. 12v. (De Hamel, fig. 138)

GUILLAUME DE MACHAUT. The influential and innovative French poet and composer Guillaume de Machaut (c.1300–1377) was associated with the courts of a number of powerful aristocrats, including John of Luxembourg (king of Bohemia); Bonne of Luxembourg (queen of France); Charles II of Navarre; Jean, duke of Berry; and Philip the Bold of Burgundy. The works he created for these wealthy patrons were often luxuriously illustrated by the best artists

of the fourteenth century and include long allegorical poems of romance, e.g., the *Dit dou vergier (The Orchard Poem)*, the *Jugement dou Roy de Behaigne (Judgment of the King of Bohemia)*, *Jugement dou Roy de Navarre*, the *Dit dou lyon (Poem of the Lion)*, and the *Dit de l'alerion (Tale of the Eaglet)*. Many of his works include musical compositions (e.g., the *Remède de Fortune*, the *Fonteinne amoureuse*, the *Livre dou voir dit*), and Machaut is responsible for hundreds of other musical pieces and poems. Some of his works also include significant descriptions and illustrations of music instruments and performances. Machaut's versatility in a variety of musical genres as well as his inventiveness have earned him a prominent position in the history of music as well as literature.

Example: Works of Guillaume de Machaut, c.1370, Paris, BN, MS fr. 1584, f. D. (Robb, fig. 185)

GUTHLAC OF CROWLAND, SAINT. The English hermit Guthlac (c.673–714) gave up his life as a soldier to become a monk at Repton and later a recluse at Crowland. His legend, first recorded in the eighth century, includes episodes of his struggles with *demons, visions of *angels, and the assistance of his patron, Saint *Bartholomew. A monastery was established on the site of his hermitage, and his cult flourished, especially in England, through the Middle Ages with accounts of miraculous healings, visions, and *exorcisms at his shrine. A detailed pictorial narrative of Guthlac's life was created in the early thirteenth century in the form of eighteen tinted drawings in roundels on a scroll (probably designed as cartoons for stained glass windows). Some scenes from his life also appear in thirteenth-century sculpture at Crowland.

Example: Guthlac Roll, c.1210, London, BL, Harley Roll Y.6. (Morgan, I, pls. 72–75)

H

HABAKKUK. Habakkuk is one of the twelve minor *prophets. The short (three-chapter) Book of Habakkuk predicts the invasion of Judah by the Chaldeans and encourages the just to live by their faith, in certainty of deliverance. In art, Habakkuk may be shown as an old man with a long beard, holding a scroll, or a whip (for chastisement). Apocryphal additions to the Book of *Daniel identify Habakkuk as the prophet who, visited by the archangel *Michael, brought food to Daniel in the lions' den. He may thus be shown with an *angel, a loaf of bread, or being lifted by his hair and lowered into the lions' den by the angel.

Example: Habakkuk, c.1220–1235, Amiens Cathedral, west portal, buttress statue. (Sauerländer, fig. 171)

HADES. In classical mythology, Hades is the god of the underworld and also the name for the realm or state of departed spirits. The word was used in Greek translations of the Bible for the Hebrew *Sheol* (the dark, silent place of the dead) and appears in the New Testament as the after-death location of both the good and bad, who await the *Resurrection of the Dead. The specific place where the wicked are punished is a related but separate location, called *Gehenna,* or *hell. Early Christian theologians frequently debated the nature of Hades, and whether or not (as some maintained) the *souls of the righteous, or especially the martyrs, bypassed Hades and went directly to *heaven, or paradise. In the writings of western theologians by the twelfth century, Hades evolved into the concept of purgatory, an interim after-death location of temporary punishment (purging, cleansing, or purifying) for souls not immediately assigned to hell or heaven. Illustrations of the *Anastasis (Harrowing of Hell; Descent into Limbo) depict Hades as the abode from which *Christ extracted Old Testament persons who had lived justly or who had anticipated Christ in some way. Christ is shown breaking open the jaws or gates and pulling figures out, leaving the *Devil

(*Satan or Hades) in the wreckage behind. See also: *Dante, *Last Judgment, *Leviathan, *Mouth of Hell.

Example: The Harrowing of Hell, c.1180–1200, mosaic, Venice, San Marco, central dome, west vault. (Dodwell, fig. 174)

HALO. A halo is an area of light around the head of a holy person, used in art to distinguish important religious figures. The symbolism appears in pre-Christian art, was used for Roman emperors, and is found in early Christian art by the fifth century. Haloes are normally circular, though square haloes may be used to identify living people (emperors, ecclesiastic figures, donors). A cross-inscribed halo, sometimes also with the Greek letters *alpha* and *omega,* identifies *Christ, and a triangular halo may be worn by *God the Father (symbolizing the *Trinity). A mandorla is an almond-shaped halo which surrounds the whole body and may be seen especially in representations of the *Ascension and *Transfiguration of Christ and the *Assumption of the Virgin.

HAMAN. Haman appears in the book of *Esther. He was the chief minister of King *Ahasuerus and the villain who plotted the massacre of the *Jews that was prevented by Esther's intercession with the king. Haman was hanged on the gallows originally intended for Esther's cousin *Mordecai (who then became chief minister). Haman features in art in biblical illustrations of Esther scenes; he is normally depicted hanging.

Example: Esther Scenes, Roda Bible, mid-eleventh century, Paris, BN MS. lat. 6, vol. III, f. 97v. (Cahn, fig. 48)

HANNAH. Hannah was the mother of *Samuel (the last of the Hebrew judges/ leaders overlapping the advent of kings). Her story is found in 1 Samuel 1–2. The first, beloved, but childless wife of Elkanah, she was chided by Elkanah's second wife, Peninnah, for her infertility. Hannah wept and fasted and promised *God that if she bore a son, she would dedicate him to God's service. Her prayers were answered, Samuel was born, and at the appropriate time she returned to the temple at Shiloh and presented her son to the priest Eli (who had previously doubted but then blessed her). Hannah appears in biblical narrative illustrations with Elkanah and Peninnah, praying at the temple, giving birth to Samuel, and presenting the infant Samuel at the temple. Medieval Christian authors saw typological connections between this story and the miraculous births in the New Testament, e.g., of the Virgin *Mary to Saint *Anne (whose name also means "grace"), and the birth of Jesus to the Virgin Mary.

Example: Elkanah and His Two Wives, Bury Bible, c.1135, Cambridge, CCC, MS 2, f. 147v. (Cahn, fig. 122)

HARP. See MUSICAL INSTRUMENTS, SYMBOLISM OF.

HARROWING OF HELL. See ANASTASIS.

HEALING OF THE BLIND. The Gospels recount several episodes of Jesus' miraculous healings of blind people. The subject is one of the most frequently represented *miracle scenes in early Christian art and can be found in numerous examples (especially sarcophagi) from the third and fourth centuries. The subject continued to be represented up through the thirteenth century in various formats. Generally, Jesus is shown actually touching the eyes of a blind person; this follows the account in *Matthew (9:27–34) of Jesus' healing two blind men by touching their eyes. Other blind men (*Mark 10:46–52; *Luke 18:35–43) were cured by Jesus' voice; in these cases the illustrations show Jesus speaking and gesturing to a seated man (or two), often in the presence of several witnesses. An architectural structure may be indicated, following Luke's account, where the healing took place outside the city of Jericho. *John (9:1–12) tells of Jesus healing a man who had been born blind by smearing the man's eyes with clay and spittle and directing him to wash his eyes in the pool of Siloam. The man's sight was restored. This image, frequent from the sixth century, is recognizable by the additional details and often sequential narrative format: Jesus is shown smearing the man's eyes; the man is shown again washing his eyes in a basin or fountain. Additional witnessing figures may be included. Although images of the healing of the blind are less frequent in later medieval art, the symbolism of the subject doubtless explains its early popularity. Jesus' opening of eyes, letting light into darkness, symbolizes his role as redeemer, "light of the world," and the fulfillment of *Isaiah's prophecy (35:5): ". . . the eyes of the blind shall be opened."

Example: Healing of the Blind, sixth century, ivory diptych, detail, Ravenna, National Museum. (Volbach, fig. 223)

HEALING OF THE DEMONIAC. There are several accounts in the Gospels of Jesus healing people possessed by *demons. As with other scenes of Jesus' *miracles, the subjects are found in simplified formats in early Christian examples. Jesus will be shown standing and gesturing toward the possessed person, who may be chained or writhing violently. The exorcised demon often appears exiting from the person's mouth or on the top of his head. When pigs are included in the scene, the miracle is that of the Gadarene swine (recounted in the first three Gospels), in which Jesus drove out many demons from one (or two) possessed men at Gerasa (or Gadara). The demons asked to be transferred into a herd of swine (sometimes the demons are shown riding on the backs of the pigs); they drove the herd over a cliff and drowned in the water. Architecture in the background and landscape details of caves and rocks indicate the setting as outside the town, where the demoniac had been driven. *Shepherds and frightened citizens from the town may also be included and, in these expanded versions, Jesus is normally accompanied by several disciples. The scenes of

Jesus healing an epileptic boy and healing a possessed man in the *synagogue, are less frequently represented than the episode of the Gadarene swine, which appears from the fifth century onward.

Example: The Gadarene Swine, c.975–1000, fresco, Oberzell (Reichenau), Sankt Georg, nave, north wall. (Demus, fig. 240)

HEALING OF THE LEPER. Jesus' miraculous healing of a man with leprosy is briefly recounted in the Gospels of *Matthew, *Mark, and *Luke and was illustrated in art as early as the fifth or sixth century. The subject occurs in art through the Middle Ages and may be identified through the conspicuous sores that are normally indicated on the leper's body. The scene may include simply Jesus standing upright and gesturing in *benediction toward the leper, who approaches him with arms outstretched, bows down, or is seated before Jesus. Sometimes a city or architectural background is indicated, and additional witnessing figures or disciples may be present. The leper may carry a horn (which lepers were required to blow to alert people of their approach during the Middle Ages). An additional episode, in which Jesus healed ten lepers, is also found in art of the tenth and eleventh centuries. One of the healed lepers returned to thank Jesus and is shown kneeling before him.

Example: Healing of the Leper, Gospel Fragment, c.830, Düsseldorf, MS B.113, f. 5. (Swarzenski, fig. 17)

HEALING OF THE PARALYTIC. The Gospels recount several episodes and different versions of Jesus' miraculous healings of crippled or lame people. *Mark (2:1–12) and *Luke (5:17–26) describe how a palsied man was brought to Jesus, who was preaching in a house in Capernaum. The crowd outside was so great that the sick man had to be lowered on his bed through the roof of the house. Jesus healed the man and directed him to take up his bed and depart. The subject appears in sixth-century mosaics and later examples and is usually recognizable by the motif of the sick man being lowered into the room containing Jesus and other figures.

*John's Gospel (5:1–9) tells another episode, more frequently illustrated, of a lame man who waited for thirty-eight years by the pool of Bethesda in Jerusalem hoping to be cured in the water (which was yearly "troubled" or stirred by an *angel and acclaimed for its curative powers). Jesus healed the man and (as above) directed him to take up his bed and walk. Sarcophagi and ivories from the fourth and fifth centuries depict simply the man walking, carrying his bed on his back; Jesus gestures toward him, and sometimes other witnesses are present. Byzantine and western examples, especially in manuscript illustration from the eleventh and twelfth centuries, include other details; the pool of Bethesda is shown (sometimes as a fountain or basin), and an angel hovers above it, often stirring the water with a stick. The subject is less frequently illustrated in Gothic and later medieval art.

Example: Healing of the Paralytic, sixth century, ivory diptych, detail, Ravenna, National Museum. (Volbach, fig. 223)

HEAVEN. A topic of much discussion among early Christian and medieval theologians, heaven has been defined and pictured in a variety of ways in medieval art and literature.

In the Genesis *Creation narratives, *God is described as creating the heavens (Genesis 1:1) and placing within them the sun, moon, and stars (Genesis 1:14–18). Heaven is thus understood to be the visible sky, as well as the realms beyond it; it is sometimes seen as the dwelling place of God and *angels, whose edge humans may glimpse in dream visions (e.g., *Jacob's Ladder) and from which God may emerge or descend (see: *Mount Sinai; *Moses). It is also the realm into which special individuals may be taken from earth at God's will (see: *Elijah; *Enoch).

The concept of heaven as a place of reward for the righteous developed later; *Ezekiel's visions of the *Heavenly Jerusalem, for example, and the *prophet *Daniel's description of the *Resurrection of the Dead provided important foundations for the evolution of the Christian conception of heaven as the place of salvation promised to the just. Heaven thus becomes the polar opposite of *hell, the place of suffering and punishment for the wicked.

The structure of heaven and the process of entry into it were discussed copiously by early Christian and medieval authors (e.g., Saints *Augustine, *Thomas Aquinas) eager to correlate the description of the *Last Judgment at the end of time (see also: *Apocalypse) with teachings such as Jesus' parable of *Dives and Lazarus (in which judgment and heavenly rewards are implied as immediate upon *death). In 1336 Pope Benedict XII proclaimed that the rewards of heaven, as well as the states of hell and purgatory, were, in fact, obtainable upon death.

In art of the early Christian period, heaven may be symbolized in a variety of abbreviated forms. Such images as the *Agnus Dei standing on a hill from which flow the Four Rivers of Paradise, and *orant figures standing in landscapes with palm trees and *vines may be seen to represent heaven and salvation (see also: *Fruit and Trees, Symbolism of) while more detailed depictions of heaven (with *Christ, or the *Madonna and Child enthroned, surrounded by *saints and angels) also appear in the early Christian period. Heaven may also be symbolized by the figure of *Abraham, holding *souls in a cloth upon his lap. Choirs of angels and rows or circles of saints surrounding God or Christ symbolize heaven in illustrations of *All Saints and the *Majestas Domini, and large-scale compositions detailing the pleasures and peaceful rewards of heaven feature prominently in Romanesque and Gothic depictions of the Last Judgment. While the wicked are tortured in hell, the blessed sit calmly and happily in the presence of God, angels, and saints, welcomed into heaven by Saint *Peter. The souls of martyrs and other holy figures are often shown carried up to the clouds of heaven by angels, and in scenes of the *Assumption and *Coronation of the Virgin, the heavenly setting may be indicated by angels, the figures of God, Christ, or the *Trinity. The apocalyptic battle between Saint *Michael and the dragon of evil may be shown taking place in the heavenly sky, as well as the

*Fall of the Rebel Angels who plummet out of heaven. Visions of heaven were described and illustrated also in the works of medieval mystics (e.g., see: *Hildegard of Bingen) and fully detailed in texts such as *Dante's *Paradiso*.

Example: Last Judgment, c.1120–1135, Autun Cathedral, tympanum. (Snyder, fig. 358)

HEAVENLY JERUSALEM. The Heavenly Jerusalem, perhaps influenced by *Ezekiel's vision of the new Temple, is described in detail toward the conclusion of the *Apocalypse (21:10–22:5). The radiant city descends from *heaven, has three gates in each of four walls, is adorned with various precious stones, and contains the throne of *God and of the Lamb (see: *Agnus Dei*). In early Christian and Carolingian art (e.g., Roman mosaics of Santa Pudenziana and Santa Prassede) the image may be represented by a walled city containing *saints, *angels, and various architectural details. A shift of perspective occurs in the Spanish illustrations of the *Beatus *Commentary on the Apocalypse* (and works influenced by this tradition) where the Heavenly Jerusalem is often shown from above, laid out as a square, symmetrical diagram with three flat arches (gates) on each side inhabited by the *apostles.

Example: Heavenly Jerusalem, Morgan Beatus, c.950, New York, PML, MS 644, f. 222v. (Williams, pl. 20)

HELENA, SAINT. Helena (c.250–330) was the mother of the first Christian Roman emperor *Constantine and the wife of the general Constantius Chlorus. She converted to Christianity c.312 and was deeply admired for her piety and charity. In 326 she undertook a *pilgrimage to the Holy Land where she died after having founded numerous churches on sites associated with the life and passion of *Christ (notably the church of the *Holy Sepulchre in Jerusalem and church of the *Nativity in Bethlehem). Although not mentioned in early biographical sources such as Eusebius, Helena's discovery of the *True Cross was described by Saint *Ambrose in the late fourth century, and later greatly elaborated in fifth-century apocryphal works (the *Acts of Judas Cyriacus*), and the *Golden Legend*. She appears in medieval art primarily in pictorial narratives of the discovery ("invention," from Latin *inventio, "coming upon"*) of the True Cross: questioning the *Jews as to the location of the *cross and overseeing the proof of the True Cross (which, unlike the other two tested, brought a dead person back to life). She is also credited with discovering several other important *relics: the nails used in the *Crucifixion and Christ's robe. She appears, crowned and garbed as an empress, with Constantine (they often stand on either side of the cross) or, accompanied by the cross-bearing *angel who appeared to her in a dream.

Example: Scenes from the Story of the True Cross, c.1154, Stavelot Triptych, New York, PML. (Snyder, cp. 54)

HELL. The English word *Hell* derives from *Hel,* the term used in ancient Germanic myths for the realms of the dead, similar to the Hebrew *Sheol* and Greek *Hades*. The specific concept of hell as a place of punishment for the wicked

derives from the Hebrew notion of *Gehenna*—a geographic location mentioned in the Old Testament as the site of various pagan atrocities, such as child sacrifice. *Jeremiah's prophecy (19:6–15) of judgment upon this evil place contributed to the idea of *Gehenna* as the place of punishment for sinners, and the term repeatedly appears in this context in the Greek and Vulgate New Testament. The attributes of *Gehenna,* or hell, include "everlasting fire" (*Matthew 18:8) and "darkness" (Matthew 8:12); it is the place of the *Devil and *demons and "wailing and gnashing of teeth" (Matthew 13:50). Unlike *Hades,* or the cleansing of *souls possible in purgatory, hell was generally regarded by early Christian and medieval theologians as a permanent location or eternal state of the sinful. Although the inhabitants of hell, the Devil and demons, appear in early Christian and early medieval art (see: *Exorcism, *Healing of the Demoniac, *Temptation of Christ), and hell (or *Hades*) is pictured in scenes of the *Anastasis, large-scale, dramatic visions of hell appear especially from the eleventh century onward in scenes of the *Apocalypse and *Last Judgment. The torments of the sinners in hell are often prominently depicted; they are chewed or prodded by demons and suffer various tortures appropriate to their earthly sins and *vices. The *Mouth of Hell appears as the gaping jaws of a fearsome beast (see also: *Leviathan) with flames and a boiling cauldron within it. The Devil, or *Satan, may preside over this suffering or may be shown chained and locked by an *angel in a pit or cavern (Rev. 20:1–3). In later medieval art, dramatic images of hell were also inspired by *Dante's *Inferno.*

Example: Hell, Codex Gigas, late twelfth century, Stockholm, RL, Cod. Holm. A 148, f. 289v. (Cahn, fig. 130)

HERACLIUS. The Byzantine emperor Heraclius (c.575–641) reigned during a troubled period of economic crises and military invasions. A skillful general, he was eventually able to overturn the Persians (c.628) but was unsuccessful in stopping further Arab invasions of portions of the Byzantine empire. He features in medieval art primarily because of his return of the *relic of the *True Cross (which had been captured by the Persians) to Jerusalem c.630. The event is well detailed in the **Golden Legend,* which describes how the emperor, instructed by an *angel, dismounted outside the city gate and carried the relic into the city on foot; the fallen stones previously blocking his way moved miraculously. He is shown on foot or on horseback, carrying the cross toward the city. The event is liturgically commemorated on September 14 in the feast of the *Exaltation of the Cross.

Example: Story of the Emperor Heraclius, Roman de Godefroi de Bouillon, 1337, Paris, BN, MS fr. 22495, f. 9. (Porcher, pl. LII)

HERBAL. See DIOSCURIDES; MANUSCRIPTS.

HERCULES. The deeds of the great hero of classical mythology, Hercules, were frequently illustrated in classical and late antique art. These scenes may

have provided pictorial sources for the early development of some Christian iconography. Cycles of his labors, including his conquest of the Nemean lion, his descent into the underworld *(*Hades)*, as well as his *apotheosis, have been cited as pictorial parallels for illustrations of scriptural or apocryphal scenes such as the *Ascension (of *Elijah and *Christ), the *Anastasis, and the struggles of both *Samson and *David with lions. He may also have served as the model for later medieval personifications of strength, or other *virtues.

Example: Nicola Pisano, *Strength (Hercules?)*, c.1260, Pisa Baptistry, Pulpit, detail. (Snyder, fig. 573)

HERESY. See VICES.

HERIBERT, SAINT. Heribert (d.1021) served as chancellor for the emperors Otto III and Henry II. Appointed archbishop of Cologne in 998, he was renowned for his charity and peaceful nature and was also credited with several *miracles (e.g., causing rainfall to end a severe drought). He founded the monastery at Deutz, where an elaborate metalwork shrine for his *relics, illustrating numerous episodes from his life, was created c.1170 by the famous Mosan metalworker Godefroy de Claire.

Example: The Virgin Appears to Saint Heribert, c.1170, Heribert Shrine, Deutz, Saint Heribert. (Abou-el-Haj, fig. 40)

HEROD. The name *Herod* occurs numerous times in the New Testament referencing four members of a family of Palestinian rulers in the first centuries B.C. and A.D. Various of these Herods appear in early Christian and medieval art, dressed as kings (in rich robes, often crowned) and feature in a number of specific episodes. The historical figures tend to be conflated into one generic image of an evil tyrant, ultimately responsible for many wicked deeds.

HEROD THE GREAT (appointed king of the *Jews by the Romans in 40 B.C.) ruled from 37–4 B.C. Jesus was born during his reign, and Herod the Great was responsible for ordering the *Massacre of the Innocents. He is also seen questioning the magi (see: *Adoration of the Magi).

One of his sons, HEROD ANTIPAS ruled c.4 B.C. to 39 A.D. This Herod was ultimately responsible for the *death of Saint *John the Baptist (see: *Feast of Herod) as well as (according to *Luke 23:7–12) one of the interrogations of Jesus before the *Crucifixion (see: *Trials of Christ).

HEROD AGRIPPA I (Herod the Great's grandson), who ruled c.37/41–44 is mentioned in Acts 12:1–2 as responsible for the death of the *apostle Saint *James the Greater and the imprisonment of Saint *Peter, while his son HEROD AGRIPPA II ruled certain northern territories from c.50–93; this is the king mentioned in Acts 25–26 who called Saint *Paul in for questioning.

HERRAD OF LANDSBERG. Herrad (c.1130–1195), abbess of the convent of Hohenbourg, is credited with the production of one of the most remarkable encyclopedic manuscripts of the medieval period: the *Hortus deliciarum (Garden of Delights)*. This comprehensive work, created for the nuns of the Hohenbourg community, covers religious history from *Creation to the *Last Judgment and was profusely illustrated with scenes from the Old and New Testaments, plus various allegorial and symbolic depictions. The original manuscript was destroyed in the shelling of Strasbourg in 1870, although much of the text had previously been published and copies of about half of the illustrations had been made (in line drawings and a few colored copies). The original illustrations (estimated 346 scenes total) may have been done by three different artists and show marked influences of Byzantine style and iconography.

Example: Hortus deliciarum, c.1170–1200, nineteenth-century copy. (Dodwell, figs. 293–95).

HILDEGARD OF BINGEN. "Sibyl of the Rhine," the mystic and *author, Hildegard (1098–1179) entered the Benedictine community at Diessenberg at the age of eight and took her vows at age fifteen. Elected abbess of Diessenberg in 1136, she moved the community near Bingen in c.1150. Her extensive writings include poems, hymns, plays, *saints' lives, scriptural commentaries, numerous letters, and remarkably comprehensive and practical works on medicine *(Causae et curae)* and natural history *(Physica)*. She also composed music and maintained written correspondence with four popes, two German emperors, the king of England, numerous German archbishops, and Saint *Bernard of Clairvaux. From the age of five, Hildegard experienced visions, which she began to record in her middle age. Her *Liber scivias* (c.1141–1150, the title derived from *sci vias Domini,* "know the ways of the Lord"), three books of twenty-six visions, was illustrated by several different artists under her direction between 1150 and 1179. It contains complex symbolic diagrams and allegorical scenes concerning the divine scheme of the cosmos, humankind's path to salvation, and the role of the *church. Another book of ten visions (the *Liber divinorum operum simplicis hominus*) was produced between 1163 and 1170. Her works were widely known and copied throughout the Middle Ages.

Example: Liber scivias, c.1150–1179, formerly Wiesbaden, Hessische Landesbibliothek. (Dodwell, fig. 281).

HIPPOLYTUS. The third-century theologian Hippolytus (*author of a number of treatises and commentaries) has sometimes been confused with the martyr mentioned in the legends concerning Saint *Lawrence. These accounts identify him as the Roman soldier and jailor who was converted to Christianity by Lawrence and who was subsequently martyred either by being dragged by a wild horse or by being torn apart by horses tied to each of his limbs. His Greek name may be interpreted as "killed by a horse." The *martyrdom of Hippolytus

appears in Romanesque hagiographic illustrations and later panel paintings; he is also represented as a Roman soldier.

Example: Martyrdom of Hippolytus, Stuttgart Passionary, twelfth century, Stuttgart, WLB, MS Fol. 2.56, f. 62. (Boeckler, fig. 107)

HODEGETRIA. One of the most popular images of the *Madonna and Child, the *Hodegetria* depicts the Virgin *Mary holding the baby Jesus on her left arm while gesturing toward him with her right hand. She may be standing, half-length, or seated on a throne. Her gaze is frontal or slightly to the side while she presents her son and guides the viewer's attention to him. Jesus appears non-infantlike, usually gazes outward as well, often holds a scroll in his left hand, and raises his right hand in *benediction. Byzantine tradition traces the image back to a depiction of the Virgin and Child created by Saint *Luke. The name for this image first appears in the ninth century, perhaps derived from the Church of the Hodegoi (the "commanders," "guides," or "pointers of the way") in Constantinople where the traditional prototype of the image was venerated. For other Byzantine types of the Madonna and Child, see: *Blacherni-tissa, *Eleousa, *Platytera.

Example: Mellon Madonna, c.1290, icon, Washington, D.C., National Gallery of Art. (Synder, cp. 25)

HOLOFERNES. See JUDITH.

HOLY FACE. The Holy Face is the name of several different *relics bearing the image of the face of Jesus, believed to have been created miraculously (see: *Acheiropoieta), such as the veil *(*Sudarium)* of Saint *Veronica and the cloth *(*Mandylion)* sent to King Abgar of Edessa. Copies of these images were widely produced in Byzantine *icons, in western sculpture and painting, and as *pilgrimage badges especially from the eleventh century following. See also: *Volto Santo.

Example: Christ of Veronica, twelfth century, icon, Moscow, Tretyakov. (*The Icon,* p. 259)

HOLY FAMILY. Although the term *Holy Family* may apply to the extended genealogy of Jesus' grandparents and other relations (e.g., the parents of the Virgin *Mary: Saint *Anne and *Joachim; Mary's relative Saint *Elizabeth and her son: Saint *John the Baptist; see: *Holy Kinship), the *Holy Family* most often refers to the triad of Jesus, Mary, and Saint *Joseph. The three frequently appear together in narrative images such as the *Nativity, *Presentation in the Temple, and *Flight into Egypt, as well as (especially in later medieval art) domestic scenes set in their home in Nazareth after their return from Egypt. Although specific details of Jesus' childhood are virtually lacking in the canonical Gospels, the narratives were supplied by several apocryphal "infancy Gospels" (e.g., the *Protevangelium of James* and *Evangelium of the*

Pseudo-Matthew) and later elaborated in works such as the **Golden Legend*. The increasing popularity of the cults of both Mary and Joseph in the later medieval period is also reflected in depictions of the Holy Family that emphasize family life and domestic virtues. Mary and Joseph may be shown watching the infant Jesus at play or engaged in household or other duties (Mary reads or sews, Joseph works with his carpentry tools) while Jesus sleeps in his cradle.

Example: Christ Wading in a Pool, London Hours, c.1400–1410, London, BL, Add. MS 29433, f. 168. (Calkins, pl. 152)

HOLY GRAIL. The French word *graal* (English: grail) means a platter, or dish. Stories of the Holy Grail first appear in French romances of the late twelfth century: the *Perceval* of Chrétien de Troyes and the *Estoire dou Graal* of Robert de Boron (see: *Arthurian Legends). In these sources and in numerous other works derived from them, the Holy Grail becomes identified with the chalice used at the *Last Supper within which *Joseph of Arimathea collected *Christ's blood at the *Crucifixion and which Joseph brought to England and buried when he founded the church at Glastonbury. The miraculous life-giving, food-providing, and spiritually nourishing properties of the Grail (the location of which was forgotten) made it the subject of numerous quests, visions, and *miracles recorded and often illustrated in various Arthurian works through the late medieval period.

Example: Procession with Holy Grail, Romances of the Holy Grail, c.1330, Paris, BN, MS fr. 12577, f. 74v. (De Hamel, fig. 133)

HOLY INNOCENTS. See MASSACRE OF THE INNOCENTS.

HOLY KINSHIP. Continuing interest in the genealogy and *Ancestors of *Christ (see: *Tree of Jesse) was further developed in the twelfth century in literary descriptions of Christ's immediate family relations among figures mentioned in the Gospels and *Apocrypha. The pictorial theme of the Holy Kinship (also "Holy Company," "Family of Saint Anne") generally follows the explication in the **Golden Legend,* which describes that Saint *Anne was married three times and in each marriage gave birth to a daughter named Mary. The offspring of these three Marys include Jesus and several of the *apostles described as Jesus' "brethren" in the Gospels. Additionally, the relationship of Saint *Elizabeth (as a "cousin") and the Virgin *Mary was explained, and the group was expanded (especially in art and literature of later medieval northern Europe) to include various later Germanic *saints. The subject was especially popular in late medieval art and generally depicts a large group of seated women bearing *haloes and holding their infants or observing them at play. The *Madonna and Child form the central elements in the composition. Husbands are often included, and all of the figures in this extended family group may be identified with inscriptions.

Example: Follower of the Saint Veronica Master, *Holy Kinship,* c.1420, Cologne, Wallraf-Richartz Museum. (Synder, NR, fig. 80)

HOLY SEPULCHRE. The Holy Sepulchre in Jerusalem is the tomb of *Christ. Presumably a rock-cut cave, the location was reidentified by the empress Saint *Helena during her *pilgrimage to the Holy Land in 326 and became the site of successive architectural constructions through the medieval period. The original church (dedicated c.335) consisted of a large basilica, courtyard, and a domed, centrally planned rotunda of the *Anastasis which enclosed the tomb of Christ. This structure was destroyed by the Persians, rebuilt in the early seventh century, remodelled in the mid-eleventh century, enlarged in the early twelfth century, and rebuilt again in the early fourteenth century. (Enlargements and alterations have gone on continuously through the modern period.)

In early Byzantine illustrations of Christ's *Deposition and *Entombment, the Holy Sepulchre is often represented as a cave although it is also shown in art as early as the third century as a small architectural structure, for example, in scenes of the *Three Marys at the Tomb. From the fourth century, it is recognizable by its domed, rounded, or otherwise centrally planned appearance, which inspired numerous architectural "copies" in Byzantium and western Europe. Chapels of the Holy Sepulchre were frequently used, especially from the tenth century in the west, in liturgical ceremonies for Good Friday and Easter. A *cross or host (eucharistic wafer, see: *Last Supper, *Seven Sacraments) was buried in the chapel on Good Friday, exhumed and carried to the altar on Sunday morning. Small, free-standing sculptures of the Holy Sepulchre, including the sarcophagus, reclining figure of Christ, *angels, and holy women, were also produced from the late thirteenth century onward.

Example: Women at the Sepulchre and Ascension, c.400, ivory, Munich, Bavarian National Museum. (Volbach, fig. 93)

HOLY SPIRIT. As developed in Christian doctrine, the Holy Spirit is the third person of the *Trinity. In the Old Testament, a rather general spirit or breath of *God operates at the *Creation, and inspires humans with strength, success, virtue, *wisdom, prophetic ability, creativity, and intellectual powers. In the New Testament, the more personified Holy Spirit operates at the miraculous incarnation of Jesus, through Jesus' life and *miracles, and, as the Holy Paraclete (Greek: "comforter"; promised by Jesus to his disciples in *John 14:16) supports and consoles believers. A topic of copious discussion among early Christian and medieval theologians, the relationship between the three persons of the Trinity was also the subject of continual dispute between the western and Byzantine churches through the Middle Ages.

In art, the Holy Spirit is most often symbolized by a white dove, following the descriptions of Jesus' *Baptism (e.g., *Luke 3:22), when the spirit descended upon him "in a bodily shape like a dove." This iconography appears in early Christian art and remains consistent through the medieval period. The dove of the Holy Spirit also appears in images of the *Annunciation to Mary and in scenes of the *Pentecost (Descent of the Holy Spirit), although some early depictions of Pentecost depict the Holy Spirit as "tongues of fire" descending

upon the *apostles, as described in Acts 2:3. The dove of the Holy Spirit may also appear in scenes of the *Coronation of the Virgin. Seven doves symbolize the *Seven Gifts of the Holy Spirit, and numerous *saints are depicted inspired or accompanied by the dove (e.g., Saints *Catherine of Siena, *Gregory the Great, *Scholastica, and *Thomas Aquinas).

Example: Holy Spirit Hovering over the Earth, Book of Hours, c.1470, Walters, MS 196, f. 30v. (Wieck, fig. 58)

HOLY TRINITY. See TRINITY.

HOLY WOMEN AT THE TOMB. See THREE MARYS AT THE TOMB.

HOMILIARY. See MANUSCRIPTS.

HONORIUS OF AUTUN. The writings of the early twelfth-century scholastic philosopher Honorius of Autun (or Augustodunensis) were extremely popular during the Middle Ages. He authored a number of influential treatises on theology (e.g., the *Elucidarium,* the *Inevitabile*), history, natural science, an encyclopedia work (the *Imago mundi*), and a collection of sermons (the *Speculum ecclesiae*). These texts, much studied and copied, were frequent features in medieval library collections.

HOPE. See VIRTUES.

HORAE. See MANUSCRIPTS.

HORN. See MUSICAL INSTRUMENTS, SYMBOLISM OF.

HORSEMEN OF THE APOCALYPSE. See APOCALYPSE.

HORTUS CONCLUSUS. The term *Hortus conclusus* (''enclosed garden'') was taken from the Song of Solomon (4:12) by medieval theologians who interpreted the reference as a prefigurative symbol of *Mary's fruitfulness but perpetual virginity (like the ''shut gate,'' *Porta clausa,* through which only *God may enter, from the vision of *Ezekiel 44:2). The symbolism was developed by numerous authors and gave rise, especially in later medieval art, to images of the *Madonna and Child seated within a lovely garden surrounded by walls or a fence. Abundant trees and flowers, especially roses and lilies (see: *Flowers and Plants, Symbolism of) may be indicated in the peaceful landscape setting. Sometimes a fountain (the ''spring shut up,'' ''fountain sealed,'' ''well of living waters,'' from the Song of Solomon 4:12, 15) and *angels are also represented. Mary may also be shown without the infant Jesus but accompanied in the garden by a unicorn, again a symbol of her purity (see: *Animals, Symbolism of). This

image is sometimes conflated in late medieval art with scenes of the *Annunciation; hence *Gabriel may also appear within or outside the garden enclosure.

Example: Virgin and Child, Book of Hours, c.1410, Walters, MS 232, f. 191. (Wieck, pl. 32)

HOSEA. The first of the twelve minor *prophets, Hosea lived in the eighth century B.C. before the Assyrian conquest of the northern Hebrew kingdom, an event of which he warned the leaders. Of special note in his writing is a narrative of his marriage, at *God's command, to a ''harlot,'' whose infidelities provided the themes of unfaithfulness and forgiveness (applied to the relationship of the Israelites and God) found in the early portion of his book. He is depicted in medieval art generally as a bearded figure in long robes, holding a scroll. He may stand on a skull, symbolizing his prophecy (13:14), interpreted by Christians, of *Christ's triumph over *death.

Example: Hosea, late eleventh–early twelfth century, stained glass, Augsburg Cathedral, nave, south side. (Dodwell, fig. 392)

HOSPITALITY OF ABRAHAM. See ABRAHAM.

HRABANUS MAURUS. See MAURUS, HRABANUS.

HUGH OF SAINT-VICTOR. The philosopher and theologian, Hugh of Saint-Victor (d.1141), became a regular canon of the Parisian abbey of Saint-Victor sometime before 1125. He was known as a great teacher and highly regarded for his copious systematic and mystical writings which include commentaries on scripture, world history (the *Chronicon*), theology *(De sacramentis Christianae fidei),* and several works interpreting the symbolism of *Noah's Ark *(De arca Noe morali, De arca Noe mystica).* In his *Didascalicon* he developed his theory of the *Seven Liberal Arts, considered a general introduction to the study of scripture and theology. The comprehensive nature of his studies, teachings, and writings earned him fame as a ''second *Augustine.'' He also inspired a number of influential students (see: *Richard of Saint-Victor). He appears in art as a cleric, scholar, and teacher.

Example: De arca Noe, late twelfth century, Oxford, BL, MS Laud Misc. 409, f. 3v. (De Hamel, fig. 103)

HUMILITY. See VIRTUES.

I

ICON. The term *icon* comes from the Greek *eikon,* which means "image." More specifically, icons are images of holy figures, most often on painted panels, but they may also be created in mosaic, fresco, ivory, and other media. The tradition may ultimately derive from ancient/classical portraiture (especially of imperial or deceased persons). Icons were produced in the Byzantine world from at least the fifth century, although the majority of surviving examples date from the ninth century onward (after the *Iconoclastic Controversy). These holy images play a critical role in Byzantine liturgy and worship, both public and private. They serve as objects of devotion and instruction and are popularly believed to possess special powers of healing and protecting. The sacred quality of the images and the tradition that the earliest icons were sanctioned by *God (e.g., the first portrait of the Virgin *Mary as *Theotokos, Mother of God, was painted by Saint *Luke, and the miraculous impression of *Christ's face on the veil of Saint *Veronica was an *acheiropoieta—image made without human hands) resulted to a large extent in the copying of specific, codified images, and a certain standardization of types through the centuries. The process of creating icons is, in itself, regarded as a spiritual activity. In the Byzantine church, icons are displayed on the *iconostasis screen; veneration involves prostration *(*proskynesis)* before the images. For specific types, see also: *Blachernitissa, *Eleousa, *Hodegetria, *Platytera.

Example: Christ, c.700, icon, Mount Sinai, Monastery of Saint Catherine. (Synder, fig. 153)

ICONOCLASTIC CONTROVERSY. In the troubled political context of the early eighth century in Byzantium, the production and veneration of *icons came under attack from the emperors Leo III and Constantine V. Leo III published an edict ordering the destruction of icons in 726, which policies were carried out and renewed by his son with the banning of all figurative imagery in

churches at the Synod of Hiereia in 754. The movement was motivated by a complex variety of factors, not the least of which was a struggle between ecclesiastic and imperial authority. Wealthy monasteries (where icons were produced and displayed and which attracted *pilgrims) were attacked; the iconoclasts destroyed icons and mosaics in churches and monasteries and persecuted and killed monks and other icon supporters (iconodules). A respite occurred during the reigns of Leo IV (775–780) and Empress Irene; the veneration of icons was officially restored in 787, but iconoclasm again came into effect in 814 during the reign of Leo V and his successors. This second phase lasted until 842. The writings of authors such as Theodore the Studite and Saint *John of Damascus clarify the significance of icons for the Byzantine church. Following the period of iconoclasm, the arts in Byzantium flourished in the "Macedonian Renaissance."

ICONOSTASIS. An iconostasis is a screen of *icons separating the nave and sanctuary in Orthodox churches. Screens or low balustrades separating clergy from congregration were found in early Christian churches and are the basis for this form, which was increasingly elaborated in Byzantine architecture. The physical separation symbolizes the division of the earthly and heavenly realms; the iconostasis symbolically unites the two realms and follows a specific program of hierarchically positioned images. In fully developed form (e.g., by the thirteenth century), the iconostasis will be multitiered with three doors on the lowest level (the central "Royal Door" leads into the sanctuary where the Eucharist is celebrated). Icons of *Christ, the Virgin *Mary, archangels, and the *Four Evangelists will be found on this level; sometimes an icon of the *saint to whom the church is dedicated or icons of local saints will be placed here as well. The top level of icons will exhibit Old Testament *patriarchs, followed by a level of *prophets, followed by a row of icons representing the major holy days celebrating events in the life of Christ and the Virgin. Below this, a *Deësis group (Christ with Mary and Saint *John the Baptist) is traditional, flanked by icons of archangels, *apostles, and saints. Iconostases may also be small, portable, folding screens used for prayer in private homes.

Example: Russian Iconostasis, sixteenth century, Novgorod, Saint Sophia Cathedral. (Ouspensky, p. 61)

IDOLATRY. See VICES.

IDOLS. The term *idol* derives from the Greek *eidolon* ("image"). The word was used in the Septuagint (Greek version of the Old Testament) to translate a number of different Hebrew words with various shades of meaning, and it appears in the Latin Vulgate Bible translated as either *idolum* or *simulacrum.* Idols may be defined as material things or images, created by humans, which serve as objects of worship or, more remotely, as symbols of illusory realities. The construction and veneration of idols (idolatry) was specifically prohibited in the

second commandment, which forbids the making and worship of "graven images," either of the Hebrew *God, or of false, foreign, pagan gods. Idols of various sorts are frequently described in the Old Testament as the Hebrews encountered and sometimes emulated the idol-worshipping practices of surrounding cultures (e.g., Egyptian, Canaanite, Assyrian, Philistine, and Chaldean) in spite of the perpetual warnings of the *prophets. Idolatry is described in the New Testament, and by early Christian and later medieval theologians as an extremely serious error, both in action and conception, inspired by *demons and the *Devil.

Idols thus appear frequently in early Christian and medieval art, especially in narrative contexts in which the worship of idols is negatively portrayed or the destruction of idols is shown as a positive event. Numerous examples range from the Israelites' *Worship of the Golden Calf (Exodus 32), to the *Holy Family's *Flight into Egypt where, upon their arrival, many little statues of pagan gods fell from their platforms. (This episode is found in New Testament *Apocrypha.) Saint *Augustine's *City of God* contains a detailed discussion of idolatry; illustrated versions of the text often show pagans worshipping statues. Frequently, idols will have a grotesque or demonic appearance (e.g., horned) or will be nude (as per classical statuary). Numerous hagiographic stories recount saintly battles against idolatry and refusals to worship pagan gods or imperial images, resultant in many *saints' *martyrdoms.

The *vice of Idolatry, often represented by a person kneeling before a pagan statue, is frequently found paired with or overcome by Faith, in cycles inspired by *Prudentius's *Psychomachia,* for example, in manuscripts and Romanesque and Gothic sculpture and stained glass. The concern for avoiding idolatry was also cited as an issue in the Byzantine *Iconoclastic Controversy of the eighth and ninth centuries.

Example: Overthrow of Egyptian Idols, c.1225–1235, Amiens Cathedral, west portal, socle. (Sauerländer, fig. 172)

IMAGO CLIPEATA. An *imago clipeata* is a medallion portrait, from the Latin *clipeus* ("round shield"). Circular disks or medallions were frequently used in classical art to frame portraits, especially in a funerary context (e.g., bust medallions of the deceased on sarcophagi). More than one bust may be contained in a *clipeus;* whole series of *imagines clipeatae* (especially in mosaic or fresco) form "portrait galleries." The form was taken over in early Christian art and continued to be used on sarcophagi as well as for images of emperors, government officals, popes, bishops, *Christ, the *apostles, and other holy figures, in ivory, mosaic, fresco, and metalwork. In Christian art, *angels will often be shown holding or elevating the bust medallion. In Byzantine iconography, the *Platytera shows the infant Jesus in a *clipeus* in front of the *orant Mary.

Example: Marble sarcophagus, c.380, Milan, Sant' Ambrogio. (Synder, fig. 10)

IMAGO PIETATIS. See MAN OF SORROWS.

IMMACULATE CONCEPTION. The doctrine of the Immaculate Conception holds that the Virgin *Mary, although conceived in a normal way by her parents *Anne and *Joachim, was born without stain or effects of original sin. This idea was discussed by early Christian writers and became especially controversial during the Middle Ages, when it was opposed by theologians such as Saints *Bernard of Clairvaux and *Thomas Aquinas, but affirmed by others, such as Duns Scotus. The belief was generally supported by the Franciscans and opposed by the Dominicans, until the Council of Basle (1439) when the doctrine was officially sanctioned. The sinless state of Mary as Mother of God (see: *Theotokos) and her role as the redemptive "New Eve," may be symbolized in medieval art in various ways, for example, in the *Meeting at the Golden Gate of her parents and her *Assumption to and *Coronation in *Heaven. (See also: *Hortus conclusus.) Standardized iconography for the image of the Immaculate Conception, based on the Woman Clothed with the Sun from the *Apocalypse, developed in the Renaissance and especially Baroque periods.

INFIDELITY. See VICES.

INJUSTICE. See VICES.

INNOCENTS. See MASSACRE OF THE INNOCENTS.

INSTRUMENTS OF THE PASSION. The Instruments of the Passion are the objects used in the *Crucifixion of *Christ as well as symbolic emblems for events related to his *Arrest and *Trials. They include the crown of thorns, nails, sponge, lance, scourge, and pillar or column where Christ was scourged (see: *Crowning with Thorns, *Flagellation), as well as a hammer, rope, pincers, the cock which crowed at Saint *Peter's denial of Christ, the dice cast by the soldiers for the robe of Christ, *Pontius Pilate's basin and towel, the head of *Judas and his thirty pieces of silver, disembodied spitting heads and the hands which struck Christ (see: *Mocking of Christ), and the veil of Saint *Veronica.

Many of the Instruments of the Passion may be found in illustrations of the Crucifixion itself, while others are present in narrative episodes leading up to the *death of Christ. Extracted from their narrative context, the Instruments of the Passion may be found as independent devotional images, popular in late medieval art (see: *Andachtsbilder), or in depictions of the *Man of Sorrows and *Mass of Saint Gregory. (See also: *Arma Christi.)

Example: Simon Bening, *Mass of Saint Gregory,* c.1520–1530, Malibu, J. Paul Getty Museum, MS 3. (De Hamel, fig. 201).

INTEMPERANCE. See VICES.

INTERLACE DECORATION. Interlace decoration is created by patterns of overlapping ribbons or threads. A style of surface ornamentation common to

many cultures, it appears in especially intricate form in insular manuscript illumination and metalwork of the early medieval period as well as in Coptic, Islamic, and Byzantine art. There are many style variants and formats; animals may be included (see: *Zoomorphic decoration) or interlace may involve strictly geometric patterns or flowing foliage forms.

Example: Book of Durrow, c.660–680, Dublin, TC, MS 57–A.4.5, f. 21v. (Synder, fig. 217)

INVENTION OF THE TRUE CROSS. See TRUE CROSS.

ISAAC. Isaac, second of the Hebrew *patriarchs, was the son of *Abraham and *Sarah; his life is described intermittently in Genesis 21–35. His parents were extremely old when *God informed them that Isaac would be born; and this characteristic, combined with Abraham's pious following of God's commands in his near-sacrifice of Isaac on a mountaintop (Genesis 22), made Isaac (in Christian interpretation) a symbolic prefiguration of the miraculous birth and sacrifice of *Christ. Among other events from his life, the sacrifice (or binding) of Isaac is most frequently represented in art; Isaac may be shown carrying wood for the fire (prefiguring Christ carrying the *cross), and as Abraham raises his sword to kill Isaac, an *angel is often shown arriving to prevent the deed. The ram that was substituted may also be shown. Narrative cycles may also depict Isaac's marriage to *Rebecca and events concerning their sons *Jacob and *Esau.

Example: Sacrifice of Isaac, Aelfric Paraphrase, mid-eleventh century, London, BL, Cotton MS Claudius B.IV, f. 38. (Cahn, fig. 55)

ISAIAH. One of the four major *prophets, Isaiah lived in the latter part of the eighth century B.C. in the southern Hebrew kingdom, as troubles with imperial Assyria escalated in the neighborhood. His lengthy book of sixty-six chapters (only the first thirty-nine often ascribed to him) is characterized by dramatic deeds, visions, and eloquent prophecies, many of which were interpreted by Christians as predictions of a future anointed king or Messiah (in Greek, *Christos*). Hence, Isaiah plays a prominent role in Christian art and can be found in both western and Byzantine manuscript illustration, sculpture, and wall painting from the early Christian through Gothic period. He normally appears as a bearded figure in long robes, often holding a book or a scroll which may be inscribed with the words: *Ecce virgo concipiet et pariet filium* (Isaiah 7:15; ''Behold a virgin/young woman shall conceive and bear a son'') understood by Christians to foretell the miraculous birth of Jesus to the Virgin *Mary (see: *Annunciation). His prophecy (Isaiah 11:1) ''And there shall come forth a rod out of the stem of Jesse'' was also understood by Christians to allude to the birth of Jesus; hence Isaiah frequently appears in representations of the *Tree of Jesse. He is also shown with an *angel who touches and purifies his lips with a burning coal (Isaiah 6:5–7) or seeing a vision of *God enthroned with sera-

phim (see: *Angels). His *death by being sawn in half (as described in apocryphal texts) is also depicted.

Example: Isaiah, c.1125–1130, Souillac, Sainte Marie, jamb. (Snyder, cp. 44)

ISIDORE OF SEVILLE, SAINT. "The Schoolmaster of the Middle Ages," Isidore (c.560–636) was the archbishop of Seville in the early seventh century and was instrumental in organizing the church in Spain, converting the Visigoths from Arianism, and promoting education. His extensive writings include biographies of famous men, historical chronicles, summaries of church doctrine, a treatise *On the Nature of Things (De natura rerum),* and the *Etymologiae,* an encyclopedic work. The title derives from his (often fantastic) etymological explanations of the names of things as indicative of their natures. The extensive work includes information on grammar, medicine, history, nature, rhetoric, theological subjects, mathematics, customs, and institutions. Often illustrated, this influential work was widely copied throughout the medieval period and was a standard feature in medieval libraries. In art, Isidore himself is often depicted as an *author, a bishop, or (especially in Spain) as a warrior *saint.

Example: Etymologiae, c.1160–1165, Munich, BS, MS Clm. 13031, f. 1. (Dodwell, fig. 27)

J

JACOB. The third of the Old Testament *patriarchs and father of the ancestors of the twelve tribes of Israel, Jacob was the son of *Isaac and *Rebecca and the grandson of *Abraham and *Sarah. His life is described in chapters 25–49 of Genesis. Events from Jacob's life often shown in medieval art include the episode where, with the help of his mother, Jacob managed to trick his twin brother, *Esau, out of receiving the blessing of their blind, aged father; Jacob's vision of a ladder to heaven (see: *Jacob's Ladder); his all-night wrestling with an unidentified man (or *angel) who blessed Jacob and renamed him "Israel"; his life with his wives *Rachel and *Leah and his uncle Laban; the adventures of his son *Joseph in Egypt; and Jacob's later life and *death in Egypt. Christian commentators (such as Saint *Augustine) saw Isaac's blessing of Jacob as a prefiguration of *Christ, and the mysterious wrestling episode was interpreted, by Christian theologians, as symbolic of the struggle between *virtue and *vice, the *church and the *synagogue, or (per Saint *Gregory Nazianzus) the interior conflict of good and evil in the human *soul.

Example: Scenes from the Life of Jacob, Vienna Genesis, sixth century, Vienna, ON, Cod. theol. gr. 31, f. 12v. (Synder, cp. 6)

JACOB'S LADDER. On an overnight stop en route from his family and birthplace to seek a new life with his relatives, *Jacob experienced a dream vision (Genesis 28:10–22) of a ladder reaching from earth to *heaven with *angels ascending and descending upon it. The subject was illustrated as early as the third century (e.g., frescoes in the synagogue of Dura Europas) and appears frequently in medieval manuscripts, sculpture, and mosaic. Jacob may be shown reclining or sleeping on his pillow of stone, and *God may appear at the top of the diagonally positioned ladder. The number of angels represented diverges as well as the number of rungs on the ladder (fifteen rungs, according to *Herrad of Landsberg, representing the *virtues; the ascending angels represent the *con-

templative life and the descending angels, the *active life). The path of the ladder from earth to heaven was also understood by Christian theologians as a symbol for the Virgin *Mary. Jacob may be shown awake after this vision and pouring oil on a pillar he made of the stone to commemorate the site as Bethel, the house of God. The Stone of Scone beneath the coronation chair in Westminster abbey is traditionally Jacob's pillow stone.

Example: Jacob's Ladder, Lambeth Bible, c.1145–1155, London, Lambeth PL, MS 3, f. 6. (Cahn, fig. 141)

JACOBUS DE VORAGINE. See GOLDEN LEGEND.

JAIRUS'S DAUGHTER, RAISING OF. See RAISING OF JAIRUS'S DAUGHTER.

JAMES THE GREATER, SAINT. The brother of *John the *apostle and son of Zebedee, the apostle James (d. c.44) was among the first disciples to be summoned by Jesus, who called him away from his life as a fisherman (see: *Calling of Peter and Andrew). He, along with *Peter and John, was present at the *Transfiguration of Jesus as well as (according to the Gospels of *Mark and *Luke) a witness at the *miracle of the *Raising of Jairus's Daughter. The first apostle to be martyred, he was beheaded at the order of King *Herod Agrippa I (Acts 12:1–2).

Early historians and theologians expanded upon the biblical accounts. The soldier who led James to his execution was said to have repented at the last minute; he was blessed and forgiven by James and then beheaded along with him. Another early account (third century) describes how James, before his *death, converted two magicians, named Hermogenes and Philetus, by exhibiting his power over *demons. These scenes, as well as his *martyrdom, appear primarily in the Romanesque and Gothic period.

The association of Saint James with Spain probably began in the seventh or eighth century (first mentioned in the Martyrology of *Florus of Lyons and in *Beatus of Liébana's *Commentary on the *Apocalypse). The discovery of his *relics (revealed by an *angel in a vision to a hermit, located by peasants guided by a star) provided the foundation for the *pilgrimage to Compostela ("the field of the star," or "burial place"), which developed into one of the most important institutions of the Middle Ages. The story of the translation and discovery of the relics of Saint James is complex. He had previously preached in Spain, miraculously received a pillar (now in Saragossa) from the Virgin *Mary, returned to Jerusalem and was executed, then borne back to Spain by his disciples with angelic guidance. His body disappeared into a stone, which the pagan queen Lupa ordered oxen to remove; they dragged the stone to her palace instead, and she was converted. Eventually his body was enshrined in a burial chapel—the location of which was later forgotten (until rediscovered by the peasants mentioned above).

These subjects are illustrated in art from the Romanesque period onward, as well as the powerful image of *Santiago Matamoros* (Saint James the Moor-slayer), which was popular especially during the expulsion of the Moors from Spain and during the Crusades. The image of Saint James, bearing a sword and riding into battle on a white horse purportedly first appeared in visions to Christian warriors during the reconquest of Spain in the Carolingian period. Hence, art and legends also link Saint James with *Charlemagne (see also: *Chanson de Roland*). Various other *miracles were recorded, especially episodes of his assistance to *pilgrims en route to his shrine, and Saint James himself is also often represented as a pilgrim, wearing a large hat bearing the scallop shell badge which identifies pilgrims to Compostela, carrying a staff and script (or knapsack). He may also be shown with a sword.

Example: Martyrdom of Saint James, c.1200, fresco, Saint-Jacques-des-Guérets, Saint-Jacques, south wall. (Demus, pl. 176)

JAMES THE LESS, SAINT. Information about the *apostle James the Less is somewhat difficult to extract from the Gospels, as perhaps three different persons with the name James are mentioned among Jesus' disciples. Two apostles named James were present in Acts 1:13 at the election of Matthias (*Judas's replacement), one of these being *James the Greater; the other James is here called "the son of Alpheus." Elsewhere (e.g., *Mark 6:3) James is referred to as a relative (brother) of Jesus. This is probably the James who became a leading figure in the church in Jerusalem (Acts 12:17, 21:18), is traditionally the author of the Epistle of James, was referred to by Saint *Paul in his Epistles to the Galatians and Corinthians, and was martyred in 62 (according to *Josephus and later, Eusebius). His austerity and constant prayer were noted by Eusebius, and accounts of his *martyrdom state that he was thrown from the Temple wall by the orders of the High Priest and was beaten to death by a cloth fuller with a fuller's club. The club is thus James's attribute; he is also depicted in bishop's robes, and scenes of his martyrdom appear in western and Byzantine mosaics and hagiographic manuscripts.

Example: Martyrdom of James, c.1200, mosaic, Venice, San Marco, south aisle. (Demus, SM, fig. 45)

JANUS. See LABORS OF THE MONTHS.

JEREMIAH. One of the four major *prophets, Jeremiah was born in the mid-seventh century B.C. and lived through the tumultuous period of the collapse of the monarchy and the Babylonian conquest of Jerusalem, making insistent and dramatic predictions of the necessity of submission to defeat and exile. Initially, the youth Jeremiah was a reluctant prophet, but *God encouraged him by touching him on the mouth (a subject which appears in art) and providing him with a vision of a flowering almond branch (understood by medieval theologians as a prefiguration of the Christian *church). During the seige of Jerusalem in 587

under *Nebuchadnezzar, Jeremiah preached surrender and was thrown into an abandoned cistern; hence, he may be shown in art with the legendary manticore, a human-eating beast which lives underground. Extrabiblical tradition suggests that he was rescued by an Ethiopian, but later, against his will and advice, was forced along on the Hebrew flight to Egypt where he was stoned to *death because of his predictions. Medieval Christians saw in the dire tone of Jeremiah's prophecies a prefiguration of the sufferings of *Christ; hence (apart from the narratives mentioned above) he may be shown with a *cross. He is also depicted as an elderly bearded figure holding a scroll.

Example: The Calling of Jeremiah, Winchester Bible, c.1150–1180, Winchester, CL, f. 148. (Dodwell, fig. 371)

JEROME, SAINT. Jerome (342–420), one of the four Latin *Doctors of the Church, was born at Stridon in Dalmatia, brought up as a Christian, studied classical literature, traveled much throughout his life, and gained great fame for his scholarship. He lived as a hermit and in community with other ascetics at various periods in his life, was ordained a priest in Antioch, studied under Saint *Gregory Nazianzus, served as secretary to Pope Damasus in Rome from 382 to 385, was extremely involved in discussions of contemporary theological controversies and heresies, and founded a monastery in Bethlehem (386) where he lived his last years. His preeminent work of scholarship was his revised translation of the Latin Bible from Hebrew and Greek sources (referred to as the "Vulgate" Bible) which he began c.382 under the direction of Pope Damasus and completed c.404. He produced three versions of the Psalter (the "Roman" and "Gallican," based on Greek sources, and the later "Hebrew" revision). He also composed numerous biblical commentaries, a bibliography of church writers *(De viris illustribus),* plus copious tracts and over 100 letters. Jerome's teaching in Rome inspired several female disciples (Melania, elder and younger) as well as Paula and her daughter, Eustochium, who both accompanied Jerome to Bethlehem and founded convents. In art, Jerome appears as a scholar (for example in *author portraits in manuscripts), as an ascetic, and may be accompanied by a lion; according to the *Golden Legend,* he withdrew a painful thorn from the lion's paw, and the beast became his companion.

Example: Story of Jerome's Translation of the Bible, Vivian Bible, c.845, Paris, BN, MS lat. 1, f. 3v. (Snyder, fig. 259)

JERUSALEM. See HEAVENLY JERUSALEM.

JESSE. See TREE OF JESSE.

JESTER. See FOOL.

JESUS CHRIST. See CHRIST, JESUS, LIFE AND PASSION OF.

JEWS. During the Middle Ages, Jews lived in Islamic and Christian areas of Europe. The Jewish contributions to medieval life, culture, and urban growth were enormous. Jewish scholars, especially in Spain, were responsible for translating many classical and scientific texts, previously unknown in the west, into Hebrew and Latin from Arabic sources. For example, the study of *Aristotle by the great Jewish scholar Moses Maimonides (1135–1204) was of great influence on the medieval theologian Saint *Thomas Aquinas. However, anti-Jewish attitudes increased through the Middle Ages, based on both religious and economic factors. Jews were persecuted during the Crusades, especially in the Rhineland during the First Crusade, and became the scapegoats for the Black Death in the mid-fourteenth century. Sporadic persecutions and expulsions of Jews from Christian territories were carried out through the High and late Middle Ages.

In early Christian and medieval art before the eleventh century, no distinctive iconography or costume was used to specifically distinguish Jewish persons in illustrations of biblical or other subjects. The *prophets, *patriarchs, and other biblical figures are understood as Jewish simply within the contexts of the pictorial narratives. Beginning in the eleventh century, however, Jews are identifiable in art through a variety of iconographic motifs, especially costumes and hats. Jews wear round caps, pointed, conical, knobbed, or funnel-shaped hats. The *Judenhut* (*pileus cornutus*, pointed hat) may have initially been a voluntary fashion but was specified among the required identifying badges for Jews at the Fourth Lateran Council of 1215. The directive of distinguishing Jews by dress was interpreted with some variation in different regions: in France, a circular badge was worn on outer garments; in England, the badge of yellow cloth was tablet shaped. The distinctive varieties of Jewish hats are, however, the most often represented in art from the eleventh century onward.

Example: Moses and Aaron with His Sons, c.1220, fresco, Berghausen im Sauerland, Sankt Cyriacus, apse. (Demus, p. 147)

JOAB. Joab was the chief commander in the army of his uncle, King *David, responsible for the treacherous murder of Abner and, later, of David's son *Absalom. Although Joab, at David's request, assisted in the elimination of *Bathsheba's husband Uriah, his many misdeeds and disobediences eventually resulted in his own killing at the orders of David's son and successor *Solomon. Joab is found in representations of the biblical narratives concerning the life of David, especially the detailed cycles in Romanesque and Gothic manuscript illustrations and stained glass.

Example: Scenes from the Life of David, Leaf from Winchester Bible, c.1180, New York, PML, MS 619v. (Cahn, fig. 145)

JOACHIM. First mentioned in the second century apocryphal *Protevangelium of James*, Joachim was the father of the Virgin *Mary and the husband of Saint *Anne. The lives of Joachim and Anne were elaborated in the thirteenth-century

Golden Legend, and although they had been previously depicted in art, narrative illustrations abound after this date especially. Their childless state, after twenty years of marriage, was criticized by the high priest of the Temple in Jerusalem; Joachim retired to the desert and fasted for forty days and nights, at the end of which an *angel appeared and announced that Anne would conceive. The angel appeared to her with a similar message. They were both directed to meet at the Golden Gate of Jerusalem. Joachim is generally shown as an old man with a beard; related narratives include his rejection at the Temple, his vigil in the desert and visit by the angel (usually understood to be *Gabriel), his embracing Anne at the Golden Gate, his standing by in amazement at Mary's birth, and finally his assisting Anne in the *Presentation of the Virgin at the Temple. (See also: *Annunciation, *Immaculate Conception, *Meeting at the Golden Gate.)

Example: Annunciation to Joachim, Hereford Troper, mid-eleventh century, London, BL, Cotton MS Caligula A.XIV, f. 26. (Dodwell, fig. 99)

JOB. The story of Job is told in the Old Testament book which bears his name. He was a very rich and extremely devout man but was forced to go through a gruesome series of tragedies and physical sufferings. The *Devil (*Satan, or adversary) accused Job of remaining pious only so long as he remained prosperous and felt protected by *God. God gave the Devil permission to test Job, which resulted in Job losing his goods, sheep, cattle, *shepherds, servants, and his children and other family members; finally the Devil caused Job to be covered with sores all over his body. Job suffered and lamented but did not curse God in spite of the urgings of his wife and the words of his friends. Eventually, God restored his fortunes in double, and Job produced ten more children. The story of Job is an exposition on the causes for human suffering and a powerful tale of faith in the face of extreme adversity. Saint *Gregory the Great's *Commentary on the Book of Job* describes Job's sufferings as prefiguring those of *Christ.

The subject of Job was extremely popular throughout early Christian and medieval art, both in narrative cycles and individual scenes. Job, covered with sores, seated on a dungheap (or ash pile), appears in early Christian catacomb frescoes and sculpture. Job's wife may be shown standing nearby, scolding him, holding her nose against the stench or throwing a bucket of water on him. Pictures of Job appear in medieval manuscripts and frequently in Romanesque and Gothic portal sculpture. He is the patron saint of lepers and plague victims.

Example: Job Afflicted by Leprosy, c.1220, Chartres Cathedral, north transept portal, right tympanum. (Sauerländer, fig. 90)

JOHN THE BAPTIST, SAINT. John the Baptist (d. c.30) plays an extremely significant role in the Gospels and in Christian art primarily in his foreshadowing and recognition of Jesus as the Messiah (the Lamb of God, *Agnus Dei*) when he baptized Jesus in the river Jordan (see: *Baptism). John had been living as

an austere preacher in the wilderness, feeding on locusts and wild honey, dressing in camel skin robes, and calling for repentance; he is described as a ''messenger,'' ''the voice of one crying in the wilderness'' (*Mark 1:1–11).

The birth and *death of John the Baptist are also described in the Gospels. His mother, *Elizabeth, was a kinswoman of the Virgin *Mary, to whom Mary paid a visit during their pregnancies (see: *Visitation). John's birth (to elderly parents) was also announced in advance by the *angel *Gabriel to his father, *Zacharias, who refused to believe it and was struck dumb until John's *circumcision and naming eight days after his birth (*Luke 1:57–64). Apocryphal sources (e.g., the *Protevangelium of James*) describe how Elizabeth and the infant John escaped the *Massacre of the Innocents by hiding in a cave and how they met the *Holy Family after their return from the *Flight into Egypt. John was imprisoned shortly after Jesus' Baptism (Mark 1:14) at the urging of Herodias, the wife of *Herod; her eventual request for John's head resulted in his decapitation (see: *Feast of Herod). The historian *Josephus stated that John's imprisonment and death took place in the fortress of Machaerus near the Dead Sea. His alleged tomb at Sebaste was destroyed in the mid-fourth century, and his *relics were scattered and distributed widely.

Scenes of the Baptism of Jesus by Saint John appear in art as early as the third century (e.g., catacomb frescoes and sarcophagi). John is normally depicted as a tall, bearded figure, clothed in a shaggy garment. He stands on the riverbank and lays his hand upon Jesus' head. This is the moment when the dove of the *Holy Spirit appeared and *God's voice was heard announcing Jesus as his son. Sometimes John holds a staff or crozier; and a honeycomb or honey jar as well as an ax jutting from the base of a tree may be included. The latter refers to John's words (recorded in *Matthew 3:10 and Luke 3:9): ''the ax is laid unto the root of the trees'' in warning that trees which do not bear ''good fruit'' will be ''hewn down.'' These elements (the ax, staff, and honeycomb) frequently function as John's iconographic attributes. He is often also shown with a lamb, which he carries or points to as it stands near his feet. He is otherwise recognizable by his ragged clothing and unkempt hair and beard. In later Byzantine *icons, John is also shown with wings, indicating his status as a heavenly ''messenger'' (see: *Angels).

Narrative scenes of John's birth and infancy and episodes surrounding his death also appear in early Christian and medieval art. Scenes of his birth and circumcision are found especially from the Romanesque period onward, while illustrations of the flight of Elizabeth and John during the Massacre of the Innocents appear as early as the sixth century. John's reproof of Herod and Herodias, the imprisonment of John, the Feast of Herod, dance of Salome, decapitation of John, and presentation of his head on a platter are all subjects found throughout medieval art, as independent episodes or in detailed narrative cycles. Saint John *preaching, baptizing the multitudes, and the entombment of Saint John also appear, as well as scenes of the discovery and burning of his relics. John is also shown (e.g., in eleventh-century Byzantine mosaics) in scenes

of the *Anastasis, present at or announcing *Christ's Harrowing of Hell, and he features frequently in scenes of the *Last Judgment in his role as intercessor, paralleling the Virgin Mary with whom he is also paired in *Deësis groups. In late medieval art, the depiction (in both two and three dimensional media) of the severed head of John on a platter became a popular devotional image (see: *Andachtsbilder).

*Example: Saint John the Baptist, c.1250–1275, icon, Mount Sinai, Monastery of Saint Catherine. (The Icon, p. 230)

JOHN CHRYSOSTOM, SAINT. One of the *Doctors of the Greek *church, John ("of the golden mouth," c.347–407) was famed for his eloquent *preaching as a priest in Antioch and later as Patriarch of Constantinople (from 398). His *Homilies* on various biblical books emphasize literal interpretation and practical application. He was a strict moralist and lived as a desert hermit before his ecclesiastic appointments. As a zealous reformer and outspoken critic of both clerical and courtly extravagence, he provoked many at the court of Constantinople (notably the Empress Eudoxia) and was twice banished. He died during his second exile. John is represented in both western and Byzantine art as a serious and austere preacher and *author. He is often grouped with Saints *Basil and *Gregory Nazianzus and may have a beehive as an attribute, signifying his eloquent speech, sweet as honey. Narrative scenes show him departing for exile and giving alms to the poor.

*Example: Saint John Chrysostom, 1350–1400, mosaic icon, Washington, D.C., Dumbarton Oaks. (The Icon, p. 81)

JOHN CLIMACUS, SAINT. Monk, hermit, and abbot of Saint Catherine's monastery at *Mount Sinai, John Climacus (c.570–649) is especially known for his treatise on the monastic life: the *Climax* or *Ladder of Paradise*. Arranged in thirty chapters, or "steps of the ladder" to spiritual perfection (the number thirty chosen to correspond with *Christ's age at his *Baptism), the text concerns *vices and temptations to be overcome by monks and *virtues to be attained. Widely copied and translated, illustrated manuscripts of and *icons inspired by the text often depict, among other subjects, the allegorical ladder to *heaven in literal form, with Christ or *God at the top, monks ascending, guided by *angels or pulled off the ladder by *demons. The image is similar to that of *Jacob's Ladder.

*Example: Heavenly Ladder, c.1150–1200, icon, Mount Sinai, Monastery of Saint Catherine. (Weitzmann, pl. 25)

JOHN OF DAMASCUS, SAINT. John of Damascus (or John Damascene, c.675–750) was an influential Byzantine theologian whose works were also highly regarded and studied in the west. After a career in church administration, he retired to the monastery of Saint Sabas near Jerusalem, where he lived the

remainder of his life. He was *author of a number of treatises and hymns; his most important theological texts include the *Fount of Wisdom* and the *Sacra parallela* (a compilation of biblical and patristic texts on the Christian life). He also authored, between 726 and 730, three significant discourses in defense of holy images, clearly refuting the iconoclastic position and hence playing an important role in the eventual reinstatement of imagery in the Byzantine church. (See: *Iconoclastic Controversy.)

Example: Scenes from the Life of John of Damascus, late fifteenth century, frescoes, Lodi, San Francesco. (Kaftal, NW, figs. 549–569)

JOHN THE EVANGELIST AND APOSTLE, SAINT. John, the son of Zebedee and brother of Saint *James the Greater, plays an important role in the Gospels and in art from the early Christian period onward. Traditionally identified as the "disciple whom Jesus loved" (John 13:23), his significance in the Gospels, his reputed authorship of the Gospel of John and several Epistles, as well as his role as recipient of the *Apocalypse have earned him an extremely prominent position in the visual arts.

As one of the *Four Evangelists, John appears in art throughout the medieval period in the guise of an *author and may be accompanied or represented by his animal symbol, the eagle, which was chosen to signify the high-soaring and inspirational quality of his writing (see also: *Animals, Symbolism of; *Tetramorphs*). Portraits of John as an author occur as prefatory illustrations in Gospel manuscripts and in a variety of other artistic contexts.

John appears in several New Testament episodes that are frequently illustrated in art. He is represented, along with his brother, as a fisherman in scenes showing Jesus summoning the *apostles; the men are shown in a boat or leaving their nets (see: *Calling of Peter and Andrew). John, James, and *Peter are named as the apostles present at the *Transfiguration as well as the companions of Jesus at the *miracle of the *Raising of Jairus's daughter. At the *Last Supper, the beloved disciple (understood to be John) is described as having been seated next to Jesus, resting his head on the table or leaning against Jesus' shoulder. John becomes thus identifiable in several scenes and is frequently shown as youthful and beardless. His prominent position at the Last Supper also inspired, in later medieval northern Europe, devotional sculptures depicting the seated Jesus and Saint John as independent images extracted from the narrative context (see also: *Andachtsbilder). John was also identified by early commentators as the bridegroom of the *Marriage at Cana (his intended bride was *Mary Magdalene), and he is traditionally shown in scenes of the *Crucifixion of Jesus, standing opposite the Virgin *Mary beside the *cross, following the text of John 19:26–27. The youthful John may also be identifiable in scenes of the *Deposition, *Lamentation, and *Entombment of Jesus.

As the recipient and author of the Apocalypse, John appears often in illustrated Apocalypse cycles, witnessing the visions as well as recording them in

writing. He may be shown seated and writing, in a landscape setting indicating the island of Patmos (where he states the writing was composed, Rev. 1:9), or he may stand, receiving a book or scrolls from *God or *Christ.

Illustrated Apocalypse cycles frequently include further episodes from the life of John, which derive from apocryphal sources such as the *Acts of John*. Many of these stories (further elaborated in the **Golden Legend*) also appear in fresco, manuscript illustration, sculpture, mosaic, and stained glass. Scenes include the episode where John was tortured in a cauldron of boiling oil under the orders of the emperor Domitian in Rome; the challenge of the pagan high priest in Ephesus in which John proved the superiority of the Christian God by making the sign of the cross over a cup of poison, causing the evil potion to come out shaped as a serpent; his raising back to life of the Ephesian widow Drusiana, who sat up in her coffin; several other *miracles involving transformations of wood and stones into gold and precious gems; as well as posthumous appearances (e.g., to the empress Galla Placidia to whom he gave one of his sandals as a *relic for the church she founded in his honor in Ravenna). According to these apocryphal sources, John, like *Elijah and *Enoch, was "assumed" into *heaven upon his *death at a very advanced age; in these scenes he is shown as an extremely elderly, bearded figure. He is also said to have dug his own (cross-shaped) grave when Christ appeared to him in a vision and alerted him of his coming death. After he lay down in the grave, a great light momentarily blinded the witnessing disciples, who then saw that John's body was gone and *manna* (or a eucharistic wafer) was left in the grave, emitting a sweet smell.

Because Jesus spoke to both John and Mary from the cross (John 19:26–27), the tradition that Jesus entrusted Mary to John's care was developed in tales of their later life in Ephesus. John is thus often present in illustrations of the *Dormition and *Assumption of the Virgin.

As an independent figure, when not accompanied by his eagle attribute, John will often be shown holding a cup or chalice containing a curling serpent.

Example: Saint John, Codex Aureus, c.750, Stockholm, RL, MS A.135, f. 150v. (Snyder, fig. 220)

JONAH. Jonah was a Hebrew *prophet, associated with the eighth century B.C., whose story is recounted in the short Old Testament book which bears his name. He disobeyed *God's command to go to Nineveh and preach against the wickedness of its citizens; instead he boarded a ship bound for another city. God hurled a great storm at the sea, and the sailors cast lots to determine the cause of the storm. Jonah was discovered to be the culprit and, at his request, the sailors threw him into the sea where he was swallowed by a huge *fish. Jonah spent three days and three nights in the belly of the fish. Finally God responded to Jonah's *prayer, and the fish disgorged Jonah upon dry land. Jonah then went to Nineveh and carried out his mission with instantaneous success; the citizens repented, and God relented from carrying out punishment on the people of Nineveh. Jonah sulked outside the city in the shade partially afforded by a gourd

tree, which God caused first to grow and then to die. God pointed out to Jonah that Jonah's sorrow about the gourd tree should help Jonah understand God's compassion for the city of Nineveh. The story ends inconclusively. Jonah's tale was referred to by *Christ as an occasion for repentance and was also understood by Christian theologians as a prefiguration of Christ's own *Entombment (for three days and nights), *Resurrection, and hence salvation for humankind. The story of Jonah was especially popular in early Christian art and appears in catacomb frescoes, in small-scale free-standing sculpture, and on carved sarcophagi. Vignettes chosen for separate or sequential illustration include Jonah cast overboard, swallowed and disgorged by the huge fish (often creatively interpreted as a sea serpent or a dragonlike or whalelike creature), and resting under the gourd tree.

Example: Jonah sarcophagus, late third century, Rome, Lateran Museum. (Synder, fig. 8)

JONATHAN. Jonathan, a skillful soldier, was the eldest son of King *Saul. He formed a close friendship with *David (who married his sister Michal) and defended and protected David against the jealousy of Saul. Although Saul found him disobedient and accused him of treason, Jonathan remained loyal to both David and Saul. He was killed in battle against the Philistines (along with two of his brothers and his father). David mourned his *death greatly. Jonathan features in biblical narrative illustrations of the lives of Saul and David, especially in the detailed pictorial cycles of Romanesque and Gothic manuscript illustration.

Example: David and Jonathan, Bible historiale, c.1430, The Hague, KB, MS 78 D 38(1), f. 171. (Marrow, pl. 38)

JOSEPH. The dramatic life of Joseph, the favored son of *Jacob, is described in chapters 37–48 of Genesis. He was a very popular subject in early Christian and medieval art; narrative scenes from Joseph's life include: his father favoring him with a gift of a multicolored or long-sleeved coat; his jealous brothers throwing him down a well and selling him into slavery; his adventures in Egypt, including fleeing from the seduction attempt by the wife of his master *Potiphar; her subsequent accusation of him and his imprisonment; his interpretation of dreams (including those of *Pharaoh) and elevation to the position of viceroy of the land; the reconciliation with his family; and Jacob's blessing of Joseph's sons *Ephraim and Manasseh. In medieval Christian interpretation, events from Joseph's life are linked typologically with the life of *Christ, for example, his being cast into and retrieved from the well is a prefiguration of the *death and *Resurrection of Jesus; his wisdom in supervising food storage in anticipation of famine prefigures Christ's miraculous feeding of the multitude; and Jacob's crossed arm gesture in delivering the right-handed blessing to Joseph's younger son Ephraim was understood as the supplanting of Judaism by Christianity. Extended narrative cycles occur in early Christian ivories, manuscripts, frescoes,

and mosaics, and also in later medieval manuscripts, sculpture, and stained glass windows. As an independent figure, Joseph may be shown with his attribute of a blade or sheaf of wheat.

Example: Scenes from the Life of Joseph, c.547, ivory, *Throne of Maximian,* Ravenna, Archepiscopal Museum. (Synder, cp. 10)

JOSEPH, SAINT. Joseph was the husband of the Virgin*Mary. He is described in the Gospels as a pious man, of kingly descent (*Matthew 1:18–20; *Luke 2: 4), a craftsman (Matthew 13:55, translated as "carpenter"). Matthew describes how he was visited by an *angel in a dream, before his marriage to Mary; the angel reassured him that his pregnant wife-to-be was divinely chosen to give birth to the savior Jesus. After their marriage, Joseph is described as having been present at the birth of Jesus (see: *Nativity), at Jesus' *Circumcision and *Presentation in the Temple, again alerted by an angel of the upcoming *Massacre of the Innocents, and taking Mary and the infant Jesus on the *Flight into Egypt. He features again in the Gospel accounts of the search for and discovery of the young Jesus in the Temple in Jerusalem (see: *Dispute in the Temple). Although mentioned by name (as Jesus' "father") several more times in the Gospels, Joseph plays no further part in the canonical narratives.

Many further details about Joseph are found in apocryphal sources such as the *Protevangelium of James* and the fifth-century *History of Joseph the Carpenter*, which provided further materials for pictorial narratives concerning the betrothal and *Marriage of the Virgin (see also: *Watching of the Rods) and clarified Joseph's advanced age (well over eighty) when he married Mary. He is also said to have instructed the boy Jesus in the carpentry trade and to have been a widower, with several children from a former marriage. Apocryphal sources also describe how Jesus, Mary, and angels were present at his *death, providing an ideal model for late medieval images of a "good" death (see: *Ars moriendi*).

Throughout early Christian and medieval art, Joseph is generally depicted as an elderly figure, with white hair and beard. He may carry a crutch, flowering rod, or carpentry tools. Although he features significantly as the recipient of angelic dream visions and in the flight of the *Holy Family into Egypt, he often appears as a somewhat ancillary figure in (especially early) images of the birth of Jesus where, if present at all, he may be shown somewhat removed, brooding, or contemplative. The tendency to characterize Joseph as an impotent old man increases in later medieval western art, in which his rough clothing and doddering old age are in stark contrast to the youthful grace of his virginal wife. While devotion to Joseph arose early in the Byzantine church, a more positive pictorial assessment and liturgical position for Joseph developed later in the west, especially in the postmedieval period.

Example: Joseph Warned by an Angel, Pericopes of Saint Erentrude, c.1150, Munich, SB, MS lat. 15903, f. 5v. (Robb, fig. 121)

JOSEPH OF ARIMATHEA. As recounted in all four Gospels, Joseph of Arimathea was a rich man, a prominent and respected member of the Jewish community, who secretly became a disciple of Jesus. After the *Crucifixion, he obtained permission from *Pontius Pilate to bury Jesus' body, which he did, in an unused tomb he had previously purchased for himself. Joseph of Arimathea thus appears primarily in scenes of the *Deposition and *Entombment of *Christ, helping *Nicodemus take the body down from the *cross (supporting the body while Nicodemus removes the nails), carrying the body to the tomb, and placing the body in the tomb or sarcophagus. Sometimes he is identifiable by his garments, which are more lavish than those of the other disciples. He is usually depicted as an elderly figure, bearded. The twelfth-century English historian Geoffrey of Monmouth credited Joseph of Arimathea with founding, at Saint *Philip's direction, the first Christian church in England, at Glastonbury, after having journeyed to Gaul with *Mary Magdalene and Lazarus (see: *Raising of Lazarus). Additions to this story recount that, at the Crucifixion, Joseph of Arimathea collected Christ's blood in the chalice previously used at the *Last Supper. This is the *Holy Grail, which Joseph buried at Glastonbury. He thus also features in the illustrated *Arthurian legends, which were especially popular in the Gothic period. He may also be recognized by his attributes: the chalice, crown of thorns, nails, and shroud of Christ.

Example: Deposition, c.1200, fresco, Aquileia Cathedral, crypt. (Dodwell, fig. 175)

JOSEPHUS. The Jewish priest, aristocrat, military leader, and historian Flavius Josephus (c.35–100) played an important role in, and wrote about, the war waged between the Romans and the *Jews (66–70). The leader of Galilean forces in the revolt, Josephus was taken prisoner by the Romans in 67, after which he won the favor of the Roman emperor Vespasian and his successors, the emperors Titus and Domitian. His surrender as well as his service as interpreter for the emperor Titus during the siege of Jerusalem in 70 perhaps inevitably caused hostility toward him on the part of the Jews. Honored with a pension and Roman citizenship, Josephus resided in Rome after the war and wrote several works, including the *Jewish War* (*De bello Judaico*) in 77–78, and the *Antiquities of the Jews (Antiquitates Judaicae)* in 94. The former work purports to be largely an eye-witness account of recent history; the latter work describes the history of the Jews from *Creation to the mid–first century A.D. Writing under Roman imperial patronage and support, his works exhibit a distinctive slant in his efforts to sympathetically present his descriptions of Jewish life, conduct, customs, and history to the Roman audience (and vice versa). The famous reference to *Christ included in his *Antiquitates* is considered by many to be an interpolation by a later Christian writer. More influential after his *death than with his contemporaries, Josephus' works were greatly appreciated and commented upon during the early Christian and medieval period when he was considered an expert source on numerous topics including history, geography,

military tactics, theology, and natural sciences. His works were frequently copied and studied and also appear in illustrated versions (especially for aristocratic patrons) through the Middle Ages.

Example: De bello Judaico, late eleventh century, Paris, BN, MS lat. 5058, f. 3. (Dodwell, fig. 216)

JOSHUA. Joshua, companion and helper of *Moses, became the leader of the Israelites after the *death of Moses and directed the conquests of the city of Jericho and other sites in the land of Canaan. Several scenes from his life are often illustrated in art, including the miraculous passage through the Jordan river, his meeting an *angel, the fall of the city of Jericho, the sun and the moon standing still, plus other scenes of battle and violence. The name Joshua is a variation of Jesus; Christian interpreters thus identified him as an Old Testament prefiguration of *Christ, and events from his life are typologically connected with New Testament episodes: the fall of Jericho foreshadows the *Last Judgment, and the twelve stones he took from the river Jordan represent the twelve tribes of Israel and the twelve *apostles. Scenes from the life of Joshua are found in early Christian mosaics, in detailed sequential narrative form in the unusual tenth-century Byzantine "Joshua Roll" and are frequent in western medieval and Byzantine manuscript illustration.

Example: Joshua and the Emissaries from Gibeon, Joshua Roll, tenth century, Rome, BAV, Cod. Palat. grec. 431. (Snyder, fig. 164)

JOSIAH. King of Judah in the late seventh century B.C., the reform effort of the great leader Josiah is described in the Old Testament books of 2 Kings and 2 Chronicles, although he features in medieval art most frequently in illustrations of the *Tree of Jesse, as a crowned figure, one of the *Ancestors of Christ.

Example: Tree of Jesse, c.1200, stained glass, Canterbury Cathedral. (Caviness, fig. 134))

JUDAS ISCARIOT. One of the twelve *apostles, Judas was responsible for the *Betrayal of *Christ, which led to Christ's *Arrest, *Trials, and eventual *Crucifixion. The Gospels recount that Judas struck a bargain with the Jewish high priests either before (*Matthew 26:14–16; *Mark 14:10–11; *Luke 22:3–6) or after (*John 13: 27–30) the *Last Supper and received thirty pieces of silver in payment for leading guards to Jesus in the garden of Gethsemane and identifying him (see also: *Agony in the Garden). Judas is less frequently depicted accepting the payment and more often shown attempting to return the money after Jesus was sentenced to *death. The high priests refused the money; Judas is depicted standing before the elders with a money bag or pouring out the silver pieces as he flees. This subject appears in sixth-century mosaics and manuscripts and is often followed by the scene of Judas's suicide. Matthew (27: 5) tells that Judas hanged himself, which subject appears, paired with the Crucifixion, on early fifth-century ivories. In sixth- and ninth-century manuscripts, the image of Judas's suicide is found next to the scene of the Betrayal. Examples

from the twelfth century and later often include the *Devil or *demons in the scene of Judas's suicide, gleefully receiving Judas's *soul. Judas's belly may be shown as slit open, with his entrails gushing out; this follows Acts 1:18 where Saint *Peter describes Judas's death by falling and bursting open. Judas is also found in images of *hell, tormented by demons or chewed by the Devil. He is frequently identifiable by his pose and gestures in images of the Last Supper as well as the episode at Bethany when he objected to *Mary Magdalene's anointing of Jesus with oil.

 Example: Suicide of Judas, c.420, ivory, London, BM. (Synder, fig. 106)

JUDAS MACCABEUS. Leader of the Jewish revolt against the Seleucid rulers in the second century B.C., Judas (called "the Hammer") was a very successful military commander and strategist. Especially acclaimed for his liberation of Jerusalem and rededication of the Temple, which had been profaned by pagan *idols and sacrifices, his rebuilding of the Temple altar is commemorated by the festival of Hanukkah. Although the Macabees did not manage to retain control over the region, Judas's legacy as a great national hero earned him lasting fame and honor. In the Middle Ages, he was included among the Nine Worthies (see: *Arthurian Legends). Scenes involving Judas Maccabeus and his brothers and sons, the Maccabees, are found primarily in biblical manuscript illustrations for the books of Maccabees (two considered canonical, two apocryphal) and include numerous battle scenes as well as the gruesome tortures and deaths of seven brothers (2 Maccabees 7) who were also venerated as martyrs by both western and Byzantine churches from the early Christian period onward.

 Example: 1 Maccabees page, Erlangen Bible, c.1175–1200, Erlangen, UL, Cod. 1 perg., f. 297v. (Cahn, fig. 160)

JUDE, SAINT. Jude (or Judas Thaddeus) was one of the twelve *apostles and traditionally the *author of the Epistle of Jude. He is mentioned by name in the Gospels (in lists of the apostles, e.g., *Luke 6:16) and is cited as having been present at the *Last Supper (*John 14:22) and *Pentecost (Acts 1:13). Apocryphal texts expand upon his role in the New Testament; the *Passion* (or *Acts*) *of Simon and Jude* (contained within the *Apostolic History* of Abdias) recounts his missionary work and many adventures with the apostle Simon in Persia, Syria, and Mesopotamia and their eventual *martyrdom by being beaten to death with clubs and sticks after they exorcised *demons from a pagan temple. He also features in the legends of the *Mandylion,* serving as the emissary to King Abgar of Edessa (healing him, or actually bringing the *relic to him). These stories are also all detailed in the *Golden Legend.* He appears in art from the fifth century onward, among groups of apostles (identifiable by his attribute, a stick or club), is often paired with Simon, and also appears in narratives detailing his deeds and martyrdom.

 Example: Martyrdom of Jude, c.1200, mosaic, Venice, San Marco, south aisle. (Demus, SM, fig. 47)

JUDGMENT. See LAST JUDGMENT.

JUDGMENT OF SOLOMON. One of the episodes from the life of the wise King *Solomon very often illustrated in early Christian, Byzantine, and western medieval art, the Judgment of Solomon is described in 1 Kings 3:16–28. The text recounts that two harlots, who shared a house and who had each recently given birth to a son, came to Solomon carrying only one infant. One of them accused the other of having stolen the living baby and substituting it for her own, which she had accidentally suffocated. They argued their rival claims to the living infant before Solomon, who then called for a sword to be brought so he could divide the baby in two. At this point, one woman surrended her claim while the other woman agreed to the slaughter. Interpreting these responses, Solomon then awarded the child to its rightful mother, who had valued the life of the child above all. This dramatic story of wise judgment is found in early Christian metalwork, manuscript illustration from the Carolingian period onward, Gothic sculpture, and stained glass. Solomon may be shown enthroned, approached by the two women, or directing a sword-bearing guard to slice the infant held up between the two mothers. Onlookers may be present, representing those witnesses who praised Solomon's *wisdom.

Example: Judgment of Solomon, c.1220, Chartres Cathedral, north transept, right lintel. (Sauerländer, fig. 90)

JUDITH. The story of Judith is told in the Old Testament apocryphal Book of Judith. She was a pious and attractive widow who became a great heroine by her murder of the Assyrian general Holofernes, thus ending the Assyrians' seige of the Jewish city of Bethulia. The inhabitants of the city were on the verge of surrendering, as advised by their chief priest, Ozias, whom Judith admonished. Pretending to have abandoned her people, Judith entered the enemy camp, attracted Holofernes and tricked him into believing that she would help him conquer the *Jews. He invited her to a banquet and when they were alone in his tent and he fell into a drunken sleep, she cut off his head, put it in a sack and escaped with her maidservant. Later, she stood on the walls of the city of Bethulia, displayed the head of Holofernes to the Assyrian army, and they fled under Israelite attack. The tale of Judith can be seen as a symbol of Jewish patriotism under enemy oppression and, in Christian interpretation, as the triumph of *virtue over *vice, and the Virgin *Mary as victorious over the *Devil. Judith is typically depicted in art with a sword and the severed head of Holofernes, in the act of cutting off his head, or fleeing with her maidservant. She frequently appears in medieval illustrated Bibles and sculpture.

Example: Judith, Hirsau Bible, late eleventh century, Munich, BS, Clm. 13001, f. 88. (Cahn, fig. 62)

JUSTICE. See VIRTUES.

K

KINGS, THREE. See ADORATION OF THE MAGI.

KISS OF JUDAS. See BETRAYAL OF CHRIST.

L

LABARUM. See CHI-RHO.

LABORS OF THE MONTHS. The cycle of human activities associated with the months and seasons of the year derives from classical art and appears in a variety of medieval artistic contexts. With some variation according to climate in different geographic areas, the monthly labors focus upon agricultural activities and frequently are paired with the twelve signs of the *zodiac. The labors of the months are found especially in illustrations of calendars in manuscripts, in architectural sculpture, and in stained glass. In the yearly cycle, human figures will be depicted performing the following tasks or activities: *January:* feasting or keeping warm by the fire (sometimes the ancient Roman double-headed god Janus is represented doing such); *February:* keeping warm by the fire, chopping wood, pruning trees; *March:* pruning or digging; *April:* training vines, picking flowers, hawking; *May:* hawking, scything; *June:* mowing hay, shearing sheep; *July:* mowing, reaping, cutting corn; *August:* threshing, harvesting; *September:* threshing, treading grapes, sowing, plowing; *October:* sowing, plowing, harvesting and treading grapes, thrashing trees for acorns; *November:* thrashing for acorns, slaughtering a pig or ox, baking, gathering wood; *December:* slaughtering or roasting a pig, baking, digging, feasting. In later medieval Books of Hours (see: *Manuscripts) the more leisurely pursuits of the aristocracy may be interspersed with the labors of the peasants.

Example: Calender, c.1225–1235, Amiens Cathedral, west portal, socle. (Sauerländer, fig. 172)

LAMB. See ANIMALS, SYMBOLISM OF.

LAMB OF GOD. See AGNUS DEI.

LAMBERT OF SAINT-OMER. Lambert, a canon of Saint-Omer, was responsible for composing an influential illustrated encyclopedia, the *Liber floridus* (c.1120, *Book of Flowers*); an autograph manuscript survives as well as many later copies. This allegorical and religious work covers a variety of topics and includes several schematic botanical diagrams illustrating the *virtues and *vices as well as scenes from the life of Saint *Omer.

Example: Liber floridus, c.1120, Ghent, UL, MS Cod. 1125, ff. 231v–232. (Grabar and Nordenfalk, Rmsq, p. 159)

LAMENTATION. Closely related to the images of the *Deposition and *Entombment of *Christ, the Lamentation over the dead body of Christ develops as an independent image in Byzantine art of the eleventh century. Although not specifically described in the Gospel narratives, the event was detailed in apocryphal works such as the *Acts of Pilate* and later developed in works such as the *Meditationes vitae Christi* and numerous other mystical and devotional compositions. The scene is extracted from representations showing the bearing of the body of Christ to the tomb (see: *Holy Sepulchre) and depicts mourning figures surrounding the body as it is momentarily laid on the ground. The figures may include Saint *John the Evangelist (often holding one of Christ's hands, as in Deposition scenes), *Nicodemus and *Joseph of Arimathea, additional women (often including *Mary Magdalene), and the Virgin *Mary, clasping the upper part of Christ's body, frequently pressing her face against his in an expression of deep grief. *Angels are often present as well as additional mourners, kneeling, seated, or standing around the body. Sometimes the *cross is indicated in the background. The image is found in western art from the twelfth century but develops especially in the fourteenth century. Varying degrees of emotion are conveyed, from controlled and contemplative to violent grief, with figures and angels weeping and gesticulating. The *Pietà (Mary alone with the dead body of Christ) is a reduced and focused version of this theme designed for pious contemplation.

Example: Lamentation, c.1164, fresco, Nerezi, Saint Panteleimon. (Zarnecki, fig. 149)

LANCE. See INSTRUMENTS OF THE PASSION; LONGINUS.

LAST JUDGMENT. Themes of justice, rewards for the righteous and punishments for evildoers, are found throughout the Old and New Testaments. As eventually developed in Judaism, the concept that earthly suffering and righteous living will be rewarded in the afterlife and penalties will be afflicted on the wicked, was further evolved in Christian teachings about the second coming of *Christ, when judgment will be carried out on all the living and the dead. Jesus spoke frequently of it in the Gospels, and the *Apocalypse contains a detailed description of the events to be anticipated at the end of time. A frequent topic in the writings of numerous early Christian and medieval theologians, the Last

Judgment has received various pictorial treatments through the Middle Ages, increasing in complexity, symbolism, and narrative detail.

*Matthew 25:31–33 recounts Jesus' description of the Son of Man enthroned, dividing the nations, as a *shepherd separates sheep from goats. This is illustrated in early sixth-century mosaics showing Christ, between two *angels, blessing the sheep on his right side. The rejected goats gather on his left. This solemn and symbolic image continued to be compositionally echoed, especially in Byzantine art, in such images as the *Deësis (Christ with the Virgin *Mary and Saint *John the Baptist as intercessors) and other static, symbolic illustrations of the prepared Throne of Judgment holding a *cross and crown.

In early medieval and especially Romanesque and Gothic art in the west, the tendency to depict the Last Judgment as a multifaceted and cataclysmic event increases. The individual episodes described in the Apocalypse are frequently gathered together, especially in the sculptured portals of Romanesque and Gothic churches. In these monumental programs, Christ appears, enthroned (sometimes on a rainbow) in the center of the composition; a sword may project from his mouth, and he may be accompanied by the four beasts (see: *Four Evangelists; *Tetramorphs), angels, and the *Twenty-four Elders of the Apocalypse. The *Resurrection of the Dead may be shown, Saint *Michael may appear weighing *souls in a pair of scales; the damned may be shown suffering torments in *hell (see also: *Demons, *Devil, *Mouth of Hell) and the blessed are led to *heaven by Saint *Peter. Angels may hold the *Instruments of the Passion, and Mary, John, and other *saints may be identifiable. Illustrations of the Last Judgment are also frequently found in manuscript illustration, fresco, and stained glass. See also: *Majestas Domini.

Example: Last Judgment, Ingeborg Psalter, c.1200, Chantilly, Musée Condé, MS 1695, f. 33. (Zarnecki, fig. 384)

LAST SUPPER. The story of the last meal, on or near the Jewish feast of Passover, which Jesus shared with his disciples in an upper room of a house in Jerusalem, receives coverage in all four Gospels. The event precedes the *Agony in the Garden and the *Betrayal of *Christ by *Judas. During the meal, Jesus bade farewell to the *apostles, announced his upcoming betrayal and *death, and shared bread and wine with the apostles—which act is celebrated in the ritual of the Eucharist (from Greek: *eucharistein,* "to give thanks"). This partaking of bread and wine in memory of the Last Supper was celebrated in the early church and remained the central sacrament (Holy Communion, Lord's Supper) through the Middle Ages (see also: *Seven Sacraments). The significance of the Last Supper is also reflected by its frequent appearance in art from the early Christian period onward, although different aspects of the story are emphasized in several divergent pictorial formulae.

Early representations from the sixth century are of two main types: the scene is presented as a meal (with Jesus and the apostles seated or reclining around a table) or as a liturgical act (Jesus stands at an altar distributing the Eucharist or

is approached by the apostles in a procession). This latter type, of greater frequency in Byzantine art until the thirteenth century, is discussed separately (see: *Communion of the Apostles).

The more typical western type, representing a meal, may show Jesus and the apostles reclining around a semicircular table. Tableware, *fish, bread, and the sacrificial lamb may be indicated on the table. The fish and bread also make reference to previous *miracles (see: *Multiplication of the Loaves and Fishes) as well as functioning as symbols for Christ. Although not all twelve apostles may be shown (pending spatial limits of the composition), the betrayer Judas is often signalled by his pose and gesture. As Jesus spoke, Judas reached out his hand to a dish on the table (e.g., *Matthew 26:23) or reached to accept a piece of bread dipped in the bowl by Jesus (*John 13:26). Some of the other apostles may also be identifiable: *Peter may be shown pensively resting his head on his hand (a premonition of his coming denial of Jesus), and *John is often shown seated next to Jesus, resting his head on Jesus' shoulder (John 13:23) or on the table. By the ninth century, the image usually shows the apostles seated at a long table; Jesus may take the central position, and Judas will be shown alone in the foreground, seated at the table opposite from the main group. A few examples omit the obvious identification of Judas, although the motif is more often included. An interior setting or architectural backdrop is frequently shown, and the image may be combined with, or narrated in a sequence preceding the *Washing of the Feet. The image appears in all media through the Gothic period.

Example: Last Supper, c.1160, Dijon, Saint-Bénigne, tympanum. (Sauerländer, fig. 23)

LAWRENCE, SAINT. One of the most popular and frequently represented *saints in art from the early Christian period onward, the Spanish-born Lawrence (d. c.258) was one of the seven deacons of Rome in the mid-third century and was martyred in persecutions under the emperor Valerian. *Constantine constructed a chapel over his catacomb tomb, which was enlarged in the sixth century (now the present basilica of San Lorenzo fuori le mura). Lawrence was famed for his humility and concern for the poor, and images of him and scenes from his life appear as early as the fourth century. He is often dressed in clerical robes, holds a book, and carries or stands near a gridiron or flaming grill. This is due to the tradition that he was martyred by being roasted on a grill, although this may be the result of a scribal error in the early copying of his legend. Scenes of Lawrence's *martyrdom and burial as well as his charitable distribution of church monies to the poor are found in Romanesque sculpture, fresco, and metalwork, and Gothic stained glass. While in prison, Lawrence converted his guard, *Hippolytus, to Christianity (he was subsequently martyred as well). See also: Saint *Romanus.

Example: Saint Lawrence, Hours of Catherine of Cleves, c.1440, New York, PML, MS 917, p. 266. (Robb, fig. 210)

LAZARUS, RAISING OF. See RAISING OF LAZARUS.

LAZARUS THE BEGGAR. See DIVES AND LAZARUS.

LEAH. Leah, the eldest daughter of Laban, became *Jacob's first wife when Laban secretly substituted her for her younger sister (and Jacob's preferred) *Rachel on their wedding night. She bore six sons to Jacob, the founders of six of the twelve tribes of Israel; hence she is counted among the Hebrew *matriarchs. She appears in art primarily in narrative illustrations of the book of Genesis in depictions of the life of Jacob and also as a personification of the *active life.

LECTIONARY. See MANUSCRIPTS.

LEGENDA AUREA. See GOLDEN LEGEND.

LEGENDARY. See MANUSCRIPTS.

LEO. See ZODIAC.

LEVIATHAN. The name Leviathan occurs in several Old Testament passages, notably *Job 41, which contains a lengthy description, spoken by *God to Job, of the fearsome and powerful beast whom God tames. The creature appears again in Psalm 104:25–26, translated as *draco* (dragon or serpent) in the Vulgate, described as living in the great, wide sea. Other references to Leviathan are found in *Isaiah 27:1, where it is described as a "crooked" and "piercing serpent," a "dragon" in the sea, and *Ezekiel 29:3–5, where *Pharaoh is equated with this evil dragon in the river. Early Christian and medieval commentators associated Leviathan with the whale or sea creature which swallowed *Jonah, as well as a symbol for evil, *Satan, and *hell. The hook that snares Leviathan (Job 41:1) was interpreted as *Christ, who triumphs over the *Devil and who breaks open the jaws of the creature (Job 41:14) in his harrowing of hell (see: *Anastasis). Leviathan, as a dragonesque sea creature, is found especially in Romanesque and Gothic illustrations of the *Last Judgment, *Mouth of Hell, and *Fall of the Rebel Angels. *Demons, the damned, flames, and a boiling cauldron may be depicted in and around the gaping jaws.

Example: Entrance to Hell, Winchester Psalter, c.1145–1155, London, BL, Cotton MS Nero C.IV, f. 39. (Dodwell, fig. 361)

LIBELLUS, LIBELLI. See MANUSCRIPTS.

LIBER FLORIDUS. See LAMBERT OF SAINT-OMER.

LIBERAL ARTS. See SEVEN LIBERAL ARTS.

LIBERATION OF SAINT PETER FROM PRISON. See PETER, SAINT.

LIBRA. See ZODIAC.

LILY. See FLOWERS AND PLANTS, SYMBOLISM OF.

LIMBO. See ANASTASIS; HADES.

LION. See ANIMALS, SYMBOLISM OF; FOUR EVANGELISTS.

LIUDGER, SAINT. Liudger (or Ludger, d.809) was offered the bishopric of Trier by *Charlemagne but accepted an appointment as bishop of Munster c.804 after many years of successful *preaching, missionary work, and *church founding and restoration. Renowned for his charity and piety, his life and posthumous *miracles were notably illustrated in a late eleventh-century manuscript produced at the monastery at Werden (which he had founded).

 Example: Liudger Is Acclaimed a Bishop, Life of Saint Liudger, late eleventh century, Berlin, SB, MS Theol. lat. fol. 323, f.11. (Abou-el-Haj, fig. 28)

LOGIC. See SEVEN LIBERAL ARTS.

LONGINUS, SAINT. The Gospel of *John (19:34) recounts that a Roman soldier pierced *Christ's side with a spear during the *Crucifixion. Although unnamed in the canonical Gospels, he was identified as Longinus (probably from the Greek, *longke,* "lance") in the apocryphal *Acts of Pilate,* which source also gave the name Longinus to the centurion in charge of the Crucifixion who proclaimed Jesus as the "Son of God" (*Matthew 27:54). Various legends hence evolved about Longinus's conversion to Christianity (his blindness was healed when he rubbed his eyes with the blood of Christ, which ran down the spear onto his hand), and stories developed concerning his later tortures and *martyrdom in Caesarea. The tales were amplified in the *Golden Legend* although the cult of Saint Longinus had already been further strengthened by the discovery of the Holy Lance (one of the *Instruments of the Passion) during the First Crusade. He often appears in scenes of the Crucifixion from the sixth century onward, dressed as a soldier, holding up his spear to pierce Jesus' side. In later medieval art he is sometimes shown on horseback. His companion Stephaton (perhaps from Greek, *spongon,* "sponge") who gave Jesus a vinegar-soaked sponge, elevated on a reed, to drink, is frequently paired with Longinus on the other side of the cross, creating a symmetrical composition.

 Example: Crucifixion, Sacramentary, c.975, Gottingen, UL, Cod. theol. fol. 231, f. 60. (Robb, fig. 75)

LOT. The nephew of *Abraham, Lot appears in Genesis 13–19. Selected episodes from his life are found in early Christian and later medieval Bible manuscripts, mosaics, and stained glass. He traveled and lived with his uncle for a number of years, but the two parted company in Canaan, where Abraham gave

Lot first choice of land. Lot settled in the fertile region near the (not yet) Dead Sea in the city of *Sodom and later had to be rescued by his uncle from northern invaders. When *God decided to destroy the cities of Sodom and Gomorrah because of the wickedness of the people and sent two *angels to do so, Lot welcomed the angels (mistaking them for travelers) into his home. When the men of Sodom demanded that he hand over the strangers to them, Lot offered his daughters instead. The angels struck the men of Sodom with blindness when they attacked Lot's house and then advised Lot to flee with his family and not look back. The cities were then destroyed by fire, but *Lot's wife looked back and was turned into a pillar of salt. Believing that their elderly father was the last man left on earth and eager to perpetuate their race, Lot's daughters tricked him into having incestuous relations with them by getting him drunk when they were living in a cave in the hills. Their offspring became the East Jordan peoples of Moab and Ammon.

Example: The Parting of Lot and Abraham, Bible of Jean de Sy, mid-fourteenth century, Paris, BN, MS fr. 15397, f. 14v. (D'Ancona, pl. 93)

LOT'S WIFE. When *Lot and his family fled from the city of *Sodom (having been warned by *angels about *God's intended destruction of the wicked cities of Sodom and Gomorrah), they were directed by the angels not to look back. Lot's curious wife could not resist, and she was turned into a pillar of salt (Genesis 19:15–26). The scene appears in early Christian Bible illustration and in later medieval manuscripts, mosaics, sculpture, and stained glass. She is represented either by a white column topped with a female head or, following the Vulgate translation (where she metamorphosizes into a *statuam salis*), as a white statue with indistinct human features. Lot and his daughters, often led by angels, may be included in this scene as they continue to journey away.

Example: The Destruction of Sodom, Saint Louis Psalter, c.1270, Paris, BN, MS lat. 10525. (Pächt, pl. XXVI)

LOUIS IX, SAINT. Louis IX (1215–1270) became king of France in 1226 at the age of twelve, when his father died. His mother, Blanche of Castile, served as regent during his minority and during his later absence from France on crusade until her *death in 1252. Louis was largely a capable and powerful ruler; dedicated to justice, he successfully defeated rebellions and established peace under royal authority. An extremely pious man, Louis supported the Franciscans, maintained stable relations with the papacy, founded numerous religious, charitable, and educational institutions, and twice went on disastrous crusades (1248–54, and 1270, when he died of typhoid in Tunisia). Although Louis's military ventures on crusade were unsuccessful, his piety, charity, justice, and courage were deeply admired. He has been termed the "ideal medieval king." He was canonized in 1297 during the reign of his grandson.

The arts flourished during Louis's reign, perhaps most notably expressed in the construction of the Sainte Chapelle in Paris (to house several important

*relics, including the Crown of Thorns, purchased from his cousin Baldwin II, the Latin ruler of Constantinople). The mid-thirteenth-century Parisian "court style" in architecture, sculpture, manuscript illumination, and stained glass was a distinct and influential phase of Gothic style, quickly emulated outside France.

Episodes in the biographies of Louis, composed in the late thirteenth and early fourteenth centuries, were illustrated in manuscripts, sculpture, and stained glass during the fourteenth and fifteenth centuries, especially under French royal patronage. As an independent figure, Saint Louis is recognizable by his crown and royal robes embellished with *fleurs-de-lys* (emblem of the French monarchy). Sometimes he holds the Crown of Thorns, or nails of the *Crucifixion.

Example: Blanche of Castile and Louis IX, Bible moralisée, 1226–1234, New York, PML, MS 240, f. 8. (Synder, fig. 560)

LUCIFER. See DEVIL; SATAN.

LUCY, SAINT. Veneration of the Sicilian virgin martyr Lucy (d. c.304) dates to the early Christian period. Legends of her life, composed in the fifth and sixth centuries, describe her as a wealthy woman who gave away her money to the poor, who refused offers of marriage, and who was turned in to the Roman authorities who tortured her and eventually killed her by stabbing her in the throat with a sword. According to the sixth-century legend, she plucked out her own eyes in order to avoid marriage, or, according to another version, she was blinded while being tortured under the orders of the emperor Diocletian. Various other sufferings endured by Lucy include (according to the *Golden Legend*) being drenched with urine, burned, and covered with boiling oil after an unsuccessful attempt to drag her (with hands and feet bound) to a brothel, but neither one thousand men nor one thousand oxen could budge her. This source also recounts that she continued to speak after she was stabbed in the throat. Earlier, Lucy's prayers to Saint *Agatha had healed Lucy's mother of a prolonged illness; Agatha appeared to Lucy in a vision alerting Lucy of her forthcoming *martyrdom. She is found in art as early as the sixth century and by the later medieval period is generally recognizable through attributes derived from specific aspects of her legend, for example, her two eyes, which she may hold in her hand or display on a platter or rod, and the sword of her martyrdom. She is often also shown with a lamp or candle (her name derives from *lux,* Latin for "light").

Example: Martyrdom of Saint Lucy, Stuttgart Passionary, mid-twelfth century, Stuttgart, WLB, MS Fol. 57, f. 6. (Ross, fig. 26)

LUDGER, SAINT. See LIUDGER, SAINT.

LUKE, SAINT. One of the *Four Evangelists, Luke is credited with having authored the Gospel of Luke (c.70–90) as well as the book of Acts. A disciple of Saint *Paul, he accompanied Paul on several missionary journeys, tradition-

ally became a leader of the Christian church in Greece, and died peacefully at the age of 84 (probably not crucified as a martyr with Saint *Andrew although such is recounted in legends).

Like the other Gospel writers, Luke features frequently throughout medieval art as an *author; he is often accompanied or represented by his animal symbol, the ox, chosen because his Gospel begins with a mention of the priestly duties (e.g., including sacrifice) of *Zacharias. (See also: *Animals, Symbolism of; *Tetramorphs.) Paul refers to a Luke as "the blessed physician" in his Epistle to the Colossians (4:14), hence Saint Luke may occasionally be shown in art with the attributes of a medical doctor.

The tradition that Luke painted a portrait of the *Madonna and Child probably originated in Byzantium in the sixth century and, during the *Iconoclastic Controversy, was frequently cited by authors in defense of visual imagery. (See also: *Acheiropoieta, *Hodegetria, *Icons, *Theotokos.) Although there is no biblical mention of Luke's artistic skills, it has been pointed out that his sensitive and detailed account of the *Nativity may suggest his having met and conversed with the Virgin *Mary in Jerusalem before composing his Gospel (as is also specified in the *Golden Legend, which additionally identifies him as one of the disciples on the *Road to Emmaus). The image of Saint Luke painting (or drawing) the Virgin and Child becomes frequent in western art of the later medieval period, especially in Books of Hours (see: *Manuscripts) as well as on altarpieces. The popularity of this image in the later Middle Ages is also reflective of the development of independent guilds for painters and their choice of Saint Luke as patron. The scene is frequently shown as taking place in an interior setting; Luke (often bearded) will be shown seated or kneeling at his desk or easel at work painting, while Mary stands or sits before him holding the infant Jesus.

Example: Saint Luke Painting the Virgin, Book of Hours, c.1430–1435, Walters, MS 281, f. 17. (Wieck, pl. 17)

LUST. See VICES.

LUTE. See MUSICAL INSTRUMENTS, SYMBOLISM OF.

LUXURIA. See VICES.

LYRE. See MUSICAL INSTRUMENTS, SYMBOLISM OF.

M

MADONNA AND CHILD. The image of the Virgin *Mary (or *Madonna,*
Italian for "my lady") with the infant Jesus is one of the earliest subjects to
occur in Christian art and is repeated with great frequency in all western and
Byzantine media through the medieval period. The two figures naturally occur
together in a number of narrative contexts referenced separately in this
dictionary (e.g., the *Nativity, *Adoration of the Magi); this entry concerns the
variety of pictorial representations of Mary and the baby Jesus which are not
associated with specific narrative episodes.

Mary's title as *Theotokos* ("Bearer of *God"), conferred at the Council of
Ephesus in 431, is reflected in the formal imagery first seen in early Christian
art and Byzantine *icons which depict the pair as seated, frontal figures staring
outward at the viewer. The infant Jesus may appear singularly unchildlike: hold-
ing a scroll or gesturing in *benediction. *Angels and *saints may flank the
solemn pair, and Mary's chair may be represented as a throne. This majestic
image also symbolizes Mary as *Regina coeli,* the queen of *heaven. She may
hold the baby firmly and centrally in both hands or support him on one arm,
gesturing toward him with her other hand. This latter type, the *Hodegetria,*
claims derivation from the very first picture of the Madonna and Child, created
by Saint *Luke. Somber and dignified, these images occur repeatedly through
the Middle Ages (see also: *Maestà, *Sedes sapientiae*). The awesome event of
the incarnation of God is also symbolized in Byzantine forms such as the
*Blachernitissa and *Platytera which depict an *orant Mary with a medallion
of the infant Jesus suspended before her.

Contrasting with these more hieratic forms, images which portray an emo-
tional relationship between mother and infant also appear early in Christian art,
such as the type of *Maria lactans* (Mary nursing the baby Jesus). The Byz-
antine *Eleousa,* depicting tender gestures between the figures, was especially
influential from the eleventh century and is frequently reflected in western ex-

amples of the Romanesque and especially Gothic period, which show a more realistically animated or humanlike infant embracing his mother or toying with her clothing while she regards him tenderly.

Other variations include images of Mary with her hands clasped in *prayer while the infant rests on her lap or on the ground before her, and the ''Virgin of Humility,'' a type popularized in the fourteenth century, which shows Mary seated on the ground, rather than on a chair or throne. Saint *Anne, Saint *Joseph and other relatives may also accompany the pair, especially in late medieval representations. (See: *Holy Family, *Holy Kinship.)

Symbolic settings, such an an enclosed garden (see: *Hortus conclusus) and symbolic flowers, animals, birds, plants, and fruit may be indicated. The baby Jesus may hold an apple (symbolizing the original sin of *Adam and Eve, which he will redeem) or grapes (symbolizing the sacrifical blood of *Christ, see *Last Supper) or a dove (symbolizing the *Holy Spirit).

With variations noted above, the image of the Madonna and Child occurs in all artistic media of the Middle Ages, both large-and small-scale: free-standing and relief sculpture, mosaics, textiles, frescoes, stained glass, and minor arts.

Example: Virgin and Child Enthroned with Angels and Saints, early seventh century, icon, Mount Sinai, Monastery of Saint Catherine. (Synder, fig. 152)

MAENAD. In classical mythology and art, Maenads are the female followers of the god Bacchus (or Dionysius) and are often depicted with *satyrs in wild and frenzied revels, partly clothed, dancing, singing, and drinking wine. They appear occasionally in early Christian art works as an aspect of lingering classical iconography.

Example: Maenad and Satyr, 610–629, silver dish, Leningrad, Hermitage Museum. (Gough, fig. 167)

MAESTA. The Italian term *Maestà* (''majesty'') derives from the Latin *Majestas Mariae* and refers to depictions of the *Madonna and Child enthroned, surrounded by *angels and *saints. The iconography was especially popular in Italian art (altarpieces and wall paintings) of the late thirteenth and fourteenth centuries.

Example: Simone Martini, *Maestà,* 1315, 1321, fresco, Siena, Palazzo Pubblico, council chamber. (Synder, fig. 583)

MAGI. See ADORATION OF THE MAGI.

MAJESTAS DOMINI. The *Majestas Domini,* ''Majesty of the Lord,'' is a pictorial theme, with variations, based on the visions of Saint *John of the end of time, primarily from Revelation 4. Also termed the Second Coming of *Christ, the representation may involve Christ enthroned or in a mandorla (see: *Halo), surrounded by *angels and the symbols of the *Four Evangelists, with the *Twenty-four Elders of the Apocalypse, and other elements (lamps, candle-

sticks, lightning, *Tetramorphs*) mentioned by John or *Ezekiel. The complex and awesome vision was a favorite for apse and triumphal arch mosaics and on facades of early Christian basilicas; it appears in Romanesque portal sculpture and wall painting and in elaborate forms on Gothic cathedral facades. (See also: *Apocalypse, *Last Judgment.)

Example: Majestas Domini, c.450, mosaic, Rome, San Paolo fuori le mura, triumphal arch. (Synder, fig. 49)

MAN OF SORROWS. *Christ as the Man of Sorrows (Latin: *imago pietatis,* image of self-sacrificing love; Greek: *akra tapeinosis,* utmost humiliation) is a nonnarrative devotional representation which first appears in Byzantine art of the twelfth century, although the type may have developed earlier. The image originated in connection with the Byzantine liturgy: the readings for Good Friday and Easter concerning the *death and *Resurrection of Christ. In Byzantine *icons, Christ is shown as a frontal figure, either three-quarter or half-length, against a plain background or in front of the *cross. His wounds are shown on his body; his head is often tilted to one side and his arms are folded across his body; his eyes may be open or closed. This powerful imagery was adapted in the west in the late twelfth and thirteenth centuries, possibly derived from a famous wonder-working icon brought to the Roman church of Santa Croce in Gerusalemme (see also: *Mass of Saint Gregory). The image is frequently found in manuscript illumination, panel and wall painting, and, by the fourteenth century, in full-length figural sculpture especially in Germany (see also: *Andachtsbilder*). The *Instruments of the Passion may be included, as well as an indication of Christ's tomb, from which he may be shown emerging. Sometimes *angels, mourners, and worshippers are present; the dove of the *Holy Spirit and *God the Father may appear; the Virgin *Mary may support the body of Christ (see also: *Mater dolorosa*), or Mary and Saint *John the Evangelist may stand beside Christ. For other related themes see: *Ecce homo, *Pietà.*

Example: Man of Sorrows, early fourteenth century, mosaic icon, Rome, Santa Croce in Gerusalemme. (*The Icon,* p. 76)

MANASSEH. See EPHRAIM.

MANDORLA. See HALO.

MANDRAKE. See FLOWERS AND PLANTS, SYMBOLISM OF.

MANDYLION. Similar to the veil (*Sudarium*) of Saint *Veronica, the *Mandylion* was a cloth upon which the image of the face of *Christ was miraculously imprinted. Numerous variations upon the tale exist, derived from late fourth-century Syriac sources which follow and expand upon Eusebius's description of written correspondence between Jesus and King Abgar of Edessa. Abgar wrote a letter to Jesus requesting that he visit Edessa to cure him of an illness;

some versions recount that Jesus replied via a letter delivered by the *apostle Thaddeus (*Jude) who healed Abgar; other versions state that Jesus sent Abgar a painted portrait of himself or a cloth with which he had wiped his face and which miraculously bore his image (the *Mandylion*). Abgar was healed and converted to Christianity. The *relic remained in Edessa until the tenth century. Some versions recount that when hidden for safekeeping in the city walls, the image of Christ's face miraculously duplicated itself on a brick. It was redis-covered in the sixth century, then taken to Constantinople in 944 (when further documents concerning it were written); then it was captured by the Crusaders in 1207 and lost (or taken to Rome, Venice, or Genoa). See also: *Acheiropoieta*, *Holy Face.

Example: King Abgar Receiving the Mandylion, after 944, icon, Mount Sinai, Mon-astery of Saint Catherine. (*The Icon*, p. 28)

MANOAH. See SAMSON.

MANUSCRIPTS. Manuscripts are books written by hand (from Latin: *manu scriptus*). The book (or codex) form, with groups (gatherings) of folded sheets sewn along one edge, supplanted the ancient roll (or scroll) form in the early Christian period. Animal skin (parchment, vellum) was the material used for the pages (folios). During the Middle Ages, a variety of different types of manu-scripts were required and developed for ecclesiastical, monastic, lay, and uni-versity use. Illustrations and pictorial programs vary per the context, cost, and patronage. Before the thirteenth century, most manuscripts were produced in monastic scriptoria. In the later Middle Ages, manuscripts were also often pro-duced in lay workshops located in larger cities.

For churches and monasteries, the BIBLE (in the early fifth-century Vulgate translation by Saint *Jerome) was the fundamental text, although infrequently (because of length) found in complete form. More commonly, several books of the Bible were grouped into volumes: such as make the Pentateuch, Hexateuch, and Octateuch (containing, respectively, the first five, six, and eight books of the Old Testament), the PSALTER (containing the Psalms), or the GOSPELS (con-taining the works of the *Four Evangelists). CANON TABLES often preface Gospel books; these indicate corresponding passages in the Gospels following the sys-tem of concordance created by Eusebius of Caesarea in the fourth century. The Pauline Epistles, Acts, and other sections of the New Testament may also be found bound together.

Gospel LECTIONARIES (or PERICOPES) are manuscripts which contain passages from the Gospels rearranged for reading during Mass through the liturgical year. Other manuscripts required for the liturgy include: BENEDICTIONALS (containing blessings recited by bishops), SACRAMENTARIES (containing the prayers recited by priests during Mass), MISSALS (which supplant Sacramentaries by the thir-teenth century and contain chants, prayers, and readings for Mass), and GRAD-UALS (choir books which contain the sung parts of the Mass, with musical

notation; sometimes also included in Missals). The BREVIARY contains the texts required for daily recitation (the Divine Office) originally only in monasteries and adapted by the Dominicans, Franciscans, and other orders in the thirteenth century. ANTIPHONARIES (or ANTIPHONALS) are large choir books containing the sung portions of the Divine Office, used especially in monasteries. TROPERS are also music books containing additions to the chants regularly sung in the Divine Office or Mass. PONTIFICALS contain the texts necessary for special sacramental services (e.g., church dedications, blessing of altars and liturgical equipment, clerical ordination) and were used only by bishops and popes. HOMILIARIES contain discourses on biblical passages by various authors and were used for sermons.

Texts concerning the lives of *saints are found in western PASSIONARIES and LEGENDARIES and in Byzantine MENOLOGIA. Shorter notices on saints' death dates, arranged according to the liturgical calendar, are found in western MARTYROLOGY and Byzantine SYNAXARY manuscripts. Books devoted to the biography of a single saint are termed LIBELLI.

BOOKS OF HOURS (or HORAE) develop in the later Middle Ages for lay use and contain, fundamentally, the Little Office of the Blessed Virgin *Mary. Modelled after the prayers and readings for the Divine Office in monasteries, Books of Hours were designed for private devotions and may be extremely elaborately illustrated, depending upon the wealth of the patron.

Other popular medieval manuscripts include: HERBALS (see also: *Dioscurides; *Plants, Symbolism of), which contain texts and illustrations concerning the identification and medicinal values of plants; and BESTIARIES, which contain descriptions of animals, birds, and fanciful beasts discussed as Christian symbols and moral exemplars (see also: *Animals, Symbolism of; *Birds, Symbolism of; *Physiologus).

Commentaries on biblical passages and various other writings by Church *Fathers and medieval theologians are frequently found in manuscript form in monastic and university libraries (see individual authors).

See also: *Apocalypse, *Bibbie atlantiche, *Bible historiale, *Bible moralisée, *Biblia pauperum.

MARGARET OF ANTIOCH, SAINT.

Devotion to the third-or fourth-century virgin martyr Margaret of Antioch became especially popular in the twelfth and thirteenth centuries. Her life, first recorded in the early Christian period, was elaborated in the *Golden Legend. She was the daughter of a pagan priest who expelled her from his home when she converted to Christianity. She became a shepherdess and caught the attention but resisted the advances of the prefect, or governor, of Antioch, who ordered her to be tortured and eventually beheaded along with the hundreds of others she had inspired to convert to Christianity. Her fantastic sufferings include attempts to drown and burn her; she was swallowed by a great dragon but emerged unharmed when the *cross she carried grew so large it split the dragon's belly. She is hence the patron saint of child-

birth. A popular figure in art especially of the Romanesque and Gothic periods, she is often shown with a dragon (emerging from it or stabbing it with a cross) and wearing a crown of pearls (from Latin: *margarita:* "pearl").

Example: Scenes from the Life of Saint Margaret of Antioch, c.1175–1180, fresco, Tournai Cathedral, north transept, east wall. (Demus, fig. 254)

MARIA LACTANS. The term *Maria lactans* refers to the image of the Virgin *Mary nursing the infant Jesus. This maternal subject appears frequently in art from the early Christian through Gothic period, presented with varying degrees of realism. The infant may be shown actually suckling at her breast or seated on her lap while one of her breasts is uncovered. The image is appropriately often found in *Nativity scenes. *Relics of the milk of the Virgin Mary were claimed by several churches, especially in fourteenth-century Italy.

Example: Virgin and Child, Amesbury Psalter, c.1240–1250, Oxford, All Souls College, MS Lat. 6, f. 4v. (Martindale, fig. 53)

MARK, SAINT. One of the *Four Evangelists, traditionally the author of the Gospel of Mark (composed c.60–70), Mark (or John Mark) is alluded to in the New Testament both in connection with Saint *Paul (as a companion on missionary journeys) and Saint *Peter. The tradition that Peter inspired Mark's writing or even dictated the Gospel to Mark dates to the early second century, when Mark was referred to as "the interpreter of Peter." Hence, the two are often shown together in art (e.g., Peter dictating and Mark writing). According to the early Christian historian Eusebius, Mark became the first bishop of Alexandria and was said to have been martyred there, c.67, during the reign of the emperor Nero.

Like the other evangelists, Mark features prominently in art throughout the Middle Ages primarily in his role as an *author, for example, in "portraits" of the evangelists (singly or in groups) prefacing their Gospels in illustrated manuscripts. The evangelists and/or their symbols frequently accompany *Christ in a variety of compositions in all media. Mark's symbol is a lion (see also: *Tetramorphs) because his Gospel begins with a description of a voice "crying in the wilderness" (Mark 1:3) and concludes with a description of the *Resurrection of Christ (see also: *Animals, Symbolism of).

Later legends recount further details of Mark's ministry and *martyrdom in Alexandria. He was said to have cured a cobbler who had an injured hand; the cobbler (Anianus) converted to Christianity, was baptized by Mark and later became his successor as bishop of Alexandria. Mark was martyred by being dragged through the streets of Alexandria, after Christ had appeared to him in prison. The hailstorm which occurred after his *death sent the pagans fleeing while Christians were able to bury his body. The transportation of his *relics to Venice in the ninth century, as well as several dramatic posthumous *miracles, are also illustrated in art: his rescue of a Christian slave sentenced to execution in Venice, and his *exorcism of *demons (intending to destroy Ven-

ice) from a boat in a storm—in which miracle he was assisted by Saints *George and *Nicholas. Many of these subjects were illustrated in the twelfth- and thirteenth-century mosaics of the church of San Marco in Venice and appear also in manuscript illustration.

Example: Saint Mark, Speier Golden Gospels, c.1045–1046, Escorial Library, MS Vitr. 17, f. 61v. (Dodwell, fig. 135)

MARRIAGE AT CANA. The Gospel of *John (2:1–11) describes, as the first *miracle performed by Jesus, his transformation of water into wine at a wedding feast in the town of Cana. Jesus, his mother *Mary, and several disciples were among the guests. When there was no more wine to drink, at Mary's intervention Jesus instructed the servants to fill six large jars with water; the chief steward then tasted it and praised the bridegroom for having reserved the better wine for later. The subject appears in Christian art as early as the fourth century (e.g., on carved sarcophagi illustrating Jesus' miracles in series) and initially is presented in a simplified form: Jesus stands in front of the water jugs, waving over or pointing at them with a staff (magic wand, derived from classical art). The image is expanded by the fifth and sixth centuries to include additional figures such as the guests at the banquet and Mary; Jesus may now be shown seated (without magic wand) at the banquet table (sometimes in a central position, as common in images such as the *Last Supper) while the servants pour water into the pots. The subject appears frequently throughout medieval art, typologically understood as the transformation of the water of Judaism (Old Testament, Old Law) into the wine of Christianity (Gospels, New Law). Medieval commentators also identified the bride as *Mary Magdalene and the bridegroom as Saint John the *apostle, who immediately left his wife to follow Jesus after witnessing this miracle.

Example: Marriage at Cana, Grandes Heures of Jean de Berry, c.1409, Paris, BN, MS lat. 919, f. 41. (Porcher, pl. LXVII)

MARRIAGE OF THE VIRGIN. The marriage of the Virgin *Mary to Saint *Joseph is not described in the canonical Gospels although the events surrounding their betrothal (the selection of the aged Joseph to wed the young virgin; see: *Watching of the Rods) receive detailed coverage in the apocryphal *Protevangelium of James* and later elaboration in the *Golden Legend.* Although the texts offer minimal information about the actual marriage ceremony, the subject is found in art especially of the later medieval period reflecting increasing devotion to Mary and interest in the details of her early life. The scene generally involves a compositional core of three figures: the elderly Joseph and youthful Mary kneel or stand before the appropriately garbed high priest who holds or joins their hands. Alternately, and especially in Italian art, Joseph will be shown placing a ring on Mary's finger. The setting is often outdoors or indicated as taking place outside the Temple in Jerusalem, which may appear as a minimal or more elaborate backdrop. The parents of the Virgin (*Anne and

*Joachim) may be present, as well as the seven maidens attending Mary, mentioned in the *Golden Legend.*

Example: Marriage of the Virgin, Book of Hours, c.1425–1430, Walters, MS 288, f. 17. (Wieck, pl. 1)

MARTHA. Martha and Mary (see: *Mary Magdalene) were the sisters of Lazarus who summoned Jesus when their brother became ill and who were present at the *miracle of the *Raising of Lazarus (*John 11:1–45). Martha is credited with pointing out the potentially foul odor of the dead body (John 11:39), and her practicality (as well as her tendency to complain) are also described in *Luke 10:38–42. This passage recounts Jesus' visit to their house (assumed to be the home of Lazarus, although he is not mentioned here by Luke), during which Mary sat at Jesus' feet and listened to him while Martha busied herself with food preparations. When she asked Jesus to tell her sister to assist her, Jesus replied that Mary had ''chosen the good part.'' The scene of Jesus' visit to the two women appears infrequently in art, although some examples can be found in Ottonian manuscript illustration depicting a centrally positioned and seated Jesus gesturing toward Martha, who approaches with outstretched hands; Mary is shown seated at Jesus' feet. Martha and Mary also appear as symbols for the *active and *contemplative lives. Martha, representing the active life, may hold a ladle, broom, or keys. Later legends also have her conquering a dragon in southern France and performing missionary work after she, her sister Mary, and brother Lazarus had sailed there in a leaky boat from Joppa. These stories (retold also in the *Golden Legend*) are found illustrated primarily in French Romanesque and Gothic sculpture and stained glass.

Example: Christ in the House of Martha, Pericopes of Henry II, c.1002–1014, Munich, SB, MS Clm. 4452, f. 162. (Beckwith, fig. 96)

MARTIN OF TOURS, SAINT. One of the most popular and frequently represented *saints in medieval art, Martin (c.316–397) became bishop of Tours c.370. His biography was written by his friend Sulpicius Severus, later elaborated in the sixth century by the historian Gregory of Tours, and again in the *Golden Legend* of Jacobus de Voragine. Famed for his piety, charity, and zealous missionary work, Martin and episodes from his life appear in art as early as the fifth century and throughout the medieval period, especially in the vast number of churches dedicated to him in France and England. Among the most popular subjects are the episode when Martin, as a soldier in the Roman army, divided his cloak with a freezing beggar (later *Christ appeared to him in a dream wearing that half of the cloak, inspiring Martin's conversion); the miraculous appearance of a ball of fire (symbolic of his burning charity) descending on his head when he was celebrating Mass dressed in a smock (he had given his chasuble to a beggar he had met while en route to church); his being knighted by Constantius II; his renunciation of military life when he stood on

a battlefield unarmed and holding only a *cross, plus various other *miracles, acts of charity, and healing scenes. He is also frequently depicted on horseback.

Example: Saint Martin Dividing his Cloak, c.1220, Chartres Cathedral, south transept, right tympanum. (Sauerländer, fig. 119)

MARTYRDOM. *Martyr* is the Greek term for "witness" and initially was used for the *apostles who witnessed the deeds of and testified to the *Resurrection of *Christ. However, and especially during the periods of Roman persecution, martyrs became those *saints who suffered for and were put to *death for their steadfast dedication to the Christian faith. The sufferings and deaths of early Christian and later martyrs are frequently represented in medieval art, and the visual catalogue of gruesome tortures and grisly deaths is lengthy. Stonings (see: Saint *Stephen, the protomartyr) and decapitations (see: *Cephalophors) are common, and martyrdom methods and their portrayal in art range from *crucifixion (see: Saints *Andrew and *Peter) to grilling (see: Saints *Foy, *Lawrence, and *Vincent) to flaying (Saint *Bartholomew) to evisceration (Saint *Erasmus) to attacks by sword, spear, or arrows. Unique methods of martyrdom will often serve as identifying attributes for specific saints while shared themes are also prevalent. Related artistic motifs also include burial scenes and the martyrs' *souls ascending to *heaven. Death dates for martyrs were celebrated as "heavenly birthdays" from the early Christian period (saints' feast days). Scenes of martyrdom appear in all western medieval and Byzantine art media from the early Christian through late Gothic period.

MARTYROLOGY. See MANUSCRIPTS.

MARTYRS. See MARTYRDOM; SAINTS.

MARY (THE VIRGIN MARY), SAINT. The Virgin Mary was the mother of Jesus and the wife of Saint *Joseph. She features briefly though significantly in the Gospels and, from the early Christian period onward, has figured prominently in the development of Christianity. The importance of Mary's role as *Theotokos* (Mother or Bearer of God) was discussed frequently by early Christian theologians and was formally established at the Council of Ephesus in 431. Majestic images of the *Madonna and Child and pictorial narratives concerning Mary appear in early Christian art and throughout the medieval period. Devotion to the Virgin Mary increased through the Middle Ages, reaching a special peak in the Romanesque and Gothic periods when, under the influence of theologians such as Saint *Bernard of Clairvaux, works such as the *Golden Legend* and newly composed *miracle collections, the Virgin Mary assumed an eminent position in church doctrine, popular literature, and artistic iconography. The following provides a roughly chronological, biographically ordered survey of the rich imagery devoted to Mary and her life in early Christian and medieval art, and notes the special symbols and formulae developed in representations of

Mary. (In all cases, further information can be found under the cross-indexed entries.)

The canonical Gospels contain no information about Mary's birth, childhood, or early life. These details were supplied by apocryphal works (such as the *Protevangelium of James*), which describe her birth to the elderly couple *Anne and *Joachim (see also: *Immaculate Conception), her early *Education, *Presentation and Service in the Temple in Jerusalem, as well as her *Marriage to Joseph (see also: *Watching of the Rods).

The virginal Mary appears in two canonical Gospels (although the Gospels diverge somewhat in their coverage and inclusion of these episodes) receiving news from the *angel *Gabriel about the upcoming birth of Jesus (*Annunciation), meeting with her kinswoman *Elizabeth (*Visitation), and giving birth to Jesus (*Nativity). Following the *Adoration of the Magi, *Purification of the Virgin, *Presentation of Jesus in the Temple and *Circumcision of Jesus, the *Holy Family's *Flight into Egypt precedes their return to Nazareth. Mary is mentioned again in the episode of the *Dispute in the Temple, discovering the young Jesus engaged in learned discussion with the elders.

Mary features less prominently in the Gospels during Jesus' public life, although she was influentially present at the *Marriage at Cana and witnessed the *Crucifixion of Jesus. Her appearance in scenes of the *Deposition and *Entombment of Jesus (events more detailed in apocryphal works such as the *Acts of Pilate* than in the canonical Gospels) doubtless results from her presence at the Crucifixion, as does her prominence in representations of the *Lamentation over the dead body of Jesus, further developed in images such as the *Pietà* (see also: *Mater dolorosa*).

After the *death of Jesus, Mary is mentioned again in the Acts of the Apostles, praying with the disciples in Jerusalem (Acts 1:13–14); thus she is sometimes included in scenes of *Pentecost and as a witness to the *Ascension of *Christ. Details about Mary's later life again must be sought in apocryphal sources and later legends which tell how Jesus entrusted Saint *John with her safekeeping and describe the last years of her life near the city of Ephesus before her death (see: *Dormition), *Assumption, and *Coronation in Heaven.

Many of these themes were greatly expanded in the *Golden Legend* and a number of medieval mystical and devotional works (e.g., the *Meditationes vitae Christi*) as well as numerous hagiographic and legendary accounts of miraculous appearances of Mary, especially to persons in need of spiritual assistance (e.g., see: *Theophilus, Legend of*). The role of Mary as an intercessor for humankind is also given visual form in the *Deësis* composition, and she frequently appears thus also in scenes of the *Last Judgment.

In addition to the forms and narrative subjects noted above, Mary appears frequently in a number of other visual and symbolic contexts. She is often prominently placed in visual schemes illustrating the genealogy of Christ (see: *Tree of Jesse, also *Holy Kinship); she may appear as a stern and imposing figure—the Throne of *Wisdom (see: *Sedes sapientiae*) or as a tender mother

(see: *Maria lactans*). Her purity is emphasized in images which show her in an enclosed garden setting (see: *Hortus conclusus*), with her floral attributes: lilies and roses (see: *Plants and Flowers, Symbolism of); she may also be accompanied by other virgins (see: *Virgo inter virgines*). Her *Seven Joys and *Seven Sorrows are illustrated in series, especially in later medieval art. Specific Byzantine types of Mary, frequent in *icons, and often influential on western art, may be found described under the headings *Blachernitissa, *Eleousa, *Hodegetria, *Platytera.

MARY OF EGYPT, SAINT. Accounts of the penitent Mary of Egypt first appear in the sixth and seventh centuries, providing the basis for further elaboration upon her widely popular biography. Episodes from her life, illustrated in both western and Byzantine art (*icons, frescoes, mosaics, sculpture, and stained glass) include her voyage from Alexandria to Jerusalem, for which passage she paid the sailors by her services as a prostitute, her being prevented by an *angel or an invisible force from entering the church of the *Holy Sepulchre in Jerusalem, her *prayer and vow of repentance before an icon (or statue) of the Virgin *Mary who directed her to pursue a solitary life in the desert, her retreat to the desert with three loaves of bread, her discovery after about forty-seven years by the priest Zosimus who heard her story and gave her communion (she miraculously walked across the Jordan river to meet him without getting wet), and Zosimus's return the next year to find her dead; he then buried her with the assistance of a lion who dug her grave. As a dramatic example of the *virtue of repentance, the story of Mary of Egypt emphasizes the extreme contrasts of her life before and after her moment of conversion. She was a great sinner who became a person of even greater holiness than Zosimus—a man who had dedicated his whole life to a search for sanctity. She is usually depicted as wild, unkempt, and emaciated, covered with long hair, sometimes holding the three loaves of bread which are her attributes.

Example: Communion of Mary of Egypt, 1596, icon, Decani Monastery. (*The Icon*, p. 349)

MARY MAGDALENE, SAINT. The woman named Mary Magdalene (from the village of Magdala) is mentioned several times in the Gospels. She appears among the followers of Jesus in *Luke 8:2 (Jesus had healed her of seven *demons); she is mentioned as present at the *Crucifixion and *Entombment of Jesus (*Mark 15:40, 47) as well as being the first witness to his *Resurrection (Mark 16:9; *John 20; see also *Noli me tangere, *Three Marys at the Tomb). These brief references provide minimal information about her, but from an early period, following the explanation given in John 11:2, western theologians (e.g., Saint *Gregory the Great) identified her as being the same person as two other ''Marys'' mentioned in the Gospels: Mary of Bethany, the sister of *Martha and Lazarus, and the unnamed woman, ''a sinner,'' who anointed Jesus' feet with oil, washed them with her tears, and wiped them with her hair while he

was dining in Simon the Pharisee's home (Luke 7:37–50). The versions of a similar episode in *Matthew (26:7) and Mark (14:3) describe that she poured oil upon Jesus' head, a premonition of his *death and burial.

Additionally, Mary Magdalene has been identified as the intended bride (of Saint *John the *apostle) at the *Marriage of Cana, and later legends also state that she accompanied Saint John and the Virgin *Mary to Ephesus, or, according to ninth-century legends from southern France, sailed to France with Lazarus and Martha, carried out missionary work, eventually became a hermit, and lived in a cave for thirty years before her death.

Illustration of the later legends about Mary Magdalene added to the iconography earlier developed in representations of the scriptural scenes. Although she is frequently undifferentiated from the other Marys in the visit to the tomb of Jesus and may also be unrecognizable in the group of mourners or witnesses in scenes of the Crucifixion (until the later medieval and Renaissance period, when she is often shown kneeling at the foot of the cross, kissing Jesus' feet or wiping them with her hair), she features prominently in scenes of the *Noli me tangere* in examples from the fourth century onward, and (as Mary of Bethany) is included in scenes of the *Raising of Lazarus. Although the subject of Jesus' visit to her home is infrequent in medieval art, when it is illustrated, Mary will be shown kneeling or seated by Jesus' feet. She may hold his feet in her lap, also a reference to her anointing of his feet—which subject also appears in Gothic and later art. She may also be shown kneeling beneath the table where Jesus and several other figures are seated dining. Hence, her long hair and ointment jar become her iconographic attributes, with which she is recognizable when portrayed as a single figure.

The later French tales about Mary Magdalene (also found in the *Golden Legend*) bear some substantial resemblances to the stories of Saint *Mary of Egypt; hence the iconography of Mary Magdalene as a "penitent sinner," kneeling in *prayer, covered with her long hair, frequently seen in later medieval and especially Renaissance example. Subjects from the legends include the miraculous voyage to Marseilles guided by an *angel (in a boat lacking sails, oars, or rudder), Mary's ascetic life in the wilderness during which she was lifted up to *heaven seven times a day by *angels, her last communion (offered by an angel or Saint Maximin), and her burial. These subjects appear primarily in French Romanesque sculpture and Gothic stained glass.

Example: Noli me tangere, Scenes from the Life of Christ, c.1150–1200, New York, PML, MS 44, f. 12. (Porcher, fig. 46)

MASS OF SAINT GILES. See CHARLEMAGNE; GILES, SAINT.

MASS OF SAINT GREGORY. A late medieval legend tells of the miraculous appearance of the crucified *Christ and *Instruments of the Passion above the altar when Saint *Gregory was celebrating the Mass. This appearance was in response to Gregory's *prayer: a disbeliever in the congregation had expressed

doubts about the real presence of Christ in the host. The mystical subject was especially popular in late medieval and Renaissance devotional art (see also: *Man of Sorrows). Christ may be shown standing, displaying his wounds, or holding the *cross. Saint Gregory kneels before the altar with accompanying figures.

Example: Simon Bening, *Mass of Saint Gregory,* c.1520–1530, Malibu, J. Paul Getty Museum, MS 3. (De Hamel, fig. 201)

MASSACRE OF THE INNOCENTS. The Massacre of the Innocents is the episode described in *Matthew 2:16 in which *Herod ordered all infants in Bethlehem and the surrounding region to be killed because he had learned of the birth of the potentially threatening ''King of the *Jews.'' (See also: *Adoration of the Magi.) Before this, warned by an *angel, Saint *Joseph and the Virgin *Mary had escaped with the infant Jesus (see: *Flight into Egypt). Apocryphal sources describe how Mary's kinswoman *Elizabeth sought refuge in a cave in the mountains with her infant, Saint *John the Baptist, while her husband, the priest Zacharias, was killed in the Temple by Herod's soldiers.

The Massacre of the Innocents appears early in art: in Byzantine ivory carvings of the fifth century, in the fifth-century mosaics of Santa Maria Maggiore in Rome, frequently in illustrated Gospel manuscripts, and in Romanesque and Gothic architectural sculpture. Customarily, armed soldiers are depicted attacking and dismembering children while women struggle and weep (a connection with *Jeremiah's description of *Rachel weeping for her children). The Holy Innocents also appear in art as a group or with other crowds of *saints bearing *haloes and martyrs' palm branches.

Example: Massacre of the Innocents, Codex Egberti, c.983, Trier, SB, Cod. 24, f. 15v. (Robb, fig. 78)

MATER DOLOROSA. Derived from a thirteenth-century Latin hymn which begins *Stabat mater dolorosa, juxta crucem lacrymosa* (''The sorrowing mother stood weeping by the cross''), *Mater dolorosa* refers to the sorrowing Virgin *Mary, lamenting the *death of *Christ. Not a single iconographic type but rather a title for the Virgin, the image of Mary grieving may be included within scenes of Christ's *Crucifixion, *Deposition, *Entombment, and the *Lamentation over his body. See also: *Man of Sorrows, *Pietà, *Seven Sorrows of the Virgin.

MATRIARCHS. The matriarchs were the spouses of the biblical *patriarchs, hence the ancestors of the tribes of Israel. *Sarah (the wife of *Abraham), *Rebecca (the wife of *Isaac), *Rachel and *Leah (the wives of *Jacob), as well as Bilhah and Zilpah (also mothers of children by Jacob) may be counted among the biblical matriarchs.

MATTHEW, SAINT. One of the *Four Evangelists, the *apostle Matthew was working as a tax collector in Capernaum when he was summoned by Jesus

(Matthew 9:9); and although he is mentioned by name (or as "Levi") several more times in the New Testament, little additional information about him is conveyed. Traditionally the *author of the Gospel of Matthew (c.60–90) as well as associated with the apocryphal *Gospel of the Pseudo-Matthew,* he features frequently throughout medieval art as an author and may be accompanied or represented by his symbol, a man (or *angel) because of the fact that his Gospel opens with a detailed account of the genealogy of Jesus. The image of the calling of Matthew, where Jesus, sometimes accompanied by other disciples, approached him at his table in the accounting house, is also found in later medieval art.

Additional scenes involving Matthew derive from apocryphal sources such as the *Acts of Andrew and Matthias,* which (apart from confusing Matthew with Matthias, who was selected to replace *Judas) recount their adventures in strange countries inhabited by cannibals, their defeating dragons, and their inspiring mass conversions (in Egypt, or Ethiopia). These stories (further elaborated in the *Golden Legend*) also describe Matthew's *martyrdom: he was stabbed from behind, at the orders of King Hirtacus, while he was praying before an altar, or, alternately, he was beheaded. Scenes of Matthew's martyrdom are found in hagiographic manuscript illustrations and in cycles (in various media) concerning the lives and deeds of the apostles.

Example: Saint Matthew, Lindisfarne Gospels, c.700, London, BL, Cotton MS Nero D. 4, f. 25v. (Synder, fig. 218)

MAURICE, SAINT. The leader of the Egyptian Theban Legion, Saint Maurice (d. c.287), and his companions refused the emperor's orders to sacrifice to the pagan gods before an important battle in Gaul. According to fifth-century legends, the emperor then ordered the entire legion (over 6,000 men) to be massacred. A warrior *saint, dark-skinned, Maurice appears in art dressed in armor, with a sword or lance and shield, normally standing, occasionally on horseback.

Example: Saint Maurice, c.1025–1050, metal book cover, Mainz, Gutenberg Museum MS 3. (Swarzenski, fig. 184)

MAURUS, HRABANUS. Hrabanus (or Rabanus) Maurus (c.780–856) was an important theologian, teacher, and *author. He was a pupil of Alcuin of Tours, served as abbot of Fulda (822–842) and as archbishop of Mainz (847–856). Active in the clerical educational reform movement of the Carolingian period, he wrote a manual for monks and clerics: *De clericorum institutione.* He also produced numerous scriptural commentaries, an extensive encyclopedia: *De universo,* based on the *Etymologiae* of *Isidore of Seville, and several poetic works, notably *De laudibus sanctae crucis,* c.810 (poems and prose tracts in praise of the Holy *Cross). An original illustrated copy of this manuscript survives (cited below) and includes clever *carmina figurata* diagrams of words and pictures. Illustrated copies of this text continued to be produced throughout

the medieval period, as well as his encyclopedia, which includes illustrations of plants, animals, constellations, monsters, and various other natural and celestial phenomena.

Example: De laudibus sanctae crucis, c.840, Rome, BAV, MS Reg. lat. 124, f. 45. (Robb, fig. 58)

MAURUS, SAINT. A disciple of Saint *Benedict, the monk Maurus (d. c.584) is also named as the founder of Glanfeuil (later Saint-Maur-sur-Loire), the first Benedictine abbey in France. Events from his life both at Monte Cassino and Glanfeuil were recorded by Odo of Glanfeuil in the ninth century and appear in illustrated manuscripts of the Romanesque period, especially in conjunction with Saint Benedict cycles. Episodes include numerous *miracle scenes (e.g., Maurus, at Benedict's direction, walked on water to rescue the drowning *Placidus from the lake), combats with the *Devil and conflicts with evildoers. His *relics were brought from Glanfeuil to Paris in the ninth century, and his life was also illustrated at the abbey of Saint-Maur-des-Fossés in the Romanesque period.

Example: Life and Miracles of Saint Maurus, c.1100, Troyes, BM, MS 2273, f. 77. (Porcher, fig. 5)

MEDITATIONES VITAE CHRISTI. *Meditationes vitae Christi (Meditations on the Life of Christ)* is the title of a popular devotional work (once attributed to Saint *Bonaventura) which was composed, probably by an Italian Franciscan (the "Pseudo-Bonaventure" or Johannes de Caulibus) in the second half of the thirteenth century. Designed as an aid to *prayer and contemplation, the text contains a series of expanded Gospel narratives concerning the life of the Virgin *Mary and the life and passion of Jesus. The author's reflections on these episodes contain abundant details and apocryphal embellishments. The reader is directed to carefully visualize and piously experience the events described. The *Meditationes* was extremely popular and frequently copied in illustrated manuscripts, especially during the fourteenth and fifteenth centuries. The text as well as the copious illustrations exerted a profound influence on later medieval art, reflecting as well as providing a source for many artistic motifs not found in other textual sources.

Example: Meditationes vitae Christi, early fifteenth century, London, BL, Royal MS 20.B.IV, f. 61v. (Alexander, fig. 114)

MEETING AT THE GOLDEN GATE. *Joachim and *Anne, the parents of the Virgin *Mary, were both directed by an *angel to meet at the Golden Gate of Jerusalem after each received news from an angel that Anne would conceive after their childless marriage of twenty years. According to the doctrine of the *Immaculate Conception, Mary, like Jesus, was conceived without stain of original sin; this privilege is symbolized in art by Anne and Joachim's embrace at the Golden Gate. They are depicted as mature figures, sometimes accompanied

by *shepherds, servants, and an angel; they kiss or embrace tenderly outside the city gate. Textual sources for the lives of Joachim and Anne include the second-century apocryphal *Protevangelium of James* and especially the thirteenth-century *Golden Legend,* following which the theme of the meeting at the Golden Gate became a very popular subject in art either independently or in narrative cycles concerning the life of the Virgin.

Example: Meeting of Joachim and Anne, mid-fourteenth century, icon, Belgrade, National Museum. (*The Icon,* p. 184)

MELCHIZEDEK. In Genesis 14:18–24, Melchizedek ("king of righteousness") was the gentile king of Jerusalem and the high priest who blessed *Abraham and offered him bread and wine after Abraham had successfully rescued his own nephew *Lot and recaptured his goods from the enemies. Melchizedek's offering of bread and wine was understood by Christian theologians as a prefiguration of the Eucharist (see: *Last Supper, *Seven Sacraments). He was also linked with Abel (see: *Cain and Abel) and Abraham, whose acceptable sacrifices similarly prefigure that of *Christ. In art, he wears priestly robes, is sometimes also crowned, and holds or offers a basket of bread and container of wine to the triumphant Abraham. He also appears symbolically paired with Abel in offering sacrifices to *God.

Example: Sacrifice of Melchizedek, c.432–440, mosaic, Rome, Santa Maria Maggiore, nave wall. (Zarnecki, fig. 51)

MENAS, SAINT. The Egyptian Saint Menas (d. c.300) was purportedly a soldier in the Roman army who was martyred during the persecutions under Diocletian. The shrine constructed over his tomb near Alexandria was a popular *pilgrimage site until it was sacked in the ninth century by Bedouins. The location of numerous *miracles recorded in several versions of his legend, his shrine was acclaimed for the curative holy water, which *pilgrims collected in phials *(ampullae).* On these objects, as well as icons, ivories, and medallions, Menas is often depicted as an *orant figure. He is frequently also shown between a pair of camels, referring to his protection of the pilgrims who traveled by camel across the desert to his shrine or to the camels who legendarily protected his *relics from being carried out of Egypt. His cult was also popular in the west.

Example: Christ and Saint Menas, sixth century, icon, Paris, Louvre. (Rice, fig. 19)

MENOLOGION. See MANUSCRIPTS.

MICHAEL, SAINT. The name *Michael* means "who is like *God"; he is the greatest among the archangels (see: *Angels) and is named in the books of *Daniel (10:13,21; 12:1), *Jude (1:9), and Revelation (12:7–9). Michael is popular and frequently represented in both western medieval and Byzantine art: ivories, mosaics, *icons, *manuscripts, sculpture, metalwork, and wall paintings.

Traditionally, Michael's primary roles are as chief opponent of the forces of evil and as weigher of *souls at the *Last Judgment. (See also: *Apocalypse.) In early Christian art, Michael is shown with the attributes of the classical god Mercury (caduceus, winged hat) who performed similar soul-weighing duties. Throughout medieval art, he appears as a powerful winged figure, often dressed in armor, carrying a shield, sword, or spear, and overcoming *Satan (the *Devil) or the symbolic dragon of evil. He also often holds a globe, representing Christian triumph over the world. Various *miracles and miraculous appearances are attributed to Michael, and shrines to Michael are often in high places; his association with danger, combat, *death, and the Last Judgment explain his position as patron of the dying.

Example: Saint Michael, Passionary, c.1100–1125, London, BL, Arundel MS 91, f. 26v. (Dodwell, fig. 328)

MILL, MYSTIC. See MYSTIC MILL.

MIRACLES. The term *miracle* derives from the Latin *miraculum* (''wonder'') and may be defined as an extraordinary event, seemingly outside the limits of apparent causality. In Jewish and Christian usage, miracles are wrought by *God's power and are signs of God's presence and frequent intervention in human affairs. In the Hebrew Old Testament, the terms *gedolot* (''great things''), *otot-u-mophetim* (''signs and wonders''), and *niphlaot* (''marvels'') are used to describe the many manifestations of God's power to direct, change, and influence the world of nature and human activity, both on a large and small scale. A sampling of such Old Testament episodes, frequently pictured in art (and referenced in this dictionary), includes the *Crossing of the Red Sea and various other events from the life of *Moses, the youths rescued from the *Fiery Furnace and *Daniel from the Lions' Den, the *Gathering of the Manna, the *Ascension of *Elijah, the *Deluge and sparing of the ark of *Noah, the destruction of *Sodom and Gomorrah, the *Plagues of Egypt, and numerous others.

In the New Testament, the various miracles performed by Jesus are understood to attest to his divine nature and to the fulfillment of Old Testament prophecies concerning the Messianic age. These miracles include acts of healing (see: *Healing of the Blind, *Healing of the Leper, *Healing of the Paralytic, *Woman with an Issue of Blood), *exorcism of *demons (see: *Healing of the Demoniac), bringing the dead back to life (see: *Raising of Jairus's Daughter, *Raising of Lazarus, *Raising of the Widow's Son), turning water into wine (see: *Marriage at Cana), providing wondrous quantities of food (see: *Miraculous Draught of Fishes, *Multiplication of the Loaves and Fishes), walking on water and stilling storms (see: *Storm on the Sea of Galilee). The *Resurrection of Christ is understood by Christians to be the central miracle of Christianity.

The theory and interpretation of miracles was a topic of frequent discussion among both Jewish and Christian writers through the Middle Ages. Accounts of miracles performed by *saints, martyrs, and *relics provided sources for the

continued production of hagiographic literature, pictorial representations, and the practice of *pilgrimage from the early Christian through late medieval period. Miracles performed by saints during their lifetimes and posthumously are frequently represented in art, as well as the hundreds of miracles attributed to the Virgin *Mary during the Middle Ages.

The miracles wrought directly by God, or through saints or *angels, are distinct from the supernatural or magical events performed by the *Devil or demonic forces (e.g., see: *Fall of Simon Magus).

MIRACULOUS DRAUGHT OF FISHES. The Gospels record two *miracles in which Jesus brought about the catching of surprisingly great amounts of *fish. *Luke (5:1–11) describes how Jesus entered a boat to preach to a huge crowd gathered on the shore of the sea of Galilee; he instructed the boat's owner, Simon (*Peter), to put out the nets even though no fish at all had been caught the previous night. So many fish were then hauled up that the nets broke, and help from a nearby boat was required. Both boats grew so filled with fish that they almost sank, but Jesus assured the disciples' safety and named them henceforth "fishers of men." The scene is hence often conflated with the *Calling of Peter and Andrew. The second account (*John 21:1–11) describes how, after Jesus' *Crucifixion, seven of the disciples were unsuccessfully fishing when a stranger, standing on the shore, asked them for food. The stranger instructed them where to cast their nets, and a huge quantity of fish was caught. The disciples then recognized the stranger as the resurrected Jesus, and they shared a meal together. These subjects are somewhat less frequently depicted in medieval art than other scenes of Jesus' miracles.

Example: Miraculous Draught of Fishes, c.1180–1190, stained glass, Canterbury Cathedral, north choir aisle. (Dodwell, fig. 401)

MISSAL. See MANUSCRIPTS.

MISSION OF THE APOSTLES. The New Testament contains several references to the duties which Jesus directed his disciples to undertake. Before his *Ascension, Jesus charged the *apostles with bearing witness of him "unto the uttermost part of the earth" (Acts 1:8); elsewhere, he enjoined them to "teach all nations" and to baptize (*Matthew 28:19); he gave them the power to save and condemn (*Mark 16:16), to heal the sick, and to perform *exorcisms (*Luke 9:1–2). These duties of the apostles are illustrated in numerous episodes of *preaching, baptizing, healing, and exorcism, which appear pictorially narrated in various contexts as well as in scenes of Jesus endowing them with power and sending them forth. Closely related to images of the Ascension and *Pentecost (the Descent of the *Holy Spirit), the Mission of the Apostles may be shown with *Christ emitting rays of power from his hands and towering over the apostles (as rather uniquely in Romanesque sculpture at Vézelay), gesturing toward

them as they walk away, or handing books or scrolls to flanking apostles (see also: *Traditio legis).

 Example: Mission of the Apostles, c.1120–1132, Vézelay, Sainte-Madeleine, tympanum. (Snyder, fig. 352)

MOCKING OF CHRIST. At the conclusion of Jesus' interrogation before the Jewish authorities (see: *Trials of Christ, *Caiaphas) the Gospels recount that he was blindfolded, spat upon, and beaten. This episode is distinct from the later mocking of Jesus under Roman jurisdiction (see: *Crowning with Thorns) and appears less frequently in art than the latter scene. Examples can be found in early seventh-century and eleventh-century manuscripts, and by the thirteenth century is sometimes included in the image of the trial itself. Jesus is normally shown standing, surrounded by several figures with hands raised to buffet him.

 Example: Mocking of Christ, Gospels of Saint Augustine, c.600, Cambridge, CCC, MS 286, f. 125. (Weitzmann, LA&EC, pl. 41)

MONSTER. See ANIMALS, SYMBOLISM OF.

MONTH. See LABORS OF THE MONTHS; ZODIAC.

MORDECAI. The cousin and guardian of *Esther, Mordecai was an official at the court of the Persian King *Ahasuerus. When he refused to bow down before the chief minister *Haman, Haman plotted to execute him and all the other *Jews. This event was prevented by Esther's intervention with the king, which resulted in the hanging of Haman (on the gallows prepared for Mordecai), Mordecai's rightful reward for past services, and his elevation to position as the king's chief minister (replacing Haman). Mordecai is found in illustrations of the Book of Esther, triumphant and finely dressed, displaying his signet ring of office, while Haman hangs on the gallows.

 Example: Esther Scenes, Roda Bible, mid-eleventh century, Paris, BN, MS lat. 6, vol. III, f. 97v. (Cahn, fig. 48)

MOSES. Numerous events from the life and deeds of the great leader and lawgiver Moses occur in art from the early Christian period onward, reflecting his extreme significance for both Judaism and Christianity. He features frequently in biblical narrative illustration and, in medieval typological programs, as a precursor of *Christ. Details from his life are recounted primarily in the books of Exodus, Numbers, and Deuteronomy. He appears as the leader of the Israelites out of captivity in Egypt, through decades of travels in their journey to the promised land, and as a frequent recipient of visions and instructions from *God.

 The following provides a roughly chronological survey of the events from the life of Moses most often represented in early Christian and medieval art (a

number of which also receive more detailed coverage in the cross-indexed entries).

Scenes of Moses' infancy include his discovery by *Pharaoh's daughter in a basket in the shallows of the Nile river. Moses' mother had hidden him there to escape Pharaoh's decree that all male Hebrew babies be drowned (this prefigures the *Massacre of the Innocents and *Flight into Egypt of the *Holy Family, in typological programs). Moses was brought up at the court of Pharaoh but fled into the desert after he killed an Egyptian who was mistreating an Israelite; he married Zipporah, daughter of Jethro, and lived as a *shepherd for twenty years until he was called by God, who spoke to him from a burning bush on *Mount Sinai. This scene appears often in art from the early Christian through Gothic period; Moses may be shown removing his sandals or kneeling before the flaming bush. In Byzantine and later medieval art, the Virgin *Mary may also appear, enthroned in the bush—her virginity typologically connected with the bush that burned but was not consumed.

Following God's instructions, Moses returned to lead the Israelites out of Egypt. Pharaoh eventually allowed the people to leave after ten *Plagues had been caused by God and copious discussions had ensued between Pharaoh, Moses, and Moses' brother *Aaron (during one conversation the staffs of Moses and Aaron turned into snakes). Following the miraculous *Crossing of the Red Sea (often typologically connected with Christian *Baptism), the Israelites, led by Moses, underwent various trials in their desert wanderings. God provided quails, *manna,* and water to keep them from hunger and thirst (see: *Gathering of the Manna). The scene of Moses striking a rock and causing water to pour forth features frequently in art from the early Christian period as a symbol for salvation. After successful battles against the Amalekites, the Israelites, now near Mount Sinai, were left to their own devices for a time while Moses, again called by God, ascended the mountain and received the Tablets of the Law. This often-represented scene may show Mount Sinai with flaming bushes and the hand of God delivering the tablets to Moses. During Moses' absence, Aaron, his brother, led the Israelites in *Worship of the Golden Calf. Moses' anger, his breaking of the tablets and destruction of the offensive golden *idol are often represented in art.

After receiving new tablets from God, Moses directed the Israelites in the construction of the *Ark of the Covenant, which they carried on their further journeys. The continued hardships inspired many to complain against Moses and God, who punished them with a plague of poisonous snakes. Moses, again directed by God, set up a metal (''brazen'') sculpture of a serpent on a pole, which cured the repentant who looked at it. Understood by Christians as a prefiguration of the *Crucifixion, this image also features in illustrations of the legend of the *True Cross; the pole used by Moses to erect the brazen serpent was made of wood from the *Tree of the Knowledge of Good and Evil (see also: *Garden of Eden) and was later to be used for the *cross of Jesus. Another prefiguration of the Crucifixion occurs when Moses sent out scouts into Canaan,

who returned bearing grapes on a pole (see also: *Mystic Wine Press). After a further revolt, in which Moses, Aaron, and *Joshua were nearly stoned to *death but miraculously saved from harm, the death of the now very elderly Moses took place. He was in view of but not allowed to enter the promised land, for a reason which remains ambiguous in the tradition. Scenes of the death of Moses on a hilltop or hidden in his tomb and guarded from the *Devil by Saint *Michael are also found in western medieval and Byzantine art (the latter images derive from medieval legends).

Apart from the Old Testament narratives above, Moses is frequently found in illustrations of the *Transfiguration of Jesus (he appeared along with *Elijah), and he may be seen in illustrations of the *Anastasis, as one of the Old Testament figures released from *hell by Christ. Moses is normally shown as an elderly, bearded figure and is additionally recognizable by being frequently depicted with horns. This may be due to a confusion in translation from the Hebrew terms for "rays of light" (which shone from his forehead after he descended Mount Sinai) to the Vulgate (Latin) *cornutam* ("horned" or "haloed" with light); Moses is commonly shown with horns especially in Romanesque and Gothic art.

Example: Moses Expounding the Law, Bury Bible, c.1135, Cambridge, CCC, MS 2, f. 94. (Dodwell, fig. 347)

MOUNT OF OLIVES. Mount Olivet (the Mount of Olives) is located to the east of the city of Jerusalem. The garden of Gethsemane was located at its base. This was the site of Christ's *Agony in the Garden, the *Betrayal and *Arrest of Christ, and traditionally also the site where an *angel appeared to the *apostles announcing Christ's *Ascension.

MOUNT SINAI. The specific identification of Mount Sinai (or Horeb) remains a matter of some scholarly dispute. *God spoke to *Moses from a burning bush on Mount Sinai. The Israelites reached the wilderness of Sinai after three months of journeying from Egypt (Exodus 19) and the mountain features as the place where Moses received the Tablets of the Law and the Ten Commandments from God. Exodus (19:18; 24:17–18) contains several descriptions of the mountain shining with fire, covered with smoke, and trembling with earthquakes and volcanoes when God descended upon it. Hence, Mount Sinai appears especially in illustrations of Moses receiving the law and is often shown with flames or fires burning on it. The site of Saint Catherine's monastery at the foot of Gebel Musa (identified as Mount Sinai) was chosen in the sixth century as the location where Saint *Catherine of Alexandria's body was miraculously transported after her *martyrdom.

Example: Moses Receiving the Law, Grandval Bible, 834–843, London, BL, Add. MS 10546, f. 25v. (Dodwell, fig. 54)

MOUTH OF HELL. Based on Old Testament descriptions of the dragon/sea serpent *Leviathan, medieval artists frequently depicted the entrance to *hell as

the gaping jaws of a huge and fearsome beast. Flames may issue forth, and *demons are often shown tormenting sinners within, or prodding them into, the beast's jaws. An *angel may be shown locking up a door or gate enclosing the damned. The image is frequently found in Romanesque and Gothic art, especially in manuscript illustration and in sculptured scenes of the *Last Judgment on church portals. These bestial jaws of hell are also found in images of the *Fall of the Rebel Angels and, especially western, illustrations of the *Anastasis. (See also: *Devil, *Satan.)

 *Example: Entrance to Hell, Winchester Psalter, c.1145–1155, London, BL, Cotton MS Nero C.IV, f. 39. (Dodwell, fig. 361)

MULTIPLICATION OF THE LOAVES AND FISHES. The Gospels contain six slightly divergent accounts of the *miracle when Jesus provided food for a multitude of people from miminal existing resources. The essential outline of the event indicates that several thousand people were miraculously fed with a few loaves of bread and a few fishes, with numerous full baskets left over. (Exact numbers vary in the different versions.) The subject appears in western and Byzantine art primarily from the fourth through twelfth centuries. The earliest examples involve a simple and reduced composition: Jesus stands in a central position, flanked by two disciples, each carrying a basket, the contents of which Jesus touches or blesses. Sometimes the disciples are absent, and Jesus is shown waving a staff over several baskets. More baskets and more disciples appear by the sixth century, and the disciples distributing food to several figures (indicating the multitudes) may also be included. Some ninth- and tenth-century ivories show Jesus seated, surrounded by figures who are holding baskets, distributing food to others, or eating. Whether Jesus is seated or standing, his central position and action of blessing food carried by flanking figures make this image similar to the symbolic presentation often found in Byzantine representations of the *Communion of the Apostles, as well as the *Last Supper (which this event was understood to prefigure and with which it is sometimes pictorially linked).

 *Example: Miracle of Loaves and Fishes, c.545–553, ivory, Throne of Maximian, Ravenna, Archiepiscopal Museum. (Volbach, fig. 233)

MUSIC. See SEVEN LIBERAL ARTS.

MUSICAL INSTRUMENTS, SYMBOLISM OF. Musical instruments are found in a variety of contexts throughout early Christian and medieval art: in pictorial narratives, as iconographic attributes, and as both positive and negative symbols for human behavior.

 Numerous references to music and musical instruments can be found in both the Old and New Testaments, and copious episodes involving music, song, and dance are illustrated in art, including triumphal processions after victorious bat-

tles, celebrations at feasts and marriages, praises to *God in religious ceremonies, and mournful occasions such as burial rites. The instruments mentioned in the Bible include: HARPS (and other stringed instruments), PIPES, FLUTES, ORGANS, HORNS, TRUMPETS (and other wind instruments), and percussion instruments such as BELLS, CYMBALS, TIMBRELS (or TAMBOURINES). The forms of these instruments, when depicted in art, generally reflect contemporary usage as per the date of illustration, as well as the translations of the names of these ancient instruments into the approximate Latin terms and types.

Apart from the general narrative contexts mentioned above, some of the specific figures most frequently represented with, or playing upon, musical instruments are King *David (as composer of the Psalms and musician at the court of King *Saul; he is often shown with a HARP or LYRE); the *Twenty-four Elders of the Apocalypse (who play stringed instruments: HARPS, LYRES, LUTES, or VIOLS); and *ANGELS (who announce the *Last Judgment by blowing on TRUMPETS, serenade God and the blessed in *heaven with HARPS and other stringed instruments, and may accompany the *Madonna and Child, or various *saints, with instruments such as portative ORGANS).

In representations of the *Seven Liberal Arts, the art of Music may be depicted by a female figure (or by *Pythagoras or Tubal-Cain) playing upon a string of BELLS or with such other instruments as an ORGAN, HARP, LYRE, or VIOL. Musical instruments also feature in other secular contexts, in illustrations of love, romance, and leisure and also serve as negative symbols for distraction or rural, low life (e.g., peasants or *grotesques playing BAGPIPES in Gothic manuscript marginalia). *Animals playing upon musical instruments are often found in Romanesque and Gothic sculpture and painting and, although some of these scenes may be purely whimsical or decorative, an ass playing upon a harp may also serve as a symbol for the *vice of Ignorance.

Musical instruments (and various theoretical diagrams, e.g., illustrating musical ratios and the harmonious ''Music of the Spheres'' produced by the stars and planets) also appear in illustrated copies of the influential early sixth-century treatise by *Boethius, *De institutione musica,* which provided a source for most later medieval musical development and inspired many later authors. The (sung) tones of the Gregorian Chant are also, somewhat curiously, illustrated by figures playing a variety of instruments in late eleventh-century sculpture at Cluny. This reflects the great significance of sung music in the medieval monastic life generally, as well as the influence of the early eleventh-century Cluniac musician, Guido of Arezzo, whose important writings on music were also frequently illustrated.

Example: First Tone of the Plainsong, c.1088–1095, Cluny, ambulatory capital. (Snyder, fig. 347)

MYSTIC MILL. The mystic mill is an allegory of the relationship of the Old and New Testaments explained by Saint *Gregory in the sixth century (see also: *Typology). The rough wheat of the Old Testament is ground in the mill into

the fine flour of the New Testament. In art, *Moses may be shown providing the Old Testament material to make the New Testament flour, collected by Saint *Paul.

Example: Mystic Mill, c.1120–1132, Vézelay, Sainte-Madeleine, nave capital. (Synder, fig. 357)

MYSTIC WINE PRESS. The wine press of *God's wrath is mentioned in *Isaiah 63:3 and Rev. 14:19–20. The blood which pours forth was likened by early Christian theologians (e.g., Saint *Augustine) and later medieval authors (e.g., *Rupert of Deutz) to the sacrifice of *Christ. Augustine and others also referenced the episode in Numbers 13:17–24 when spies, sent out by *Moses to Canaan, returned bearing grapes on a pole (as a prefiguration of the *Crucifixion). The symbolism of grapes-wine-blood is frequently found in early Christian and medieval art (e.g., see: *Fountain of Life, *Last Supper, *Vine/ Vineyard); the Mystic Wine Press further develops the symbolism by depicting Christ treading on grapes or being crushed in a winepress out of which his blood flows. The image is often found in illustrated manuscripts of the *Apocalypse and became very popular in late medieval stained glass. Christ may be shown kneeling before the wine press or standing in it and treading on grapes (the machinery of the press may be shown as an upright *cross behind Christ), or Christ may be shown horizontally, actually squeezed in the press. Vats of his blood may be collected by kneeling and praying figures.

Example: Christ in the Winepress, Apocalypse, c.1260–1270, Eton College Lib., MS 177, p. 84. (Morgan, II, fig. 177)

N

NAHUM. One of the twelve minor *prophets, Nahum (probably mid-seventh century B.C.) foretold the destruction of the city of Nineveh in a series of dramatic visions contained in the Old Testament book bearing his name. Christian theologians found references to the advent of the Messiah in his prophecies; hence he appears in medieval art typically as a bearded figure in a long robe, holding an inscribed scroll.

Example: Nahum, Bible of San Daniele, c.1150–1175, San Daniele del Friuli, Biblioteca Guarneriana, Cod. III, f. 23. (Cahn, fig. 148)

NAILS, HOLY. See INSTRUMENTS OF THE PASSION.

NAMING OF THE ANIMALS. The *Creation narrative of Genesis 2:19–20 describes *God directing *Adam to give names to all the recently created animals which God brought to Adam in the *Garden of Eden. In this way, Adam became familiar with the created animals, their superior. In art, the subject may show Adam standing or seated, in a lush garden setting, surrounded by pairs or single representatives of various *birds, beasts, and *fish. The serpent may also be present. The episode precedes the creation of Eve. The image is similar to classical depictions of the poet/musician Orpheus charming the animals with his music and also to early Christian representations of Christ as the *Good Shepherd. (See also: *Animals, Symbolism of.)

Example: Adam Naming the Animals, late twelfth century, fresco, Ferentillo, San Pietro in Valle, nave. (Dodwell, fig. 149)

NAOMI. The mother-in-law of *Ruth, Naomi returned from Moab to her native Bethlehem after the deaths of her husband and two sons. When Ruth was gleaning in the fields at harvest time, she met Boaz (a relative of her deceased husband) and, at Naomi's encouragement, initiated an encounter with Boaz,

resulting in the eventual marriage of Ruth and Boaz. Boaz helped Naomi redeem her own land. Naomi is pictured in illustrations of the Book of Ruth, conversing with Ruth and present at the birth of Obed, the son of Ruth and Boaz.

Example: Preface to Ruth, Lambeth Bible, c.1140–1150, London, Lambeth PL, MS 3, f. 130. (Grabar and Nordenfalk, Rmsq., p. 168)

NATHAN. The *prophet Nathan was an advisor to King *David and hence appears primarily in illustrations concerning the life of David in episodes from the Old Testament books of 2 Samuel and 1 Kings. Nathan's rebuke of David (for his adultery with *Bathsheba and for ordering the murder of her husband Uriah so as to marry her) is most frequently illustrated. Nathan is shown as an elderly, bearded figure gesturing in admonition toward the couple and predicting future punishment for the repentant David (2 Samuel 12:1–14). He also appears as consultant to David in the construction of the Temple and as advisor to Bathsheba regarding the succession to the throne of her son *Solomon.

Example: Nathan Reproaching David and Bathsheba, Psalter, c.1170, Copenhagen, Kongelige Bibliotek, MS Thott 143 2°, f. 68. (Swarzenski, fig. 316)

NATIVITY. *Nativity* means "birth" (from Latin: *nativus*). Scenes depicting the births of a number of important or holy figures are often found in medieval art (e.g., the birth of Saint *John the Baptist; birth of the Virgin *Mary), but the Nativity of Jesus is among the earliest and most frequently represented subjects in Christian art through the Middle Ages. The event itself, however, is described only briefly in the Gospels of *Matthew and *Luke. Sources for the artistic iconography of the Nativity of Jesus primarily derive from apocryphal writings (e.g., the *Protevangelium of James* and the *Evangelium of the Pseudo-Matthew*), as well as commentaries by early Christian and medieval theologians, the *Golden Legend,* and later medieval mystical writings.

The earliest images of the Nativity (on sarcophagi and ivories of the fourth and fifth centuries) depict simply the infant Jesus, wrapped in cloths, lying in a basket or trough (the "manger" mentioned in Luke 2:7), while an ox and an ass stand nearby or peer down at the baby. These two animals are not mentioned in any of the early texts concerning the Nativity (until the *Evangelium of the Pseudo-Matthew*) although they remain consistently represented in virtually all Nativity scenes. Their presence may be explained by the passages in *Habakkuk 3:2 and *Isaiah 1:3 (Isaiah: "The ox knows his owner and the ass his master's crib") which were related to the Nativity of Jesus by a number of early Christian theologians. One or two *shepherds, or a *prophet may also appear in these early scenes.

The scene of the *Adoration of the Magi is sometimes combined with early Nativity images; Mary will be shown seated, holding the infant on her lap while the magi approach or kneel before them. Both Mary and Saint *Joseph are included in Nativity scenes by the fifth century and may be shown seated on either side of the crib or manger. By the sixth and seventh century, Mary is

more frequently shown reclining. Following the descriptions in the *Protevangelium of James,* the setting for the birth may be indicated as a cave (which image continues in Byzantine examples), and the additional stories of the midwives (one Salome who doubted Mary's virginity was stricken with a paralyzed hand, which was healed by touching the infant Jesus), and the scene of the bathing of the infant also appear. *Angels, shepherds, the magi en route, and a star emanating a beam of light down upon the infant are frequently included in Byzantine examples of the tenth and eleventh century. In the domed cruciform churches of Byzantium from the eleventh century, the Nativity (in fresco or mosaic) was customarily located in a prominent position in a pendentive (or niche) of the central dome.

Western examples from the ninth century onward tend to depict the location of the Nativity as a stable, shed, or other architectural structure, and by the twelfth century, the manger is often extremely prominent, elevated above (behind) the reclining figure of Mary, resembling a slab or altar upon which rests the swaddled infant (hence making a connection with the Eucharist and *Last Supper). In Romanesque and especially Gothic examples, Mary will often be shown reaching tenderly toward the infant. Sometimes she is shown nursing the baby (see: *Maria lactans). The midwives and the scene of the bathing of the infant tend to be deleted in these later western examples (because of criticism from western theologians), although angels, a seated Joseph, and the ox and ass remain. Later medieval mystical works (e.g., the thirteenth-century *Meditationes vitae Christi* and the fourteenth-century visions of Saint Bridget of Sweden) influenced the development of later examples that show Mary kneeling in *prayer before the infant, who is in the manger or lying on the ground in a bundle of straw.

Example: Nativity, c.1143, mosaic, Palermo, Cappella Palatina. (Synder, cp. 27)

NAVICELLA. *Navicella* means "little boat." The term is sometimes used for the scene of *Christ's miraculous walking on the water (and Saint *Peter's attempts to do so) during a *Storm on the Sea of Galilee.

NEBUCHADNEZZAR. King of Babylon in the sixth century B.C., Nebuchadnezzar was responsible for the destruction of Jerusalem. Imaginative stories of his life are told in the book of *Daniel. Scenes illustrated in medieval manuscripts of the Bible and *Apocalypse and found in Romanesque and Gothic architectural sculpture, include his dream vision of a great image of gold, silver, and brass, with feet of clay and iron, which was broken into pieces by a stone, and his dream of a great tree cut down to its stump. Daniel was called upon to interpret these portents and correctly prophesied the downfall of Babylon and the madness of Nebuchadnezzar, who is also depicted in art crawling on all fours and eating grass. See also: *Fiery Furnace.

Example: The Story of Daniel, Farfa Bible, c.1000–1025, Rome, BAV, MS lat. 5729, f. 227v. (Robb, fig. 102)

NEW JERUSALEM. See HEAVENLY JERUSALEM.

NICASIUS, SAINT. Bishop of Reims in the fifth century, Nicasius was martyred in the doorway of his cathedral, decapitated by invading barbarian soldiers (probably Huns, c.451). Patron *saint of Reims, Nicasius generally appears as a *cephalophor, holding his decapitated head still wearing the bishop's mitre. His legend recounts that his severed head continued to speak and completed the Psalm he was reciting when his head was cut off. He is often accompanied by *angels and by his sister Eutropia, who was martyred with him.

Example: Saint Nicasius, Book of Hours, 1430s, Walters, MS 164, f. 173v. (Wieck, fig. 94)

NICHOLAS, SAINT. One of the most popular and frequently represented *saints in both western medieval and Byzantine art, Nicholas (d. c.342) was the bishop of Myra in Asia Minor. Very few facts are known about his life although many episodes involving his legendary deeds and *miracles are illustrated in frescoes, mosaics, *icons, sculpture, manuscript illustration, stained glass, and minor arts media through the Middle Ages. His cult, which appears to have begun in Byzantium, became popular in the west by the ninth century. The translation of his *relics to Bari in 1087 and the construction of a basilica created a popular *pilgrimage site (notable for the sweet-smelling myrrh or oil emitted by his relics). Episodes of his legend frequently illustrated in art include his birth (he stood up and prayed to *God immediately, or in his bath); his refusal of his mother's breast on fast days; his gift of gold (symbolized by bags of coins or golden balls) to the three daughters of a poor man to provide their dowries and prevent their becoming prostitutes; his miraculous restoration to life of little children whom an innkeeper had cut up, salted, and placed in a tub to serve as meat during a famine; and his posthumous appearance to rescue sailors lost in a storm at sea. These subjects appear especially often as narrative vignettes in cycles on Byzantine icons and on western baptismal fonts, as well as in other media. Nicholas often appears dressed as a bishop with mitre and crozier or holding a book, *cross, three golden balls, or an anchor. In western folklore, Saint Nicholas gradually became *Santa Claus.*

Example: Saint Nicholas, early thirteenth century, icon, Mount Sinai, Monastery of Saint Catherine. (*The Icon,* p. 67)

NICODEMUS. According to the Gospel of *John, Nicodemus was a prominent *Jew (a member of the high court: the Sanhedrin) who acknowledged that Jesus was "a teacher come from *God." He paid a secret nighttime visit to Jesus and engaged in lengthy conversation with him (John 3:1–21). He later defended the absent Jesus before the Pharisees (John 7:50–51) and assisted with the *Deposition and *Entombment of Jesus (John 19:39). Apocryphal traditions identify Nicodemus as the person who extracted the nails from Jesus' body (see also: *Instruments of the Passion); hence, he features in scenes of the Deposition,

removing the nails with pincers while *Joseph of Arimathea supports the body. He and Joseph of Arimathea are shown carrying the body to the tomb and, accompanied by others, placing Jesus' body in the cave or sarcophagus. Legends also recount that Nicodemus was a sculptor; he is said to have carved an image of the *Crucifixion now in the cathedral of Lucca (see: *Volto Santo). The apocryphal Gospel of Nicodemus (or, Acts of Pilate) contains detailed accounts of Jesus' *Trials and *death, as well as the *Anastasis and *Resurrection.

Example: Deposition, c.1164, fresco, Nerezi, Saint Panteleimon. (Rice, fig. 117)

NINE WORTHIES. See ARTHURIAN LEGENDS.

NOAH. Noah appears in Genesis 6:8–9, introduced as a "just man" who found favor with *God. God instructed him in the construction of an ark (or boat) within which Noah, his family, and groups of *animals sought refuge during the great and destructive *Deluge caused by God. When the storms and flooding subsided, these chosen survivors emerged from the ark, assured both by God that the land was habitable and by a dove, which returned with an olive branch when sent out from the ark; Noah gave thanks and made sacrifices to God. All of these subjects appear regularly in early Christian and medieval art, especially the scene of Noah's ark surviving the Deluge, which appears frequently in the early Christian period (e.g., in catacomb frescoes and on sarcophagi) as a symbol of salvation. The image may be extremely simple, showing an *orant Noah floating in a little box or later, a more elaborate and properly boatlike structure filled with people and animals is indicated. God instructing Noah in the building of the ark, Noah sending out the dove, the return of the dove, the survivors emerging from the ark, and the sacrifices offered in thanks to God after the Deluge also appear in art through the Middle Ages. Noah is generally represented as an elderly bearded figure wearing a long robe. An incident described in Genesis 9:21–27 also appears in art from the early Christian period onward; here, Noah became intoxicated with wine (he had planted a *vineyard) and fell asleep, naked, in his tent. His son Ham (Canaan) ran to tell his brothers about this humiliating sight; the brothers Shem and Japheth walked backward into the tent and covered Noah who, when he later awoke, cursed Ham and blessed Shem and Japheth for their more respectful behavior.

Example: Noah's Ark, c.1100, fresco, Saint-Savin-sur-Gartempe, nave vault. (Snyder, cp. 48)

NOLI ME TANGERE. Noli me tangere is Latin for "Touch me not," a fragment from the fuller words spoken by *Christ to *Mary Magdalene when he appeared to her after his *Resurrection. The conversation is recorded in *John 20:14–17 which describes how Mary, left alone and weeping at Christ's empty tomb, initially mistook Christ for the gardener and queried him as to the whereabouts of the body. When Christ addressed her by name, she recognized him, at which point he directed her not to cling to him but to go to the other

disciples and tell them of his reappearance and coming *Ascension. The subject appears in early Christian ivories of the fourth century and frequently in manuscript illustration and sculpture through the Gothic period. Mary is often shown kneeling before the standing Christ, who gestures toward her; she may reach out her arms toward him, and he may draw away from her. A landscape setting may be indicated, and occasionally Christ will hold a hoe or shovel (in reference to Mary's initial assumption that he was the gardener).

 Example: Noli me tangere, Scenes from the Life of Christ, early fourteenth century, New York, PML, MS 643, f. 27. (Robb, fig. 183)

NOTITIA DIGNITATUM. First composed and illustrated in the early fifth century, the *Notitia dignitatum* contains lists of the military and civilian titles, ranks, and insignia of Roman officials in the western and eastern empires. Provincial divisions and military commands are symbolically illustrated with seated figures, coins, and emblems of rank and prestige. The manuscript was copied in Carolingian times and studied and copied again especially in the Renaissance period.

 Example: Notitia dignitatum, c.1427, Cambridge, Fitzwilliam Museum, MS 86.1972, f. 2. (Alexander, fig. 226)

O

OAK. See FRUIT AND TREES, SYMBOLISM OF.

OBEDIENCE. See VIRTUES.

OCCUPATIONS OF THE MONTHS. See LABORS OF THE MONTHS.

OLIVE. See FRUIT AND TREES, SYMBOLISM OF.

OMER, SAINT. Omer (or Audomarus, d. c.670) was born near Coutances, became a Benedictine monk at Luxeuil, and c.637 was appointed by King Dagobert as bishop of Therouanne. He founded the monastery of Sithiu, where he spent the last years of his life. Several versions of his life were composed in the early ninth through early eleventh centuries; a notable late eleventh-century manuscript contains a detailed pictorial narrative cycle of various episodes in the *saint's life as well as posthumous *miracles.

Example: Saint Omer Set Upon by his Adversaries, Life of Saint Omer, second half of the eleventh century, Saint Omer, BM, MS 698, f. 34. (Dodwell, fig. 191)

ONUPHRIUS, SAINT. Legends recount that the Egyptian desert hermit Onuphrius (d. c.400) was originally a prince who, guided by a column of fire, retreated into the desert to spend sixty or seventy years in a completely solitary state. He dressed in palm fronds, let his hair and beard grow very long, was brought food by a raven, and received communion from *angels every Sunday. When the bishop Paphnutius came to visit him toward the end of his life, he found Onuphrius crawling on all fours like an animal. Onuphrius alerted the bishop of his upcoming *death and instructed the bishop to bury him after he died, which the bishop did, with the assistance of two lions who dug the grave.

Onuphrius is recognizable in art primarily by his wild and unkempt appearance; he appears especially in Byzantine art (mosaics, frescoes, and *icons).

Example: Saint Onuphrius, mid-thirteenth century, icon, detail. (*The Icon,* p. 212)

ORANT. An orant is a standing, frontal figure with arms extended or upraised in *prayer. Found in ancient and classical art, *orantes* are frequent in early Christian funerary contexts (catacomb frescoes, sarcophagi) as symbols of piety, hope, salvation, and the *souls of the deceased.

Example: Orant Figure, third century, fresco, Rome, Catacomb of Santa Priscilla. (Synder, cp. 1)

ORGAN. See MUSICAL INSTRUMENTS, SYMBOLISM OF.

ORIGINAL SIN. See ADAM AND EVE.

OX. See ANIMALS, SYMBOLISM OF; FOUR EVANGELISTS.

P

PALM. See FRUIT AND TREES, SYMBOLISM OF.

PANTALEON, SAINT. Popular in both Byzantium and the west, the "all compassionate" Saint Pantaleon (or Panteleimon) of Nicomedia (d. c.305) was a physician at the imperial court. His legend recounts how the dissolute nature of court life inspired his lapse into paganism. After his reconversion, he contributed his possessions to the poor and offered his medical services without charge. During the persecutions under Diocletian, he suffered a variety of tortures and was finally decapitated. He appears in art most often with the attributes of a medical doctor, such as a vial or box of ointments.

Example: Saint Pantaleon, Siegburg Lectionary, c.1130, London, BL, Harley MS 2289, f. 66v. (Swarzenski, fig. 228)

PANTELEIMON, SAINT. See PANTALEON, SAINT.

PANTOCRATOR. The image of *Christ-Pantocrator ("Ruler of All") appears often in Byzantine *icons and, in fresco or mosaic, in the domes of Byzantine churches. Haloed, bearded, and often very stern in appearance, the Pantocrator may be an enthroned or full-length figure, in a mandorla, surrounded by *angels or symbols of the *Four Evangelists. He may also be presented as a half-length figure or an enlarged bust. His flowing, dark hair is parted in the middle; he raises his right hand in a gesture of blessing (see: *Benediction) and holds a closed or open book in his left hand. The book, if open, will traditionally be to the text from *John 8:12 ("I am the light of the world . . ."). This format, found on icons dating from the late seventh century, continued to be reproduced through the Middle Ages. In monumental form, and in canonical placement in

the church dome, the image is an especially powerful representation of the power of *God.

 Example: Pantocrator, c.1080–1100, mosaic, Daphni, Church of the Dormition, dome. (Synder, cp. 23)

PARADISE. See GARDEN OF EDEN.

PARALYTIC, HEALING OF THE. See HEALING OF THE PARALYTIC.

PARTING OF LOT AND ABRAHAM. See ABRAHAM; LOT.

PASSION OF CHRIST. See CHRIST, JESUS, LIFE AND PASSION OF.

PASSIONARY. See MANUSCRIPTS.

PATIENCE. See VIRTUES.

PATRIARCHS. In the Bible, the patriarchs are the male founders of the human race, the leaders of tribes or clans. More specifically, the term is used to single out *Abraham, *Isaac, and *Jacob, as well as Jacob's twelve sons, who founded the twelve tribes of Israel. King *David, as *ancestor of *Christ, was also termed a patriarch by Saint *Peter (Acts 2: 29–30). (See also: *Tree of Jesse.) The title was also used from the sixth century for the bishops of Rome, Alexandria, Antioch, Constantinople, and Jerusalem. In art, the biblical patriarchs are often illustrated as venerable, bearded figures; *icons depicting the patriarchs are included on the top level of the traditional Byzantine *iconostasis, and narrative scenes from their lives are frequent in medieval art. (See individual entries, and also: *Matriarchs.)

PATRICK, SAINT. "Apostle of Ireland," the Romano-British Christian, Patrick (c.389–c.461), was captured by Irish raiders when he was sixteen and served as a slave in Ireland for six years before escaping, traveling to France, studying at several monasteries, and becoming a student of Saint Germanus at Auxerre. Consecrated as a bishop, he was sent back to Ireland as a missionary by Pope Celestine I, around 432. He was extremely successful in converting the Irish, encouraged monasticism and scholarship, and established his bishopric at Armagh. His legend credits Patrick with several *miracles (e.g., expelling snakes from Ireland). Somewhat infrequently represented in medieval art, Patrick appears wearing bishop's robes and mitre, often holding a crozier, and sometimes trampling upon a snake.

 Example: Saint Helena and Saint Patrick, fifteenth century, fresco, Colzate (Bergamo), San Patrizio. (Kaftal, NW, fig. 478)

PAUL, SAINT. Although not one of the original twelve *apostles, Paul (c.3–65) is often depicted among them because of his experiencing a direct revelation

or vision of *Christ and also because of his great significance in the development of the early Christian church. A *Jew, with Roman citizenship, Paul was born in Tarsus (Asia Minor), was originally named Saul, and was educated and brought up as a Pharisee (a strict, law-oriented, and separatist Jewish party). He is first mentioned in the book of Acts as a consenting witness at the stoning of Saint *Stephen, when he guarded the clothing of Stephen's attackers (Acts 7: 58). An opponent and persecutor of Christians, Saul's conversion is dramatically recounted in Acts 9:1–19 (also Acts 22:5–16, 26:12–18) and frequently illustrated in art from at least the sixth century onward. He was traveling from Jerusalem to Damascus when he was blinded by a light from *heaven; he fell to the ground and heard the voice of Jesus asking, "Saul, Saul, why do you persecute me?" Illustrations may show him falling forward or backward, crouching or covering his eyes, or stretching out his hands in a *prayerlike gesture. The hand of *God or a bust medallion of Christ may be shown, emanating rays of light. His companions, who also heard the voice and who assisted him to Damascus, may also be included. Until the later Gothic period, scenes of this event normally show him on foot; from the fourteenth century onward he may be shown falling off a horse (which is not mentioned in the biblical text).

At Damascus, Saul's sight was restored by the disciple Ananias, and Saul was baptized (these subjects occur in Carolingian and later art). Although he is still named "Saul" in the book of Acts (until 13:9), traditionally Paul became his Christian name at this point, reflecting his conversion and new life as a now ardent preacher and supporter of Christians.

Paul's later dramatic escape from Damascus (fleeing from Jews who intended to kill him) by being lowered down outside the city wall in a basket is also illustrated in art from the Carolingian period onward (Acts 9:23–25). His subsequent journeys (to Jerusalem, Caesarea, Syria, Cilicia, and Antioch) and missionary travels alone or with Saint Barnabus (to Cyprus, Lystra, Philippi, Athens, and Ephesus) provided materials for several scenes, for example, Paul *preaching and performing various *miracles of healing, as well as the arrest, imprisonment, and scourging of Paul at Philippi. When he returned to Jerusalem, Paul again met with violent Jewish opposition, was imprisoned by the Roman authorities for several years, questioned by King *Herod Agrippa II, and allowed to go to Rome to stand trial. The boat was shipwrecked off the coast of Malta, and Paul's miraculous survival of a bite from a poisonous viper (he shook the snake off into the fire, Acts 28:1–7) appears in fifth-century ivories, Romanesque frescoes, Gothic stained glass, and later manuscript illustration.

Reaching Rome, Paul remained in loosely guarded captivity, and the subsequent chronology of his life and *martyrdom is primarily provided by apocryphal sources: the second-century *Acts of Paul* (including the *Acts of Paul and *Thecla* and the *Martyrdom of Paul*) and the fourth-century *Apocalypse of Paul*. The latter text was widely popular in the early Christian and medieval periods;

the detailed visions of *heaven and its inhabitants were influential on illustrations of the *Last Judgment and on authors such as *Dante. The decapitation of Paul in Rome, sometimes shown with the *crucifixion of Saint *Peter, which traditionally took place on the same day, features largely in Romanesque and Gothic hagiographic illustration, although the scene of his arrest appears in the early Christian period.

Paul's chief iconographic attribute is the sword of his execution. He is also generally recognizable by his physical appearance (detailed in the *Acts of Paul and Thecla*) as a short, bald or balding man, sometimes with heavy eyebrows, and bearded. He is frequently depicted holding books or scrolls, indicating his authorship of the majority of Epistles contained in the New Testament.

For other scenes including Paul, see: *Fall of Simon Magus, *Mystic Mill, *Traditio legis.

Example: Scenes from the Life of Paul, Pauline Epistles, c.1150, Oxford, BL, MS Auct.D.1.13, f. 1. (De Hamel, fig. 98)

PAUL THE HERMIT, SAINT. The biography of Saint Paul the Hermit (or Paul of Thebes, d. c.345) was constructed from Greek sources by Saint *Jerome. To escape the persecutions of the emperor Decius, Paul retreated to the Theban desert c.250 where he lived the remainder of his (nearly hundred-year) life as a hermit. His life of contemplative solitude and asceticism was paralleled by a number of other early desert fathers whose lives similarly recount various temptations, apparitions, and miraculous events (e.g., Paul, like *Elijah, was fed by a raven who daily brought him bread). He is depicted in art as an elderly figure with white hair and a long beard, often wearing clothing of palm fronds, and frequently in company with Saint *Anthony who, inspired by a vision, visited when Paul was near death (on the occasion of Anthony's visit, the raven brought extra bread). The visit of Paul and Anthony is to be noted on several early sculptured high crosses in the British Isles. Paul may also be accompanied by the two lions who helped dig his grave. Scenes from the lives of Paul and Anthony are found in Byzantine hagiographic manuscripts, Coptic and Romanesque frescoes and sculpture, illustrations of the *Golden Legend,* and related works.

Example: Saint Paul Witnesses a Christian Youth Resisting Temptation, The Belles Heures of Jean de Berry, c.1408–1409, New York, Cloisters Collection, f. 191. (Thomas, pl. 25)

PEACOCK. See BIRDS, SYMBOLISM OF.

PELERINAGE DE LA VIE HUMAINE. See GUILLAUME DE DEGUILE-VILLE.

PELICAN. See BIRDS, SYMBOLISM OF.

PENTECOST. Pentecost referred originally to the traditional Jewish celebration of the grain harvest, which was held on the fiftieth day after Passover. The festival came also to commemorate *Moses' receipt of the Tablets of the Law. In the New Testament (Acts 2), the *apostles were gathered at the time of Pentecost, after Jesus' *death, and a great wind from *heaven and ''cloven tongues as of fire'' descended upon them. They were filled with the *Holy Spirit, all spoke in different languages, and they were inspired to spread the message of the Gospel throughout the world. This dramatic event (often also titled the Descent of the Holy Spirit) is illustrated in various ways in medieval art. The apostles are normally shown seated; often the Virgin *Mary is depicted in the center of the group; the hand of *God or the figure of *Christ may appear at the top of the composition; and rays of light or flames may enamate downward to the heads of the apostles. The dove, symbolizing the presence of the Holy Spirit, is often shown, as well as an old man with a scroll (or twelve scrolls), symbolizing the prophet Joel (whom *Peter quotes as predicting the event). Additional smaller figures, when included, represent the twelve nations of the world. See also: *Seven Gifts of the Holy Spirit.

Example: Pentecost, Cluny Lectionary, early twelfth century, Paris, BN, MS nouv. acq. lat 2246, f. 79v. (Synder, cp. 45)

PERICOPES. See MANUSCRIPTS.

PETER, SAINT. The *apostle (Simon) Peter (d. c.64) features prominently in the New Testament and in the history of the Christian church. His importance is reflected in his very frequent appearance in art from the early Christian period and throughout the Middle Ages. He appears in a great variety of scenes (both scriptural and apocryphal) and is more often illustrated in art than any of the other apostles. He is also, traditionally, the author of the Epistles of Peter.

One of the first disciples to be summoned by Jesus, he and his brother *Andrew were fishermen who left their nets to follow Jesus (see: *Calling of Peter and Andrew). During Jesus' life, Peter's prominence among the disciples was reflected by his presence at the *Transfiguration and (in some versions) the *miracle of the *Raising of Jairus's Daughter. Peter was (or had been) married, and Jesus' healing of his mother-in-law is also recorded in the Gospels and illustrated in art. At the *Last Supper and *Washing of the Feet, Peter's objection to Jesus' humble actions and his eventual recognition of their significance form important subjects in art, as does Peter's attempt to walk on water (see: *Storm on the Sea of Galilee; *Navicella*). Peter's anger at the *Arrest and *Betrayal of Jesus (see also: *Agony in the Garden) are illustrated in scenes showing him with a sword, cutting off the ear of the high priest's servant. During the *Trials of Christ, Peter denied his relationship to Jesus three times while a cock crowed in the background at each denial, fulfilling Jesus' earlier prophecy. This scene is frequently found in cycles of the Passion of Christ from the ninth century onward, as well as in earlier examples (e.g., included within scenes

showing the bearing of the *cross to *Calvary). A rooster is shown on top of a column while Peter speaks to the female servant in the courtyard or weeps grievously (e.g., *Matthew 26:69–75). Other episodes from the Gospels in which Peter features prominently include an incident in Capernaum (Matthew 17:24–27) when Jesus directed Peter to go to the sea and find a coin (in the mouth of a *fish) with which to pay the tribute required by the tax collectors and Jesus' speech to Peter (Matthew 16:18–19) in which he describes Peter as the "rock" upon which the church will be built and promises Peter the "keys of the kingdom of *heaven." In the early Christian period, this episode is often represented as, or combined with, the *Traditio legis (Giving of the Law; Saint *Paul may also be present); Jesus handing keys to Peter in the presence of the disciples also appears as an independent image. Hence, a key, or bunch of keys, is Peter's chief iconographic attribute.

Peter also features frequently in the book of Acts, performing various miracles (healing a cripple, bringing *Tabitha back to life, and announcing the *death of the fraud Ananias and his wife Sapphira, who fell down dead at his words), seeing a vision of unclean beasts, and baptizing the centurion Cornelius and his companions, all of which subjects can be found in early Christian and medieval art. According to Acts 12:3–11, he was imprisoned under the orders of *Herod (Agrippa I) but miraculously released from prison by an *angel who appeared and helped him to escape. Peter's chains fell away, and he was led out of prison by the angel. This subject became popular in the Romanesque period.

Many apocryphal stories of Peter are also frequently depicted in art. These largely derive from the second century Acts of Peter and include such episodes as his defeat of a magician (see: *Fall of Simon Magus) and his meeting with a vision of Christ on the outskirts of Rome. He asked Christ where he was going ("Domine, quo vadis?"), and Christ's reply inspired Peter to return to Rome. The account of his *martyrdom is also found in the Acts of Peter; his request to be crucified upside down (as lesser than Jesus) was granted, and this subject appears in art especially from the Carolingian period onward. These episodes, and many others, are also found in the *Golden Legend.

Peter is generally represented as an older man, balding, or with short curly hair and a short beard. Although keys are his most frequent attribute (and he often appears in scenes of the *Last Judgment, holding keys and welcoming the blessed into *heaven), a rooster, crozier, upturned cross, and papal robes and tiara may also serve to identify Peter. His tomb and shrine in Rome were early honored and the site upon which *Constantine erected the basilica of Saint Peter, the cathedral of the bishop of Rome (the pope), of which Peter was traditionally considered the first.

Example: Christ Gives Peter the Keys to Heaven, Pericopes of Henry II, c.1007–1012, Munich, BS, MS Clm. 4452, f. 152v. (Calkins, pl. 10)

PETER LOMBARD. The works of the theologian Peter Lombard (c.1100–1160) were especially influential during the twelfth and thirteenth centuries.

After studies in Bologna and Reims, he taught at the cathedral school in Paris from 1139 and was appointed bishop of Paris shortly before his *death. The author of commentaries on the Psalms and Pauline Epistles, his major work, the *Sententiarum libri (Sentences,* c.1148–1150) contains numerous quotations from earlier theologians (both western and Byzantine) and covers topics including *Creation, the *Trinity, the incarnation of *Christ, and the *Seven Sacraments of the church. Although his ideas were disputed by some scholars, his *Sentences* were formally accepted at the Fourth Lateran Council in 1215 and widely studied and copied. He is represented in frontispiece illustrations as a bishop with mitre and crozier.

Example: Peter Lombard, Sentences, c.1150–1200, Valenciennes, BM, MS 186, f. 2v. (Porcher, fig. 37)

PETRARCH, FRANCESCO. The Italian poet, scholar, and collector Francesco Petrarch (1304–1374) exerted a profound influence on the later medieval and early Renaissance periods through his writings, travels, political involvements, and friendships with notable contemporaries (e.g., *Boccaccio). An avid scholar and copier of classical texts, he amassed an impressive private library of ancient Roman works and authored many poems, treatises, dialogues, and historical compositions. He was influential in the development of classically based "humanistic" styles of script, and his own works were frequently copied and illustrated in the later medieval period and well into the Renaissance. His collection of love poems (the *Canzoniere,* written in Italian and inspired by his love for Laura) and his allegorical poem, the *Trionfi,* were widely popular, as well as his treatise on famous men of the past *(De viris illustribus).* Other works include reflections on the *contemplative life, solitude, and redemption. Petrarch himself is represented in art as a scholar, or *author, often at work in his book-filled study.

Example: Petrarch, De viris illustribus, late fourteenth century, Darmstadt, HB, MS 101, f. 1v. (De Hamel, fig. 221)

PHARAOH. *Pharaoh* is the title for the kings of Egypt. The name appears numerous times in the Old Testament in connection with the history of the Hebrews, although specific pharaohs are not identified. Images of pharaohs (garbed as rulers, often with crowns, swords or sceptres) appear especially in narratives concerning *Joseph and *Moses. Joseph interpreted one pharaoh's dreams, and another pharaoh and his army drowned in the *Crossing of the Red Sea. See also: *Plagues of Egypt.

Example: Pharaoh's Dream, Vienna Genesis, sixth century, Vienna, ON, Cod. theol. gr. 31, f. 35. (Rodley, fig. 83)

PHEBUS, GASTON. The Count of Foix and Béarn in southwest France, the well-traveled Gaston III (1331–1391) wrote a comprehensive treatise on hunting: the *Livre de chasse (Book of Hunting),* c.1387–1388. This illustrated guide was

translated into several languages and was a special favorite of artistocratic patrons in the fifteenth century. About forty manuscripts of this work survive, several with beautiful and naturalistic illustrations providing much information on medieval hunting methods and aristocratic life. Text sections cover the habits and appearances of numerous animals, the training of hunting dogs, methods of tracking and trapping animals, and many practical hints for the "good huntsman."

Example: Livre de chasse, early fifteenth century, New York, PML, MS 1044, f. 11. (De Hamel, fig. 150)

PHILIP, SAINT. Philip, a fisherman from Bethsaida, was one of the twelve *apostles, the third to be called by Jesus. He is mentioned primarily in the Gospel of *John: summoned by Jesus and bringing Nathanael (*Bartholomew) to Jesus (John 1:43–46), present at the *miracle of the *Multiplication of the Loaves and Fishes (John 6:5–7), with Jesus in Jerusalem (John 12:21–22), and at the *Last Supper (John 14:8–9). He is also mentioned in Acts 1:13 as being present at the selection of *Judas's replacement Matthias. *Apocrypha and later legends (which may confuse Philip the Apostle with Philip the Evangelist or Deacon) tell of Philip's later *preaching in Greece and Phrygia, and his *martyrdom in Hierapolis after he exorcised the *Devil or a *demon (in the shape of a dragon) from the pedestal of a statue. The dragon exited, emitting fire, poison, and a foul stink which killed many people. Philip was then stoned, tied to a *cross, and crucified head downward. His attributes are loaves, stones, and a cross. Scenes from his life and martyrdom are somewhat rare; he is sometimes paired with Saint Bartholomew.

Example: Saint Philip, 950–1000, icon, Mount Sinai, Monastery of Saint Catherine. (*The Icon,* p. 34)

PHILOSOPHY. The love or pursuit of *wisdom, the source and inspiration for human art and knowledge, was notably given allegorical form in medieval literature by *Boethius in his early sixth-century treatise *De consolatione philosophiae (The Consolation of Philosophy).* Boethius describes his vision of a crowned and stately female figure holding books and a sceptre; her height alternated as she spoke, and she appeared to console and converse with him in prison. As thus described, the figure of Philosophy appears in illustrations of Boethius and in Gothic architectural sculpture and stained glass, frequently with the *Seven Liberal Arts, over whom she presides.

Example: Philosophy, De consolatione philosophiae, c.975–1000, Cambridge, TC, MS 0.3.7, f. 1. (Dodwell, fig. 82)

PHOENIX. See BIRDS, SYMBOLISM OF.

PHYSIOLOGUS. The *Physiologus (Natural Philosopher),* a Greek text, probably of the second century A.D., contains descriptions of some fifty animals (real

and imaginary), birds, insects, plants, and stones. Perhaps composed by a Christian in Alexandria, the work draws moral lessons from the natural world and, as typical of its genre, also discusses the etymologies (origins of the names) of the subjects covered. Revised, expanded, and translated into numerous languages, the work may have been first illustrated in the early Christian period; however, the oldest extant illustrated copy dates to the ninth century. The *Physiologus* provided an important foundation for the medieval bestiaries (see: *Manuscripts) which were widely produced and illustrated especially in the twelfth and thirteenth centuries. (See also: *Animals, Symbolism of; *Birds, Symbolism of.)

Example: The Nature of the Serpent, Physiologus, c.825–850, Bern, Burgerb., MS 318, f. 12v. (Mütherich and Gaehde, pl. 16)

PIETA. Italian for "pity," the *Pietà* is an image of the sorrowing Virgin *Mary holding the dead body of *Christ across her lap. The scene is not described in the Gospels and is distinct from *Deposition, *Lamentation, and *Entombment scenes, where more figures are normally present. The type is first seen c.1300 in Germany and developed from the mystical writings of authors such as Saint Mechthild of Helfta (c.1241–1289) and later, Saint Bridget of Sweden (c.1303–1373). As a nonnarrative, devotional image (see: *Andachtsbilder*) the figural group was designed to inspire pious contemplation on the sacrificial *death of Christ for the redemption of humankind. Also known as *Vesperbild,* the image was inspired by monastic services and prayers for the late afternoon–sunset hour (office) of Vespers for Good Friday. The *Pietà* is often a sculptural image; Mary is shown with a pensive expression or more violently grieving, inclining her head toward Christ or looking outward toward the viewer. Christ often wears the crown of thorns; his head, if not supported by Mary's hand, may fall backward; the wounds on his body may be grimly exaggerated: enlarged or emphasized with painted indications of dripping blood. The image was especially popular in Germany, later adopted in France, Italy, and elsewhere.

Example: Pietà, c.1330, Bonn, Landesmuseum. (Synder, fig. 559)

PIG. See ANIMALS, SYMBOLISM OF.

PILATE, PONTIUS. See PONTIUS PILATE.

PILGRIM, PILGRIMAGE. A pilgrim is one who undertakes a journey (pilgrimage) to a site believed to be holy, in order to worship, seek spiritual aid or physical healing, or to fulfill a vow or obligation (e.g., do penance). The practice of visiting sites associated with the life and passion of *Christ is attested from the very early Christian period; it increased following the empress Saint *Helena's pilgrimage to the Holy Land in 326, her discovery of important *relics, and her foundation of churches and shrines. Jerusalem and Rome were major pilgrimage goals from the early Christian period, while the growth of the cult

of *saints and relics through the Middle Ages as well as the increased practice of imposing pilgrimage as a penance, inspired and institutionalized numerous other pilgrimages, for example, the journey to Santiago da Compostela (the shrine of Saint *James the Greater) in northern Spain and the pilgrimage to Canterbury (the shrine of Saint *Thomas Becket; see also: *Chaucer). When pilgrims are represented in medieval art, they are often identifiable by their costume and possessions (a walking staff, scrip, or knapsack) or by the badges they wear, such as the scallop shell emblem of Saint James. In illustrations of the *Road to Emmaus and the *Supper at Emmaus, Christ and the disciples may be dressed as pilgrims. Saint *Roch often appears as a pilgrim. Pilgrimage souvenirs, badges, medals, flasks, or *ampullae* were widely produced through the medieval period. The floor pavement labyrinths in Gothic cathedrals were also used as surrogate pilgrimages, slowly traced by the devout, kneeling or walking around to the center, which was often labeled as Jerusalem. The motif of pilgrimage (as a physical journey or spiritual quest) is frequent in medieval literature (see: *Arthurian Legends, *Dante, *Guillaume de Deguileville, *Guillaume de Lorris and Jean de Meun).

PIPE. See MUSICAL INSTRUMENTS, SYMBOLISM OF.

PISCES. See ZODIAC.

PLACIDUS, SAINT. The sixth-century Benedictine monk Placidus was a disciple of Saint *Benedict and features in illustrations of the life of Benedict (e.g., as composed by *Gregory the Great) as the youth who was rescued from the lake at Subiaco by Saint *Maurus, at Benedict's prescient directions. Later stories, composed at Monte Cassino in the eleventh and twelfth centuries, recount Placidus's missionary work and eventual *martyrdom in Sicily. He occurs in art primarily in connection with Saints Benedict and Maurus, being pulled from the lake by Saint Maurus, who grabs him by the hair.
 Example: The Rescue of Placidus, Stuttgart Passionary, mid-twelfth century, Stuttgart, WLB, MS Fol. 57, f. 196. (Ross, fig. 39)

PLAGUES OF EGYPT. Chapters 7–11 of Exodus describe the ten plagues inflicted by *God and *Moses to convince the Egyptian *Pharaoh to free the Israelites from slavery. The plagues, in succession, involved (1) all the water, including the Nile river, being turned to blood; (2) a great swarm of frogs; (3) dust turning into lice; (4) swarms of flies; (5) the *death of all the Egyptians' *animals; (6) eruptions of boils on people and animals; (7) the destruction of crops by hail, rain, and thunder; (8) swarms of locusts; (9) a three-day darkness; and (10) the death of all the firstborn males, human and animal, in Egypt. After each plague, including the last, Pharaoh defaulted on his promise to free the Israelites. The Israelites were spared all of the plagues and, after celebrating the Passover, went forth from Egypt, eventually *Crossing the Red Sea. Depictions

of the plagues appear especially in Bible illustration and may also include
*Aaron and Moses in conversation with Pharaoh.

Example: The Plagues of Egypt, Theodore Psalter, 1066, London, BL, Add. MS
19.352, f. 104. (Rodley, fig. 209)

PLATYTERA. From a Greek title for the Virgin *Mary, *Platytera ton ouranon*
("she who is wider than the heavens"), the *Platytera* is a representation of the
Virgin standing in *orant position (see also: *Blachernitissa*), with a bust me-
dallion (see: *Imago clipeata*) of the infant Jesus suspended in front of her. The
round shape alludes to her womb and the incarnation of *Christ predicted by
the *prophet *Isaiah (7:14) as a "sign" from God. Hence, the image may also
be termed "Our Lady of the Sign." Also related to *Annunciation imagery, the
type became especially popular in Byzantine art from the eleventh century fol-
lowing, although western examples are found as well.

Example: Platytera, eleventh century, marble icon, Venice, Santa Maria Mater Domini.
(Weitzmann, fig. A)

PLINY THE ELDER. The one surviving work of the Roman scholar and
official Pliny the Elder (Gaius Plinius Secundus, 23–79) was known and copied
during the medieval period and served as a source and inspiration for many
medieval scientists and encyclopedists. His *Historia naturalis* (completed c.77),
in thirty-seven books, covers geography, animals, medicine, the cosmos, plants,
human psychology, and many more topics. Compiled from a vast number of
writings by earlier Greek and Roman authors, this was an essential source for
early Christian and medieval scholars and was frequently copied and illustrated.

Example: Pliny and the Emperor Titus, Historia naturalis, twelfth century, Florence,
BML, MS Plut. 82.1, f. 2v. (D'Ancona, pl. 67)

POMEGRANATE. See FRUIT AND TREES, SYMBOLISM OF.

PONTIFICAL. See MANUSCRIPTS.

PONTIUS PILATE. Pontius Pilate, the Roman governor (or procurator) of
Judea from c.26–37 A.D., presided over the trial which resulted in *Christ's
*Crucifixion (see: *Trials of Christ). Accounts of the trial are detailed in the
Gospels (e.g., *John 18:28–40) as well as the apocryphal *Acts of Pilate*. Pilate
features in scenes of Jesus' trial, found in art from the early Christian through
late medieval period, traditionally depicted as a seated figure symbolically wash-
ing his hands (to deny his responsibility) in a basin held by an attendant, while
Jesus stands before him or is led away. *Matthew's Gospel recounts Pilate's
initial unwillingness to sentence Jesus to *death and his wife's dream-inspired
advice to avoid Jesus (she is named Procula in noncanonical sources). Pilate
offered to free either Jesus or the murderer Barabbas; Barabbas was chosen, and

Pilate presented Jesus to the people of Jerusalem (see: *Ecce homo*) before the *cross was carried to and erected on Mount *Calvary.

Example: Pilate Washing His Hands, c.420, ivory, London, BM. (Synder, fig. 106)

POTIPHAR'S WIFE. The wife of *Pharaoh's official Potiphar features in Genesis 39:7–20 because of her attempted seduction of her husband's servant *Joseph, which resulted in Joseph's imprisonment. Illustrated in biblical manuscripts from the sixth century and frequently in fresco, sculpture, and mosaic through the Middle Ages, the episode involves several stages. Joseph may be shown resisting her advances (pulling away from her as she reclines on her bed); she may be shown grabbing his cloak as he flees and later presenting it to her husband as evidence for her false accusation of Joseph's attempt to rape her. The events may be illustrated in sequential narrative format or condensed to the attempted seduction or accusation scene that will show Potiphar's wife angrily addressing Joseph while he is led away to prison.

Example: Joseph and Potiphar's Wife, Bible, mid-thirteenth century, Walters, MS 106, f. 15. (Robb, fig. 155)

PRAYER. Prayer is an essential element in the Jewish and Christian religions. Praying is an act of worship and may involve oral or silent recitations of praise, supplication, and thanks to *God. The practice of both public and private prayer is detailed in both the Old and New Testaments and was a subject of frequent commentaries by early Christian and medieval theologians. Figures in prayer occur repeatedly in Christian art through the Middle Ages and can be recognized by distinctive gestures and bodily attitudes. In early Christian art, praying figures are often represented as *orant(es),* standing upright with palms raised upward and arms outstretched. The gesture derives from ancient practices, although the outstretched arms were also specified in the early Christian period as a symbolic remembrance of *Christ's *Crucifixion. In early medieval art, praying figures may be shown with arms bent and open hands held closer to the chest. The practice of clasping hands together in prayer appears to be a Romanesque form, perhaps derived from feudal gestures of homage and obedience. Other prayerful attitudes involve kneeling or prostration (see: *Proskynesis).* *Saints in medieval art are often depicted in prayer and may be the recipients of special visions (e.g., Saint *John's apocalyptic visions, the *Mass of Saint Gregory); sometimes the setting will indicate the identity of the praying saint (Saints *Anthony and *Jerome in the desert; Saint *Thomas Becket attacked by soldiers while praying before an altar). Jesus is customarily shown in prayer during the *Agony in the Garden.

Example: Saint Demetrius in Prayer, eleventh century, enamel, Berlin, SM. (Weitzmann, pl. 15)

PREACHING. Preaching is oral teaching and exhortation, delivered to a group. Following Jewish customs of directed scriptural reading and interpretation in

*synagogue services, the early Christian church relied heavily upon preaching to gain converts and to inspire and instruct believers. Jesus directed the *apostles to preach (see: *Mission of the Apostles) and himself spoke frequently to both large and small audiences (see: *Sermon on the Mount). The importance of preaching was emphasized by numerous early Christian theologians, a number of whom were famed as excellent speakers (e.g., Saints *Ambrose, *Augustine, *Basil, and *John Chrysostom) and whose sermons were written down, either by audience members or in self-authored collections. During the Middle Ages, sermons were delivered in churches and monasteries, additionally recorded in manuscripts, and became important aspects of the cathedral school and university curriculum. Widespread preaching to popular (nonclerical or university) audiences was given great impetus especially with the founding of the mendicant orders (Franciscans and Dominicans) in the thirteenth century. Preachers are represented in art standing before a group of seated or standing listeners, within a church, cloister, or public square. Additionally, Saint *Francis is often shown preaching to the birds and Saint *Anthony of Padua to fish.

Example: Saint Denis Preaching, Vie de Saint Denis, 1317, Paris, BN, MS fr. 2091, f. 99. (Porcher, pl. L)

PRESENTATION IN THE TEMPLE. Following Jewish law, the Virgin *Mary and Saint *Joseph brought the infant Jesus (as their firstborn male child) to the Temple in Jerusalem to present him to *God and to offer a sacrifice. The event is described in *Luke 2:22–40 and illustrated in several slightly divergent manners in early Christian and medieval art. The earliest extant representation (fifth-century mosaics at Santa Maria Maggiore, Rome) depicts Mary holding the infant, accompanied by Joseph and several *angels, walking toward the prophetess Anna and the aged *Simeon, who bows in reverance. Carolingian and Ottonian examples show either Mary or Joseph handing the infant to Simeon in the presence of several witnesses; often an altar is included upon which the infant is placed by Simeon or the high priest. In later examples, attendant figures may be shown holding candles and a basket containing two doves. The doves are, as well, references to the *Purification of the Virgin one month after childbirth (appropriately if creatively often conflated with the scene of the Presentation). Simeon's recognition of Jesus as the Messiah and his prophecy to Mary concerning her upcoming sorrow cause this episode to be counted first among the *Seven Sorrows of the Virgin and hence often included in pictorial narrative cycles of the lives of Mary and Jesus.

Example: Presentation in the Temple, Pericopes, c.1040, Munich, BS, MS Clm. 15713, f. 24v. (Dodwell, fig. 145)

PRESENTATION OF THE VIRGIN IN THE TEMPLE. The apocryphal *Gospel of the Pseudo-Matthew* and *Protevangelium of James* describe how the Virgin *Mary's parents (*Anne and *Joachim) brought her to the Temple in Jerusalem when she was three years old to dedicate her to *God's service.

Following these accounts, and *Josephus's descriptions of the fifteen steps of the Temple entrance, the story was elaborated again in the *Golden Legend* and illustrated in western art especially of the late Gothic period. The image is also found in Byzantine manuscripts and mosaics from the eleventh century which show the infant Mary (sometimes accompanied by her parents) walking in a procession with other torch-bearing virgins. In western examples, the infant Mary may be shown starting to climb the Temple steps toward the high priest, watched or assisted by her parents in the presence of numerous onlookers. Additional subjects from the period of Mary's service in the Temple, found especially in Byzantine manuscripts and mosaics, include her being fed by an *angel and receiving purple wool for weaving the veil of the Temple. (See also: *Education of the Virgin.)

Example: Taddeo Gaddi, *Presentation of the Virgin in the Temple,* c.1330, fresco, Florence, Santa Croce, Baroncelli Chapel. (Alexander, fig. 236)

PRIDE. See VICES.

PRISCIAN. The works of the early sixth-century Latin grammarian, Priscian, were studied and copied through the Middle Ages (notably the *Institutiones grammaticae* and *De accentibus*) and figured importantly in the development of the medieval university curriculum. Priscian (or alternately, the fourth-century Donatus) appears in illustrations of the *Seven Liberal Arts as a representative of Grammar.

Example: Seven Liberal Arts, c.1145–1155, Chartres Cathedral, west portal, right door, archivolt. (Sauerländer, fig. 15)

PRODIGAL SON. Jesus' parable of the Prodigal Son is found in *Luke 15: 11–32. The story concerns a younger son who, asking for and receiving his inheritance while his father was still alive, left home and squandered his money wastefully, unlike his elder brother, who remained at home and worked diligently on the family land. When the prodigal son was reduced to poverty, working as a swineherd and starving, he decided to return home, ask forgiveness of his father, and offer himself as a hired hand. The father, moved with compassion at the sight of the younger son, prepared a feast and gave him his best clothing. This treatment angered the elder son greatly, but the father affirmed his love for both sons and his joy at the younger's repentance. This tale of penitence and forgiveness is often found in art of the Gothic period and may be illustrated in several episodes: the finely dressed prodigal son leaving home, feasting and spending his money, tending pigs, and returning home to the joyful embraces of his father.

Example: Departure of the Prodigal Son, c.1210–1215, stained glass, Bourges Cathedral. (Grodecki, fig. 69)

PROPHETS. Prophets are those who reveal *God's word to humans or speak about the future. The term refers to numerous divinely inspired Old Testament

figures who conveyed God's will by their words or actions and whose deeds (if not, in all cases, purported writings) are contained in the biblical books named after them. The Four Major Prophets (longest books) are *Isaiah, *Jeremiah, *Ezekiel, and *Daniel. The Twelve Minor Prophets are *Hosea, Joel, Amos, Obadiah, *Jonah, Micah, *Nahum, *Habakkuk, Zephaniah, Haggai, *Zechariah, and Malachi. Following *Christ's several references to and reliance upon Old Testament prophecies concerning the Messiah, New Testament and later church writers assiduously linked the Hebrew prophetic writings to Christian events, emphasizing and interpreting the fulfillment of the Old Testament texts in the Christian religion (see: *Typology). The Four Major Prophets were thus symbolically linked with the *Four Evangelists, and the Twelve Minor Prophets were linked with the Twelve *Apostles. The prophets of the Old Testament hence play a critical role in Christian art and literature. In art, they may appear as aged, bearded figures bearing symbolic attributes or scrolls inscribed with their prophecies relevant to Christianity. They appear in scenes of the *Last Judgment, on the Byzantine *iconostasis, and in numerous other Christian artistic contexts as busts, full-length figures, or in narrative vignettes. (See individual listings.)

Example: Prophets, c.1200, Chartres Cathedral, north transept, jamb figures. (Zarnecki, fig. 371)

PROSKYNESIS. The Greek term for prostration, *proskynesis* is a gesture of respect appropriate before *God, emperors, important clerics, and *icons. The gesture may involve assuming a fully prone position or kneeling with one's face to the ground as also shown in the Muslim *prayer position. In Byzantine art, emperors may be depicted in this attitude paying homage to *Christ. *Proskynetaria* are stands upon which icons for special veneration are placed.

Example: Leo VI before Christ, late ninth century, mosaic, Istanbul, Hagia Sophia, imperial doorway, lunette. (Synder, fig. 159)

PRUDENCE. See VIRTUES.

PRUDENTIUS. Prudentius (c.348–410) was a Spanish lawyer, hymn writer, and poet, whose works include several influential collections, for example, the *Peristephanon* (hymns to Spanish and Italian martyrs), the *Cathemerinon* (hymns for daily use), several poems on theological subjects, and the *Psychomachia,* an allegorical poem describing the conflict of *virtues and *vices. The interior battle of good and evil in the human *soul, as previously discussed by Tertullian (in the early third century), is described in this work via a series of personifications of the virtues and vices as female figures whose appearances and actions are discussed in detail. Faith rushes into the battle unprotected but triumphs over Idolatry. Uncontrolled Anger rages against calm Patience and commits suicide. Pride prances on horseback and falls into a pit dug by Dis-

honesty. Hope cuts off the head of Pride. Temperance upsets the jeweled cart of Self-indulgence, and so on. The virtues always triumph. The detailed descriptions in this work inspired artists and writers throughout the medieval period. Several illustrated texts survive, and the text and format inspired several other authors (among them: *Herrad of Landsberg, *Hugh of Saint-Victor, *Isidore of Seville, and *Vincent of Beauvais). Depictions of the virtues and vices are frequent in Romanesque and Gothic architectural sculpture.

Example: Christian Faith Defeating Pagan Worship, Psychomachia, ninth century, Bern, Burgerb., MS 264, p. 69. (Dodwell, fig. 68)

PSALTER. See MANUSCRIPTS.

PSYCHOMACHIA. See PRUDENTIUS.

PTOLEMY. The works of the Greek astronomer and geographer Claudius Ptolemy (c.100–170) were of profound influence upon medieval science and conceptions of the universe, especially after his works (or excerpts) became more widely available and translated into Latin, often from Arabic sources, in the twelfth century. The mathematical astronomy of his *Almagest* details an earth-centered conception of the universe—an idea not seriously challenged until the Renaissance. Ptolemy appears in depictions of the *Seven Liberal Arts as a representative of Astronomy. He is sometimes shown wearing a crown; this is due to confusion with the Ptolemaic rulers of Egypt.

Example: Seven Liberal Arts, c.1145–1155, Chartres Cathedral, west portal, right door, archivolt. (Sauerländer, fig. 6)

PURIFICATION IN THE TEMPLE. Leviticus 12 states the requirements and procedures for women's cleansing and purification after giving birth. Depending upon the sex of the child, different waiting periods are specified, after which the woman must complete her purification by offering a sacrifice at the Temple (a lamb, doves, or pigeons). The scene of the Purification of the Virgin *Mary is often conflated in art with the image of the *Presentation in the Temple (as per *Luke 2:22–24) and is indicated by showing either Mary, or *Joseph, or a maidservant, carrying doves as they approach the altar where *Simeon accepts the infant Jesus.

Example: Presentation in the Temple, Psalter of Henry the Lion, c.1168–1189, London, BL, Landsdowne MS 381, f. 8. (Dodwell, fig. 285)

PYTHAGORAS. The ancient Greek philosopher and mathematician Pythagoras (d. c.497 B.C.) frequently appears in medieval illustrations of the *Seven Liberal Arts as a personification of Arithmetic and Music. His writings in both closely related fields were highly influential on early Christian and medieval authors (e.g., *Boethius, *Isidore of Seville, and *Martianus Capella) and in the development of geometrical concepts, systems of ratios, and musical forms of wide-

ranging significance for medieval architecture, music, mathematics, and philosophy. He may be depicted writing, teaching, or with appropriate instruments such as bells and scales.

Example: Seven Liberal Arts, c.1145–1155, Chartres Cathedral, west portal, right door, archivolt. (Sauerländer, fig. 15)

Q

QUEEN OF SHEBA. The Queen of Sheba's visit to King *Solomon in Jerusalem is described in 1 Kings 10:1–13. The text explains that she had learned of Solomon's fame and came to "test him with hard questions." She arrived with an elaborate retinue, was extremely impressed with Solomon's prosperity and *wisdom, engaged in extensive conversation with him, and departed after praising him and giving him many lavish gifts. She is mentioned again as the "queen of the south" by Jesus, who cites her effort and perceptiveness in seeking to learn wisdom and states that she will rise up on judgment day to condemn the willfully ignorant (*Matthew 12:42; *Luke 11:31). She features in medieval art primarily in connection with Solomon; they are, for example, paired as jamb figures in Gothic portal sculpture (both elaborately garbed, Sheba may stand on a small figure of a black man who is holding a money bag, bespeaking her wealth and speculated African origin), or she may be shown kneeling before the enthroned Solomon. Her paying homage to Solomon is sometimes typologically linked to the *Adoration of the Magi, or they are seen as types of *Christ (Solomon) and the *Church/*Ecclesia* (Sheba). (See also: **Sponsa-sponsus*.) The Queen of Sheba also features in the legend of the *True Cross, recognizing the sacred nature of the wood (which had been used for a bridge) and, according to the **Golden Legend,* alerting Solomon of her vision of the *death of the savior of the world, which event would put an end to the kingdom of the *Jews.

 Example: Queen of Sheba, c.1220, Chartres Cathedral, north transept, jamb figure. (Sauerländer, fig. 92)

QUENTIN, SAINT. According to legend, Saint Quentin was a third-century Roman who preached in Gaul and was martyred after a gruesome series of tortures. His decapitated but otherwise intact body was discovered in a river in the mid-fourth century by a blind woman whose sight was miraculously restored and who founded a church dedicated to him. His life and posthumous *miracles

were first illustrated in the late eleventh or early twelfth century in a manuscript produced for the church of Saint-Quentin and later in the fourteenth century in another work for the church: an illustrated scroll. He appears in relief sculpture at Chartres Cathedral with nails driven into his head and fingertips.

Example: Tortures of Saint Quentin, Life of Saint Quentin, late eleventh/early twelfth century, Saint-Quentin, Chapter Library, f. 43. (Dodwell, fig. 190)

QUINITY. An extremely rare subject in art, the Quinity is a figural grouping of *God the Father, God the Son (*Christ), the Virgin *Mary with the infant Jesus, and the *Holy Spirit (Dove). The human and divine natures of Jesus are thus emphasized.

Example: Quinity, New Minster Prayer Book, c.1023–1035, London, BL, Cotton MS Titus D. XXVII, f. 75. (Synder, fig. 279)

R

RABANUS MAURUS. See MAURUS, HRABANUS.

RABBIT. See ANIMALS, SYMBOLISM OF.

RACHEL. Rachel was the daughter of Laban, sister of *Leah, wife of *Jacob, and mother of *Joseph and Benjamin. Apart from her important role in the Genesis narratives, she is later singled out in *Jeremiah 31:15, at Ramah, ''weeping for her children . . . because they were not.'' Ramah, probably identifiable with the site of her *death while giving birth to Benjamin, is also linked by Jeremiah (40:1) to the Babylonian exile. Jeremiah's description of Rachel weeping for her children is later repeated by *Matthew (2:18) in reference to the *Massacre of the Innocents under King *Herod. Hence, the weeping Rachel often appears in illustrations of the Massacre of the Innocents as well as in pictorial narrative scenes from Genesis, such as her meeting Jacob, her marriage to Jacob (following and in conjunction with her sister Leah), and her stealing and hiding the *teraphim* (household gods) of her father Laban.

Example: Rachel Lamenting, fourteenth century, fresco, Markov Manastir. (Rice, fig. 197)

RADEGONDE, SAINT. See RADEGUND, SAINT.

RADEGUND, SAINT. The dramatic life of Saint Radegund (or Radegonde, 518–587) was recorded by her friend, the poet and priest Venantius Fortunatus. Abducted as a child from her home in Germany by invading Franks, she was forced at about age twenty to marry King Clotaire I whose violent temperament she suffered for several years before becoming a nun. Founder of the monastery of the Holy Cross at Poitiers (c.557), she was renowned for her piety, charity, austerity, and scholarship. Her life was illustrated in a manuscript produced at

Poitiers in the late eleventh century, and she appears also in stained glass and frescoes of the Gothic period (e.g., at Chartres and Poitiers) dressed as a queen or as a nun.

Example: Life of Saint Radegund, late eleventh century, Poitiers, BM, MS 270, f. 27v. (Dodwell, fig. 217)

RAISING OF THE CROSS. The Gospels contain few details about the actual process or stages involved with the *Crucifixion of Jesus, although various preparatory episodes are illustrated in art. Byzantine Psalters of the ninth century, illustrating Psalm 22, include scenes of Jesus being nailed to the *cross as well as the soldiers casting lots for his garments (also mentioned in *Matthew 27: 35) fulfilling the Psalm verses (22:16) ''. . . they pierced my hands and feet'' and (22:18) ''They part my garments among them, and cast lots. . . .'' The image of Jesus being nailed to the cross, with the cross already upright or on the ground, is taken up in western art by the thirteenth century and is developed into compositions often involving a number of spectators. The scene may appear as an independent image or in cycles following the bearing of the cross to *Calvary. Other motifs of Byzantine origin adopted in later western medieval art are the scenes of Jesus ascending the cross (climbing up a ladder or pushed and pulled by other figures) and Jesus watching while soldiers erect the cross. Further details about the Crucifixion process were also supplied by apocryphal accounts (e.g., the *Acts of Pilate*) and many later medieval mystical and devotional treatises (e.g., the **Meditationes vitae Christi*). It is primarily from these sources that images such as Jesus being stripped of his garments derive. A soldier may be shown pulling off Jesus' robe, or Jesus may undress himself. In late medieval art especially in northern Europe, the scene of a seated Jesus, stripped of his garments, usually apart from a loincloth, develops into a type of devotional image known as *Christus im Elend* (''Christ in Distress'') which appears in painting and sculpture of the late fourteenth century. (See also: **Andachtsbilder.*) This focused image represents Jesus' final suffering and humiliation before the Crucifixion. The cross, *Instruments of the Passion, and mocking, witnessing, or mournful figures may or may not be included.

Example: Jesus Nailed to the Cross, Psalter, c.1280–1290, Křivoklát Castle Library, MS 1.b.23, f. 10v. (Morgan, II, fig. 398)

RAISING OF JAIRUS'S DAUGHTER. One of the three episodes in the Gospels where Jesus brings a dead person back to life, the raising of Jairus's daughter follows the account of Jesus' healing of the *Woman with an Issue of Blood whom he had encountered while on his way to Jairus's home. Jairus had summoned Jesus to his daughter's deathbed, but she was already dead when Jesus arrived. Jesus took her hand and told her to arise. The physical contact between Jesus and Jairus's daughter is not always shown in images of this *miracle; Jesus may stand over the reclining woman and gesture toward her. *Matthew (9:18–26) recounts that Jesus went alone into her room, while *Mark (5:35–43)

and *Luke (8:49–56) tell that her parents and several *apostles (*Peter, *James, and *John) witnessed the miracle. Hence, these additional figures may be included; Jairus may stand by the bed, and the girl's mother may be shown assisting her as she sits upright. The subject is found on early Christian sarcophagi and ivories and in Romanesque and Gothic manuscripts and frescoes but is infrequent in later medieval art.

Example: Raising of Jairus's Daughter, c.1150, fresco, Copford, Essex, Church of Saint Mary. (Dodwell, fig. 333)

RAISING OF LAZARUS. One of the most frequently represented subjects in art from the early Christian period onward, the *miracle of Jesus bringing Lazarus back to life is recounted in the Gospel of *John (11:1–45). As a manifestation of *Christ's power over *death, a sign prefiguring his own *Resurrection and the *Resurrection of the Dead at the *Last Judgment, the event assumed a prominent position in early Christian sepulchral art (e.g., catacomb frescoes and sarcophagi) and is found in all media through the Middle Ages. The earliest images depict Jesus standing and gesturing (often with a magic rod or cross staff) toward a small architectural structure (the opened tomb) within which is indicated a small standing figure wrapped like a mummy. In fourth-century examples, further figures may be shown—either or both of Lazarus's sisters, *Mary and *Martha, who had summoned Jesus when Lazarus fell ill. They are depicted kneeling at Jesus' feet. Additional witnessing figures are included by the sixth century, often exhibiting gestures of amazement, and at least one figure will be shown holding his nose or covering his face against the smell of the corpse (which had been in the tomb for several days). In Byzantine art, the grave may be represented as a cave, and in western art of the eleventh century onward, Lazarus may be shown sitting up in, or climbing out of, a sarcophagus.

Example: Raising of Lazarus, fourth century, sarcophagus, detail, Rome, Museo della Thermae. (Rodley, fig. 17)

RAISING OF THE WIDOW'S SON. *Luke (7:11–15) recounts that when Jesus and his disciples arrived at the city of Nain, they encountered a funeral procession for a widow's only son. Jesus took pity on the bereft widow and revived her son by touching his coffin and speaking to him. The scene first occurs on fourth-century sarcophagi; Jesus is shown touching the coffin with a wand or standing above it while the small, swathed corpse rises to a sitting position. The widow kneels before Jesus or gestures toward him in grief or astonishment. Later examples (e.g., tenth-century manuscripts) include more witnesses and mourners; figures are shown bearing the funeral bier while the boy sits up and appears fully revived. The subject is also found in eleventh-century manuscripts, ivories, and frescoes but is infrequent in later medieval art.

Example: Raising of the Widow's Son, c.340, *Sarcophagus of Adelphia,* detail, Syracuse, National Museum. (Volbach, fig. 38)

RAM. See ANIMALS, SYMBOLISM OF; ZODIAC.

RAPHAEL, SAINT. An archangel (see: *Angels) whose name means ''*God heals,'' Raphael is described especially in the apocryphal books of *Enoch and *Tobit. He protected and accompanied Tobit's young son *Tobias on a journey without revealing his identity until later, and he helped Tobit escape from and catch a medicinal *fish to cure his father's blindness. Under his guidance, evil spirits were driven out of Tobit's wife, Sara. Tradition associates Raphael with the angel who ''troubled the waters'' in the healing pool of Bethesda in Jerusalem (described in *John 5:2–7; see also: *Healing of the Paralytic). Raphael is the patron of travelers, *pilgrims, and pharmacists and is normally depicted in art as a winged figure, sometimes dressed as a pilgrim or traveler. His attributes include a fish and medicine vial.

Example: Tobit Scenes, Florence Cathedral Bible, c.1100–1125, Florence, BML, MS Edili 126, f. 73. (Cahn, fig. 111)

RAVEN. See BIRDS, SYMBOLISM OF.

REBECCA. Rebecca, the divinely approved wife of *Isaac, was discovered by *Abraham's servant Eliezer at a well outside the city of Nahor. She answered Eliezer's conditions in being the first woman to appear and offer water to himself and to his camels (Genesis 24: 1–28). The union of Rebecca and Isaac produced *Esau (loved by his father) and *Jacob (whom Rebecca favored). The meeting of Rebecca and Eliezer at the well appears often in medieval art and was interpreted, by Christian theologians, as a prefiguration of the *Annunciation (women being informed that they had been selected by *God for special purposes). Rebecca also features in biblical narrative illustrations encouraging and assisting Jacob in his deception of Isaac.

Example: Rebecca at the Well, Vienna Genesis, sixth century, Vienna, ON, Cod. theol. gr. 31, f. 7. (Synder, fig. 95)

REBELLION. See VICES.

RED SEA. See CROSSING OF THE RED SEA.

RELICS. Relics are the physical remains of holy persons: objects owned by or associated with them or actual body parts. Relics serve as memorials of the dead, objects for remembrance, affection, and veneration and are also believed to possess powers to perform healings and *miracles. An interest in relics is attested in both the Old and New Testaments: the Old Testament describes miracles performed by the cloak of *Elijah (2 Kings 2:14) and the bones of *Elisha (2 Kings 13:21), and the New Testament (Acts 19:12) describes healings performed by cloths which had touched Saint *Paul. During the early centuries of persecution of Christians, the relics of martyrs were collected and venerated;

this tradition firmly established the practice, which continued and expanded through the Middle Ages. The relics of *saints were often enshrined in elaborate containers (reliquaries) and provided focal points for *pilgrimage.

REMI, SAINT. See REMIGIUS, SAINT.

REMIGIUS, SAINT. The ''Apostle of the Franks,'' Saint Remigius (or Remi, c.438–c.533) was ordained archbishop of Reims at the age of twenty-two. A zealous missionary, famed for his *preaching and piety, he baptized Clovis I, King of the Franks, as well as three thousand others in c.496. Legends state that the dove of the *Holy Spirit arrived to this event bearing a vial of holy oil, the *Sainte Ampoule,* still one of the chief *relics of the cathedral of Reims. The scene of the *baptism of Clovis appears especially in Gothic sculpture and stained glass, along with other *miracles attributed to Saint Remigius, such as his extinguishing a fire in Reims and causing wine to pour forth from a cask. In art, he can be recognized by his ecclesiastic vestments and is frequently shown with the Holy Dove.
 Example: Saint Remigius, c.1225–1230, Reims Cathedral, north transept, jamb figure. (Sauerländer, fig. 247)

RENE OF ANJOU. René (1409–1478), King of Sicily and Duke of Anjou, was an important patron of the arts and also an *author. Although often occupied with administrative and military duties, he composed poetry, a treatise on conducting tournaments, and *Le Livre du cuer d'amours espris (The Book of the Heart Seized by Love)* c.1457, an allegorical work in the tradition of the *Romance of the Rose* (see: *Guillaume de Lorris and Jean de Meun). The work, tracing the search of the Heart for Sweet Grace, recounts the adventures of Heart and Desire involving encounters with numerous personified figures, placed within a dream-vision framework of courtly elegance and etiquette. Six beautifully illustrated copies of this work survive from the late fifteenth century, the earliest of which was, traditionally, illustrated by René himself, although this is a matter of scholarly dispute.
 Example: Amour Takes the Heart of the King, Livre du Cuer, c.1457–1465, Vienna, ON, Cod. vind. 2597, f. 2. (Synder, NR, cp. 44)

REST ON THE FLIGHT INTO EGYPT. See FLIGHT INTO EGYPT.

RESURRECTION OF CHRIST. Following the *Crucifixion and *Entombment, the body of *Christ remained in the tomb for three days before he rose from the dead (returned to earth after the *Anastasis) and made various appearances to the disciples before his *Ascension. The Gospels do not describe the actual process of Christ's Resurrection but rather concentrate upon the discovery of the empty tomb (see: *Three Marys at the Tomb) and Christ's post-resurrection appearances (see: *Noli me tangere, *Road to Emmaus, *Supper

at Emmaus, Saint *Thomas). Hence, in early Christian art the Resurrection is commonly represented by the pictorial narratives noted above or, as on fourth-century sarcophagi, in the symbolic form of a *cross bearing the *Chi-rho monogram in a triumphal wreath, flanked by *birds and the sleeping soldiers (tomb guards). By the tenth century, new iconographic formulae were developed for picturing the event: Christ is shown rising up from or stepping out of his sarcophagus, holding a cross staff or triumphal banner. A landscape setting may be indicated; *angels and soldiers may also be present. This image was especially popular in later medieval art of the fourteenth century onward, although examples may be found in the Romanesque and Gothic periods as well.

Example: Resurrection of Christ, Missal, c.1260, Hamburg, SB, MS in scrin. 1, f. 1. (Robb, pl. XXVI)

RESURRECTION OF THE DEAD. The belief that the dead will rise is a central concept in both Christianity and late Judaism, the meanings and specifics of which were frequently discussed by numerous commentators. Connected, for *Jews, with the vindication of the good over the wicked and for Christians, with the Second Coming of *Christ, representations of the dead bodily rising up from their graves appear especially in scenes of the *Apocalypse and *Last Judgment. Naked or semiclothed figures may be shown climbing out of coffins, boxes, cracks in the earth, or rising from the sea while *angels blow trumpets (Rev. 8: 2; *Matthew 24: 31) and Christ appears. Saint *Augustine stated that the resurrected dead would all reappear as the same age as Jesus when he died (approximately thirty years old); hence, the rising dead are generally undifferentiated by age or other physical attributes. Individual stories of the dead being brought to life figure in early Christian cycles and many later examples illustrating the *miracles of Jesus, whose own Resurrection is a crucial tenet of Christianity (see: *Raising of Jairus's Daughter, *Raising of Lazarus; *Raising of the Widow's Son; *Resurrection of Christ). Other accounts of miraculous restorations are found in the Acts of the *Apostles, various apocryphal works, and numerous hagiographic tales (e.g., the raising of *Tabitha by Saint *Peter; Saint *Benedict restoring a monk, killed in a construction accident, to life). The *True Cross was proven by Saint *Helena when it revived a dead person.

Example: Raising of the Dead, Pericopes of Henry II, c.1007–1012, Munich, BS, MS Clm. 4452, f. 201v. (Calkins, pl. 82)

REVELATION. See APOCALYPSE.

RHETORIC. See SEVEN LIBERAL ARTS.

RICHARD OF SAINT-VICTOR. A disciple of *Hugh of Saint-Victor, Richard (c.1123–1173) became prior of the Parisian abbey of Saint-Victor in 1162. He authored a number of influential texts, including *De Trinitate* (a philosoph-

ical treatise on faith and the *Trinity), *Benjamin minor*, and *Benjamin major* (mystical and contemplative treatises on scripture).

RIDERS OF THE APOCALYPSE. See APOCALYPSE.

RISEN CHRIST. See RESURRECTION OF CHRIST.

RIVERS OF PARADISE. See GARDEN OF EDEN.

ROAD TO CALVARY. See CALVARY.

ROAD TO EMMAUS. *Christ's post-*Resurrection appearance to two disciples who were journeying from Jerusalem to Emmaus sometimes appears as an independent scene or is linked in sequential narratives with the illustration of the *Supper at Emmaus. The episode is detailed in *Luke 24:13–27, which describes how the disciples did not recognize Christ and told him the news of Jesus' *death, burial, and reported resurrection. The stranger admonished them for their apparent failure to see the fulfillment of Old Testament prophecies in these events but agreed to join them for supper at the inn at Emmaus, where they eventually recognized his identity as he broke bread for them. A landscape scene and view of the village of Emmaus may provide the setting for this encounter. Christ is frequently dressed as a *pilgrim (i.e., a stranger in the area, unfamiliar with the recent events). The three figures may be indicated as speaking together as they walk along.

Example: Road to Emmaus, Lectionary, c.1320, Walters, MS 148, f. 45v. (Robb, fig. 176)

ROCH, SAINT. Renowned for his charity and care for the sick, the wealthy French youth Roch (or Rock, c.1350–1380) sold all his goods to support hospitals and the poor, traveled to Rome on a *pilgrimage, became infected when caring for plague victims, returned home to Montpellier and, emaciated and unrecognized, was mistaken for a spy and thrown into prison, where he died after five years. Variations on his legend were extremely popular in literature and art of the late fourteenth and fifteenth centuries, when his assistance against various diseases, illnesses, and especially the plague was regularly invoked. He often appears in art dressed as a *pilgrim, accompanied by a dog (who brought him food in a forest), or the *angel who visited him in prison and healed the plague spot on his thigh.

Example: Saint Roch and the Angel, sixteenth century, stone sculpture (destroyed), Troyes, Cathedral. (Mâle, LMA, fig. 108)

ROCK, SAINT. See ROCH, SAINT.

ROMAN D'ALEXANDRE. See ALEXANDER THE GREAT.

ROMAN DE LANCELOT DU LAC. See ARTHURIAN LEGENDS.

ROMAN DE LA ROSE. See GUILLAUME DE LORRIS AND JEAN DE MEUN.

ROMANUS, SAINT. According to the legends of Saint *Lawrence, Romanus (d. c.258) was a soldier converted to Christianity by Lawrence. He continued to preach even after his tongue was pulled out; eventually he was thrown into prison, strangled, or decapitated. He may be depicted as a *cephalophor.

Example: Saints Romanus and Roch, c.1478, fresco, Deruta, San Francesco. (Kaftal, C&S, fig. 1140)

ROSE. See FLOWERS AND PLANTS, SYMBOLISM OF.

RUPERT OF DEUTZ. The theologian Rupert of Deutz (c.1075/80–1129) became a Benedictine monk at Liège, a priest in 1106, and was appointed abbot of Deutz (near Cologne) in 1120. A scholar and prolific *author, he produced numerous works, including theological treatises, liturgical and scriptural commentaries, and hymns, which were extremely influential in the fields of both religion and art. His allegorical interpretation of scripture (e.g., in his commentaries on *John, *Matthew, the *Apocalypse, and Twelve Minor *Prophets) is reflected in the further development and expansion of typological symbolism so frequently seen especially in Germanic art of the Romanesque and Gothic period. Other important works include *On the Divine Office* (an analysis of liturgy), *On the *Trinity and Its Works, On the Victory of the Word of *God* (a theology of history), and the *Dialogue between a Christian and a *Jew*.

RUTH. The story of Ruth is recounted in the Old Testament book which bears her name. A Moabite woman who married a Hebrew immigrant, she accompanied her mother-in-law, *Naomi, back to Bethlehem after the deaths of both of their husbands. She was allowed, by Boaz, her right by law to glean in his fields; Boaz eventually married Ruth. Their son Obed became the father of Jesse (see: *Tree of Jesse); they thus figure among the *Ancestors of Christ. Ruth is found in Bible illustration especially of the twelfth century, gleaning in the fields, conversing with Naomi, kneeling before Boaz, and giving birth to Obed.

Example: Preface to Ruth, Lambeth Bible, c.1140–1155, Lambeth PL, MS 3, f. 130. (Grabar and Nordenfalk, Rmsq., p. 168)

S

SACRAMENTS. See SEVEN SACRAMENTS.

SACRAMENTARY. See MANUSCRIPTS.

SACRIFICE OF ISAAC. See ABRAHAM; ISAAC.

SACRIFICE OF NOAH. See NOAH.

SAGITTARIUS. See ZODIAC.

SAINTS. The term *saint* comes from the Latin *sanctus* (''holy'') and was initially used in the early Christian period to refer to all faithful members of the Christian *church. During the periods of persecution however, the special status of those who suffered *death (*martyrdom) for their faith resulted in increasing specification of saintly categories. The MARTYRS (from Greek: *martus,* ''witness'') were early venerated (see also: *Relics, *Pilgrimage) and tales of their lives, tortures, and deaths formed materials for myriad literary and artistic productions through the Middle Ages. Others who suffered but survived were classified by the third century as CONFESSORS and those who adopted an ascetic life or otherwise renounced certain worldly concerns (e.g., HERMITS and VIRGINS) were afforded special status by the early fourth century. The ranks of saints continued to grow through the medieval period; prayers offered to saints were believed to be particularly efficacious, and the accounts of *miracles performed at saints' shrines were popularized in art and literature. Particular saints were chosen by groups or individuals as ''patrons'' or protectors, often because of their previous vocation or some special episode in their lives (e.g., see: *Fourteen Holy Helpers). By the late twelfth century, papal authorization was officially required for a person to be declared a saint, a process known as

canonization. The study and composition of works concerning saints is known as hagiography. Saints' tales were recorded and often illustrated in a number of different formats (see: *Golden Legend, *Manuscripts). Individual saints are frequently recognizable by their iconographic attributes, which are often objects or *animals pertaining in some unique way to their lives or deaths. In general, saints are represented with *haloes; martyrs frequently hold palm branches, and other symbols of holy or heavenly status may include crowns, books, chalices, and scrolls. See also: *All Saints, *Cephalophors, *Stylites.

SALOME. See FEAST OF HEROD.

SALVATOR MUNDI. The depiction of *Christ as *Salvator mundi* ("Savior of the World") developed especially in later western medieval art as a devotional image representing a full-or half-length figure of Christ holding a globe which is often topped with a *cross (signifying the salvation of the world) and raising his right hand in a gesture of *benediction. *Angels and the Virgin *Mary may also be present. Occasionally, the infant Jesus is depicted in this manner.

 Example: Simone Martini, *Salvator mundi*, c.1340–1344, sinopia, Avignon, Notre Dame des Doms. (Martindale, fig. 157)

SAMSON. The adventures of the heroic but often unwise Samson are recorded in Judges 13–16 and are frequently illustrated in early Christian and medieval art. Many events from the life of Samson were interpreted by Christian theologians as prefigurations of events in the life of Jesus; hence he often features in typological programs of illustration as well as in other pictorial contexts.

 He was an incredibly strong man whose birth to Manoah and his previously barren wife was announced in advance by an *angel who predicted Samson's partial triumph over the Philistines. The angelic annunciation of Samson's birth may be paired with the *Annunciation to the Virgin *Mary and the *Nativity of Jesus in typological illustrations. Among the most frequently represented scenes from Samson's youth is the episode of his slaying a lion with his bare hands. This demonstration of strength, similar to one of the labors of *Hercules, is found in art from the fourth century onward. He may be shown astride, wrestling with, and prying open the jaws of a fierce lion. In typological programs, this scene may be connected with *Christ's descent into *hell (see: *Anastasis), where Christ broke open the gates (or jaws) of *Leviathan and released the Old Testament righteous.

 Following this episode, Samson's marriage to a Philistine woman resulted in disaster when, at his wedding feast, he challenged the guests to solve a riddle (the answer to which they eventually extracted from his wife); the angry Samson stormed away, slaughtered thirty Philistines, eventually returned to his wife, who had remarried in the interim, and sought further revenge by burning the Philistines' fields and orchards by tying firebrands to the tails of 300 foxes and

setting them loose in the fields. This chain of events resulted in the murder of his wife and father-in-law and in Samson's eventually being turned over to the Philistines from whom he escaped, after slaying 1,000 of them with the jawbone of an ass, like the apocryphal murder weapon of *Cain. When hiding in the wilderness and suffering from thirst, Samson asked *God for water, which miraculously gushed forth from the ground; Samson is often depicted drinking from the jawbone of an ass perhaps because of mistranslation of the Hebrew word for *spring*.

Another popular subject in art is the scene of Samson carrying away the doors (or gates) of the city of Gaza in a later escape from the Philistines, who were planning to ambush him there. He wrenched up the city gates at midnight and carried them for thirty or forty miles. Christian theologians interpreted this event as a prefiguration of Jesus carrying the *cross to *Calvary. Samson's betrayal by the Philistine harlot Delilah is also found in medieval art. She discovered from him that the secret of his strength was in his hair, which he had vowed not to cut; she cut his hair while he was sleeping, and so he was captured and blinded by the Philistines. Medieval interpreters related this to the *Betrayal and *Mocking of Christ.

Final episodes from the life of Samson include his humiliation by being put on display in the Philistine temple to their god Dagon and his *prayer to God, who caused the temple to collapse as Samson leaned against the columns. This deed resulted in Samson's *death as well as the deaths of thousands of Philistines.

Example: Samson and the Doors of Gaza, late twelfth century, stained glass, Stuttgart, WLM. (Dodwell, fig. 395)

SAMUEL. The life of the Hebrew priest and *prophet Samuel is recounted in the Old Testament first book of Samuel. He was the last of the Hebrew judges (leaders) before the advent of kings; he anointed, advised, and criticized the first king, *Saul, and also anointed the next king, the shepherd boy *David. After Samuel's death, Saul commanded the Witch of Endor to conjure up Samuel's ghost, which appeared and foretold defeat and *death for Saul and his sons in a coming battle.

Scenes from the life of Samuel appear in the third-century frescoes of the *synagogue at Dura Europas and in early Christian and medieval manuscript illustration and sculpture. Subjects include: the infant Samuel being presented in the Temple, Samuel offering a sacrificial lamb, Samuel anointing Saul and later David with a horn of oil, Samuel killing the Amalekites and their king Agag, and the ghost of Samuel conjured up by the Witch of Endor. Samuel's attributes are a lamb and a horn of oil.

Example: Scenes with Samuel and Saul, Quedlinburg Itala, late fourth–early fifth century, Berlin, SB, MS theol. lat., fol. 485, f. 2. (Cahn, fig. 4)

SANTIAGO. See JAMES THE GREATER, SAINT.

SAPIENTIA. See WISDOM.

SARAH. The first *matriarch, Sarah was the wife and half-sister of *Abraham and the mother of *Isaac. She is introduced in Genesis 11:29–30 as the barren *Sarai,* who accompanied Abraham in and out of Egypt and eventually settled with him near Hebron. Her beauty attracted the attentions of both the Egyptian *Pharaoh and later the king of Gerar; Abraham was fearful that those wishing to possess his wife would kill him; thus she posed as Abraham's sister and was presumably spared from committing adultery when dream visions and plagues sent by *God revealed the truth to her admirers. Convinced, in her old age, that she would never bear a child, Sarah offered her maidservant Hagar to Abraham; Hagar gave birth to Ishmael, and the jealous Sarah forced them away from the household twice. Sarah was ninety-one years old when Isaac was born, and this miraculous event, promised by God (at which point *Sarai* was renamed *Sarah:* ''princess''), was announced in advance by three men (heavenly messengers, *angels) who visited Abraham (the angels were en route to *Sodom). Abraham's hospitality to the visitors and his directions to Sarah to prepare cakes for them are scenes frequently illustrated in early Christian and medieval art. The elderly Sarah, standing in the doorway of their tent, overheard the prophecy; at first she was amused, later afraid. The adventures of Sarah and Abraham in Egypt, their parting company with Abraham's nephew *Lot, Sarah's presentation of Hagar to Abraham, and the birth of Isaac are also subjects found in early Christian Bible illustration and later medieval sculpture, manuscript illustration, and metalwork.

Example: Hospitality of Abraham, Psychomachia, tenth century, Brussels, BR, MS 100073–74. (Bologna, p. 87)

SATAN. The Hebrew word *satan* (''adversary'') appears frequently in the Old Testament to refer to evil forces (both human and supernatural) that tempt and entice humans away from *God. *Satan* is retained in the Greek and Vulgate translations, although it was additionally translated into the Greek and Latin *diabolos* (to become ''*Devil''). Satan, then, as the general source or magnet for evil causation in the world, was pictorially personified in various ways through early Christian and medieval art.

Old Testament apocryphal works, crediting the origin of evil to *angels who rebelled against God, specified Satan as the leader of the rebels (see: *Fall of the Rebel Angels); hence Satan may be shown in angelic/humanoid form. This appears to be the case in early sixth-century mosaics (e.g., the scene of *Christ in judgment separating the sheep and goats at Sant' Apollinare Nuovo, Ravenna, where the blue angel who stands at Christ's left, with the goats, may represent the wicked Satan).

The *exorcism of *demons from possessed persons, a subject which appears in early Christian art (see: *Healing of the Demoniac) will show demons as small, winged creatures exiting from the mouths of the possessed. Enlarged

versions of these monstrous creatures appear in images from the ninth century following, representing Satan in an ugly, hybrid, humanoid, or bestial form. In Romanesque and Gothic art, images of Satan are increasingly hideous (see further under Devil).

Evil is also personified by specific animals, among them snakes, serpents, and dragons (see: *Animals, Symbolism of). Early Christian writers, such as Saint *Jerome, also used the name Lucifer (Latin: "light bearer," *Isaiah 14:12) to apply to Satan and the Devil. See also: *Apocalypse, *Hell, *Last Judgment, *Leviathan, *Mouth of Hell.

Example: Saint Michael Triumphs over the Dragon of Evil, c.1100, fresco, Civate, San Pietro al Monte. (Demus, pp. 71–72)

SATYR. In classical mythology, satyrs are the companions of Bacchus; they are riotous, hairy, and lecherous drunkards, half-man and half-goat, with horns, hooves, and tails. The *Devil acquires many of their physical features in early medieval art; hence satyrs are generally associated with evil and *vice. A helpful satyr however, gave Saint *Anthony of Egypt directions on his journey to visit Saint *Paul the Hermit. Satyrs also appear as decorative features and as marginal *grotesques in manuscript illustration.

Example: Canon Table, Gospels, 845–882, New York, PML, MS 728. (Bologna, p. 74)

SAUL. Saul was the first king of Israel (eleventh century B.C.); his life is recounted in 1 Samuel 9–31. He features in art primarily in episodes illustrating his variable relations with his successor *David. Saul was anointed as king by the prophet *Samuel but repeatedly disobeyed *God's commands (e.g., in sparing the life of the Amalekite king Agag and in disobeying Samuel's command and making sacrifices to *God). Hence, God instructed Samuel to anoint the youthful *shepherd David as Saul's successor. David was brought to Saul's court, where he entertained him and soothed his melancholy with his harp playing, but Saul became jealous and suspicious after David's victory over *Goliath, David's formation of close relations with Saul's son *Jonathan, and David's marriage to Saul's daughter Michal. Saul had hoped to kill David by requiring that he slay 100 Philistines in order to gain Michal, but David triumphed by killing 200 Philistines. Saul tried to murder David with a lance while David was playing music for him (a scene frequently shown in art); David fled from Saul's court but was pursued by Saul, whose life he later spared in an encounter in the hills. Saul was eventually defeated in battle with the Philistines, as foretold by the ghost of Samuel whom Saul contacted through the medium or Witch of Endor, and he committed suicide by falling on his own sword.

Various scenes involving Saul and David are found in art from the early Christian through late Gothic period: David refusing the arms offered by Saul before the combat with Goliath, David presenting Saul with the severed head of Goliath, Saul soothed by David's harp playing but also attempting to kill

David with his lance, David sparing Saul's life, the *death of Saul and David's grief.

Example: David Before the Enthroned Saul, 610–641, silver plate, New York, Met. (Snyder, fig. 125)

SAVIN AND CYPRIAN, SAINTS. The brothers Savin and Cyprian were martyred in the mid-fifth century after undergoing a series of horrifying tortures resultant from their refusal to worship pagan *idols. Their lives, tortures, *martyrdoms, and *miracles appear in detailed narrative frescos in the crypt of their resting place, the church of Saint-Savin-sur-Gartempe in France.

Example: Tortures of Saints Savin and Cyprian, c.1100, fresco, Saint-Savin-sur-Gartempe, crypt. (Dodwell, fig. 230)

SCALES. See ZODIAC.

SCHOLASTICA, SAINT. The twin sister of Saint *Benedict, Scholastica (c.480–c.543) founded the first community of Benedictine nuns near Monte Cassino. *Gregory the Great recorded the few details known of her life and described her final (yearly) visit with Benedict when a storm (for which she had prayed) prevented Benedict from leaving as he had planned. They spent the night discussing spiritual matters, and upon her *death three days later, Benedict saw a vision of Scholastica's *soul flying to heaven in the form of a dove. The dove is thus her primary attribute; she is otherwise depicted as a Benedictine abbess, often in company with Benedict.

Example: Funeral of Saint Scholastica, fourteenth–fifteenth century, fresco, Subiaco, Sacro Speco. (Kaftal, C&S, fig. 1163)

SCORPIO. See ZODIAC.

SCORPION. See ZODIAC.

SCOURGING OF CHRIST. See FLAGELLATION.

SEBASTIAN, SAINT. Probably born in Milan, the Christian soldier Sebastian (d. c.288) joined the Roman army in the late third century and was appointed captain of the praetorian guard by the emperor Diocletian. When Sebastian gave emotional support and encouragement to Christians being persecuted, thus inspiring numerous conversions, the emperor ordered that he be shot to *death with arrows; however, Sebastian recovered under the care of a Roman widow, Saint Irene, and returned to confront the emperor who then had him stoned (or whipped) and thrown into the sewer. A basilica was constructed over his tomb on the Via Appia in the fourth century. Sebastian's popularity continued through the Middle Ages; he was especially invoked against plague. He is commonly represented in art tied to a column or post, shot full of arrows. Archers (variable

number) may be shown ranged on either side. He is often bearded, wearing a
loincloth, although may also appear wearing a toga, or garbed as a Roman
soldier.

 Example: The Martyrdom of Saint Sebastian, c.1100–1130, fresco, Rome, Old Lateran
Palace. (Dodwell, fig. 162)

SECOND COMING OF CHRIST. See APOCALYPSE; LAST JUDGMENT.

SEDES SAPIENTIAE. *Sedes sapientiae* ("Throne" or "Seat" of "*Wis-
dom") refers specifically to solemn and majestic images of the *Madonna and
Child, particularly the smallish, free-standing, wood sculptures or cult statues
frequently produced in western Europe from the tenth century onward and es-
pecially during the Romanesque period. Often covered with thin sheets of gold
or silver, decorated with gemstones, or painted, the sculptures show an en-
throned Virgin *Mary (sometimes wearing a veil or crown) stiffly supporting a
rigid and unchildlike infant Jesus seated in the center of her lap. He may be
shown holding a book and making a gesture of *benediction. The figures usually
stare outward, exhibiting no interaction with each other apart from physical
proximity. Mary is represented as the *Regina coeli* (the queen of *heaven), the
Theotokos (bearer of *God), and *Christ as God incarnate. Early Christian
theologians often referred to Mary as the "throne of God," and medieval au-
thors linked this image to the throne of the wise Old Testament King *Solomon;
hence, Mary became the "Throne of Wisdom." The free-standing sculptures
were placed on altars, carried in processions, and sometimes used as containers
for *relics. Although the term generally refers to wood sculptures, the iconog-
raphy is found in other media (painting and relief sculpture).

 Example: Morgan Madonna, twelfth century, NY, Met. (Synder, cp. 50)

SERAPHIM. See ANGELS.

SERGIUS AND BACCHUS, SAINTS. The martyred brothers Sergius and
Bacchus (d. c.303) appear primarily in Byzantine art from the sixth century
onward. Their legend tells that they were soldiers in the Roman army who
refused to enter a pagan temple and offer sacrifice; they were tortured under the
orders of the emperor Maximian; Bacchus died of scourging, and Sergius was
decapitated.

 Example: Saints Sergius and Bacchus, twelfth–thirteenth century, fresco, Aquileia,
basilica, crypt. (Kaftal, NE, figs. 1201–1202)

SERMON ON THE MOUNT. Jesus' Sermon on the Mount is a lengthy speech
recounted in *Matthew 5–7 (sometimes compared with *Luke 6:20–49) which
contains the essence of his moral and spiritual teachings (see also: *Beatitudes
of the Soul). The Sermon on the Mount may be illustrated in early Christian
and medieval art by the depiction of Jesus seated, his hand raised in a gesture
of speech or *benediction, surrounded by variable numbers of listeners. The

image of Jesus as teacher (or philosopher) develops in very early Christian art (in catacomb frescoes and sculpture) and was probably influenced by classical representations of teachers or *authors. As the image evolved in the early Christian and medieval period, the scene of Jesus seated or enthroned among the *apostles may take on additional symbolism (see: *Mission of the Apostles, *Preaching, *Traditio legis).

Example: Christ Teaching, c.400, mosaic, Milan, San Lorenzo Maggiore. (Synder, fig. 60)

SERPENT. See ADAM AND EVE; ANIMALS, SYMBOLISM OF.

SEVEN CHURCHES. See APOCALYPSE.

SEVEN DEADLY SINS. See VICES.

SEVEN GIFTS OF THE HOLY SPIRIT. Early Christian and medieval theologians, following the passage in *Isaiah 11:2–3, identified the Seven Gifts of the *Holy Spirit as specific qualities granted to virtuous believers. These gifts were related by Saint *Augustine to the *Beatitudes of the Soul, described by Saint *Gregory as aids against evil, and especially developed by Saint *Thomas Aquinas who drew a distinction between the gifts and *virtues. The seven gifts are *sapientia* (*wisdom), *intellectus* (understanding), *consilium* (counsel), *fortitudo* (fortitude), *scientia* (knowledge), *pietas* (piety), and *timor Domini* (fear of *God). In art, especially Gothic manuscripts and stained glass, the gifts are most often symbolized by seven birds, usually doves (see: *Birds, Symbolism of). They are sometimes also represented as lamps or flames. They may appear independently or surrounding the figure of *Christ, the *Madonna and Child, or the *Tree of Jesse. Sometimes the gifts are identified by inscriptions (e.g., on scrolls held in the birds' beaks).

Example: Seven Gifts of the Holy Spirit, Berthold Missal, c.1215–1217, New York, PML, MS M. 710, f. 65. (Calkins, cp. 15)

SEVEN JOYS OF THE VIRGIN. Joyful moments in the life of the Virgin *Mary were discussed by theologians and illustrated in art from the early Christian period onward. The codification of seven specific events was popularized in the thirteenth century in Italy and later adopted especially by the Franciscans. Meditation upon these events parallels the contemplation of the *Seven Sorrows of the Virgin. The joys may be illustrated separately or as a group and appear especially in late medieval panel paintings. The core events are the *Annunciation, *Visitation, *Nativity, *Adoration of the Magi, *Dispute in the Temple, *Resurrection of *Christ, and the *Assumption of the Virgin, although other scenes (especially of Jesus' *miracles) may be included.

Example: Hans Memlinc, *The Joys of Mary,* c.1480, Munich, Alte Pinakothek. (Snyder, NR, fig. 175)

SEVEN LIBERAL ARTS. The areas of secular education considered ''liberal'' have their foundation in classical antiquity and were codified in the medieval period into a distinct set of seven, with two subdivisions. The upper division, the *quadrivium,* consists of Geometry, Arithmetic, Astronomy, and Music; while the lower division, or *trivium,* is made up of Grammar, Logic (or Dialectic), and Rhetoric.

Numerous early medieval authors (including Saint *Augustine, *Boethius, Cassiodorus, Hrabanus *Maurus, *Isidore of Seville, and other encyclopedists) wrote treatises on the liberal arts. Many later medieval authors also produced treatises and commentaries on some or all of the liberal arts.

The tradition of artistic representation of the Seven Liberal Arts may be traced to the fifth-century work of Martianus *Capella; his allegorial treatise, *De nuptiis philologiae et mercurii libri novem (The Marriage of Philology and Mercury)* describes the Seven Liberal Arts as personified female figures with specific attributes and companions. In illustrations of Capella's text and in Romanesque and Gothic architectural sculpture and stained glass, GRAMMAR is often identified by the whip she carries (to encourage or admonish her students), and she may be accompanied by *Priscian or Donatus; LOGIC may carry a snake (symbolizing wily argument) and be accompanied by *Aristotle; RHETORIC wears armor and may also carry a book or scroll, in company with *Cicero; GEOMETRY holds compasses and/or a globe or other measuring instruments and may be accompanied by *Euclid; multiplying rays may spring from the head of ARITHMETIC who appears in companionship with *Pythagoras, she may also carry a tablet and ruler; ASTRONOMY, in the company of *Ptolemy, is winged and has a crown of stars and may carry a globe and instruments of measurement; and MUSIC is normally represented playing a musical instrument (the type varies), accompanied either by *Pythagoras or the biblical descendant of *Cain, Tubal-Cain, considered in medieval tradition to be the inventor of music.

The descriptions of Capella were generally followed rigorously in medieval art with some variations and additions from other sources and traditions. Frequently, the Seven Liberal Arts are paired with the seven major *virtues (see also: *Prudentius) and may be headed by the figure of *Philosophy, the ''mother'' of the Liberal Arts. In the thirteenth century, the traditional group of seven was expanded to include, for example, personified figures of Architecture, Astrology, Alchemy, and Painting.

Example: Seven Liberal Arts, c.1145–1155, Chartres Cathedral, west portal, archivolt. (Sauerländer, fig. 15)

SEVEN SACRAMENTS. The English term *sacrament* derives from the Latin *sacramentum* (''signs''). The sacraments of the Christian church are foundational and significant actions or rituals in which believers participate to confirm faith. The ceremonies are understood to be outward, material signs of invisible realities and were developed in the early Christian period, partially mirroring certain actions and teachings of Jesus as recounted in the Gospels and interpreted

by early theologians (e.g., Saint *Augustine). The definition and form of the sacraments was an issue of much discussion through the Middle Ages, with as many as thirty sacraments being defined by authors such as *Hugh of Saint-Victor in the twelfth century. The codification of Seven Sacraments was developed by *Peter Lombard in the twelfth century, adopted by Saint *Thomas Aquinas in the thirteenth century, and formally accepted at church councils in the mid-fifteenth century. (They were revised variously later in the Reformation period.) The Seven Sacraments are *Baptism, Confirmation*, the *Eucharist, Reconciliation* (or *Penance*), *Anointing of the Sick* (or *Extreme Unction*), *Ordination,* and *Marriage*—all of which appear illustrated in various artistic contexts—as narrative episodes in the lives of *Christ, the Virgin *Mary, and other holy figures and as illustrations in liturgical manuals and handbooks. See for example: *Ars moriendi*, *Baptism, *Benediction, *Communion of the Apostles, *Death, *Last Supper, *Washing of the Feet.

SEVEN SEALS. See APOCALYPSE.

SEVEN SLEEPERS OF EPHESUS. The popular legend of the Seven Sleepers of Ephesus (known in both east and west by the sixth century) tells how seven Christian youths took refuge from persecution and were sealed in a cave near Ephesus, by order of Decius, in the mid-third century. *God caused them to sleep for about 200 years and when they emerged, under the reign of Theodosius II, they found their city had become Christian. Their miraculous ''return to life'' resembles the anticipated *Resurrection of the Dead at the *Last Judgment, hence their religious significance and the popularity of their cave as a *pilgrimage site. Representations of the Seven Sleepers are found in both western and Byzantine art from the early medieval period. They are generally depicted sleeping, seated, or reclining in a circle in the interior of a cave.

Example: Seven Sleepers, c.1500, icon, Athens, City of Athens Museum. (*HIHS,* pl. 61)

SEVEN SORROWS OF THE VIRGIN. Frequently represented as a group in late medieval art of northern Europe, the sorrows of the Virgin *Mary originate from the passage in *Luke 2:35 where *Simeon, during the infant Jesus' *Presentation in the Temple, prophesied to Mary that a sword would pierce her *soul. The themes of Mary's sorrow and compassion for the sufferings of her son were developed by numerous medieval theologians and pictured in art as the following episodes: the *Presentation in the Temple, *Flight into Egypt, *Dispute in the Temple, Jesus carrying the *cross to *Calvary, the *Crucifixion, *Deposition, and *Entombment. The scenes appear independently or, especially in late medieval altarpieces produced for the Confraternities of the Virgin of the Seven Sorrows, in small vignettes or medallions surrounding a central image of the Virgin mourning at the foot of the cross (see: *Mater dolorosa*) or *Pietà. The

seven sorrows may also be symbolized by seven swords piercing the heart of the Virgin. See also: *Seven Joys of the Virgin.

Example: Virgin of the Seven Swords, sixteenth century, stained glass, Brienne-la-Ville, Church of Saints Peter and Paul. (Mâle, LMA, fig. 67)

SHEBA, QUEEN OF. See QUEEN OF SHEBA.

SHEPHERD. Shepherds and sheep feature frequently in early Christian and medieval art in a variety of contexts, both narrative and symbolic. Sheep are often mentioned in the Bible, and their importance (for sacrifice, food, and wool) is emphasized throughout the Old Testament. Among the many figures associated with sheep in the Old Testament (and who may be recognizable in their portrayals as shepherds) are Abel (see: *Cain and Abel), the youthful *David, and *Jacob. In a more symbolic context, *God is also referred to as a shepherd (e.g., Psalm 23:1), and leaders such as *Moses are likened to shepherds who guide their flocks. *Ezekiel 34 also contains a description of poor leaders, bad shepherds, who misuse their office and neglect their responsibilities.

The duties and responsibilities of shepherds are themes further developed in the New Testament and Jesus' reference to himself as the *Good Shepherd (e.g., *John 10:11) gave rise to the early established prevalence of sheep and shepherd symbolism in Christian art (see also: *Agnus Dei*). Shepherds also feature in the New Testament as having been early alerted of the birth of Jesus (see: *Annunciation to the Shepherds, *Nativity) and among the first to visit the *Holy Family. Apocryphal sources also describe the annunciation (of *Mary's birth) to *Joachim while he was sojourning with shepherds; hence this annunciation scene may also be shown in a landscape containing shepherds and sheep.

Several saints may also be represented with sheep (or lambs), e.g., *Agnes, *Francis, *Geneviève, *John the Baptist, and *Margaret. The chaste *Susanna (Old Testament) may also be shown with, or as, a lamb.

Example: Three Shepherds and the Vine Harvest, late third century, sarcophagus, Rome, Lateran Museum. (Snyder, fig. 7)

SIBYL. A sibyl is a female prophet, for example, a priestess of Apollo from the pre-Christian period. Early Christian and medieval theologians identified twelve sibyls of the ancient world whom they cited as having predicted the coming of *Christ. These classical sibyls thus provided the pagan or Gentile counterparts to the twelve major Jewish *prophets in announcing the coming Messiah, as well as the counterparts to the twelve *apostles. Authors such as Saint *Augustine, Bede, *Isidore of Seville, and *Vincent of Beauvais specified the names of these ancient sibyls: Agrippine, Cimmerian, Cumaean, Delphic, Erythraean, European, Hellespontic, Libyan, Persian, Phrygian, Samian, and Tiburtine. They are represented in art as young women, often holding books, other attributes, and wearing turbans. The Erythraean sibyl (who prophesied the *Last Judgment) and the Tiburtine sibyl (who revealed a vision of the *Madonna and

Child to the emperor Augustus) are often singled out. Sibyls may appear in manuscripts with typological programs of illustration, in Gothic stained glass and portal sculpture, and in illustrations of the *Tree of Jesse.

Example: The Tiburtine Sibyl, Speculum humane salvationis, early fifteenth century, Manchester, John Rylands Library, MS lat. 27, f. 11. (Robb, fig. 206)

SIMEON. According to *Luke 2:22–39, Simeon met *Mary and *Joseph when they brought Jesus to the Temple as an infant (see: *Presentation in the Temple). Simeon is described as a just and devout man to whom *God had revealed that he would not die until he had seen the Messiah. He took the baby Jesus in his arms, praised God, and prophesied to Mary that a sword would pierce her *soul (see: *Seven Sorrows of the Virgin). In art, Simeon is usually represented in scenes of the Presentation in the Temple as an elderly man holding the baby Jesus in his arms or reaching out for the infant. In the later medieval period, he is often shown wearing the robes of a high priest of the Temple.

Example: Simeon, c.1220, Reims Cathedral, west facade, jamb figure. (Synder, fig. 499)

SIMEON STYLITES, SAINT. Of the two *stylite* (or pillar) *saints named Simeon; the elder (c.390–459) is credited with having founded this austere form of asceticism when, beginning in about 423, he set up a series of increasingly taller pillars at a site northeast of Antioch and lived on top of them. Already famous for his asceticism, Simeon wished to avoid physical contact with the *pilgrims who had been coming to see him; he also wished to ''fly to *heaven'' from his lofty abode. The last pillar upon which he lived may have been close to sixty feet high. He continued to attract many pilgrims to whom he preached and offered guidance. After his *death, a sanctuary was founded on the spot, and his pillar continued to provide a popular *pilgrimage site. Like the several other *stylite* saints, Simeon appears primarily in Byzantine art (sculpture, *icons, manuscripts, and frescoes) standing or seated, often praying, on top of his pillar.

Example: Saint Simeon Stylites, sixteenth century, icon, Paris, Louvre. (Ouspensky, p. 131)

SIMON MAGUS. See FALL OF SIMON MAGUS.

SINAI. See MOUNT SINAI.

SINS. See VICES.

SLAUGHTER OF THE INNOCENTS. See MASSACRE OF THE INNO-CENTS.

SLOTH. See VICES.

SNAKE. See ADAM AND EVE; ANIMALS, SYMBOLISM OF.

SODOM AND GOMORRAH. The cities of Sodom and Gomorrah were destroyed by *God who caused fire and brimstone to rain down from *heaven upon them (Genesis 19:24). *Lot and his family escaped from Sodom before it was destroyed (see also: *Lot's wife). Described as sinful and wicked cities, the iniquities attributed to the men of Sodom appear to have included homosexual rape (Genesis 19:5). In art, the cities are symbolized by architecture that is crumbling, toppling over, burning, or being rained upon by flames from the sky.

Example: Destruction of Sodom, Saint Louis Psalter, c.1270, Paris, BN, MS lat. 10525. (Pächt, pl. XXVI)

SOLOMON. The wise King Solomon was the son of *David and *Bathsheba and the successor to the kingdom of David (c.971–931 B.C.) His lengthy reign was a period of great prosperity and stability, marked by artistic achievements (e.g., the construction of the magnificent Temple in Jerusalem), much foreign trade, as well as toleration of pagan religions (which eventually resulted in *God's punishment during the reign of Solomon's son Rehoboam). Solomon's reputation for great *wisdom, which he requested from and was granted by God (1 Kings 3:5–15), gained him international fame during his lifetime and long after. A model ruler over a splendid court, Solomon is also credited with composing the biblical books of Proverbs, Ecclesiastes, the Wisdom of Solomon, the Song of Songs, and several Psalms.

Illustrations of the life of Solomon frequently found in medieval art include his anointing and coronation (he rode into Jerusalem on David's mule to be anointed by the priest and later placed his mother on the throne next to him; medieval theologians found these episodes as prefigurations of *Christ's *Entry into Jerusalem and the *Coronation of the Virgin); his wise handling of rival claimants to an infant (see: *Judgment of Solomon); the construction of the Temple in Jerusalem; and the visit of the *Queen of Sheba to Solomon's court.

The detailed descriptions of the materials, construction, and objects placed within the Temple (1 Kings 6–8), as well as the description of Solomon's stunning throne (1 Kings 10:18–20) provided inspiration for many medieval commentators. The throne of the wise Solomon was likened to the Virgin *Mary (see: *Sedes sapientiae); the "molten sea" supported by twelve metal oxen (1 Kings 7:23–26) inspired twelfth-century baptismal fonts; the seven-branched candlestick and *Ark of the Covenant are also illustrated in art.

Illustrations of the life of Solomon are found in biblical manuscripts from the Carolingian period onward. He is frequently paired with the Queen of Sheba in Gothic portal sculpture and also appears in stained glass and fresco.

Example: Solomon, c.1215–1220, Chartres Cathedral, north transept, jamb figure. (Snyder, fig. 481)

SOMME LE ROI. See FRERE LORENS.

SONG OF ROLAND. See CHANSON DE ROLAND.

SOUL. A topic of much discussion among classical philosophers, Hebrew, early Christian and medieval theologians, the soul may be defined as the life spirit (Greek: *psuche;* Latin: *anima;* Hebrew: *nephesh*) which animates each person. In early Christian art, souls may be represented as *orant figures, and in medieval art, souls are generally represented as small, naked figures or babies ascending to *heaven with the assistance of *angels. The souls of the righteous are represented wrapped in cloth in the bosom of *Abraham (see also: *Dives and Lazarus), and *Christ holds the soul of the Virgin *Mary in scenes of her *Dormition. Angels and *demons are shown battling over souls in scenes of the *Last Judgment and in funeral and deathbed illustrations such as found in the *Ars moriendi. The interior conflict between good and evil in the human soul is represented by a series of personifications in illustrations of, and derived from, the *Psychomachia* of *Prudentius.

Example: The Soul of Abbot Lambert Ascends to Heaven, Augustine, Various Works, c.1125, Boulogne, BM, MS 46, f. 1. (Porcher, pl. XXVII)

SPECULUM HUMANAE SALVATIONIS. The *Speculum humanae salvationis (Mirror of Human Salvation)* was composed in the early fourteenth century by an anonymous author, perhaps a German Dominican. Drawing from a variety of sources (e.g., *Josephus, the *Golden Legend,* Saint *Thomas Aquinas), the text is a detailed typological description of the redemption of humankind through *Christ as prefigured in the Old Testament. Intended as a manual for preachers, it was widely copied and illustrated in manuscript form and appeared in early printed editions. It was translated into several languages (including Dutch, French, German, English, and Czech). The text and its standardized program of illustrations exerted a profound influence on late medieval Christianity and art; it was used as a sourcebook by both artists and preachers. In most versions, forty-two chapters are each illustrated with four images (one scene from the New Testament correlated with three Old Testament prefigurations); three additional chapters (with nontypological illustrations) concern stages in the Passion of Christ (see: *Stations of the Cross), the *Seven Joys, and the *Seven Sorrows of the Virgin *Mary. (See also: *Typology, *Bible historiale, *Bible moralisée, *Biblia pauperum.)

Example: Speculum humane salvationis, 1379, London, BL, Add. MS 16578, f. 17v. (De Hamel, fig. 213)

SPONSA-SPONSUS. The Old Testament Song of *Solomon was interpreted allegorically by early Christian theologians who explained the text's dialogue of love in terms of the relationship between *Christ and the *Church (*Ecclesia). A topic taken up by many medieval authors (e.g, *Saint Bernard of Clairvaux), the concept was given pictoral form beginning in the twelfth century with images of the *Sponsus* (Christ, Bridegroom) approached or embraced by the *Sponsa* (*Ecclesia*, Bride). The detailed and physical descriptions of the text were rephrased visually as a mystical and spiritual "marriage" symbolized by the two

standing or embracing figures. The imagery is found especially in biblical man-
uscript illustrations and may also be accompanied in typological schemes with
the figures of Solomon and the *Queen of Sheba as Old Testament prefigura-
tions. The Virgin *Mary may also be represented as *Sponsa-Ecclesia,* expressing
a tender relationship with her son (perhaps ultimately influenced by Byzantine
*Madonna and Child images showing affection between mother and child, e.g.,
see: *Eleousa*). The *Sponsa-Ecclesia* figure is also included, along with the
Virgin Mary, in Gothic illustrations of the *Crucifixion; she may reach up to
embrace Christ's body on the *cross or press her cheek against his face while
holding a chalice to collect blood flowing from his wounds.

 Example: Song of Solomon initial, Alardus Bible of Saint-Amand, c.1100, Valenci-
ennes, BM, MS 10, f. 113. (Cahn, fig. 70)

STAG. See ANIMALS, SYMBOLISM OF.

STATIONS OF THE CROSS. Also known as the *Via dolorosa* or Way of the
Cross, the Stations of the Cross refer to specific moments and incidents which
took place in Jesus' journey through the streets of Jerusalem from his sentencing
by *Pontius Pilate to his *Crucifixion on *Calvary and his *Entombment. The
practice of physically retracing this path and meditating upon the events of
*Christ's passion became a popular activity for *pilgrims in the early Christian
period. The practice of pictorially recreating these series of episodes in paintings
and sculpture inside churches or in roadside shrines in Europe became common
especially during the Crusades. In the mid-fourteenth century the Franciscans
took charge of the holy sites in Jerusalem and formalized the processions along
the *Via dolorosa* as well as encouraged devotion to the Stations of the Cross in
all Franciscan monasteries and churches. The practice became widespread and
illustrated booklets were produced, especially in the fifteenth century, aiding
worshippers in their devotions. The number of ''stations'' (''stops'') varied
widely from five (in the fifth century) to seven, to as many as forty-three in the
later Middle Ages. The fourteen specified (in the sixteenth century) include a
number of scenes illustrated in art from the early Christian period onward: (1)
Jesus is sentenced by Pilate, (2) he is given the *cross to carry, (3) he stumbles,
(4) he converses with the Virgin *Mary, (5) Simon of Cyrene takes the cross
briefly, (6) Saint *Veronica wipes Jesus' face, (7) the cross-bearing Jesus stum-
bles again, (8) he tells the women of Jerusalem not to grieve for him, (9) he
falls to his knees, (10) he is stripped of his garments, (11) he is nailed to the
cross (see: *Raising of the Cross), (12) he dies, (13) he is removed from the
cross (see: *Deposition, *Lamentation, *Pietà*), and (14) he is laid in the *Holy
Sepulchre (see: Entombment).

STEPHEN, SAINT. The first martyr (protomartyr) Stephen (d. c.35) was one
of the seven deacons chosen by the *apostles to assist with the supervision of
the early *church in Jerusalem. Described as ''a man full of faith,'' who did

"great wonders and miracles" (Acts 6:5, 8), his *preaching and *wisdom brought him to the attention of the Jewish religious leaders who accused him of blasphemy and brought him to trial. Acts 7 recounts Stephen's lengthy speech in which his detailed knowledge of Jewish history and his proclamation of the Son of Man (*Christ) "standing on the right hand of *God" so angered the audience that they rushed upon him and stoned him to *death. Saul (later Saint *Paul) is mentioned among the witnesses to this event.

Stephen's importance in the early church and the dramatic nature of his death at the hands of the *Jews made him a prominent figure in art and religion from the early Christian period onward. He appears in art from at least the fifth or sixth century, and scenes of his *martyrdom are among the most frequently represented subjects in hagiographic illustration through the Gothic period. Cycles depicting his martyrdom (frequently including his arrest and trial as well as stoning) are found in Carolingian manuscripts and frescoes of the ninth century, Byzantine manuscripts of the eleventh century, and with great frequency thereafter in manuscripts, sculpture, metalwork, and stained glass.

Some different pictorial formats may be noted for the martyrdom scene; Stephen may kneel or stand, the stone-throwing attackers may vary in number and approach from right or left, many or a few stones may fly through the air, and the hand of God may appear in the sky. A stone is the iconographic attribute by which Stephen may be identified when shown as a single figure; he is also often shown dressed as a deacon.

A number of later legends concerning Stephen's early life, posthumous *miracles, as well as the discovery and translation of his *relics are also illustrated in art from the Romanesque period onward. Scenes include his body being guarded by wild animals before he was entombed (in the same grave as *Nicodemus); the visionary appearance of the Rabbi Gamaliel four centuries later who directed the discovery and identification of the grave; and the translation of the relics to the basilica of San Lorenzo in Rome where the martyr Saint *Lawrence moved over in the grave to provide room for Stephen's body. Stephen is also depicted being ordained by Saint *Peter, preaching, in dispute with the Jewish elders, and seeing a vision of Christ.

Example: Stoning of Saint Stephen, c.1165–1180, fresco, Müstair, Benedictine Convent, south apse. (Demus, pl. 84)

STIGMATA. Stigmata (from Latin, *stigma*: "mark") are wounds which appear on the human body reproducing those received by *Christ at the *Crucifixion; that is, on hands, feet, and near the heart, or also on the back, shoulders, and head (see *Flagellation, *Crowning with Thorns, *Instruments of the Passion). Saint *Francis of Assisi is said to be the first person to have received the stigmata (in 1224). Growing devotion to and mystical contemplation of the sufferings of Christ from the thirteenth century onward resulted in numerous other recorded instances. See also: Saint *Catherine of Siena.

STORM ON THE SEA OF GALILEE. The Gospels contain several episodes and versions of Jesus' miraculous calming of tempests and saving his disciples caught in storms at sea. Power over water is an attribute of *God in the Old Testament; hence these episodes also communicate about the identity of Jesus. *Matthew 8:23–27 describes one incident in which Jesus and his disciples were all together in a boat. Jesus was asleep when they got caught in a storm, and the frightened disciples woke him up. He rebuked them for their lack of faith and caused the sea and wind to become calm. This episode is frequently illustrated (especially in manuscripts) up through the twelfth century; Jesus may be shown sleeping in the boat or sitting up and gesturing in *benediction; the winds may be personified as little puffing heads (see: *Four Winds), and the boat may be shown with sails and/or oars.

Matthew 14:22–23 also recounts another episode when Jesus instructed his disciples to go before him and travel by boat across the sea without him. When a storm came up, Jesus walked across the water to them. *Peter, wishing proof, also wanted to walk on the water, and he became frightened and began to sink, at which point Jesus rescued him. This scene was also popular in art from the early Christian period; the disciples may be shown watching from the boat while Jesus pulls the sinking Peter from the water, or Jesus may be shown standing on the water or climbing into the boat. See also: *Navicella.

Example: Storm at Sea, Hitda Codex, c.1000–1020, Darmstadt, HB, MS 1640, f. 117. (Dodwell, fig. 139)

STYLITES. Stylites (from Greek, *stylos:* ''pillar'') are *saints who lived on the top of columns or pillars. Saint *Simeon Stylites the Elder appears to have originated this extremely austere form of asceticism in Syria in the fifth century. He had several imitators, notably Daniel the Stylite (409–493) who lived on a series of pillars outside Constantinople. Although elevated from the world, stylites often preached and prophesied from their platforms and attracted many visitors and *pilgrims. They appear in art (especially Byzantine *icons and manuscripts) standing or kneeling in *prayer atop their pillars.

Example: Saint Simeon Stylites, sixteenth century, icon, Louvre, Paris. (Ouspensky, p. 131)

SUDARIUM. *Sudarium* is the Latin term for the cloth (veil or napkin) with which Saint *Veronica wiped the face of *Christ and upon which the image of his face was miraculously imprinted. Also known as the *vernicle* (Middle English), the *relic has been preserved in Rome since the eighth century and was a popular focus of *pilgrimage especially during the thirteenth and fourteenth centuries. Saint Veronica, or *angels, may be shown displaying the *sudarium;* the image also appears independently, for example, on *icons and pilgrimage badges. See also: *Acheiropoieta,* *Holy Face, *Mandylion.

Example: Christ of Veronica, twelfth century, icon, Moscow, Tretyakov. (*The Icon,* p. 259)

SUPERBIA. See VICES.

SUPPER AT EMMAUS. One of *Christ's appearances after his *Resurrection, the Supper at Emmaus receives a detailed account in *Luke 24. Two of the disciples on their journey from Jerusalem to Emmaus (see: *Road to Emmaus) encountered a stranger to whom they recounted the recent events, the *death and burial of Jesus and the report of his resurrected appearance to a disciple (see: *Noli me tangere). The stranger countered their recital with a narration drawn from Old Testament *prophets. Agreeing to join them for the evening meal at the inn at Emmaus, he blessed and distributed bread to them. At his sharing of food, their "eyes were opened," and the disciples recognized him as Christ, at which point he vanished. They then returned to Jerusalem to tell the news joyfully to the other disciples. The subject receives pictorial treatment as a sequence to the encounter on the road to Emmaus and also as an independent subject distinct in detail but compositionally similar to other scenes such as the *Last Supper and *Marriage at Cana. The three figures are normally shown seated at a table with Christ in the center; *fish and bread may be represented on the table and Christ may be shown breaking and distributing bread to the disciples; sometimes other figures (e.g., the innkeeper, servants) are present; an architectural enframement or interior space may be indicated. The subject appears frequently in manuscript illustration and sculpture from the eleventh century following.

*Example: Supper at Emmaus, Saint Albans Psalter, c.1120–1135, Hildesheim, Saint Godehard, p. 70. (Dodwell, fig. 335)

SUSANNA. The story of Susanna forms an apocryphal addition to the Old Testament book of *Daniel (located as the thirteenth chapter of Daniel in the Vulgate). This short text tells how the chaste and beautiful Susanna (married to the wealthy and honored Joakim and living in Babylon) was falsely accused of adultery by two elders who hid themselves in the garden and surprised her while she was bathing. She refused their advances, and they retaliated by charging her with having committed adultery under a tree with a young man. She was condemned to *death, but her prayers to *God were answered; God inspired the youthful Daniel to question the two elders separately, and when their stories differed (concerning the type of tree under which they had spied Susanna in her alleged act), they were convicted of bearing false witness and were put to death. This story of faith, salvation, answered prayers, and justice is illustrated in early Christian sculpture and catacomb frescoes, sometimes in the symbolic form of a lamb between two wolves or paired with the image of Daniel flanked by lions; the enthroned Daniel judging wisely may also be paired with the *Judgment of Solomon. Illustrations are found through the Gothic period although the image of the partly clothed or nude Susanna in her bath becomes most popular in the postmedieval period.

*Example: History of Susanna, c.865, Lothair Crystal, London, BM. (Swarzenski, fig. 29)

SYLVESTER, SAINT. Sylvester, the bishop of Rome (Pope) from 314 to 335, is a popular figure in legends and the visual arts. Early tales recount that he baptized the emperor *Constantine (a scene frequently illustrated in art), curing the emperor of leprosy (rather than bathing in the blood of 3,000 children, the advice of the emperor's doctors). Other *miracles attributed to Sylvester include: bringing a dead ox or bull that had been killed by a magician back to life; his tying up the jaws of a poisonous dragon; and his curing a man who had choked on a fishbone. Additionally, Sylvester was said to have obtained from Constantine a document that gave him and his papal successors great wealth and power (this ''Donation of Constantine'' was in fact a Carolingian forgery). Scenes from the life of Pope Sylvester appear especially in Romanesque and Gothic frescoes, manuscripts, and stained glass. As an independent figure he is often clothed in papal robes and tiara, accompanied by either a bull or a dragon.

Example: Scenes from the life of Saint Sylvester, mid-thirteenth century, fresco, Rome, Quattro Coronati, Chapel of Saint Sylvester. (Martindale, fig. 135)

SYNAGOGUE. Synagogues are buildings used by Jewish communities for religious gatherings, *prayer, and reading of scripture. In medieval art, the religion of Judaism was often symbolized by the personified female figure of Synagogue, (*Synagoga*) often paired with the personification of the Christian *church (**Ecclesia*) in images of the *Crucifixion. While some few early (e.g., Carolingian) examples present both as equals (or with the old law symbolized by the *prophet *Hosea or a personification of the city of Jerusalem), the triumph of *Ecclesia* over Synagogue is emphasized from the mid-ninth century following. Synagogue is stripped of her authority (crown, globe, sceptre) by *Ecclesia* or depicted in a tattered robe, blindfolded, with a broken lance, torn banner, and with the Tablets of the Law slipping from her grasp. She may also hold a knife and be accompanied by a goat (symbolizing Old Testament sacrifice) or carry the *Instruments of the Passion (signifying responsibility for the *death of Jesus). The antithesis of old and new covenants was explicated in the writings of early Christian theologians such as Saint *Augustine, and the representation of Synagogue in negative pictorial forms is reflective of the growing and pervasive anti-Judaism of the medieval period.

Example: Synagoga, c.1240, Strasbourg Cathedral, formerly south transept jamb figure. (Synder, fig. 543b)

SYNAXARY. See MANUSCRIPTS.

T

TABITHA. Tabitha (or Dorcas) was the name of the woman brought back to life by Saint *Peter in the city of Lydda. The *miracle is described in Acts 9: 36–42 and can be found in art as early as the fourth century (e.g., on sarcophagi). The text recounts the event as taking place within an interior; Tabitha was laid out on a bier, and Peter approached, prayed, and told her to rise. She sat up, took Peter's hand, and he presented her to her mourning friends. The event and image are similar to Jesus' *Raising of Jairus's Daughter, but the episode may be identifiable through its frequent inclusion in cycles narrating events from the life of Saint Peter.

Example: Raising of Tabitha, twelfth century, portal sculpture, Ripoll, Monastery of Santa Maria. (Künstler, fig. 79)

TABLETS OF THE LAW. See MOSES.

TAMBOURINE. See MUSICAL INSTRUMENTS, SYMBOLISM OF.

TAURUS. See ZODIAC.

TEMPERANCE. See VIRTUES.

TEMPTATION OF SAINT ANTHONY. See ANTHONY, SAINT.

TEMPTATION OF CHRIST. As recounted in the Gospels of *Matthew (4: 1–11) and *Luke (4:1–13) and mentioned in *Mark (1:12–13), after Jesus' *Baptism, he spent a period of forty days fasting and praying in the wilderness, at the end of which time the *Devil appeared to test and tempt him with offers of extraordinary riches and power. The three specific temptations are ordered slightly differently in Matthew and Luke; the Devil demanded that Jesus prove

his sonship to *God by turning stones into bread; next, he transported Jesus to the pinnacle of the Temple in Jerusalem and demanded that he test God by jumping off to see if *angels would save him; finally, he took Jesus up on a high mountain and offered him power over the kingdoms of the world if Jesus would worship him. In each case, Jesus quoted Old Testament passages and resisted the Devil, and after the Devil departed, angels appeared and ministered to Jesus. The subject seems not to appear in medieval art before the ninth century but is then found in Insular, Carolingian and Byzantine manuscripts and ivories and in Romanesque and Gothic manuscripts, frescoes, and sculpture. Sometimes all three temptations are represented simultaneously or in a continuous narrative: Jesus and the Devil are shown on a mountaintop, on top of an architectural structure, and gesturing toward a pile of stones. Cups, bowls, jewelry or other objects symbolizing worldly wealth may be included, as well as angels. The Devil may be disguised as a man, or, more commonly, is recognized by his demonic appearance (claws, wings, horns, beak, black coloring, hairy and grotesque features). A tree may be shown, perhaps as a reference to the original temptation in the *Garden of Eden (see also: *Tree of the Knowledge of Good and Evil) and the failure of *Adam and Eve to resist temptation, in contrast to Jesus.

Example: First Temptation of Christ, c.1150, fresco, Brinay-sur-Cher, Saint-Aignan, choir, south wall. (Demus, fig. 154)

TEMPTATION OF MAN. See ADAM AND EVE.

TEN COMMANDMENTS. See MOSES.

TETRAMORPHS. Based on complex visions in *Ezekiel 1 and 10 and Revelation 4, the *Tetramorphs* are the "four living creatures" with multiple wings, full of eyes, who appear in a whirlwind with radiant or flaming wheels and *angels. They also have the appearance of a lion, ox, man, and eagle. They are represented in art with appropriate human or animal heads, with wings, many eyes, rings or wheels, and flames. They appear especially in scenes illustrating Ezekiel and the *Apocalypse, the *Last Judgment, *Ascension of Christ, and *Majestas Domini.* The lion, ox, man, and eagle become the symbols of the *Four Evangelists.

Example: Ascension, sixth century, fresco, Bawit, Monastery of Apollo, apse. (Synder, fig. 104)

THECLA. Although Thecla died peacefully, she is considered to be the first female Christian martyr. Her story, told in the late second-century apocryphal *Acts of Paul and Thecla,* is represented in art from at least the fifth century onward. A young woman of Iconium (Phrygia), she was converted to Christianity by Saint *Paul, resolved to remain chaste, and accompanied Paul on several of his missionary journeys. She suffered various tortures, including an

unsuccessful attempt to burn her, after which she was thrown into an arena with lions and other wild beasts that refused to harm her. She was eventually set free, went about *preaching, and lived to an advanced age when finally, to escape further tormentors, she prayed and a rock opened up to enclose her. She is frequently seen in art as an *orant figure, flanked by lions, or tied to a burning stake. She can be found in both western and Byzantine art (metalwork, frescoes, mosaics, manuscripts) through the Gothic period.

 Example: Saint Thecla with Lions, c.475, silver reliquary casket, Adana Museum. (Gough, fig. 130)

THEODORE, SAINT. His legends recount that Theodore (d. c.306) was a soldier in the Roman army (in the Black Sea area) who refused to worship pagan *idols, set fire to a pagan temple, was put on trial, tortured, and eventually martyred by being burned to *death in a furnace. One of the most popular Byzantine soldier-saints, he was also widely venerated in the west. By the tenth century, additions to his life story had become so complicated that two Saints Theodore were venerated: *Theodore Tiro,* the recruit (who is shown in art as a simple soldier), and *Theodore Stratelates,* the general (who is often more dramatically presented, riding on horseback, with a lance or spear). Sometimes the two Theodores are depicted together. Theodore often accompanies Saint *George on Byzantine *icons. He appears in mosaics, manuscripts, ivories, frescoes, and sculpture from the sixth century onward. Scenes from his life and *martyrdom can be found in stained glass at Chartres Cathedral and in the mosaics of San Marco, Venice (both places where his *relics were translated).

 Example: Saint George and Saint Theodore on Horseback, 1250–1300, icon, Mount Sinai, Monastery of Saint Catherine. (*The Icon,* p. 220)

THEOPHANY. *Theophany* means the ''manifestation of *God.'' It refers, in the Old Testament, to the appearances of God, especially to the *prophets and *patriarchs, in various temporary, visible forms—whether anthropomorphic or in other guises (e.g., the burning bush from which God spoke to *Moses). In Christian doctrine, the incarnation of Jesus *Christ (with his dual nature: human and divine) is understood to be the manifestation of God on earth. Artistic representations vary according to the context; for example, see: *Apocalypse, *Majestas Domini,* *Trinity.

THEOPHILUS. Author of an important handbook on art techniques, *De diversis artibus* (c.1126), Theophilis may be the pseudonym of the German Benedictine metalworker Roger of Helmarshausen. His ''how to'' manual describes all the arts required in an ecclesiastic/monastic context (e.g., painting, metalwork, stained glass) and provides much technological and practical information. The text gives excellent evidence of the techniques known to and materials used by well-informed medieval artisans of the early twelfth century.

THEOPHILUS, LEGEND OF. The tale of the greedy and ambitious vicar Theophilus is one of several hundred accounts of *miracles performed by the Virgin *Mary that were extremely popular in medieval art and literature. Known by the eighth century, the story was used in sermons in the eleventh and twelfth centuries, included in collections of miracle tales, and became a popular mystery play of the thirteenth century. Depictions of the tale may be found especially in Romanesque and Gothic sculpture and stained glass. A forerunner of the later Faust, Theophilus sold his *soul to the *Devil and denied *Christ and the Virgin in return for power and wealth. The contract was made on a piece of parchment that Theophilus signed and the Devil took away. Theophilus eventually repented and prayed to the Virgin, who finally appeared to him in a dream and pardoned him. He awoke to discover the parchment in his hand, publicly confessed his sins to the bishop and, not much later, he died, after distributing his goods to the poor. The popularity of the Theophilus legend is reflective also of the growing devotion to the Virgin in the High Middle Ages.

Example: The Story of Theophilus, c.1130, Souillac, Church of Sainte Marie, relief. (Synder, fig. 336)

THEOTOKOS. *Theotokos* is a Greek term meaning the "Bearer of *God." It was the official title given to the Virgin *Mary at the Council of Ephesus in 431, emphasizing *Christ's dual nature (human and divine) and Mary's significance in the incarnation of the deity. The Latin equivalent is *Dei Genitrix* ("Mother of God"). Not a single iconographic type in art, Mary appears as *Theotokos* in various forms and pictorial narratives; see also: *Madonna and Child.

THIEVES ON THE CROSS. All four Gospels recount that Jesus was crucified along with two other men who were "thieves" or "criminals." *Luke (23:39–43) recounts a conversation that ensued when one of the thieves affirmed Jesus' innocence but acknowledged their guilt and asked Jesus to "remember him." The apocryphal *Acts of Pilate* supplied names for the thieves: the "good" (or repentant) Dysmas and the "bad" Gestas and further described how Dysmas was later rescued by *Christ from *hell (see: *Anastasis). Later legends also connected these men with the bandits who had accosted the *Holy Family on their *Flight into Egypt. The two thieves appear in the earliest images of the *Crucifixion from the fifth century and frequently thereafter. The good thief is normally located on Jesus' right. They are often depicted as slightly smaller than Jesus, or placed a bit below him compositionally. They may also be further differentiated by being shown as tied rather than nailed to their crosses. An *angel may hover over the good thief and a *demon over the bad.

Example: Crucifixion, Sacramentary, c.975, Göttingen, UL, Cod. theol. fol. 231, f. 60. (Robb, fig. 75)

THOMAS, SAINT. Thomas, also called Didymus (twin), was one of the twelve *apostles. He is popularly known as "Doubting Thomas" because of his prag-

matic disbelief in (1) the *Resurrection of *Christ and (2) the *Assumption of the Virgin *Mary. In both cases (the former canonical, the latter from apocryphal sources), Thomas was not present when Christ first appeared after his *death and when the Virgin ascended to *heaven. Thomas needed to be personally convinced of these events, which proof Christ effected by prompting Thomas to touch the wound in his side and which the Virgin offered by throwing down her belt from heaven. The former story (from *John 20:19–29) was especially popular in medieval art; Thomas the skeptic stands before Christ, who displays his wounds and encourages or even guides Thomas in the convincing physical contact.

Apocryphal tales concerning Thomas, illustrated especially in the Gothic period, recount his travels to and missionary work in India. One legend describes how he was commissioned by King Gundaphorus to construct a palace, received payment in advance, and gave the money to the poor. He then told the king that the palace had been built in heaven, which event was attested by the king's dead brother, who miraculously returned to life. Thomas is thus the patron of architects and can be identified in art by his attribute: the architect's T-square. Additional legends tell that he was martyred near Madras in India by being stabbed with lances.

Example: Doubting Thomas, early eleventh century, ivory, Berlin, SM. (Synder, fig. 297)

THOMAS AQUINAS, SAINT. The Dominican theologian and philosopher Thomas Aquinas (c.1225–1274) exerted a profound influence on the development of medieval theology. His copious and comprehensive works (treatises, commentaries, hymns) earned him great fame as a ''universal teacher'' and became established foundations in the medieval university curriculum (although not without inspiring controversy as well). Educated at Monte Cassino and Naples, he joined the Dominican Order in 1244, studied with Albertus Magnus in Paris, was ordained a priest in Cologne, appointed Master of Theology at the University of Paris in 1256, taught in several Italian cities as well as in Paris, and established a Dominican school in Naples in 1272.

His studies of *Aristotle shaped much of his own systematic thinking; foremost among his many important works are his *Summa theologica* (begun c.1266 and unfinished at his *death; a five-volume exposition of Christian doctrine) and the *Summa contra gentiles* (1259–1264, a reasoned defense of the Christian faith). He wrote commentaries on *Peter Lombard, Aristotle, *Boethius, Dionysius the Aeropagite, and several books of scripture (including *Isaiah, *Jeremiah, *Job, the Psalms, and the Gospels), and composed hymns for the feast of *Corpus Christi.

Saint Thomas is represented in art as a large man in black and white Dominican robes, holding a book, or with a star on his breast (the shining star seen by his mother before his birth). He may also be shown with a dove, symbolizing the *Holy Spirit, the source of his *wisdom. Scenes from his life are found

especially in fourteenth-century Italian panel painting, including illustrations of Thomas at *prayer and the episode of his unsuccessful temptation by a woman brought to him by his brothers who thought him too devoted to his studies. He is otherwise and most frequently represented as a teacher, sometimes also enthroned, with philosophers at his feet.

Example: Thomas Aquinas Teaching, Hours of Etienne Chevalier, c.1450, Chantilly, Musée Condé. (Porcher, fig. 81)

THOMAS BECKET, SAINT. The rich iconography of Thomas Becket (1118–1170) developed immediately after his *martyrdom in the cathedral of Canterbury in 1170 and his canonization in 1173. A clerk, deacon, and archdeacon of Canterbury, he was appointed Chancellor of England by King Henry II in 1155 and in 1162 was (unwillingly) appointed Archbishop of Canterbury by Henry II. Although a former loyal courtier with a taste for luxury and a close friend of the king, he unexpectedly became a loyal ecclesiastic after his priestly ordination the day before his episcopal consecration. Defender of ecclesiastical independence, the new archbishop repeatedly came into conflict with the king, especially over the question of royal versus ecclesiastical law. He went into exile in France (1164–1170), was protected by the French king, Louis VII, sought support from Pope Alexander III, and eventually was allowed to return to England, where his actions again angered the king. Enraged, Henry exclaimed his desire to be rid of the "turbulent priest." Three or four of his courtiers interpreted his words literally, traveled to Canterbury, and attacked and murdered Becket as he was kneeling before the altar in his own cathedral. Becket's martyrdom shocked the Christian world and forced Henry to perform public penance in 1174. Becket's fame spread rapidly; numerous *miracles were immediately reported at his tomb (over 700 in the first ten years). Becket's *relics were enshrined in a prominent chapel in the cathedral in 1220, and Canterbury became an immensely popular *pilgrimage site from the late twelfth century onward (see also: *Chaucer).

Becket appears in art throughout Europe from the late twelfth century, and in a vast variety of media. As a single figure, he may be dressed in episcopal robes, wearing a mitre, and holding a *cross staff and book. Pilgrimage badges and *ampullae* from his shrine may also show him on horseback. The image of simply his mitred head was also popular. Some examples also show Becket with a cleft or sword in his head. Literary compositions detailing the life, deeds, martyrdom, and posthumous miracles of Becket also inspired abundant artistic production especially from the thirteenth century onward. Cycles appear in manuscripts, frescoes, stained glass, sculpture, and metalwork. The illustration of his martyrdom was overwhelmingly popular, although extended narratives include events from his birth, court life, consecration, travels, conflicts and conversations with kings and the pope, and numerous miracles (including many episodes of healing, visions, and *exorcisms reported at his tomb).

Example: Martyrdom and Apotheosis of Becket, c.1185–1200, fresco, Santa Maria de Tarrasa, south transept, apse. (Dodwell, fig. 266)

THREE LIVING AND THREE DEAD. One of several themes concerning the inevitability of *death, especially popular in the later Gothic period, the tale of the Three Living and the Three Dead was developed in French poetry of the thirteenth century and enjoyed a widespread literary and artistic dissemination in manuscript illustration, wall painting, and woodblock prints. The salient episode most frequently illustrated in art involves the encounter between three living men (frequently dressed as youthful aristocrats, often on horseback) and three skeletons or corpses in varying stages of decay. The skeletons speak to the living and announce, ''What you are, we once were. What we are, you will become.'' The shock of this surprising and sobering encounter may also be registered by the horses who back away from the skeletons, and the youths' falcons or hunting dogs, who flutter or run away. Although the number of living and dead figures may vary, three of each are most common (perhaps because of an association with the three kings of the New Testament, also on horseback, frequently crowned; see: *Adoration of the Magi). For related imagery, see: *Dance of Death, *Triumph of Death.

Example: Three Living and Three Dead, Psalter of Robert de Lisle, c.1325–1330, London, BL, Arundel MS 83, f. 127. (Robb, fig. 173)

THREE MARYS AT THE TOMB. All four Gospels recount that the first people to receive the news of *Christ's *Resurrection were several women who went to his tomb early in the morning on the third day after his *Entombment, bringing oils and spices to anoint the body. They found the tomb unsealed and the body missing. The Gospel accounts vary as to the number and identities of these women and the events surrounding the discovery of the empty tomb. *Matthew (28:1–8) records their conversation with an *angel who rolled away the stone from the door of the tomb. *Mark (16:1–8) identifies them as *Mary Magdalene, Mary (the mother of Saint *James), and Salome and describes their conversation with a young man clothed in white who was sitting within the tomb. *Luke (24:1–12) states that two men in shining garments spoke to the women when they entered the tomb. *John (20:1–18) describes Mary Magdalene's visit to the tomb, her summoning of two *apostles (Saints *Peter and *John), and her later conversation with two angels before Christ's appearance to her (see: *Noli me tangere). The Three Marys are commonly understood to be Mary Magdalene, Mary Salome, and Mary Cleophas (Clophas), the companions of the Virgin *Mary, who were all present at Christ's *Crucifixion. The divergences in the Gospel accounts are reflected in the different ways in which the story is depicted in art. The subject appears in Christian art as early as the third century and remained popular throughout the Middle Ages. Two or three women and one or two angels (or men) are shown in conversation by an architectural structure (the *Holy Sepulchre), cave, or an empty sarcophagus with the lid removed. The women may carry jars of ointment (they are also known as the *myrophores*—bearers of myrrh); the linen cloths in which Christ's body were wrapped may be shown on the tomb slab or dangling over the sarcophagus. Sometimes the sleeping soldiers (tomb guards) are also present. The scene was

among the most common ways of representing Christ's Resurrection before the later medieval period.

Example: Three Marys at the Tomb, Ingeborg Psalter, c.1200, Chantilly, Musée Condé, MS 1695, f. 28v. (Robb, cp. XXIII)

THREE THEOLOGICAL VIRTUES. See VIRTUES.

THRONE OF WISDOM. See SEDES SAPIENTIAE.

THRONES. See ANGELS.

TIMBREL. See MUSICAL INSTRUMENTS, SYMBOLISM OF.

TIMOTHY, SAINT. Timothy (d. c.97) became a disciple and companion of Saint *Paul (Acts 16:1–5) on several missionary journeys and was the recipient of two letters (epistles) from Saint Paul. According to the historian Eusebius, Timothy was appointed the first bishop of Ephesus. The fourth-century apocryphal *Acts of Timothy* recounts his *martyrdom (he was clubbed and stoned to *death) because of his opposition to pagan cults and festivals. His *relics were translated to a shrine in Constantinople in the mid-fourth century, and several *miracles of healing were recorded. He may be represented in art holding the martyrs' palm branch, stones or a club, receiving epistles from Saint Paul, or present at the *Dormition of the Virgin.

Example: Saint Timothy, c.1145–1150, stained glass, Paris, Musée de Cluny. (Grodecki, fig. 2)

TOBIAS. Tobias was the son of *Tobit and features in the Old Testament apocryphal book of Tobit as the dutiful son who brought about the restoration of health and prosperity to his despairing family. The archangel *Raphael (disguised as a relative) guided Tobias and his dog on a journey to collect a debt and instructed Tobias to save the liver, heart, and gall from a huge *fish that attacked the youth from the Tigris River. Tobias exorcised a *demon by burning the heart and liver of the fish and successfully married his relative Sarah (whose previous seven husbands had been killed by the demon on their wedding nights). Tobias returned to his parents with his wife and cured his father's blindness with the gall from the fish. These subjects appear in early Christian sculpture and frequently in Romanesque and Gothic manuscript illustration and architectural sculpture.

Example: The Departure of Tobias, Bible, c.1170–1180, Clermont-Ferrand, BM, MS 1, f. 203. (Porcher, pl. XXXVII)

TOBIT. The Old Testament apocryphal book of Tobit has provided engaging subject matter for art from the early Christian period onward. The pious and charitable Tobit was a Jewish captive of the Assyrians in Nineveh; he dutifully

persisted in burying the bodies of dead *Jews and followed the ritual of sleeping outdoors after these burials, but one night he was blinded by droppings from sparrows in the trees above. Unable to work, eventually reduced to poverty, despairing and wishing to die, he even unjustly accused his wife, Anna, of stealing a goat from her employer. Tobit was later assisted by *God, who sent the archangel *Raphael (disguised as one of Tobit's relatives) to accompany Tobit's son *Tobias on a journey to another relative from whom he collected a debt and returned to cure his father's blindness, as per the angel's instructions, with the gall of a *fish. These stories of faith and miraculous intervention appear in early Christian sculpture and in illustrated manuscripts and sculpture through the Romanesque and Gothic period.

Example: Tobit Scenes, Florence Cathedral Bible, c.1100–1125, Florence, BML, MS Edili 126, f. 73. (Cahn, fig. 111)

TOWER OF BABEL. Described in Genesis 11:1–9, the descendants of *Noah, who all spoke the same language, presumptuously decided to build a city for themselves and a tower reaching up to *heaven on a plain in Babylon. In extrascriptural tradition, Nimrod is sometimes credited with inspiring this act. In punishment for their pride, *God caused them all to speak in different languages. Unable to communicate, they left the tower and city unfinished and were scattered abroad. The tale, held to explain the diversity of human language, also comments on human pride and prefigures the speaking in tongues at *Pentecost. Ziggurats (stepped pyramids) are often cited as architectural background for the story, and archaeological remains of ziggurats exist in the vicinity of the ancient city of Babylon. The Tower of Babel is represented in art as a partially constructed edifice, either abandoned or being built by a crowd of workers observed by God.

Example: The Building of the Tower of Babel, c.1100, fresco, Saint-Savin-sur-Gartempe, nave vault. (Dodwell, fig. 229)

TRADITIO LEGIS. The *Traditio legis* ("giving of the law") is a symbolic motif of theological and political significance frequently found in early Christian art. It refers to the image of *Christ delivering the New Law, ushering in the new Christian era to supplant the laws of the Old Testament. The concept is pictorialized primarily in compositions depicting Christ seated or standing, handing a scroll or book to Saint *Peter, in the presence of Saint *Paul. These two *apostles flank Christ. Additional figures may be present, and the theme may also symbolize the *Mission of the Apostles, as well as the *Dominus legem dat Petro* ("the Lord gives the law to Peter"). The sources for this image may derive from the giving of the law to *Moses on *Mount Sinai and have also been traced to Roman imperial iconography: images of emperors distributing largesse, receiving bounty, sitting in judgment, or distributing aid, instructions or awards to approaching figures. In early Christian sculpture and mosaics,

Christ may also be shown standing on the mountain of paradise, atop a world globe, or treading on an allegorical figure representing the universe.

Example: Traditio legis, c.359, Sarcophagus of Junius Bassus, detail, Rome, Vatican. (Snyder, fig. 14)

TRANSFIGURATION OF CHRIST. The Transfiguration of *Christ is an event described in the Gospels of *Matthew (17:1–9), *Mark (9:2–9), and *Luke (9:28–36). The three texts diverge slightly in detail, although all writers recount that Jesus took *Peter, *James, and *John up to a high mountain and the three witnessed him glorified with shining light, conversing with *Moses and *Elijah. A bright cloud appeared from which *God spoke, declaring Jesus to be his son. All three Gospels describe the *apostles as filled with awe and fear; Luke states that they were sleepy; Matthew recounts that they fell down and hid their faces in fright. This dramatic moment is often illustrated in art, with some variations in presentation. In early Christian mosaics, Jesus appears with a cruciform *halo in a mandorla, radiating beams of light; Moses and Elijah stand on the same level gesturing toward Christ, and the three apostles kneel or sprawl on the ground below. An interesting symbolic variant in the mid-sixth-century apse mosaic of Sant' Apollinare in Classe, Ravenna, shows Saint Apollinarus in *orant pose beneath a great jeweled *cross within a circle; half-length figures of Moses and Elijah float in the clouds beside the cross, and the apostles are represented by three sheep. The more traditional type appears in Ottonian, Romanesque, and Gothic manuscripts and in Gothic portal sculpture. In Byzantine manuscripts and *icons, the full-length figures of Jesus, Moses, and Elijah may each perch on separate mountain peaks, and the radiating beams of light and responses of the witnessing apostles may be emphasized dramatically. The Transfiguration is one of the twelve major feasts of the Byzantine church and, hence, icons of the scene are frequently found on the *iconostasis. It was a subject to which many Byzantine writers devoted attention (e.g., *John of Damascus, *John Chrysostom). It was understood to be a prefiguration of the second coming of Christ at the *Last Judgment, with Moses and Elijah representing the fulfillment of law and prophecy. The location of the event is traditionally Mount Tabor, where Saint *Helena later built a church in c.326.

Example: The Transfiguration, c.550–565, mosaic, Mount Sinai, Monastery of Saint Catherine, apse. (Synder, fig. 151)

TREE OF JESSE. An image of great frequency in western medieval art, especially of the Romanesque and Gothic periods, the Tree of Jesse can be seen in manuscript illumination, stained glass windows, and sculpture. The subject was inspired by the prophecy of *Isaiah (11:1–3) that a Messiah would come from the family of the *patriarch Jesse, the father of *David. Early Christian writers such as Tertullian and Saint *Jerome and medieval authors such as Saint *Bernard of Clairvaux interpreted the prophecy to apply to *Christ: the root or stem *(radix)* refers to Jesse, the rod or shoot *(virga)* refers to the Virgin *Mary,

and the fruit or flower (*flos*) of the shoot refers to Christ. Hence, the Tree of Jesse was seen as an allegorical interpretation of the royal genealogy of Christ.

Translated into visual form, the Tree of Jesse appears in several variants ranging in complexity and emphasis. Jesse may be shown alone, reclining, sleeping or dead, with a flowering tree growing from his body. Often, seven doves hover above or alight upon the branches of the tree; the doves symbolize the *Seven Gifts of the Holy Spirit from Isaiah's prophecy. The Virgin Mary may feature as the most prominent element, enthroned in or standing as the central stem of the tree. More elaborate versions of this motif expand the number of branches springing from the stem and include depictions of numerous other *Ancestors of Christ plus additional allegorical figures; the central lineage still traced upward through the figures of Jesse, David, and the Virgin Mary to Christ. Jesse trees are frequently found in sculpture in the portal archivolts of Gothic cathedrals. See also: *Holy Kinship.

Example: Tree of Jesse, c.1145–1155, stained glass, Chartres Cathedral, west front. (Dodwell, fig. 381)

TREE OF THE KNOWLEDGE OF GOOD AND EVIL. The Tree of the Knowledge of Good and Evil is described in the narratives of Genesis 2–3. It was located in the *Garden of Eden and was, among all the other beautiful and fruit-bearing trees, specifically singled out by *God to be avoided by *Adam and Eve. God had directed Adam not to eat the fruit of this tree because it would cause Adam's *death (Genesis 2:17). A crafty serpent however, suggested to Eve that knowledge rather than death would result from eating this forbidden fruit (Genesis 3:1–5). The subsequent disobedience of both Adam and Eve in eating this fruit caused their expulsion from paradise.

Because Adam and Eve are described (Genesis 3:7) as covering their nakedness (of which they first became aware after eating the forbidden fruit) with aprons sewn of fig leaves, the Tree of the Knowledge of Good and Evil may be represented as a fig tree, although it is more often rather unrecognizably stylized. As the Latin term for "evil" (*malum*) also means "apple," this tree may also be shown as an apple tree. (See also: *Fruit and Trees, Symbolism of.)

It features in illustrations from the early Christian through late Gothic period in scenes of the temptation and fall of humankind, often centrally located, flanked by the standing or seated figures of Adam and Eve. A serpent may be shown twining itself around the base of the tree or winding through the branches, sometimes holding the forbidden fruit in its jaws. A little *demon or dragonlike form may also assist or play the role of the serpent, handing the fruit to Eve, who eats and offers fruit to Adam. Later medieval representations will show the serpent with a female face or as a half-lizard, half-female form. When not engaged with eating the fruit, Adam and Eve may stand to either side of the tree covering themselves with leaves.

Legends of the *True Cross also suggest that the *cross upon which *Christ

was crucified was created of wood ultimately derived from a shoot or branch of this tree. Typologically then, the sins of Adam associated with this tree are redeemed by Christ's later sacrifice on the same tree.

Example: Fall of Adam and Eve, Saint Albans Psalter, c.1120–1135, Hildesheim, Saint Godehard, p. 9. (Snyder, fig. 374)

TREE OF LIFE. In the description of the *Garden of Eden in Genesis 2:9, two special trees are mentioned: the Tree of Life and the *Tree of the Knowledge of Good and Evil (*God specifically forbade *Adam and Eve to eat fruit from the latter tree). Paradisical life-giving trees are described in a vision of *Ezekiel (47:12) and in Rev. 22:2 as a feature associated with the *Heavenly Jerusalem. The connection between the *cross upon which Jesus was crucified with the Tree of Life was worked out by medieval theologians and mystics (notably Saint *Bonaventura) and amplified as well as confused by the popular legends of the *True Cross. Although a number of early images of the *Crucifixion depict the cross as a tree with lopped-off branches or stumps, the full-blown imagery of the cross with flowers, fruit, tendrils, and leafy branches develops largely in the twelfth century and is found often in later medieval examples. The image maintains the standard Crucifixion elements: Christ is shown on the cross, the Virgin *Mary, Saint *John, and other figures are often present; however the cross itself seems to be sprouting and growing—giving life through the *death of Jesus. Symbolic doves and grapes may be found among the branches and a pelican may perch on top. (See: *Animals, *Birds, *Flowers, *Fruit and Trees, Symbolism of.) Later fourteenth-century expanded compositions may include figure- or bust-filled roundels of *prophets and *ancestors (combining the Crucifixion with the *Tree of Jesse) or various other typological figures.

Example: Crucifixion, Psalter and Hours of Yolande de Soissons, c.1275, New York, PML, MS 729, f. 345v. (Robb, fig. 159)

TRIALS OF CHRIST. Following the *Agony in the Garden, *Betrayal, and *Arrest of Christ, the Gospels, with some variation in detail, describe that Jesus was first brought before the Jewish high court (the Sanhedrin) where he was questioned by the high priest *Caiaphas (perhaps in a formal procedure, or perhaps not). When Jesus did not deny that he was the Messiah, Caiaphas accused him of blasphemy and sentenced him to *death. This scene is less often illustrated than Jesus' later questioning under Roman authority, though examples can be found in early Christian and medieval art where the scene is often combined with the denial of *Peter, trial by *Pontius Pilate, *Mocking, and *Crucifixion. One, two, or three priests may be shown (*John 18:13 mentions Annas, the father-in-law of Caiaphas). Jesus stands before them, often surrounded and gripped by several figures; the seated Caiaphas tears his own garments in indignation.

Jesus was then taken to the Roman procurator, Pontius Pilate, who questioned

Jesus and his accusers extensively. Pilate was at first unwilling to condemn Jesus; *Luke 23:7–12 recounts that Pilate sent Jesus to *Herod, who was similarly unwilling to pass such a judgment. Pilate then offered to free a criminal and asked the populace to choose between Jesus and the condemned murderer Barabbas. Barabbas was chosen and set free; Jesus was sentenced to death, and Pilate symbolically washed his hands to signify his lack of responsibility. Depictions of these events are found in art from the fourth century onward, and most often include the motif of the seated Pilate washing his hands in a basin held by an attendant. Jesus stands before him or is shown already being led away to *Calvary. Pilate may be shown turning away from Jesus or thoughtfully watching him as he departs. Sometimes the hand-washing motif is omitted, and the seated Pilate gestures in speech toward Jesus, who is standing among his accusers. Pilate's wife may watch the scene, and a *demon may be shown next to Pilate. The image of Pilate presenting Jesus to the people *(*Ecce homo)* is found especially in later medieval art.

Example: Christ before Pilate, Rossano Gospels, sixth century, Rossano, Archepiscopal Treasury, f. 8v. (Synder, fig. 100)

TRINITY. The doctrine of the Trinity of God as three distinct "persons" sharing a common nature: *God the Father, *Christ the Son, and the *Holy Spirit (*Matthew 25: 19) was developed in the early Christian period and formed a topic of discussion and refinement through the Middle Ages, especially for authors such as Saints *Augustine, *Gregory the Great, and *Thomas Aquinas. The relationship of the three persons of the Trinity was also an issue of major dispute between the western and Byzantine churches and resulted (with other causes) in their formal separation in the eleventh century.

The pictorialization of this fundamental Christian dogma was handled in a variety of symbolic images and compositions. The earliest examples show experimentation with a number of formulae: early sarcophagi may show three men, three sheep (or lambs; see also: *Agnus Dei*), or a combination of symbolic devices such as the hand of God, the dove of the Holy Spirit, and a cross-bearing lamb (all of which appear separately or combined in other media as well.) The early fifth-century mosaics of Santa Maria Maggiore imply the Trinity as the Throne of God upon which is placed a *cross and triumphal wreath; the dove is also included in later western and Byzantine examples.

Christian theologians saw a prefiguration of the Trinity in the three heavenly visitors (or *angels) whom *Abraham hosted; hence, illustrations of this scene may give *haloes to the three men, or one of the visitors will be shown enclosed in a mandorla. This "Old Testament Trinity" (of three seated, identical figures) provided inspiration for some later medieval and Byzantine representations. However, the distinction between the three different aspects of the Trinity is also early represented in scenes of the *Baptism of Jesus where, in examples from at least the sixth century onward, both the hand of God and the dove of the Holy Spirit will hover over Jesus.

The pictorial themes and symbols developed in the early Christian period were retained, modified, and transformed during the Middle Ages. The Trinity may be shown as two seated men with cruciform haloes, who may hold books inscribed with the Greek letters *alpha* and *omega* (the beginning and the end); each man may hold up a hand in *benediction, and a dove may hover above or between them. In Gothic manuscripts and sculpture, the Trinity (as two figures and the dove) may be shown in scenes of the *Coronation of the Virgin, and, in scenes of the *Crucifixion from the twelfth century onward, the Trinity may be indicated by the figure of God the Father standing or seated behind and supporting the *cross while the dove hovers overhead. This image, known as the ''Throne of Grace,'' also became a popular subject for free-standing devotional sculptures, especially in the later medieval period. (See also: *Quinity.)

Example: Andrei Rublev, *Old Testament Trinity,* early fifteenth century, icon, Moscow, Tretyakov. (*The Icon,* p. 270)

TRIUMPH OF DEATH. Various scenes illustrating the power and inevitability of *death became popular in western art of the later medieval period, especially during and following the mid-fourteenth-century devastation of the bubonic plague (Black Death). Although images of death and the illustration of literary themes (such as the tale of the *Three Living and the Three Dead) occur earlier in art, large-scale and macabre compositions emphasizing widespread destruction, often presided over by a scythe-bearing skeleton trampling corpses under the wheels of a chariot, are found primarily in later medieval art. The imagery was also developed in sermons and by medieval commentators and mystics who emphasized, as well, the fearful *Last Judgment. Hence, *demons spiriting away the *souls of the damned to *hell or battling with *angels may be included in these scenes. For related themes and imagery, see also: *Ars moriendi,* *Dance of Death.

Example: Francesco Traini, *Triumph of Death,* mid-fourteenth century, fresco, Pisa, Campo Santo. (Snyder, fig. 603)

TROPER. See MANUSCRIPTS.

TRUE CROSS. Jesus was crucified with two other men (see: *Crucifixion, *Thieves on the Cross). The *cross upon which Jesus was crucified came to be known as the True Cross. The first reports of the discovery of this important *relic in Jerusalem date from the mid-fourth century, rapidly evolved into detailed accounts (e.g., the fifth-century apocryphal *Acts of Judas Cyriacus*), and were further elaborated in works such as the *Golden Legend,* which traced the origins of the True Cross back to a shoot or branch from the *Garden of Eden acquired by *Adam's son Seth. (See: *Tree of the Knowledge of Good and Evil; *Tree of Life.) This wood was later used by *Moses to set up the brazen serpent and even later became a bridge over a stream near Jerusalem. The *Queen of Sheba, alerted by a vision en route to visit *Solomon, recognized

the future significance of this wooden bridge. Eventually, the wood was taken from the healing pool of Bethesda in order to form the cross for *Christ's crucifixion.

The discovery (or "invention," from Latin *invenio,* "to find") of the True Cross in 326 was attributed to Saint *Helena by Saint *Ambrose. Hence, Helena plays a primary role in the pictorial narratives of the story. Alerted by an *angel to undertake a *pilgrimage to Jerusalem, Helena questioned the *Jews and ordered the torture of one Judas who, after being thrown into a dry well for seven days, revealed where the three crosses had been buried. All three crosses were excavated, but the True Cross was proven when it alone revived a dead youth (or a dying woman). The cross was enshrined in the church of the *Holy Sepulchre (founded by Helena), later stolen by the Persians in 615, but returned to Jerusalem by the Byzantine emperor *Heraclius in 630 (see also: *Exaltation of the Cross). Pieces of the True Cross were among the most sought after and the most abundant of medieval relics.

Example: Scenes from the Story of the True Cross, c.1154, *Stavelot Triptych,* New York, PML. (Synder, cp. 54)

TRUMPET. See MUSICAL INSTRUMENTS, SYMBOLISM OF.

TWELVE MONTHS. See LABORS OF THE MONTHS; ZODIAC.

TWENTY-FOUR ELDERS OF THE APOCALYPSE. Mentioned several times in the book of Revelation, the Twenty-four elders appear in Saint *John's vision seated around the throne of *God, wearing white garments and golden crowns and accompanying the *angels and four beasts of the *Apocalypse who praise and worship God. The elders carry harps and golden vessels of incense which are described as containing the prayers of *saints. John communicated with the elders several times; he asked questions, and they offered explanations. The elders can be understood as symbolizing the twelve *prophets or *patriarchs of the Old Testament with the twelve *apostles of the New Testament. They appear in all art media (manuscripts, wall paintings, sculpture, and textiles) which illustrate the Apocalypse and may be depicted as lively, gesturing figures or as more static and iconic.

Example: Majestas Domini, c.1115–1130, Moissac, Saint Pierre, tympanum. (Synder, fig. 332)

TWINS. See ZODIAC.

TYPOLOGY. Typology, a method employed extensively by early Christian and medieval theologians, recognizes concordances between events described especially, but not exclusively, in the Old and New Testaments. Typological method posits that events (*types,* from Greek: *tupos,* "mold") from the Old Testament can be seen to prefigure occurences *(antitypes)* in the New Testament. Old Tes-

tament figures and episodes were understood as foreshadowings of events to come, or to be completed, in the New Testament. These linkages served to underscore the Christian belief in the redemption of humankind through *Christ; such typological method holds that the New Testament is a fulfillment of the Old.

Early Christian authors (such as Saint *Augustine) and other early medieval theologians (such as *Isidore of Seville) energetically elaborated the concept of typology in their writings, providing the foundation for much continued discussion and connection making by numerous other writers (e.g., see: *Vincent of Beauvais, *Rupert of Deutz).

Typological schemes were exceedingly popular in medieval art, both in large- and small-scale media. Illustrated manuscripts (such as the *Bible moralisée, *Biblia pauperum, and *Speculum humanae salvationis) are based on typological interpretations, with pictures from the Old Testament paired with New Testament scenes and explained in captions. For example, the brazen serpent which *Moses erected prefigures the *Crucifixion; Christ is the "New *Adam;" the Virgin *Mary is the "New Eve"; Christ's *Resurrection is prefigured by *Jonah's disgorgement from the whale; *Abraham's near-sacrifice of his son *Isaac is fulfilled and completed by the sacrifice of Christ. Typology is also applied in hagiography, in which events in *saints' lives frequently mirror episodes in both the Old and New Testaments. The sacraments (see: *Seven Sacraments) and liturgy of the Christian church are also typologically connected with Old and New Testament events, for example, the sacrament of *Baptism is prefigured by the *Crossing of the Red Sea, and the sacrament of Communion continuously mirrors and fulfills the sacrifice of Christ.

The catalogue of typological connections is lengthy and complicated, and theological advisors may have assisted in the creation of the more elaborate and erudite pictorial programs, such as found in twelfth-century Mosan enamels and Gothic stained glass windows. The concept of typology was an essential guiding factor in the choice, development, and evolution of early Christian and medieval iconography.

Example: Nicholas of Verdun, *Klosterneuberg Altarpiece,* 1181, Klosterneuberg, Stiftsmuseum. (Synder, fig. 434)

U

UNICORN. See ANIMALS, SYMBOLISM OF.

URSULA, SAINT. The basis for the legend of Saint Ursula may be traced to the ninth or tenth century, when an early fifth-century inscription was discovered in Cologne commemorating the dedication of a church to eleven virgin martyrs. A misreading of the Roman numerals of the inscription resulted in their expansion to 11,000 virgins, and a similarly expansive elaboration of the legend (e.g., in the twelfth century by the English historian Geoffrey of Monmouth, in the thirteenth century by Jacobus de Voragine in the *Golden Legend,* and in the fourteenth century visions of Elisabeth of Schonau). Although details diverge, these sources largely recount that Ursula was a Christian princess of Brittany who was sought in matrimony by the son of an English (pagan) king. She had consecrated her virginity to *God; and to avoid war, an *angel advised her to ask for a stay of three years. During this period, she undertook a journey by land and boat, accompanied by ten maidens, each with a thousand companions. After landing at Cologne, they made a *pilgrimage to Rome; upon their return to Cologne they were attacked by Huns. She and all her companions were killed; Ursula was shot with an arrow for refusing to marry the pagan chief. The citizens of Cologne gathered up the remains, and a basilica in their honor was constructed.

Cycles illustrating the story of Saint Ursula and the Eleven Thousand Virgins are numerous in later medieval art, especially panel painting and stained glass. As an independent figure, she is depicted as richly dressed, wearing a crown, holding the arrow of her *martyrdom, and protectively spreading her cloak over a crowd of kneeling maidens who flank her on either side, their hands clasped in *prayer.

Example: Saint Ursula, Book of Hours, c.1440, New York, PML, MS 349, f. 181v. (Marrow, pl. 51)

V

VANITY. See VICES.

VERNICLE. See SUDARIUM; VERONICA, SAINT.

VERONICA, SAINT. Several legends concerning Saint Veronica derive from New Testament *Apocrypha and later additions. The most significant version for medieval artistic iconography identifies her as a woman of Jerusalem who came forward from the crowd and wiped the sweat from *Christ's face with a cloth when he paused in carrying the *cross to the site of his *Crucifixion. The image of Christ's face was miraculously imprinted on this cloth, perhaps offering an explanation for Veronica's name (*vera icon* = true image). The appearance of this image created without human hand but sanctioned by *God (see: *Acheiropoieta*) offered significant support to those in favor of pictorial imagery, especially during the Byzantine *Iconoclastic Controversy. The *relic of Veronica's veil (*Sudarium,* *Holy Face, Vernicle) has been kept in Rome since the eighth century. Veronica may appear in scenes of the procession to *Calvary, often wearing a turban. She also is found as an independent full- or half-length figure, extracted from the pictorial narrative context, holding and displaying the cloth with the image of Christ's face in front of her (see also: *Stations of the Cross). Late medieval works include expanded versions of the Veronica story (she journeyed to Rome to cure the emperor Tiberius with the relic; she accompanied her husband Zacchaeus, *Mary Magdalene, and *Martha to Rocamadour in France; she was the cousin of Saint *John the Baptist). She has also been identified as the *Woman with an Issue of Blood. For eastern variations on a similar story, see: *Mandylion.*

Example: Christ Carrying the Cross, Hours of Etienne Chevalier, c.1450–1455, Chantilly, Musée Condé. (Robb, fig. 213)

VESPERBILD. See PIETA.

VICES. Contrasting to and opposing the catalogue of *virtues necessary for the Christian life, the vices were also avidly described by early Christian and medieval authors and frequently illustrated in art. Authors such as Cassian, Tertullian, *Prudentius, Saint *Gregory the Great, and Saint *Thomas Aquinas were among the many especially concerned with this topic. The seven principle vices (or: Seven Deadly Sins, for which the punishment is eternal damnation) are: *Pride, Covetousness, Lust, Envy, Gluttony, Anger,* and *Sloth.* Related or derivative vices include: *Rebellion, Dishonesty, Despair, Cowardice, Heresy, Intemperance,* and so forth. As with the virtues, variant descriptive terms occur; *Covetousness* is often termed *Greed* or *Avarice,* and *Anger* may be translated as *Wrath.* The vices are represented in medieval art as female warriors battling with the virtues (as described in the *Psychomachia* of Prudentius), in other personified allegorical forms, and in narrative exemplars. Typical formats may include: *Heresy* represented by a figure kneeling before an *idol, *Anger* killing herself with a sword, *Pride* falling from horseback, and *Cowardice* fleeing from small, harmless animals (like rabbits). *Covetousness* and *Lust* were especially popular in art; the former is often shown by a figure hoarding coffers of goods or money, and the latter by a woman whose breasts are attacked by serpents. Comprehensive cycles of virtues and vices are frequently found in Gothic sculpture and stained glass windows.

Example: Virtues and Vices, c.1220, Paris, Notre Dame, west facade, socle reliefs. (Sauerländer, fig. 151)

VINCENT, SAINT. The story of the deacon and martyr Saint Vincent of Saragossa (d. c.304) was recorded by *Prudentius and later much elaborated. The accounts of his tortures provided artistic subject matter especially from the eleventh century following. He was imprisoned, starved, scourged, scraped with iron hooks, and roasted on a spiked gridiron (like Saint *Lawrence). His corpse was guarded by a raven from the attacks of wild beasts and eventually was cast into the sea tied to a millstone, to be miraculously recovered later. He is sometimes shown with a raven, or with the other deacon *saints: *Stephen and Lawrence, wearing the long-sleeved dalmatic (robe).

Example: Martyrdom of Saint Vincent, c.1007, fresco, San Vincenzo a Galliano. (Demus, fig. 3)

VINCENT OF BEAUVAIS. The major work of the French Dominican scholar Vincent of Beauvais (c.1190–c.1264) was the massive and influential encyclopedia: the *Speculum maius,* which he composed between 1244 and 1260, with support from the French king *Louis IX. Drawing from over 400 sources, Vincent arranged the encyclopedia in three parts: the *Speculum naturale (Mirror of Nature)* dealing with natural history and *God's *Creation, the *Speculum historiale (Mirror of History)* concerning the history of humankind from Creation

to 1254, and the *Speculum doctrinale (Mirror of Instruction)* concerning the arts and sciences. The *Speculum morale (Mirror of Morals),* largely derived from the writings of Saint *Thomas Aquinas, was added by an anonymous author c.1310–1315. The *Speculum maius* was frequently copied—whole or in sections—summarized and excerpted. Translations (into several languages) were frequently illustrated, especially for aristocratic patrons. Vincent authored several other works, including a treatise on the education of royal children and a text concerning the *virtues and duties of rulers, but the encyclopedia takes prominence as a comprehensive source of medieval knowledge, thought, and typological method.

Example: Spieghel Historiael (Dutch translation of the *Speculum historiale*), c.1330, The Hague, KB, MS Ak.XX, f. 213v. (De Hamel, fig. 149)

VINE, VINEYARD. Vines, vineyards, grapes, and wine are mentioned frequently in both the Old and New Testaments in both practical and symbolic contexts. The stable conditions required for the practice of viticulture generally make vines, grapes, and wine very positive symbols of peace, prosperity, and *God's favor throughout the Old Testament (with a few exceptions). Jesus referred frequently to viticulture in his teachings, perhaps most notably in his parables of the vineyard and in his elaboration of the figure in which he described himself as the "true vine" and his followers as the fruitful "branches" (*John 15:1–9). When Jesus poured wine and distributed it to the disciples at the *Last Supper, he called the wine his own "blood of the new covenant" (e.g., *Mark 14:24); this action is reenacted in the Christian sacrament of the Eucharist (see: *Seven Sacraments). Vines and grapes thus feature, from the early Christian period onward, as symbols for *Christ and Christianity, and are found on early sarcophagi, in catacomb frescoes, and in all media through the Gothic period. The infant Jesus may be shown holding grapes in representations of the *Madonna and Child; the *miracle of Jesus turning water into wine is illustrated in scenes of the *Marriage at Cana; Jesus distributing wine to the *apostles at the Last Supper is also illustrated in scenes of the *Communion of the Apostles; and Jesus treading on grapes (or squeezed in a winepress producing blood) is found in the image of the *Mystic Wine Press. This subject may appear independently or in cycles illustrating the *Apocalypse, in which *angels are shown harvesting vines and gathering grapes into the "great winepress of the wrath of God" (Rev. 14:15–20). Apart from these symbolic contexts, the harvesting of grapes and production of wine is also often found in medieval cycles of agricultural activities (see: *Labors of the Months).

Example: Leaves and Grape Vines, c.1269, stained glass, Darmstadt, HL. (Grodecki, fig. 202)

VIOL. See MUSICAL INSTRUMENTS, SYMBOLISM OF.

VIOLET. See FLOWERS AND PLANTS, SYMBOLISM OF.

VIRGIN MARY. See MARY, SAINT.

VIRGINS. See SAINTS; WISE AND FOOLISH VIRGINS.

VIRGO. See ZODIAC.

VIRGO INTER VIRGINES. Latin for "Virgin among virgins," the image of the *Virgo inter virgines* developed in later medieval devotional art, especially associated with religious orders and establishments for women. The term refers to the depiction of the *Madonna and Child surrounded by female (virgin) *saints (often identifiable by their attributes); frequently *angels are also included. The image is often found in Books of Hours (see: *Manuscripts) and late medieval altarpieces.

Example: Virgo inter virgines, Book of Hours, c.1480, The Hague, KB, MS 135 K 40, f. 175v. (Marrow, pl. 95)

VIRTUES. Early Christian and medieval theologians devoted much attention to describing and cataloguing the virtues required for Christian life. Saint *Paul (in 1 Cor. 13:13) lists *Faith, Hope,* and *Charity;* to these three "theological" virtues were added the four "cardinal" virtues: *Temperance, Fortitude, Prudence,* and *Justice.* These latter four values were adapted by Saint *Ambrose from the writings of Plato and further expounded by Saint *Augustine, *Isidore of Seville, Hrabanus *Maurus, Saint *Thomas Aquinas, and others. Many other virtues derive from, or represent semantic variations on the canon of the major seven (e.g., *Beneficence, Chastity, Humility, Obedience*). The virtues are represented in a number of different ways in medieval art: as personifications with attributes, in narrative exemplars, and as female warriors paired in combat with their opposite *vices (the later format derived especially from the *Psychomachia* of *Prudentius). Detailed cycles of virtues and vices were especially popular in Gothic sculpture and stained glass windows. *Faith* may be represented by a female figure holding a chalice or *cross-inscribed shield; *Hope* gazes up to *heaven; *Charity* gives alms to the poor; *Humility* holds a small *bird; *Obedience* may be represented with a kneeling camel. The triumph of virtue over vice may be represented by female figures trampling on or spearing contorted figures or *demons.

Example: Virtues Trampling Vices, c.1275, Strasbourg Cathedral, west facade, jamb figures. (Zarnecki, fig. 422)

VISION OF CONSTANTINE. See CONSTANTINE.

VISITATION. The Gospel of *Luke (1:39–56) describes how the Virgin *Mary, informed by the *angel *Gabriel at the *Annunciation that her elderly kinswoman *Elizabeth was pregnant, journeyed to visit her. When the two women greeted each other at Elizabeth's home, Elizabeth, "filled with the Holy

Ghost,'' saluted Mary as the mother of the Lord. They both recognized prophecies being fulfilled; three months later Elizabeth gave birth to Saint *John the Baptist; Mary later gave birth to Jesus. The scene of the Visitation occurs in art as early as the fifth or sixth century and involves either the two women embracing each other or standing apart and conversing. Both types are repeated throughout the Middle Ages. An architectural structure may be indicated as background, and servants or other onlookers may be present. The women may be shown hugging, clasping each other's arms, shaking hands, bowing, or standing quietly and gazing at each other. In late medieval art, the elderly Elizabeth may be shown kneeling in front of Mary, or, tiny figures of the two infants may be indicated on (within) the women—also exchanging greetings. This latter imagery derives from the Byzantine *Platytera and is found only briefly in very late medieval (especially German) representations.

Example: Visitation, c.1230–1233, Reims Cathedral, west portal, jamb figures. (Snyder, fig. 500)

VOLTO SANTO. Italian for ''*Holy Face,'' *Volto Santo* refers especially to a carved wooden crucifix which was venerated in the cathedral at Lucca from the eighth century and was said to have been carved by *Christ's disciple *Nicodemus. It depicts Christ on the cross wearing a long, belted robe *(colobium).* While the present *Volto Santo* at Lucca probably dates from the Gothic period, the iconographic type was frequently copied, especially from the eleventh century onward.

Example: Volto Santo, c.1173, Brunswick Cathedral. (Snyder, fig. 429)

W

WANDREGISILUS, SAINT. See WANDRILLE, SAINT.

WANDRILLE, SAINT. Wandrille (or Wandregisilus, c.600–668) was of noble birth and separated from his wife of an arranged marriage to become a monk in 628 (she became a nun). A disciple of Saint *Omer, and the founder of Fontenelle abbey in Normandy, Wandrille's life was illustrated in a late tenth-century manuscript.

Example: Life of Saint Wandrille, tenth century, Saint Omer, BM, MS 764, f. 9. (Porcher, fig. 7)

WASHING OF THE FEET. According to the Gospel of *John (13:4–17), during the *Last Supper, Jesus paused and washed the feet of the disciples. This act, traditionally performed by slaves (or the hosts of highly respected guests), startled Saint *Peter in particular, who objected to his teacher's actions. Jesus explained the gesture of service, humility, love, and cleansing, and directed the disciples to be willing to serve others rather than expect to be served. The subject appears in art from the early Christian through late medieval period, and the symbolism is also reflected in liturgical and monastic practices where ritual feet washing formed part of the rite of *Baptism during the early Christian period and was performed, especially by monks and bishops, on Maundy Thursday through the Middle Ages. On early sarcophagi, the image may show Jesus (bare-foot and often with a towel around his neck) standing before the seated Peter, who raises his foot over a basin. In early seventh-century manuscripts, the scene becomes more active; Jesus is shown stooping over the basin; Peter gestures toward him, and the disciples stand watching. The motif of the disciples removing their sandals occurs in tenth-century and later examples. Medieval theologians interpreted both the removal of shoes and the feet washing as symbols of cleansing and liberation from sin. Sometimes the seated Peter is shown touch-

ing his own head as Jesus stoops to wash his feet. This makes reference to their conversation (John 13:9) in which, once Peter understood the significance of Jesus' action, he requested that Jesus wash not only his feet but also his head and hands. An architectural background or interior setting is often indicated for this theme. It is sometimes combined or paired with the Last Supper but also occurs as an independent image. The subject is found in all media in both western and Byzantine art (i.e., an *icon illustrating the major feast is traditionally found in *iconostasis programs) through the Middle Ages.

Example: Washing of Feet, c.1300, fresco, Mount Athos, Church of the Protaton. (Rice, fig. 234)

WATCHING OF THE RODS. An event not found in the canonical Gospels but described in some detail in the *Protevangelium of James* (and the *Golden Legend*), the Watching of the Rods refers to the episode in which the elderly *Joseph was selected to become the husband of the Virgin *Mary. The texts recount that the High Priest *Zacharias, directed by an *angel, assembled all the widowers of Judaea and instructed them to bring a wand or rod to the Temple in Jerusalem. These rods were to be given to the priest and then returned to the men; the rod which flowered would signal *God's choice for the groom. Although Joseph was well advanced in years, his rod flowered, and a dove appeared over his head. He was reluctant to take such a young bride, but Zacharias admonished him to fulfill God's will. This episode is sometimes conflated with scenes of the *Marriage of the Virgin and is depicted taking place outside the Temple. The other disappointed candidates may be present (sometimes breaking their rods), while Joseph is shown with a flowering staff and dove hovering above him. This scene is found especially in later medieval cycles illustrating the life of Mary.

Example: Giotto, *Suitors Presenting the Rods*, c.1305, fresco, Padua, Arena Chapel. (Hartt, cp. 24)

WAY TO CALVARY. See CALVARY.

WEDDING AT CANA. See MARRIAGE AT CANA.

WEDDING OF THE VIRGIN. See MARRIAGE OF THE VIRGIN.

WEIGHING OF THE SOULS. See APOCALYPSE; LAST JUDGMENT.

WHEEL OF FORTUNE. A metaphor for the precariousness of human existence, the medieval depiction of the wheel of fortune derives from the classical figure of the goddess Fortuna, the personification of fate, luck, and chance, who is often depicted standing on a wheel or sphere. Medieval authors, such as *Boethius and *Honorius of Autun, expanded the metaphor into a vision of the vanity and transience of wordly pursuits: power, fame, glory, and riches, fol-

lowed by defeat, despair, and poverty. In medieval art the wheel of fortune may be represented by figures perched on a wheel; they are understood to be perpetually rising up and falling down as the wheel revolves. The topmost figure may be crowned and may hold other symbols of power (e.g., a globe or sceptre) while crowns fall from the heads of the descending figures. The wheel is often shown as being turned or cranked by a crowned, or blindfolded, female figure: Dame Fortune.

Example: The Wheel of Fortune, Works of Christine de Pisan, c.1405, Paris, BN, MS fr. 606, f. 35. (Thomas, pl. 18)

WHORE OF BABYLON. See APOCALYPSE.

WIDOW'S SON, RAISING OF THE. See RAISING OF THE WIDOW'S SON.

WILD MAN. The figure of the Wild Man first appears in the late Gothic period as part of the expanding vocabulary of *grotesques and alternately comic and frightening forms which develop in later medieval art (especially as marginalia in manuscripts). He is covered with long hair, shaggy and unkempt, often carries a club or crawls on all fours, and engages in abducting maidens and battling with knights. Akin to *satyrs and *maenads, he is a symbol for uncontrolled behavior, as well as being prone to trickery and practical jokes. A popular subject for literary compositions in the later Middle Ages, Wild Men, as well as Wild Women and Wild Children, were said to dwell in forests; they were adept at hunting all sorts of animals and often ride on unicorns, as depicted in secular art (especially ivories and tapestries) of the fourteenth and fifteenth centuries.

Example: Master of the Playing Cards, King of the Wild Men, c.1440, engraving. (Snyder, NR, fig. 280)

WINE PRESS, MYSTIC. See MYSTIC WINE PRESS.

WISDOM. The term *wisdom* appears throughout the Old and New Testaments in a number of significant contexts. It is both an attribute and a near-personification of *God in the Old Testament, manifested in *Creation, and the presumed "mind" behind world governance and justice as well as the source of certain human actions. Human wisdom is a gift from God, manifested in those who live according to God's will, those who are successful in moral and intellectual decision making. In the ancient Near East, wisdom was related to education, technology, and skill; wise men and women (counsellors) offered advice on practical and theoretical matters. Wisdom also refers to a set of biblical books (e.g., Job, Proverbs, Ecclesiastes, Wisdom of Solomon, Ecclesiasticus) which contain short sayings and advice for successful living or longer monologues or dialogues dealing with spiritual matters, for example, existence and the relationship of God and humans. In the New Testament, Wisdom is

manifested in *Christ (the incarnate Word, or *Logos*). Essential for church leaders and all believers, wisdom is one of the *Seven Gifts of the Holy Spirit.

A subject of continued discussion for early Christian and medieval theologians, in pictorial form Wisdom may be symbolized by King *Solomon, the Virgin *Mary (as *Sedes sapientiae,* the "Throne of Wisdom"), the angelic Saint *(Hagia) Sophia* with her three daughters, Faith, Hope, and Charity, by the figure of *Ecclesia* (*church), and by images of Christ enthroned, often holding a book and accompanied by figures representing the *virtues. In medieval illustrations of the Old Testament Wisdom books, the image of Wisdom may also appear as an enthroned and crowned female figure, holding or surrounded by books. An architectural setting may be indicated, symbolizing the house or Temple of Wisdom (from Proverbs 9:1–2).

Example: The Temple of Wisdom, Bible of Saint-Vaast, c.1025–1050, Arras, BM, MS 559, vol. III, f. 1. (Cahn, fig. 69)

WISE AND FOOLISH VIRGINS. Jesus told the parable of the five wise and five foolish virgins in *Matthew 25:1–13, reminding his audience to be always ready for the second coming and *Last Judgment. The lesson contrasts the well-prepared (wise) virgins, who have supplies of oil for their lamps, with the unprepared (foolish) virgins, who have no oil for their lamps at a critical moment. On the eve of a wedding, the ten went out according to custom to meet and accompany the bridegroom, but the foolish virgins were not ready and needed to purchase more oil for their lamps. In their absence, the wise virgins accompanied the bridegroom to the wedding, and the foolish five returned to find the door shut against them. In art, the foolish virgins are often shown with expressions of dismay, sometimes standing outside the closed door, with their empty vessels turned upside down; the wise virgins are shown with lighted lamps and smiling (often smug) expressions. The subject appears in early Christian manuscripts and was quite popular in Gothic portal sculpture.

Example: Parable of the Wise and Foolish Virgins, Rossano Gospels, sixth century, Rossano, Archepiscopal Treasury, f. 2v. (Synder, fig. 99)

WISE MEN. See ADORATION OF THE MAGI.

WOMAN CLOTHED WITH THE SUN. See APOCALYPSE.

WOMAN OF SAMARIA. The conversation between Jesus and a Samaritan woman at a well is narrated in *John 4. The event took place when Jesus was traveling between Judaea and Galilee through the region of Samaria; the Samaritans, related historically to the northern kingdom of Israel, were regarded with hostility by the *Jews of Jerusalem; but Jesus engaged in a lengthy and significant conversation with the Samaritan woman, who then announced him to her people as Messiah. Their meeting is illustrated in Christian art as early as the third century (e.g., in catacomb frescoes) and is found in various media

up through the twelfth century. The initial popularity of the image is probably due to the references to salvation through *Baptism which Jesus implied in his words concerning the water of "everlasting life" (John 4:14). The story also reveals Jesus' prescient knowledge (of the history and status of this perhaps adulterous woman) and his willingness to engage in conversation with people of all social and religious classes. The scene is always depicted taking place outdoors, around a well; the woman may be drawing up water (for Jesus to drink) with a bucket suspended on a rope, or she may bend over with a bucket to approach the well. Jesus may be shown seated or standing, gesturing toward the woman, indicating speech. Occasionally, additional figures may be present— the disciples who are later mentioned in the text in further conversation with Jesus.

Example: Christ and the Samaritan Woman, c.1475–1500, icon, Athens, Kanellopoulos Museum. (HIHS, pl. 57)

WOMAN TAKEN IN ADULTERY. The Gospel of *John (in certain manuscripts, 8:1–11) describes the incident when some Jewish authorities brought a woman caught in the act of adultery to Jesus in an attempt to entrap him in legal and moral matters and political issues (Jewish law required that adulterers be stoned to *death). Jesus listened, wrote (words unspecified in the text) on the ground, and eventually spoke: "He that is without sin among you, let him first cast a stone at her," at which point the accusers, apparently "convicted by their own consciences," gradually departed. Jesus, left alone with the woman, questioned her; none of her accusers remained, and Jesus did not accuse or condemn her but told her to depart and "sin no more." The subject appears in early Christian art but is more frequent from the ninth century through the early Gothic period. Jesus is normally depicted seated, gesturing toward the woman; he may also point to, or be shown writing on, the ground. Sometimes the words he writes are legible, for example, a portion of his spoken reply to the accusers. The accusers are normally shown; they may be presenting the woman to Jesus, holding stones in readiness, or turning to depart. The woman may hang her head in shame, cringe, or raise her hands in acknowledgment of Jesus' words. One or two disciples may be present.

Example: Christ and the Woman Taken in Adultery, c.1072–1087, fresco, Sant' Angelo in Formis, nave, north wall. (Demus, fig. 27)

WOMAN WITH AN ISSUE OF BLOOD. The *miracle of Jesus healing a woman with a persistant hemorrhage is represented in art from as early as the fourth century. The episode is recounted in the Gospels of *Matthew, *Mark, and *Luke, which describe that when Jesus was en route to the house of Jairus (who had summoned Jesus to his daughter's deathbed; see: *Raising of Jairus's Daughter), a woman emerged from the crowd and touched Jesus' robe as he walked by. She was immediately cured of her prolonged illness. When Jesus sensed what had happened, he turned and spoke to her as she fearfully fell on the ground. He reassured her that her faith had made her whole. In fourth- and

fifth-century examples, the woman may be shown kneeling and touching or pulling on Jesus' robe as he turns around and gestures toward her (sometimes he touches her head) while speaking to her or to one of the disciples. Jairus may also be present. Sixth-century mosaics show the woman throwing herself on the ground in front of Jesus as he gestures toward her. The image remains thus presented through the later centuries, with a tendency to an increased number of witnessing figures (the "crowd" described in the Gospels). The unnamed woman was associated, in later sources, with Saint *Veronica and also identified as *Martha (the sister of Lazarus).

Example: Healing of the Woman with an Issue of Blood, fourth–fifth century, ivory casket, Brescia, Museo Civico Cristiano. (Rodley, fig. 36)

WORSHIP OF THE GOLDEN CALF. The Golden Calf was an *idol, constructed by *Moses' brother, the priest *Aaron, at the request of the Israelites. It was created from golden ornaments which the Israelites donated and was set up as an object of worship during Moses' absence on *Mount Sinai (Exodus 32). This greatly angered *God and Moses who, upon his return, seeing the Israelites singing and dancing before the idol, broke the Tablets of the Law which he had received from God, melted down the Golden Calf, ground it into powder, mixed it with water, and made the Israelites drink it. The Golden Calf appears primarily in Romanesque and later biblical illustrations; it is elevated on an altar or pedestal and the Israelites are shown dancing, singing, blowing trumpets, or bowing down before it. The scene is often combined with Moses receiving and breaking the Tablets of the Law (occasionally on the head of the Golden Calf). The scene of the destruction of the idol is also found in Romanesque and Gothic frescoes, sculpture, and manuscripts.

Example: Worship of the Golden Calf, Somme le Roi, c.1311, Paris, BA, MS 6329, f. 7v. (Alexander, fig. 200)

WRATH. See VICES.

WRITER. See AUTHOR.

Z

ZACHARIAS. The priest Zacharias was the father of Saint *John the Baptist and the husband of Saint *Elizabeth. *Luke (1:5–25) suggests his lack of belief when an *angel appeared to him in the Temple and announced that the elderly and childless couple would have a son; the angel indicated that Zacharias (who had asked for a sign) would remain mute until the birth of the child. Zacharias regained his speech when he concurred (in writing) with Elizabeth that the child would be called John. Zacharias may thus be shown holding a finger to his lips or present at the birth of John the Baptist writing on a tablet. Apocryphal sources also name Zacharias as the priest present at the betrothal of Mary (see: *Marriage of the Virgin, *Watching of the Rods) and describe his murder in the Temple when *Herod's soldiers were searching for Elizabeth and the infant John during the *Massacre of the Innocents. He is often dressed in priestly robes, holds a censer, and may carry a knife (symbolizing the violent nature of his *death).

 Example: Virgin and Child with Zacharias and Saint John the Baptist, c.810, Lorsch Gospels, ivory cover, London, V&A. (Synder, fig. 268)

ZECHARIAH. One of the twelve minor *prophets, Zechariah lived in the late sixth century B.C., when the *Jews had returned from exile in Babylon but had not yet rebuilt the Temple in Jerusalem—a project which he encouraged them to do. His book (part of which may come from a later era) contains a number of dramatic visions, prophecies, and promises emphasizing the advent of the Messiah ("anointed one") which Christians understood to predict the coming of *Christ. Hence, Zechariah and illustrations of his prophecies are featured in medieval art, especially in typological and allegorial illustration schemes. In particular, his prophecy (9:9) of the king riding humbly on an ass was understood to prefigure Christ's *Entry into Jerusalem, and his vision of a man paid thirty pieces of silver for releasing sheep to be slaughtered was seen as a pre-

figuration of *Judas receiving the same sum for betraying Christ. He is shown as an elderly, bearded figure, holding a scroll, or a seven-branched candlestick (described in another of his many visions).

Example: Zechariah, Bible of Saint-Laurent de Liège, c.1150, Brussels, BR, MS 9642–44, f. 133v. (Cahn, fig. 150)

ZENO, SAINT. The African-born Zeno (d. c.372) was bishop of Verona from c.361. Famed for his *preaching and charity, he authored numerous sermons and zealously fought against the Arian heresy. A number of *miracles attributed to Zeno are illustrated in art, especially *exorcisms. Normally depicted as a bishop, dark-skinned Zeno is often shown fishing or with a *fish hanging from his crozier. This detail may derive from an episode in his legend when he was called away from fishing to exorcize a *demon from the emperor's daughter and a fish stolen from him could not be cooked. Alternately, the fish symbol may refer to his position as a fisher of *souls. Eleventh-century bronze doors of the cathedral of San Zeno at Verona contain several scenes from his life.

Example: Saint Zeno, c.1398, fresco, Parma, Baptistery. (Kaftal, NW, fig. 941)

ZENOBIUS, SAINT. Zenobius (c.334–424), the bishop of Florence, is represented especially in Italian art of the later medieval and Renaissance period. Eleventh-century legends credit him with numerous *miracles (reviving to life a child trampled by oxen and several other similar incidents) and describe that upon his *death, citizens wishing to touch his body pushed it against a dead tree which miraculously grew new leaves. He thus may be depicted with a dead tree bursting into new growth, garbed as a bishop.

Example: Scenes from the Life of Saint Zenobius, c.1240–1250, panel, Florence, Opera del Duomo. (Kaftal, Tuscan, fig. 1161)

ZODIAC. The term *zodiac* derives from the Greek *zoion* (''animal,'' ''living being,'' ''figure''), signifying the imaginary forms created by the stars in twelve major constellations through which the sun passes each year. Developed as navigational aids in ancient Eastern and Near Eastern cultures, the signs of the zodiac are found in classical art and enter the vocabulary of early Christian and medieval art relatively unaltered from the Greek and Roman forms. Each sign is roughly associated with the duration of one month and depicted, as follows: *Aquarius* (January/February), the water bearer, a man pouring water from a jug; *Pisces* (February/March), two fish; *Aries* (March/April), the ram; *Taurus* (April/May), the bull; *Gemini* (May/June), a set of human twins; *Cancer* (June/July), the crab; *Leo* (July/August), the lion; *Virgo* (August/September), the virgin; *Libra* (September/October), the scales, sometimes held by a human figure; *Scorpio* (October/November), the scorpion; *Sagittarius* (November/December), the archer; *Capricorn* (December/January), a goat with fishtail. The signs of the zodiac are found in a variety of medieval art contexts: in illustrated calendars, especially in Martyrologies and Books of Hours (see: *Manuscripts), as mosaic

pavements in churches, and in Romanesque and Gothic portal sculpture and stained glass. They represent the order of the cosmos as created and directed by *God and are frequently accompanied by the *Labors of the Months. They appear in scientific/astrological treatises (e.g., see: *Aratus) and in astrological/medical diagrams indicating the influence of constellations over human organs and body parts (e.g., the zodiac man). The twelve signs of the zodiac are also associated with the twelve *apostles (replacing the pagan gods) and, in various groupings, with the four archangels (see: *angels), *Four Evangelists, and *Four Elements.

Example: Calendar, c.1225–1235, Amiens Cathedral, west portal, socle. (Sauerländer, fig. 172)

ZOOMORPHIC DECORATION. Zoomorphic decoration refers to patterns based on animal shapes, often abstracted and interlaced, found especially in the early medieval art of northern Europe. Common to many ancient and nomadic cultures (e.g., Celtic, Scythian), zoomorphic ornament appears particularly in Anglo-Saxon, Hiberno-Saxon, Scandinavian, and Viking art, both Christian and non-Christian, in sculpture, manuscripts, and metalwork, and continued to be popular, with variations, into the Romanesque period. The symbolism of entangled, often battling, *birds, beasts, and snakes may have sources in pre-Christian mythology and/or may symbolize the combat of good and evil.

Example: Carved doorway, late eleventh century, Urnes Stave Church. (Zarnecki, fig. 199)

Selected Bibliography

GENERAL SOURCES

Attwater, D. *The Avenel Dictionary of Saints*. New York: Avenel Books, 1981.

Biedermann, H. *Dictionary of Symbolism: Cultural Icons and the Meanings behind Them*. New York: Meridian, 1994.

Butler, A. *Butler's Lives of the Saints*. New York: P. J. Kenedy, 1956.

Christe, Y., et al. *Art of the Christian World A.D. 200–1500: A Handbook of Styles and Forms*. New York: Rizzoli, 1982.

Cohn-Sherbok, D. *A Dictionary of Judaism and Christianity*. Philadelphia, PA: Trinity Press, 1991.

Cross, F. L. *The Oxford Dictionary of the Christian Church*. London: Oxford University Press, 1958.

Delaney, J. *Dictionary of Saints*. Garden City, NY: Doubleday, 1980.

Dictionary of the Middle Ages. J. R., Strayer, editor-in-chief. 13 vols. New York: Scribner, 1982–1989.

Duchet-Suchaux, G., and M. Pastoureau. *The Bible and the Saints*. Paris: Flammarion, 1994.

Farmer, D. H. *The Oxford Dictionary of Saints*. Oxford: Clarendon Press, 1978, 1982.

Ferguson, E., ed. *Encyclopedia of Early Christianity*. New York: Garland, 1990.

Ferguson, G. *Signs and Symbols in Christian Art*. New York: Oxford University Press, 1967.

Garnier, F. *Le langage de l'image au môyen age*. 2 vols. Paris: Le Léopard d'Or, 1982.

Hall, James. *Dictionary of Subjects and Symbols in Art*. New York: Harper and Row, 1974.

Hughes, A. *Medieval Manuscripts for Mass and Office: A Guide to Their Organization and Terminology*. Toronto: University of Toronto Press, 1982.

Jacobus de Voragine. *The Golden Legend: Readings on the Saints*. W. Ryan, trans. 2 vols. Princeton: Princeton University Press, 1993.

Jameson, A. B. *Legends of the Monastic Orders*. Boston: Houghton Mifflin, 1895.

Jones, A. *Saints*. Edinburgh: W. and R. Chambers, 1992.

Kelly, S., and R. Rogers. *Saints Preserve Us!* New York: Random House, 1993.

Kirschbaum, E., et al. *Lexikon der Christlichen Ikonographie*. 4 vols. Freiburg im Breisgau: Herder, 1968–1972.

Künstle, K. *Ikonographie der Christlichen Kunst*. 2 vols. Freiburg im Breisgau: Herder, 1924–1928.

Metford, J. C. J. *Dictionary of Christian Lore and Legend*. London: Thames and Hudson, 1983.

Réau, L. *Iconographie de l'art chrétien*. 6 vols. Paris: Presses Universitaires de France, 1955–1959.

Schiller, G. *Iconography of Christian Art*. 2 vols. Greenwich, CT: New York Graphic Society, 1971–1972.

Snyder, J. *Medieval Art: Painting, Sculpture, Architecture, 4th-14th Century*. Englewood Cliffs, NJ: Prentice-Hall, 1989.

Stokstad, M. *Medieval Art*. New York: Harper and Row, 1986.

Zarnecki, G. *Art of the Medieval World*. New York: Harry N. Abrams, 1975.

STUDIES OF SPECIFIC PERIODS AND MEDIA

Alexander, J. J. G. *The Decorated Letter*. New York: Braziller, 1978.

––––––. *Medieval Illuminators and Their Methods of Work*. New Haven, CT: Yale University Press, 1992.

Avril, F. *Manuscript Painting at the Court of France: The Fourteenth Century (1310–1380)*. New York: Braziller, 1978.

Beckwith, J. *Early Medieval Art*. New York: Praeger, 1964, 1969.

Boase, T. *English Art 1100–1216*. Oxford: Clarendon Press, 1953.

Bologna, G. *Illuminated Manuscripts: The Book before Gutenberg*. New York: Weidenfeld and Nicolson, 1988.

Branner, R. *Manuscript Painting in Paris during the Reign of St. Louis*. Berkeley: University of California Press, 1977.

Cahn, W. *Romanesque Bible Illumination*. Ithaca, NY: Cornell University Press, 1982.

Calkins, R. *Illuminated Books of the Middle Ages*. Ithaca, NY: Cornell University Press, 1983.

Caviness, M. *The Early Stained Glass of Canterbury Cathedral*. Princeton: Princeton University Press, 1977.

Cormack, R. *Writing in Gold: Byzantine Society and Its Icons*. New York: Oxford University Press, 1985.

Cuttler, C. *Northern Painting from Pucelle to Bruegel*. New York: Holt, Rinehart and Winston, 1968.

D'Ancona, P., and E. Aeschlimann. *The Art of Illumination*. London: Phaidon, 1969.

De Hamel, C. *A History of Illuminated Manuscripts*. Oxford: Phaidon, 1986.

Demus, O. *The Mosaic Decoration of San Marco, Venice*. Chicago: University of Chicago Press, 1988.

––––––. *Romanesque Mural Painting*. New York: Harry N. Abrams, 1970.

Dodwell, C. R. *The Pictorial Arts of the West: 800–1200*. New Haven, CT: Yale University Press, 1993.

––––––. *Theophilus: The Various Arts*. London: Nelson, 1961.

Eorsi, A. *International Gothic Style in Painting*. Budapest: Corvina, 1984.

Gaehde, J., and F. Mütherich. *Carolingian Painting.* New York: Braziller, 1976.

Gough, M. *The Origins of Christian Art.* London: Thames and Hudson, 1974.

Grabar, A., and C. Nordenfalk. *Early Medieval Painting from the Fourth to the Eleventh Century.* Lausanne: Skira, 1957.

———. *Romanesque Painting from the Eleventh to the Thirteenth Century.* Lausanne: Skira, 1958.

Greek Ministry of Culture. *Holy Image, Holy Space: Icons and Frescoes from Greece.* Athens: Byzantine Museum, 1988.

Grodecki, L., and C. Brisac. *Gothic Stained Glass: 1200–1300.* Ithaca, NY: Cornell University Press, 1985.

Harthan, J. *The Book of Hours.* New York: Park Lane, 1977.

Hartt, F. *History of Italian Renaissance Art: Painting, Sculpture, Architecture.* New York: Harry N. Abrams, 1994.

Hearn, M. *Romanesque Sculpture.* Ithaca, NY: Cornell University Press, 1981.

Hubert, J. *Europe of the Invasions.* New York: Braziller, 1969.

Hubert, J., J. Porcher, and W. F. Volbach. *The Carolingian Renaissance.* New York: Braziller, 1970.

Hutter, I. *Early Christian and Byzantine Art.* London: Weidenfeld and Nicolson, 1971.

Katzenellenbogen, A. *The Sculptural Programs of Chartres Cathedral.* Baltimore: Johns Hopkins Press, 1959.

Kauffmann, C. M. *Romanesque Manuscripts: 1066–1190.* Vol. 3, *A Survey of Manuscripts Illuminated in the British Isles.* London: Harvey Miller, 1975.

Künstler, G. *Romanesque Art in Europe.* Greenwich, CT: New York Graphic Society, 1968.

Lasko, P. *Ars Sacra: 800–1200.* Harmondsworth: Penguin, 1972.

Mâle, E. *The Gothic Image.* New York: Harper and Row, 1958.

———. *Religious Art in France, The Late Middle Ages.* Princeton, NJ: Princeton University Press, 1986.

———. *Religious Art in France, The Twelfth Century.* Princeton, NJ: Princeton University Press, 1978.

Marrow, J. *The Golden Age of Dutch Manuscript Painting.* New York: Braziller, 1990.

Martindale, A. *Gothic Art from the Twelfth to the Fifteenth Century.* London: Thames and Hudson, 1967.

Meiss, M. *Painting in Florence and Siena after the Black Death.* Princeton, NJ: Princeton University Press, 1951.

Morgan, N. *Early Gothic Manuscripts (I): 1190–1250.* Vol. 4.1, *A Survey of Manuscripts Illuminated in the British Isles.* London: Harvey Miller, 1982.

———. *Early Gothic Manuscripts (II): 1250–1280.* Vol. 4.2, *A Survey of Manuscripts Illuminated in the British Isles.* London: Harvey Miller, 1988.

Nordenfalk, C. *Celtic and Anglo-Saxon Painting: Book Illumination in the British Isles, 600–800.* New York: Braziller, 1977.

Ohlgren, Thomas, ed. *Insular and Anglo-Saxon Illuminated Manuscripts: An Iconographic Catalogue C. A.D. 625 to 1100.* New York: Garland, 1986.

Ouspensky, L., and V. Lossky. *The Meaning of Icons.* Crestwood, NY: Saint Vladimir's Seminary Press, 1983.

Pächt, O. *Book Illumination in the Middle Ages.* London: Harvey Miller, 1986.

Porcher, J. *French Miniatures from Illuminated Manuscripts.* London: Collins, 1960.

Rice, D. T. *Art of the Byzantine Era.* London: Thames and Hudson, 1963.

Rickert, M. *Painting in Britain: The Middle Ages*. Harmondsworth: Penguin, 1954, 1965.

Robb, D. M. *The Art of the Illuminated Manuscript*. Cranbury, NJ: A. S. Barnes, 1973.

Rodley, L. *Byzantine Art and Architecture: An Introduction*. Cambridge: Cambridge University Press, 1994.

Sauerländer, W. *Gothic Sculpture in France: 1140–1270*. London: Thames and Hudson, 1972.

Seidel, L. *Songs of Glory: The Romanesque Facades of Aquitaine*. Chicago: University of Chicago Press, 1981.

Snyder, J. *Northern Renaissance Art: Painting, Sculpture, the Graphic Arts from 1350 to 1575*. Englewood Cliffs, NJ: Prentice-Hall, 1985.

Stone, L. *Sculpture in Britain: The Middle Ages*. Harmondsworth: Penguin, 1955.

Swaan, W. *The Late Middle Ages: Art and Architecture from 1350 to the Advent of the Renaissance*. London: Elek Books, 1977.

Swarzenski, H. *Monuments of Romanesque Art*. Chicago: University of Chicago Press, 1967.

Thomas, M. *The Golden Age: Manuscript Painting at the Time of Jean, Duc de Berry*. London: Chatto and Windus, 1979.

Volbach, W. F. *Early Christian Art*. New York: Harry N. Abrams, 1961.

Weitzmann, K. *The Icon: Holy Images, Sixth to Fourteenth Century*. New York: Braziller, 1978.

———. *Late Antique and Early Christian Book Illumination*. New York: Braziller, 1977.

———. *Studies in Classical and Byzantine Manuscript Illumination*. Chicago: University of Chicago Press, 1971.

Weitzmann, K., et al. *The Icon*. New York: Dorset Press, 1987.

Wieck, R. *Time Sanctified: The Book of Hours in Medieval Art and Life*. New York: Braziller, 1988.

Williams, J. *Early Spanish Manuscript Illumination*. New York: Braziller, 1977.

STUDIES OF SPECIFIC PICTORIAL THEMES

Abou-el-Haj, B. *The Medieval Cult of Saints: Formations and Transformations*. Cambridge: Cambridge University Press, 1994.

Beer, R. *Unicorn: Myth and Reality*. New York: Mason/Charter, 1977.

Bise, G. *Medieval Hunting Scenes "The Hunting Book" by Gaston Phoebus*. Fribourg: Productions Liber, 1978.

Blunt, W., and S. Raphael. *The Illustrated Herbal*. New York: Thames and Hudson, 1979.

Boeckler, A. *Das Stuttgarter Passionale*. Augsburg: Dr. Filser Verlag, 1923.

Borenius, T. *Saint Thomas Becket in Art*. Port Washington, NY: Kennikat Press, 1931.

Camille, M. *The Gothic Idol: Ideology and Image-making in Medieval Art*. Cambridge: Cambridge University Press, 1989.

———. *Image on the Edge: The Margins of Medieval Art*. Cambridge, MA: Harvard University Press, 1992.

Clark, W., and M. McMunn, eds. *Beasts and Birds of the Middle Ages: The Bestiary and Its Legacy*. Philadelphia: University of Pennsylvania Press, 1989.

Colledge, E., and J. Marler. "Céphalogie, A Recurring Theme in Classical and Medieval Lore." *Traditio* 37 (1981):411–426.

Davidson, C., ed. *The Iconography of Heaven*. Kalamazoo, MI: Medieval Institute Publications, 1994.

Egbert, V. W. *The Medieval Artist at Work*. Princeton, NJ: Princeton University Press, 1967.

Eleen, L. *The Illustrations of the Pauline Epistles in French and English Bibles of the Twelfth and Thirteenth Centuries*. Oxford: Clarendon Press, 1982.

Forsyth, I. *The Throne of Wisdom: Wood Sculptures of the Madonna in Romanesque France*. Princeton, NJ: Princeton University Press, 1972.

Friedman, J. *The Monstrous Races in Medieval Art and Thought*. Cambridge, MA: Harvard University Press, 1981.

Friedmann, H. *A Bestiary for Saint Jerome: Animal Symbolism in European Religious Art*. Washington, D.C.: Smithsonian Institution Press, 1980.

Godwin, M. *Angels: An Endangered Species*. New York: Simon and Schuster, 1990.

Goodburn, R., and P. Bartholomew, eds. *Aspects of the Notitia Dignitatum*. Oxford: British Archaelogical Reports, Supplementary Series 15, 1976.

Grabar, A. *Christian Iconography: A Study of Its Origins*. Princeton, NJ: Princeton University Press, 1968.

Jones, C. W. *Saint Nicholas of Myra, Bari and Manhattan*. Chicago: University of Chicago Press, 1978.

Kaftal, G. *Iconography of the Saints in Central and South Italian Painting*. Florence: Sansoni, 1965.

———. *Iconography of the Saints in the Painting of North East Italy*. Florence: Sansoni, 1978.

———. *Iconography of the Saints in the Painting of North West Italy*. Florence: Casa Editrice le Lettere, 1985.

———. *Iconography of the Saints in Tuscan Painting*. Florence: Sansoni, 1952.

Kantorowicz, E. "The Quinity of Winchester." *Art Bulletin* 29 (1947):73–85.

Kartsonis, A. *Anastasis: The Making of an Image*. Princeton, NJ: Princeton University Press, 1986.

Katzenellenbogen, A. *Allegories of the Virtues and Vices in Medieval Art*. London: Warburg Institute, 1939.

Klingender, F. *Animals in Art and Thought to the End of the Middle Ages*. Cambridge, MA: Massachusetts Institute of Technology Press, 1971.

Kraus, H. *The Living Theatre of Medieval Art*. Bloomington, IN: Indiana University Press, 1967.

Loomis, R., and L. Loomis. *Arthurian Legends in Medieval Art*. New York: Modern Language Association of America, 1938, 1966, 1975.

McCulloch, F. *Mediaeval Latin and French Bestiaries*. Chapel Hill: University of North Carolina Press, 1960, 1962.

McDannell, C., and B. Lang. *Heaven: A History*. New Haven, CT: Yale University Press, 1988.

Murdoch, J. *Album of Science: Antiquity and the Middle Ages*. New York: Charles Scribner's Sons, 1984.

Pächt, O. "The Illustrations of Saint Anselm's Prayers and Meditations." *Journal of the Warburg and Courtauld Institutes* 19 (1956):68–83.

Panofsky, E. "Imago Pietatis." In *Festschrift Für Max Friedländer*, 261–308. Leipzig: E. A. Seemann, 1927.

Randall, L. *Images in the Margins of Gothic Manuscripts*. Berkeley: University of California Press, 1966.

Ross, L. *Text, Image, Message: Saints in Medieval Manuscript Illustrations*. Westport, CT: Greenwood Press, 1994.

Russell, J. B. *Lucifer: The Devil in the Middle Ages*. Ithaca, NY: Cornell University Press, 1984.

Scheller, R. W. *A Survey of Medieval Model Books*. Haarlem: De Erven F. Bohn, 1963.

Ševčenko, N. *The Life of Saint Nicholas in Byzantine Art*. Bari: Centro Studi Bizantini, 1983.

Unterkircher, F. *King René's Book of Love*. New York: Braziller, 1975.

Van Der Meer, F. *Apocalypse: Visions from the Book of Revelation in Western Art*. New York: Alpine Fine Arts Collection, 1978.

Voelkle, W. *The Stavelot Triptych: Mosan Art and the Legend of the True Cross*. New York: Oxford University Press, 1980.

Watson, A. *The Early Iconography of the Tree of Jesse*. Oxford: Oxford University Press, 1934.

Webster, J. C. *The Labors of the Months in Antique and Medieval Art to the End of the Twelfth Century*. Princeton, NJ: Princeton University Press, 1938.

Wilson, A., and J. Wilson. *A Medieval Mirror: Speculum Humanae Salvationis, 1324–1500*. Berkeley: University of California Press, 1984.

Winternitz, E. *Musical Instruments and Their Symbolism in Western Art*. London: Faber and Faber, 1967.

General Index

Boldface page numbers indicate location of main entries.

Index of Saints

About the Author

LESLIE ROSS is Professor and Chair of the Art History department at Dominican College of San Rafael. She has received numerous grants, including a Fulbright to the United Kingdom and a Graves Award for Excellence in Teaching in the Humanities. She is the author of *Text, Image, Message: Saints in Medieval Manuscript Illustrations* (Greenwood Press, 1994).

ISBN 0-313-29329-5

90000>

9 780313 293290

HARDCOVER BAR CODE